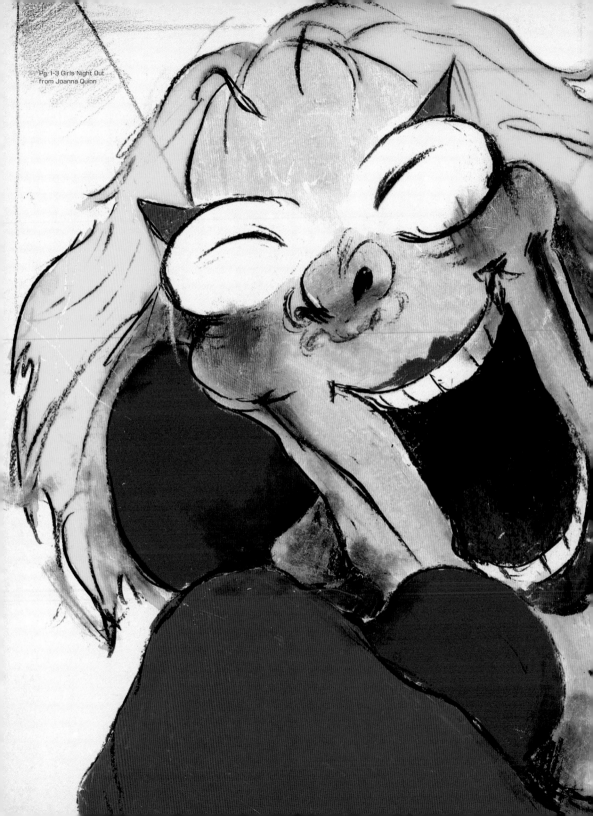

Pg. 1-3 Girls Night Out
from Joanna Quinn

ANIMATION NOW!

Anima Mundi
Ed. Julius Wiedemann

TASCHEN

HONG KONG KÖLN LONDON LOS ANGELES MADRID PARIS TOKYO

INTRODUCTION

Aída Queiroz, Cesar Coelho, Léa Zagury and Marcos Magalhães

A FEW WORDS FROM THE EDITORS

Movement is created from still images. Once the movement has been recorded on film, video, bytes or by means of some other process or system yet to be invented, the animator is no longer much interested in the images. The animator's objective and passion are to alter, extend or even destroy the images in order to achieve one fundamental objective, which is movement, action.

This book, which was compiled by the four animators who direct Anima Mundi – The International Animation Film Festival of Brazil – uses the reverse process, and in its pages it immobilizes the images that make up some of the most beautiful movements created in the world. This is done with just cause: the paintings, drawings, photos, collages, puppets, in short, all of these works of art, deserve to be contemplated longer than just the fractions of seconds that they are flashed on the movie screen.

This reissue of *Animation Now!*, first published in 2004, forms a part of the comemoration to the 25th anniversary of the TASCHEN publisher. This work offers a panorama of current animation, and it attempts to be as complete as possible. The most diverse techniques have been considered, from simple *graffiti* on paper and sand on glass to the generation of computer images and hybrid languages that are endlessly being developed. It includes the sophisticated work derived from the plastic arts and the swift lines of impact communication. There is a place for narrative elements and experimental fragments, for the concrete and the abstract, and for paying homage to the past and to the seeds of the future.

Despite their efforts, it was impossible to include all the artists, studios and animation schools that deserve to appear in an anthology. Animation has experienced a burst of popularity around the world. Thousands of artists emerge each year and thousands of films inundate festivals like Anima Mundi, in search of their place in cinemas, television, Internet and in the minds and senses of an enthusiastic public. The series of images that appears in these pages does not intend to be a catalogue of the names of active animators, but rather a display of the diversity and excellence that this art achieved in the millennium that just ended.

This book is dedicated to the reader who, if they do not already share our passion, will certainly be fascinated by this universe, where nothing is impossible and all forms of expression and movement are welcomed and appreciated.

UN MOT DES ÉDITEURS

À partir d'images fixes naît le mouvement qui, une fois enregistré sur l'un des supports vidéo actuels ou à venir, rend ces images d'origine sans grand intérêt pour l'animateur. Ce dernier n'a pour seul objectif et passion que de les déformer, de les étirer, voire de les détruire pour finalement les mettre en mouvement et créer une action.

Élaboré par les quatre animateurs à la tête d'Anima Mundi, le festival international d'animation du Brésil, cet ouvrage suit la démarche inverse et vient figer les images composant les plus beaux mouvements créés à ce jour pour servir une juste cause. En effet, tous ces cadres, dessins, photos, collages, marionnettes, toutes ces œuvres d'art en somme, méritent d'être contemplées plus que le temps de quelques fractions de seconde d'apparition à l'écran.

Cette réédition de *Animation Now!*, publié pour la première fois en 2004, fait partie du programme de célébration du 25^e anniversaire des éditions TASCHEN. Ce livre offre donc un panorama actuel de l'animation aussi complet que possible. Y est abordée une grande variété de techniques, du simple graffiti sur papier ou du sable sur verre à la génération d'images par ordinateur et aux langages hybrides qui ne cessent de voir le jour. Ces pages présentent également le travail sophistiqué venant des arts plastiques et le tracé vif comme mode efficace de communication. Des éléments de narration et des extraits d'expériences y trouvent aussi leur place : s'enchaînent alors concret et abstrait, hommage au passé et regard vers l'avenir.

Il est pourtant impossible de répertorier tous les artistes, studios et écoles d'animation méritant de figurer dans une anthologie. L'animation a connu une véritable explosion à l'échelle mondiale et chaque année voit naître des milliers d'artistes et de films inondant des festivals comme Anima Mundi. Tous tentent de se faire une place au cinéma, sur le petit écran, sur Internet et dans l'esprit d'un public passionné. Par conséquent, plus qu'un catalogue de noms d'artistes en activité, le défilé d'images qui suit prétend donner un échantillon de la diversité et de l'excellence atteintes par cet art depuis la fin du siècle passé.

Ce livre est dédié au lecteur qui, sans partager encore notre passion, se fera au moins adepte de cet univers où tout est possible et où n'importe quelle forme d'expression et de mouvement est bienvenue.

EINLEITENDE WORTE DER HERAUSGEBER

Die Bewegung geht von festen Bildern aus. Sobald die Bewegung einmal auf Zelluloid, Magnetbänder, digitale Datenträger oder auf sonst einen Bildträger mit der entsprechenden Technik gebannt ist, erlischt das Interesse des Trickfilmers an besagten Bildern. Seine Absicht und seine Leidenschaft gelten der Veränderung, der Ausweitung und sogar der Zerstörung von Bildern, um das vordringliche Ziel zu erreichen, das da heißt: Bewegung, Handlung.

Das vorliegende Buch, das von vier Trickfilmern zusammengestellt wurde, die das Internationale Festival für Animation „Anima Mundi" in Brasilien leiten, beschreitet den umgekehrten Weg und fixiert Bilder – Bilder, die Bestandteil von einigen der schönsten Bewegungsabläufe der Welt sind. Und das aus gutem Grund: diese Gemälde, Zeichnungen, Fotos, Collagen, Puppen, ja letzten Endes all diese Kunstwerke verdienen es, nicht nur während der Sekundenbruchteile betrachtet zu werden, in denen sie normalerweise auf der Leinwand zu sehen sind.

Die Neuauflage der Originalausgabe von *Animation now!* (2004) erscheint im Rahmen des Jubiläumsprogramms anlässlich des 25-jährigen Bestehens des TASCHEN Verlags. Dieses Buch präsentiert ein möglichst umfassendes Panorama der aktuellen Animationskunst. Dabei wurden die unterschiedlichsten Techniken berücksichtigt, angefangen beim einfachen Graffiti auf Papier oder Sand auf Glas bis hin zur Generation computergenerierter Bilder und den Mischsprachen, die sich pausenlos entwickeln. Es fehlt weder die raffinierte Arbeit, die sich aus der bildenden Kunst herleitet, noch der rasche Strich einer treffsicheren Kommunikation. Erzählerische Elemente finden genauso ihren Platz wie experimentelle Fragmente, das Konkrete genauso wie das Abstrakte, die Würdigung der Vergangenheit genauso wie der Keim der Zukunft.

Dennoch konnten nicht alle Künstler, Studios und Schulen für Bildanimation in diese Anthologie aufgenommen werden, wenngleich sie es verdient hätten. Die Welt hat eine Explosion der Animation erlebt. Tausende von Künstlern tauchen jedes Jahr neu auf und Tausende von Filmen überschwemmen Festivals wie Anima Mundi; sie suchen ihren Platz in den Kinos, im Fernsehen, im Internet und in der sinnlichen und mentalen Wahrnehmung eines begeisterten Publikums. Die Bildparade, die hier an uns vorüberzieht, will mehr noch als ein Namenskatalog aktiver Trickfilmer eine Schau der Vielfalt und Vorzüglichkeit sein, zu der es diese Kunst in gerade abgeschlossenen Jahrtausend gebracht hat.

Das Buch ist einem Leser gewidmet, der sich, wenn er nicht ohnehin schon unsere Leidenschaft teilt, von dieser Welt, in der nichts unmöglich und jegliche Ausdrucks- und Bewegungsform willkommen ist und geschätzt wird, verführen lässt.

CONTENTS

AARDMAN ANIMATIONS

United Kingdom
Gas Ferry Road, Bristol,
England BS1 6UN
E-mail: mail@aardman.com
Phone: +44 (0) 117 984 8485

Animated Conversations, 1978
Conversation Pieces, 5 shorts,
1981-1983
Sledgehammer, 1986
My Baby Just Cares for Me, 1987
Lip Synch, 5 shorts, 1989
A Grand Day Out, 1989
Adam, 1991
The Wrong Trousers, 1993
Pib & Pog, 1994
A Close Shave, 1995
Wat's Pig, 1996
Stage Fright, 1997
Rex the Runt, series, 1997/2001
Angry Kid, series, 1999/2002
Chicken Run, 2000
Creature Comforts, series, 2003

8th MTV Award, 1987
Academy Award Best Animated
Short, 1991/1994/1996.
Best Animation BAFTA,
1990/1994/1996/1998
Golden Hugo Chicago, 1990/1993
Best Children's Film Zagreb, 1990
Special Jury Prize Annecy, 1991
Grand Prize Espinho, 1993
Grand Prix Zagreb, 1994
Grand Prix Ottawa, 1994
Special Jury Prize Ottawa, 1996
Emmy Award, 1996
First Prize and Best Stop motion
WAC/USA, 1997
Audience Prize Annecy, 1997
Special Jury Prize Hiroshima, 2000

Stop-motion animation,
Computer Generated
Imagery (CGI)
Pixillation
Mixed techniques

AARDMAN

www.aardman.com

Everything began with Aardman, a rather inept superhero that school friends Peter Lord and David Sproxton created with a small 16 mm camera for a BBC program in 1972. More than 30 years later, this adventure culminated in the consolidation of Aardman Animations as the most successful Plasticine animation studio in the whole world. The Deadpan Aardman character was followed by the adorable Morph and by a whole entourage of delightful characters that entertain children and adults all around the world.

Aardman took a big step in 1982 when, in the series *Conversation Pieces*, they created an innovative technique that involved using real-life conversation recordings as the starting point for the animation script. An unmistakable style of mundane and irresistible comedies thus emerged, as can be seen in *Early Bird* and, later, in *War Story* and *Creature Comforts*.

The talented director Nick Park joined Lord and Sproxton in 1986 with the film *A Grand Day Out* and with the duo of *Wallace & Gromit*, a scatterbrained inventor and an intelligent dog who wonderfully represent the most typical traits of the British character. Aardman's shorts are full of brilliant ideas, impeccable techniques and a masterful sense of film drama. The seven Oscar nominations that the studio has received and the three statues it has won attest to their talent.

The agreement to co-produce five feature films with the American company Dreamworks has given the studio a new boost. The first movie, *Chicken Run*, was one of the most popular animated films of all times, and in 2005 the first *Wallace and Gromit* feature film will make it to the big screen. Yet that is not all; the success of the *Creature Comforts* series, also *Rex the Runt* and *Angry Kid* have established Aardman's leadership in television, Internet and cellular phones, making it impossible for anyone to remain indifferent to their charming characters.

Tout commence avec Aardman, un super héros un tant soit peu maladroit que deux camarades d'école, Peter Lord et David Sproxton, créent en 1972 pour un programme de la BBC avec une caméra 16 mm. Plus de 30 ans passent et l'aventure débouche sur la confirmation d'Aardman Animations comme principal studio d'animation en pâte à modeler au monde. Au personnage d'Aardman succède l'adorable Morph et une foule de personnages qui étonnent et amusent petits et grands à travers la planète.

C'est en 1982 qu'Aardman franchit un cap décisif, lorsque la série *Conversation Pieces* tente d'instaurer une technique inédite à base d'enregistrements de conversations réelles comme inspiration pour l'animation. Naît alors un style unique de comédies prosaïques et irrésistibles que sont par exemple *Early Bird* ou, plus tard, *War Story* et *Creature Comforts*.

Nick Park apporte son talent à l'équipe Lord/Sproxton à partir de 1986 ; ensemble, ils produisent *A Grand Day Out* et donnent ainsi vie au duo *Wallace & Gromit* formé par un inventeur peu convaincant et un chien futé, caricatures parfaites de la mentalité britannique. Les courts d'Aardman sont truffés d'idées brillantes, d'une technique implacable et d'un sens magistral du drame cinématographique. Preuve en est les sept nominations aux Oscars, dont trois leur ayant valu la célèbre statuette.

L'accord de coproduction avec Dreamworks pour cinq longs métrages a donné un nouvel élan au studio. Le premier film, intitulé *Chicken Run*, s'inscrit parmi les films d'animation phares de l'histoire et en 2005 sortira sur les écrans le premier long métrage de *Wallace & Gromit*. Sans oublier le succès remporté par la série *Creature Comforts*, *Rex the Runt* et *Angry Kid*, tous offrant à Aardman une place de choix à la télévision, sur Internet et sur les téléphones portables. Impossible de rester insensible au charme de ces créations...

Alles begann mit Aardman, einem ziemlich idiotischen Superhelden, den die beiden Schulkameraden Peter Lord und David Sproxton für ein BBC-Programm 1972 ersannen, wobei sie eine 16 mm-Kamera einsetzten. Nach mehr als dreißig Jahren mündete das Abenteuer in die Konsolidierung von Aardman Animation als dem weltweit erfolgreichsten auf Knetfiguren spezialisierten Trickfilmstudio. Aardman folgte als Charakter der bewundernswerte Morph und ein ganzes Gefolge von verblüffenden Figuren, das Kinder und Erwachsene auf der ganzen Welt erheitert.

Aardman Animations gelang 1982 der Durchbruch, als es mit der Serie Conversation Pieces eine innovative Technik ausprobierte, die darin bestand, Tonbandaufnahmen realer Gespräche als Basis für den Trickfilm einzusetzen. Das war die Geburtsstunde jenes unverwechselbaren Stils, den man in so banal-alltäglichen wie unwiderstehlichen Komödien wie *Early Bird* und später *War Story* und *Creature Comforts* findet.

1986 schloss sich der hochtalentierte Nick Park Lord und Sproxton an. Sein Beitrag: A Grand Day Out und, damit verbunden, die Einführung des Duos *Wallace & Gromit*, das aus einem verrückten Erfinder und einem pfiffigen Hund besteht und auf wunderbare Weise die typischsten Züge des britischen Charakters verkörpert. Die Kurzfilme von Aardman sind prall gefüllt mit glänzenden Ideen, einer makellosen Technik und einem meisterhaften Sinn für filmische Dramaturgie. Zeugnis dafür legen die sieben Oscar-Nominierungen und die drei tatsächlich errungenen Statueten ab, mit denen das Studio ausgezeichnet wurde.

Der Koproduktionsvertrag zwischen dem Studio und den amerikanischen Dreamworks über fünf Spielfilme sorgte für neuen Ansporn. Der erste Film, *Chicken Run – Hennen Rennen*, wurde zu einem der erfolgreichsten Trickfilme in der Geschichte, und 2005 wird der erste Spielfilm von *Wallace & Gromit* auf die Leinwand kommen. Und als ob das noch nicht genug wäre, hat der Erfolg der *Creature Comfort*-Serien und auch von *Rex the Runt* und *Angry Kid* Aardmans Führungsrolle im Fernsehen, Internet und im Bereich der Mobiltelefone endgültig besiegelt, indem sie es fast unmöglich machen, sich dem Charme seiner Schöpfungen zu verschließen.

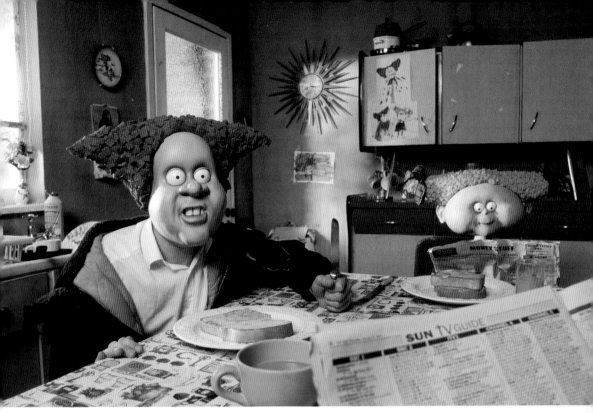

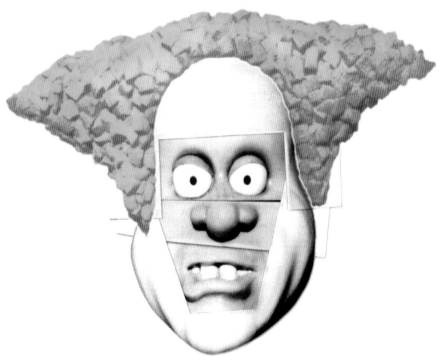

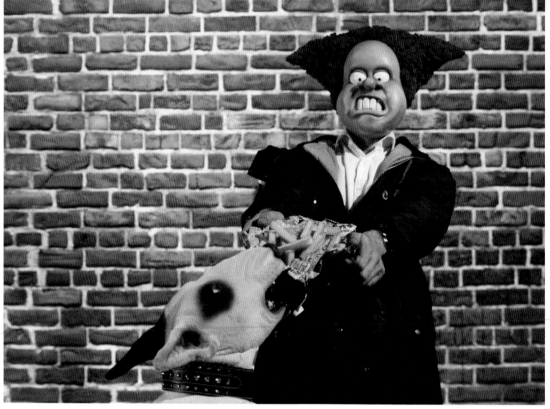

Pg. 11 Top Angry Kid, Series 2, Curious
© Aardman Animations Ltd 2002.

Pg. 12 Top Angry Kid, Series 1, Chips
© Aardman Animations Ltd 1999

Pg. 11 Bottom Angry Kid - Photofit
© Aardman Animations Ltd 1999.

Pg. 12 Bottom Angry Kid Masks
© Aardman Animations Ltd 2002

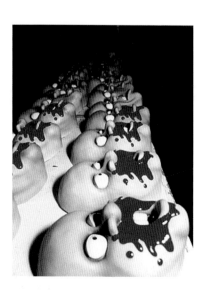

Pg. 13 The Porridge Sequence from A Close Shave
A Close Shave © Aardman/Wallace & Gromit Ltd, 1995

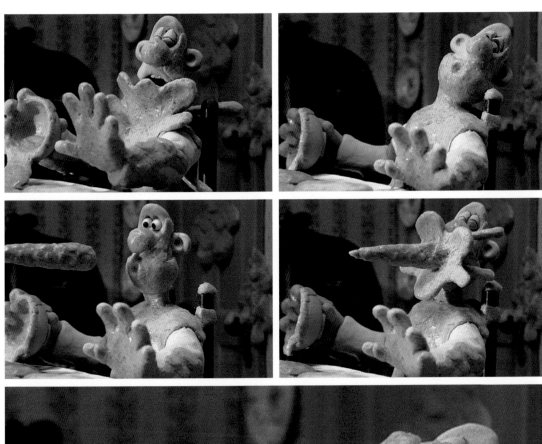

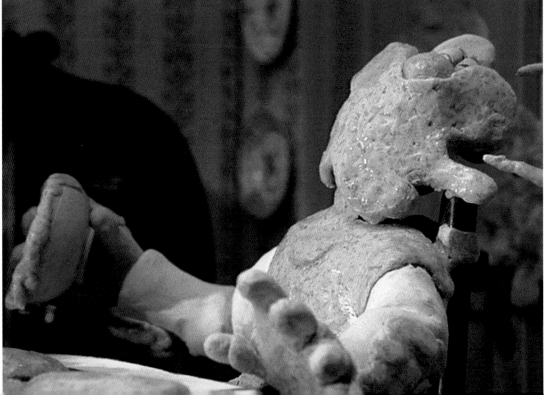

ACME FILMWORKS.

USA
Contact: Ron Diamond
6525 Sunset Blvd. Garden,
 Suite 10, Hollywood, CA 90028
E-mail: rjd@acmefilmworks.com
Phone: 323.464.7805
Fax: 323.464.6614

The Monk and the Fish - Michael
 Dudok de Wit, 1994
Impressions - Aleksandra
 Korejwo, 1995
Drawn from Memory - Paul
 Fierlinger, 1995
When the Day Breaks - Wendy
 Tilby & Amanda Forbis, 1999
Father and Daughter - Michael
 Dudok de Wit, 2000
Nibbles - Chris Hinton, 2003

Clio Awards

Traditional animation
Stop motion
Photo collage
Computer graphics

ACME FILMWORKS

www.acmefilmworks.com

The list of directors linked to Acme Filmworks almost seems a replica of this book. Some of the most important names of worldwide animation appear on the list: Paul Driessen, Joanna Quinn, Koji Yamamura, Aleksandra Korejwo, Caroline Leaf, Michael Dudok de Wit, Piotr Dumala, Barry Purves, Wendy Tilby and Amanda Forbis, among many others. Although it may be difficult to find these people actually working together in the famous Hollywood studio, their works circulate virtually through Acme's computers.

Founded in 1990 by Ron Diamond, the company is a kind of United Nations of commercial animation. Their objective is to attract the greatest independent talents from across the world to the advertising market, and to find an appropriate and personal style for each corporate message.

Acme produces commercials, animated logos and openning credits for clients from Microsoft, Universal Pictures, Nabisco or Disney, to Nike, NBC, Coca-Cola or Campbell's Soup. Among Acme's great animators it is worth mentioning names like that of Peter Chung, who alternates his own work on movies and television shows with commercials for motorcycles and self-serve restaurants for Acme. Equally important is Bill Plympton, who, when he is not committing one of his animated "crimes", is surely drawing commercials for insurance or telephone companies.

An emphasis on artistic quality and the search for a balance between creative freedom and objectivity in communication generate a stimulating environment for filmmakers. Little by little the studio has also ventured into the production of short films, such as the recent short Nibbles by Chris Hinton, which received an Oscar nomination.

Au vu des grands noms de l'animation mondiale qu'elle regroupe, la palette de réalisateurs ayant collaboré avec Acme Filmworks ressemble à une copie du présent ouvrage : il est question de Paul Driessen, Joanna Quinn, Koji Yamamura, Aleksandra Korejwo, Caroline Leaf, Michael Dudok de Wit, Piotr Dumala, Barry Purves, Wendy Tilby et Amanda Forbis, parmi tant d'autres. Certes serait-il difficile de tous les croiser dans le célèbre studio de Hollywood, mais leurs œuvres circulent virtuellement entre les ordinateurs d'Acme.

Fondée en 1990 par Ron Diamond, la compagnie s'apparente à une sorte d'ONU de l'animation commerciale. Son objectif est d'attirer à la publicité les plus grands talents indépendants du monde entier et d'inventer un style personnel adapté à chaque message corporatif.

Acme produit des spots publicitaires, des logos animés et des ouvertures pour la télévision, comptant parmi ses clients Microsoft,

Universal Pictures, Nabisco ou Disney, ainsi que Nike, NBC, Coca-Cola ou les soupes Campbells. L'un des poids lourds de l'animation qu'est Peter Chung alterne créations personnelles et productions pour la télévision, telles que des spots pour des motos et des restaurants ; pour sa part, Bill Plympton dessine souvent des annonces pour des compagnies d'assurance ou de télécommunication, avec des parenthèses pour commettre l'un de ses « délits » animés.

La priorité donnée à la qualité artistique et la quête d'équilibre entre liberté de création et objectivité du message font évoluer les cinéastes dans un contexte stimulant. De plus en plus, le studio s'engage dans la production de courts métrages d'auteur, comme le tout récent Nibbles de Chris Hinton, nominé aux Oscars.

Die Truppe von Regisseuren, die mit Acme Filmworks verbunden sind, scheint fast eine Replik auf dieses Buch. Hier tauchen einige der wichtigsten Namen für die internationale Animation auf: Paul Driessen, Joanna Quinn, Koji Yamamura, Aleksandra Korejwo, Caroline Leaf, Michael Dudok de Wit, Piotr Dumala, Barry Purves, Wendy Tilby und Amanda Forbis, neben vielen anderen. Obgleich nicht immer physischreal in dem berühmten Studio in Hollywood versammelt, so zirkulieren ihre Arbeiten doch virtuell durch die Computer von Acme.

Die 1990 von Ron Diamond gegründete Firma ist eine Art Vereinte Nationen für die Werbebranche die größten Talente, die unabhängig arbeiten, aus der ganzen Welt anzuziehen und die persönliche Note für die jeweilige Botschaft der Corporation zu finden.

Acme produziert Werbespots, animierte Logos und Fernseh-Vorspanne für eine Kundschaft, die von Microsoft, Universal Pictures, Nabisco und Disney bis zu Nike, NBC, Coca-Cola und Campbells-Suppen reicht. Unter den großen Trickfilmern kann man Namen wie den von Peter Chung anführen, der abwechselnd eigene Filme und Auftragsarbeiten für Acme fürs Fernsehen macht, mit Spots für Motorräder und Drive-in Restaurants; oder den Namen von Bill Plympton, der, wenn er nicht gerade eines seiner animierten „Verbrechen" begeht, sicher gerade Werbung für Versicherungen oder Telefone entwirft.

Die Betonung auf der künstlerischen Qualität und die Suche nach einem Gleichgewicht zwischen schöpferischer Freiheit und Objektivität in der Kommunikation schafft ein stimulierender Nährboden für die Filmemacher. Allmählich traut sich das Studio auch an die Produktion von kurzen Autorenfilmen heran, wie kürzlich mit Chris Hintons Nibbles, der für einen Oscar nominiert wurde.

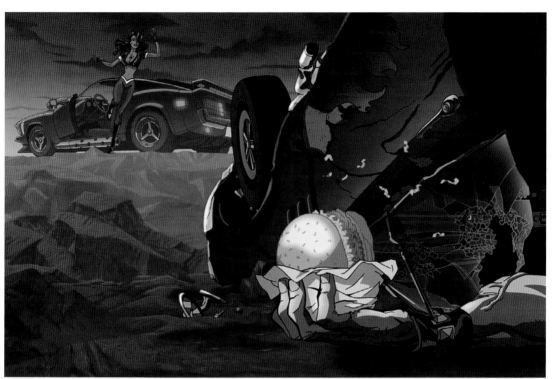

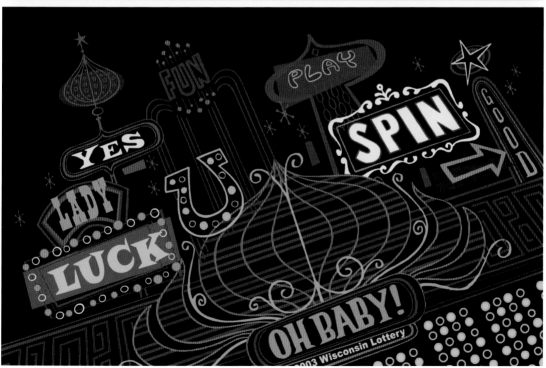

Pg. 17 Top left
"Kick in the Shins"
Bank Atlantic
Agency: Harris, Drury, Cohen

Pg. 17 Bottom left
"Flamingo"
Dir.: Joanna Quinn
Charmin
Agency: D'Arcy, London

Pg. 17 Top right
"Woman"
Bigmouth US Unwired
Agency: Lawler Ballard Van Durand

Pg. 17 Bottom right
"Landscape"
Dir.: Aleksandra Korejwo
Colorado Lottery
Agency: Karsh & Hagan Communications

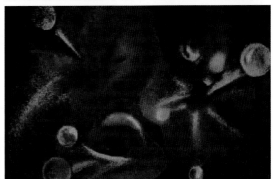

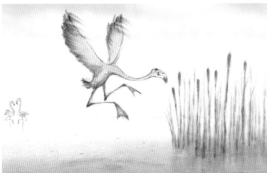

ALEXANDER PETROV

Russia
Studio of Alexander Petrov
150054 Yaroslavl, Shapova
 Street, 10 - Box 6
E-mail: petroff@yaroslavl.ru
Phone: + 0852 308538

Cow, 1989
**The Dream of a
Ridiculous Man,** 1992
The Mermaid, 1996
The Old Man and the Sea, 1999

Special Jury Prize - Annecy, 1997
Grand Prize - Espinho, 1997/1999
First Prize - Zagreb, 1998/2000
Hiroshima Prize, 1998
Academy Award and Grand Prix
- Annecy, 2000

Paint on glass

ALEXANDER
PETROV

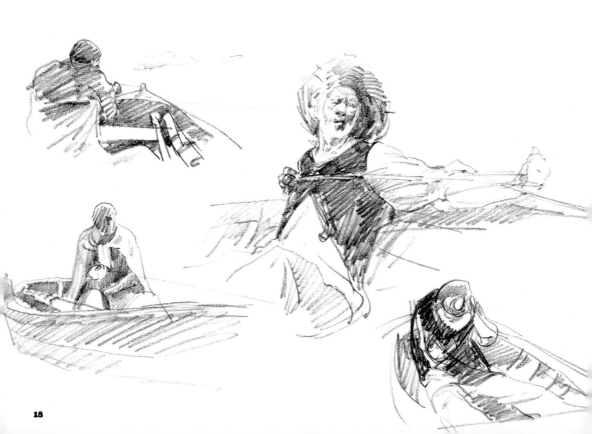

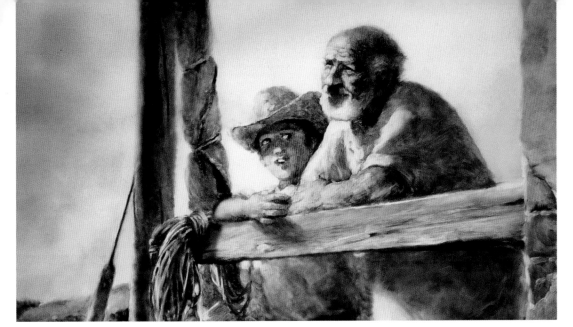

The Russian animator Alexander Petrov had already been relegated to animation history books when he completed his first movie for the giant IMAX screens together with the Canadian producer Pascal Blais Animation. This film, *The Old Man and the Sea*, also won an Oscar for the best short animation film in 2000.

The great dimensions of this projection contrast with Petrov's meticulous handiwork in the creation of his films. For each frame he uses his fingers to paint on a retroilluminated glass surface and, afterwards, he photographs the results. *The Old Man and the Sea* is made up of 29,000 takes, painstakingly prepared over the course of almost three years. Ernest Hemingway's old fisherman's fight against the sea and an enormous fish is a fitting metaphor for the patient and exhaustive work of Alexander Petrov.

This genius of Russian animation was born in 1957 and began his career as art director in Moscow in 1981; hence, the great importance of art direction and storyboards in his films. Petrov works with portraits, landscapes, and historical events, always from a realistic perspective. His paintings transmit in detail the texture of the materials used as well as the smoothness of people's skin. He generally uses human models, such as his son Dimitri, who inspire the movements and positions of his characters.

Literature is a very important source for his work. In addition to Hemingway's novel, he has also adapted works by Dostoyevski (*The Dream of a Ridiculous Man*) and Andrei Platonov (*Cow*). The latter film and *The Mermaid* were both nominated for Academy awards. Petrov has been directing his own studios, the Panorama Animation Film Studio, since 1992.

Le Russe Alexander Petrov figurait déjà dans les annales de l'animation quand il a réalisé le premier film du genre pour des écrans géants IMAX avec la maison de production canadienne Pascal Blais Animation. Par ailleurs, *Le vieil homme et la mer* a obtenu l'Oscar du meilleur court métrage d'animation en 2000.

La taille des écrans de projection tranche avec le travail manuel si méticuleux de Petrov pour la réalisation de ses films. Chaque tableau est peint à la main sur une plaque de verre rétroéclairée, puis photographié. Ainsi, *Le vieil homme et la mer* se compose de 29 000 prises dont l'élaboration a demandé près de trois années. Dans sa lutte contre la mer et un gros poisson, le vieux pêcheur de l'œuvre d'Ernest Hemingway s'inscrit donc comme une métaphore toute trouvée du travail de patience et de perfection d'Alexander Petrov.

Né en 1957, ce génie de l'animation russe débute sa carrière à Moscou en 1981 comme directeur artistique, d'où la place prédominante de cette discipline et des story-boards dans ses films. Le travail de Petrov s'appuie sur des portraits, des paysages et des faits historiques, et ce toujours d'un point de vue réaliste. Ses peintures transposent parfaitement la texture des matériaux et de la peau des personnages. Il a généralement recours à des modèles humains, comme son fils Dimitri, que lui inspirent mouvements et postures.

La littérature joue un rôle capital dans son œuvre. Outre Hemingway, il a adapté Dostoïevski, dans *Le rêve d'un homme ridicule*, et Andrei Platonov, avec *La vache*. Ce dernier film et *La sirène* ont été nominés par l'Académie de Hollywood. Depuis 1992, Petrov est à la tête de sa propre compagnie, la Panorama Animation Film Studio.

Der Russe Alexander Petrov war schon in die Annalen des Trickfilms eingegangen, als er den ersten Film dieses Genres für die IMAX Großbild-Leinwände für die kanadische Produktionsfirma Pascal Blais Animation drehte. *The Old Man and the Sea* wurde im Jahr 2000 mit dem Oscar für den besten Zeichentrick-Kurzfilm ausgezeichnet.

Petrov stellt seine Filme in minutiöser Handarbeit her. Jedes einzelne Bild malt er zunächst mit den Fingern auf eine von hinten beleuchtete Glasscheibe, um das Resultat dann zu fotografieren. *The Old Man and the Sea* besteht aus 29.000 solcher Aufnahmen, die mit hohem Arbeitsaufwand innerhalb von drei Jahren entstanden. Der alte Fischer in seinem Kampf gegen das Meer und den großen Fisch in Ernest Hemingways Buchvorlage ist eine sehr passende Metapher für die geduldige und erschöpfende Arbeit von Alexander Petrov.

1957 geboren begann dieses Genie des russischen Zeichentrickfilms seine Karriere 1981 in Moskau als Art Director; daher wohl auch die große Bedeutung, die er diesem Bereich und dem Storyboard mit seinen graphischen Erläuterungen für seine Filme einräumt. Petrov zeigt seine Porträts, Landschaften und historische Ereignisse immer aus einer realistischen Perspektive. Seine Bilder vermitteln detailgetreu die Materialbeschaffenheit, so auch die zarte Haut der Personen. Meistens übernimmt er für seine Figuren Bewegungen und Stellungen von menschlichen Modellen, z.B. seinem Sohn Dimitri.

Die Literatur ist eine wichtige Inspirationsquelle für sein Werk. Neben Hemingway adaptierte er Fjodor Dostojewski (*The Dream of a Ridiculous Man*) und Andrej Platonov (*Cow*). Cow und *The Mermaid* wurden von der Academy in Hollywood nominiert. Seit 1992 leitet Petrov sein eigenes Filmstudio, das Panorama Animation Film Studio.

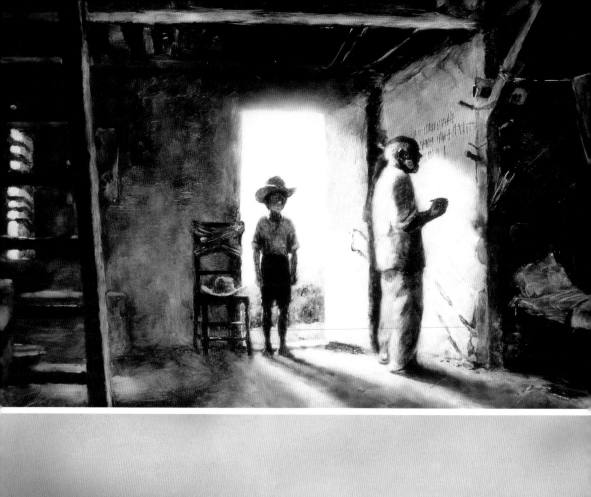
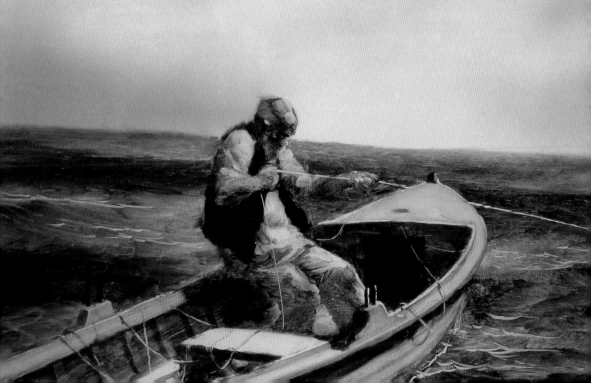

Pg. 18 Sketches for The Old Man and the Sea, 1999

Pg. 19-21 The Old Man and the Sea
Paint on glass, 1999

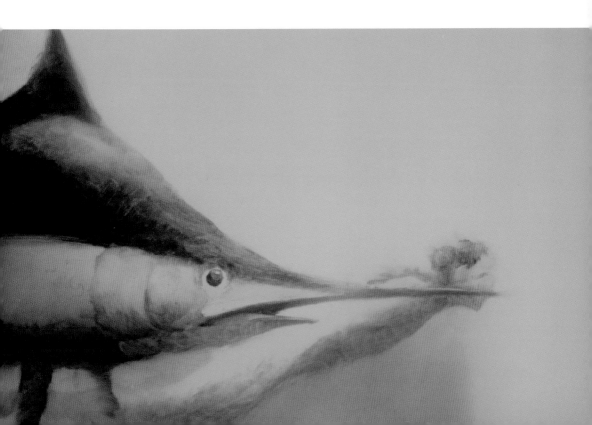

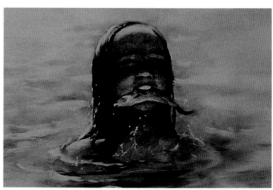
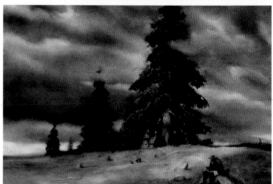
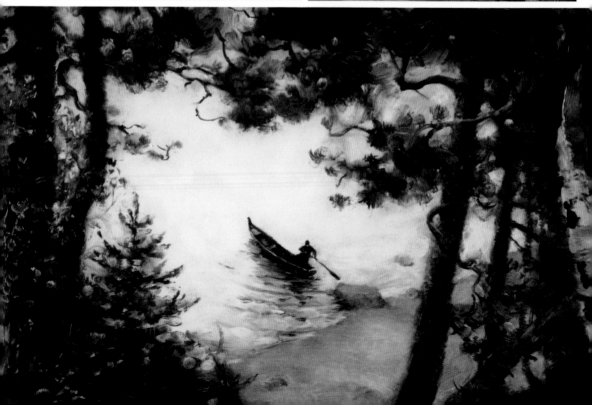

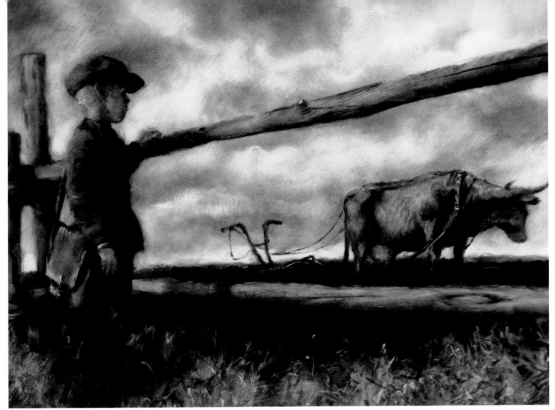

Pg. 23 Cow, 1989
Paint on glass

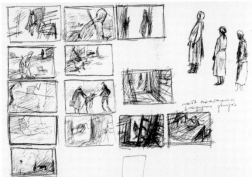

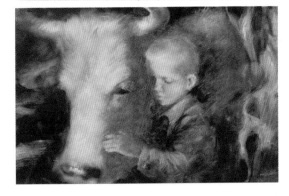

Pg. 22 The Mermaid, 1996
Paint on glass

ANDREAS HYKADE

Germany
Ostendstraße 106,
 70188 Stuttgart
E-mail: andreas@hykade.de
Fax: 00 49 711 489 1925

The King Is Dead, 1990
We Lived in Grass, 1995
Ring of Fire, 2000
Tom TV series, 2003

German Short Film Award in Silver, 1996
Special Prize of the
 Jury - Hiroshima, 1996
Best Student Film - Stuttgart, 1996
Grand Prize Studentfilm - Ottawa, 1997
Grand Prize - Ottawa, 2000
Best animated short Sitges - Spain, 2000
Animago Award - Germany, 2003

Traditional animation
Computer graphics

ANDREAS HYKADE

www.hykade.de

While his father amused himself with his friends in a pub in Bavaria, Germany, young Andreas Hykade, born in 1968, would sit and draw in a corner. Some years later the sounds of that masculine world, made up of beer, sex and some violence, would influence the professional career of one of the most fascinating contemporary German animators.

Hykade's films examine in depth the myths of male chauvinism, heroism and power in a society dominated by men, and at the same time they maintain a sense of poetry and disconcerting humor. *The King Is Dead* is a disturbing portrait of the decadence of Elvis Presley. *We Lived in Grass*, a work with autobiographical resonances, studies the complicated formation of the mentality of a child growing up in a small town. *Ring of Fire* illustrates the tumultuous entrance of two cowboys in a brothel of the Old West before they discover the true feminine soul. Hykade uses unusual creation processes. In *Ring of Fire*, for example, the main action of the film alternates with 30 erotic images that were created based on a public survey about sexual fantasies. The combination of the 2D design with graphic design resources creates excellent effects of depth.

Andreas Hykade studied in the Fine Arts Academy and in the Filmakademie Baden-Württemberg, both in Stuttgart, later becoming professor of these disciplines. Today, he maintains a pleasant collaboration with the producer Gambit. Since 1992 he has been an independent filmmaker and has directed more than 60 videos, TV trailers, advertising films, interactive games, multimedia presentations and children's movies.

Pendant que son père prenait du bon temps avec ses amis dans un pub de Bavière, en Allemagne, le petit Andreas Hykade, né en 1968, s'installait dans un coin pour dessiner. Les échos de ce monde si masculin, fait de bière, de sexe et d'une dose de violence, se feront entendre par la suite dans la vie professionnelle de l'un des animateurs contemporains allemands les plus fascinants.

Les films de Hykade explorent en profondeur les mythes du machisme, de l'héroïsme et du pouvoir dans une société gouvernée par l'homme, sans pour autant abandonner une approche poétique et un surprenant sens de l'humour. *The King Is Dead* trace le portrait dérangeant de la décadence d'Elvis Presley. Aux allures autobiographiques, *We Lived in Grass* se penche sur le développement mental complexe d'un enfant dans un village. Son western *Ring of Fire* présente, quant à lui, l'arrivée rocambolesque dans un bordel de deux cow-boys, auxquels se révèlera l'âme féminine dans toute sa splendeur.

Hykade utilise de procédés inédits de création. Dans *Ring of Fire* par exemple, l'action principale est assortie d'un va-et-vient de 30 images érotiques, élaborées à partir d'une enquête sur les fantasmes sexuels. La combinaison de la conception 2D et de techniques de design graphique donne d'incroyables effets de profondeur.

Entre ses stages prolongés dans ce pub bavarois et sa collaboration actuelle avec la maison de production Gambit, Andreas Hykade a étudié à l'Académie des Beaux-Arts et à la Filmakademie Baden-Württemberg, deux institutions de Stuttgart, avant d'enseigner à son tour ces disciplines. Réalisateur indépendant depuis 1992, il a dirigé plus de 60 clips vidéo, bandes-annonces pour la télévision, spots publicitaires, jeux interactifs, présentations multimédia et films pour enfants.

Während sein Vater sich mit seinen Freunden in einer bayerischen Kneipe amüsierte, zog sich der kleine Andreas Hykade, Jahrgang 1968, dort in eine Ecke zum Zeichnen zurück. Das Echo jener männlichen Welt, die aus Bier und Sex und durchaus auch Gewalt bestand, klang im späteren professionellen Leben eines der faszinierendsten zeitgenössischen Trickfilmzeichner Deutschlands nach.

Hykades Filme erforschen eingehend die Mythen des Machismos, des Heldentums und der Macht in einer von Männern beherrschten Welt, ohne dabei den Sinn für das Poetische und einen verblüffenden Humor zu verlieren. *Der König ist tot* zeichnet ein verstörendes Porträt Elvis Presleys in seinem Niedergang. *Wir lebten im Gras*, eine Arbeit mit autobiografischen Anklängen, untersucht den komplizierten Prozess, wie sich die Mentalität eines Dorfkindes formt. *Ring of fire* zeigt, wie zwei Cowboys im Wilden Westen polternd in ein Bordell einfallen, bevor sie die wahre weibliche Seele kennen lernen.

Hykades Schaffensweise ist unüblich. In *Ring of Fire* beispielsweise stehen dreißig erotische Bilder, deren Zusammenstellung eine öffentliche Befragung über sexuelle Fantasien zum Ausgangspunkt hatte, quer zur Haupthandlung. Die Kombination von zweidimensionaler Zeichnung mit Rückgriffen auf Grafikdesign bringt großartige Tiefeneffekte hervor.

Zwischen seinen Erfahrungen, die er in jener bayerischen Kneipe sammelte, und der angenehmen Zusammenarbeit, die er zur Zeit mit der Produktionsfirma Gambit genießt, lag seine Stuttgarter Studienzeit an der Kunstakademie und an der Filmakademie Baden-Württemberg, wo Hykade inzwischen selbst lehrend tätig ist. Seit 1992 hat er als freier Regisseur mehr als sechzig Videoclips, Fernsehtrailer, Werbefilme, interaktive Spiele, Multimedia-Präsentationen und Kinderfilme gedreht.

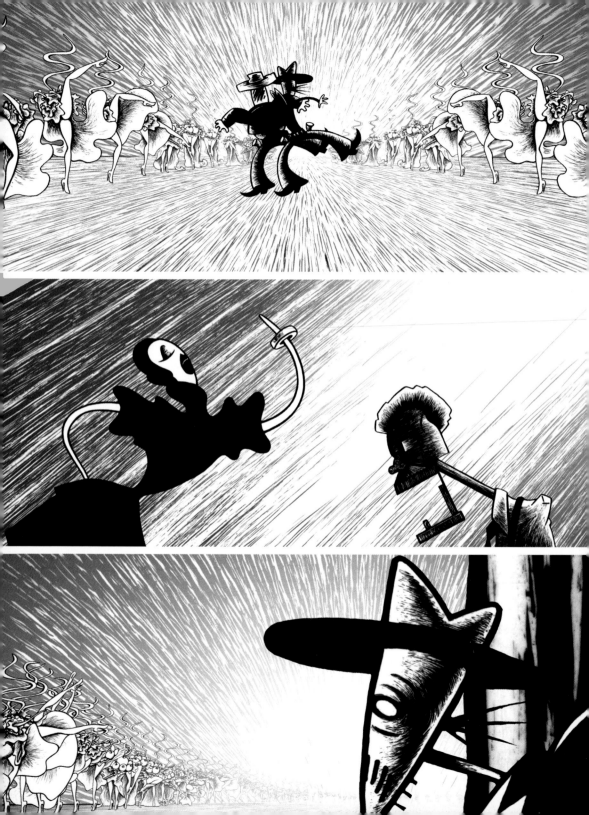

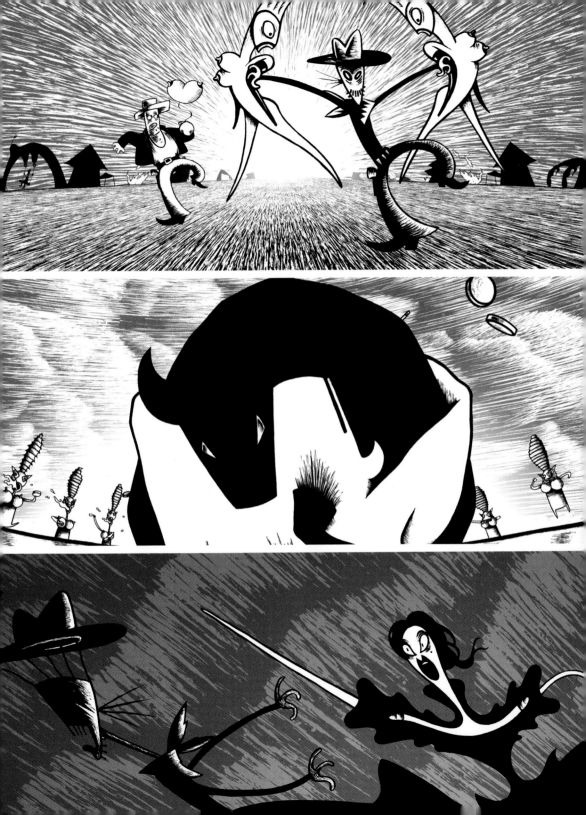

Pg. 29 coversketch for PLÂSIR DO LE
MONDE, 2003
Ink on paper

Pg. 26–27 Ring of Fire, 2000
Ink on cell & Lightwave postproduction

Pg. 28 filmstills from TOM, 2003
Flash

ARNALDO GALVÃO

Brazil
Contact: ARNALDO GALVÃO
E-mail: arg@uol.com.br
Rua Manoel Jacinto 667
BL 8-72, São Paulo SP
Cep 05624.001
Phone: + 55 11 3743 8152

Uma saida política / Political Trick, 1990
Deus nasceu foi no Brasil / God was Born in Brazil, 1990
Disque N para nascer / Dial B for Birth, 1992
Dr. Galvão, 1998/2000
Podrera & OVNI, 2000
Almas em chamas / Souls'n Flames, 2000
The Xtremers, 2002
Saudade de casa / Homesickness, 2003
Assédio / Harassment, 2003

Curta nas Telas/Shorts on Screen Award, 1990/1992
Fiat Prize, 1990
Jury Special Prize and Best Screenplay Gramado /Brazil, 2000
Best Animation Grand Prize of Brazilian Cinema, 2001
Best Screenplay Miami, 2001

Traditional animation
Cut out
2D and 3D computer graphics

ARNALDO GALVÃO

Souls'N Flames, the ardent story of love and passion between a fireman and a dancer, made Arnaldo Galvão famous in Brazil as well as abroad. This Brazilian animator is a veteran of the trade and, in fact, in 2003 the Anima Mundi Festival hosted a retrospective of his work that included everything from the self-help sessions of Dr. Galvão—the author's entertaining alter-ego—to the political rally sung as a comic opera in *Political Trick,* or the TV pilot program *Podrera & OVNI*—the incredible saga of two nihilistic dogs that bark very little and move even less.

In fact, Arnaldo Galvão's first characters did not move at all: they were all caricatures and illustrations that he drew for well-known Brazilian newspapers and magazines like *O Pasquim, Movimento, Versus* or *Folha de São Paulo.* It was not until 1980, in the midst of his college education, that he was drawn to animation. Five years later Galvão was to work with Mauricio de Souze, one of the pioneers of the Brazilian animation industry, with his infamous *Turma da Mônica.* For the small screen he has formed part of the teams of *Castelo Ratimbum* and other successful children's programs.

Galvão is versatile in his techniques, genres and production methods. He has completed more than 200 advertising films and 10 shorts, and in them he gives free rein to satire. The different pilot programs for TV that appear on his résumé show his firm determination to explore animation's potential together with Brazil's enormous television-viewer public. In 2003 he became one of the founding members of the Brazilian Association of Animated Film.

Almas em chamas raconte l'histoire d'amour enflammée entre un pompier et une danseuse : une œuvre qui a apporté la gloire à Arnaldo Galvão, tant dans son Brésil natal qu'à l'étranger. Cet animateur est un véritable vétéran de l'animation dont le festival Anima Mundi a proposé une rétrospective pour son édition de 2003. La programmation incluait la diffusion de séances d'auto-assistance du Docteur Galvão (amusant alter ego de l'auteur), d'un meeting chanté sous la forme d'un opéra bouffe dans *Uma saida politica,* ou encore du pilote de la série télévisée *Podrera & OVNI,* incroyable saga de deux chiens nihilistes qui aboient peu et bougent encore plus rarement.

De fait, les premiers personnages d'Arnaldo Galvão sont totalement statiques : il s'agit de caricatures et d'illustrations qui paraissent dans des journaux et revues de renom au Brésil, tels que *O Pasquim, Movimento, Versus* ou *Folha de São Paulo.* C'est en 1980 qu'il goûte à l'animation, lors de ses études universitaires. Cinq ans plus tard, il travaille avec l'un des pionniers de l'industrie de l'animation brésilienne, Mauricio

de Souza, pour le célèbre *Turma da Mônica.* Côté petit écran, il intègre les équipes de *Castelo Ratimbum* et autres célèbres programmes pour enfants.

Versatile sur le plan technique, se prêtant à plusieurs genres et modes de production, Galvão a déjà à son actif plus de 200 spots publicitaires et 10 courts métrages franchement satiriques. Les divers pilotes réalisés pour la télévision soulignent sa volonté ferme d'explorer le potentiel de l'animation par rapport à l'énorme audience de son pays. En 2003, il est l'un des fondateurs de l'Association brésilienne de cinéma d'animation.

Almas em chamas, die brennende Geschichte von Liebe und Leidenschaft zwischen einem Feuerwehrmann und einer Tänzerin, machte Arnaldo Galvão inner- und außerhalb Brasiliens berühmt. Der brasilianische Animationskünstler gehörte schon zu den echten Veteranen des Trickfilms, als das Festival Anima Mundi 2003 eine Retrospektive seines Werkes in sein Programm für 2003 aufnahm. Dort konnte man sozusagen den Stunden, die Dr. Galvão – ein unterhaltsames Alter Ego des Autors – in Selbsthilfe gab, beiwohnen, dann, in *Uma saida politica,* einer Kundgebung, die in Art einer komischen Oper gesungen wurde, und natürlich in dem TV-Pilotprogramm *Podrera & OVNI,* die unglaubliche Geschichte von zwei nihilistischen Hunden verfolgen, die wenig bellen und noch viel weniger sagen.

Die ersten Figuren von Arnaldo Galvão bewegten sich übrigens keinen Deut: denn es handelte sich um Karikaturen und Illustrationen, die er für namhafte brasilianische Zeitschriften und Zeitungen wie *O Pasquim, Movimento, Versus* oder *Folha de São Paulo* zeichnete. 1980 dann im studentischen Milieu nahm ihn der Trickfilm gefangen. Fünf Jahre später arbeitete er bereits mit Mauricio de Souza, einem der Pioniere der brasilianischen Trickfilmindustrie, an dem berühmten Kinofilm *Turma da Mônica.* Er gehörte auch zur Mannschaft von *Castelo Ratimbum* und anderen erfolgreichen Kinderprogrammen, die im Fernsehen liefen.

Galvão, der hinsichtlich der Technik, der Produktionsarten und -methoden sehr wandlungsfähig ist, hat schon mehr als 200 Werbefilme gedreht, außerdem 10 Kurzfilme, in denen er der Satire freien Lauf ließ. Die etlichen Fernseh-Pilotprogramme, die in seinem Curriculum auftauchen, zeigen seinen festen Entschluss, das Potential, das im Trickfilm steckt, zu erobern, und damit das immense Fernsehpublikum in Brasilien. 2003 gehörte er zu den Gründungsmitgliedern der Brasilianischen Animationsfilm-Vereinigung (Associação Brasileira de Cinema de Animação).

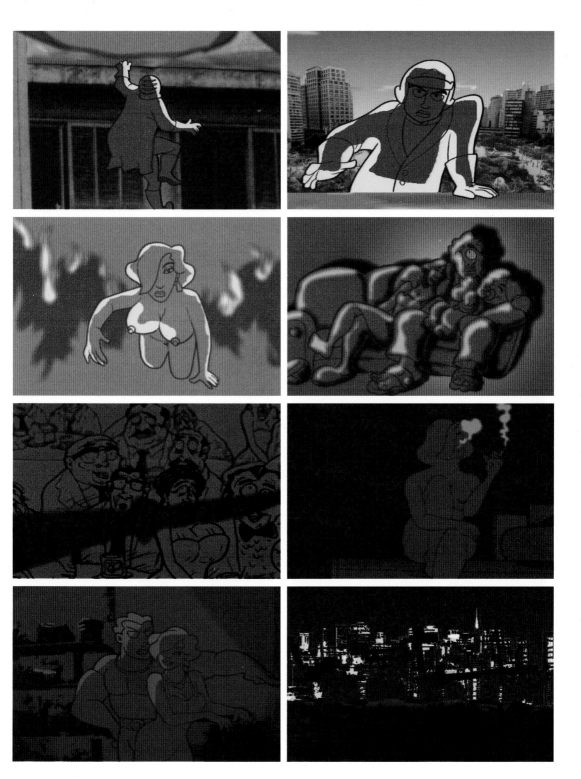

Pg. 31 Almas em Chamas/Souls'n
Flames, 2000
Traditional animation

Pg. 32 Dr. Galvão (TV series), 1998/2000
Traditional animation

Pg. 33 Haina (TV series), 2000
Traditional animation

BARRY J. C. PURVES

United Kingdom
5 Woodleigh, Bradgate Road,
Altrincham, Cheshire, WA14 4QU
achilles@purvesb.freeserve.co.uk
Phone: + 44 161 928 8955

Next, 1989
Screen Play, 1992
Rigoletto, 1993
Achilles, 1995
**Gilbert & Sullivan – The
 Very Models,** 1998
Hamilton Mattress, 2001

Grand Prix - Shanghai, 1992
Best Animation - Oberhausen, 1993
Gold Plaque - Chicago, 1993
Suddeutsch Rundfunks Prize -
 Stuttgart, 1994
Best Animation Mediawave, 1994
Best in 5-15 minutes - Hiroshima, 1994
Special Prize - Ottawa, 1994
Golden Dove - Leipzig, 1995
Special Jury Prize - Hiroshima, 1996
Special Jury Prize - Seoul, 1997
Best Film Anima Mundi - Rio de
 Janeiro, 1998
Best Direction - Seoul, 1999
Best TV Special - BAA, 2002
Grand Prix - Annecy, 2002

**Puppet and objects
 animation
CGI**

BARRY PURVES

www.barrypurves.com

Barry Purves has brought to life bras, potato chips, dancing cro-
quettes and love-making soft drink straws (complete with bubbles at the
end). Nonetheless, his passion is for puppets, creations from which he is
capable of eliciting unforgettable expressions. In the award-winning film
Next, for example, Shakespeare, transformed into a puppet, lives crucial
moments of his plays, while in *Rigoletto*, Verdi's characters experience all
the opera's miseries and shed an enormous amount of blood. *Achilles*
pays homage to Greek theater with an erotic vision of friendship, and
Screen Play, which received an Oscar nomination, is inspired in Japanese
Kabuki Theater.

Purves never wants to limit animation to vignettes, but rather tries
to associate it to other arts, especially those of the stage. He started his
career in the theater, but soon gave up the idea of being an actor. He was
motivated by the idea that he could make his puppets more expressive
than he himself could ever be, which he has proven to be true, above all
as he perfects the puppets' body language to the detriment of dialogue.

Born in 1955, the English animator Barry Purves exchanged the
theater for the audiovisual world in 1978. He has directed and animated
several feature films and television series for the Thames TV channel,
and his method consists of choosing different animators to create spe-
cific characters. Since 1986 he has filmed 70 commercials, animation
advertising inserts, title sequences, etc., in studios like Aardman or in his
own Bare Boards studio, founded in the early nineties.

The American cinema grabbed him to work on the puppets that
perform in *Mars Attacks!* and, more recently, he worked on the pre-
animation phase of Peter Jackson's *King Kong*. He was also consulted for
the movie *The Lord of the Rings: The Return of the King*. Graphic digital
design is the new frontier of Purves' characters.

Barry Purves a déjà donné vie à des soutiens-gorge, des chips, des
croquettes dansantes et des pailles qui font l'amour (avec bulles en pri-
me). Sa véritable passion reste toutefois les marionnettes dont il parvient
à tirer de remarquables expressions. Tel est le cas de son Shakespeare
qui repasse les scènes clés de son œuvre dans *Next*, primés de plusieurs
récompenses, tandis que dans *Rigoletto* les personnages de Verdi con-
naissent une série de malheurs et versent beaucoup de sang. Pour sa
part, *Achilles* rend hommage au théâtre grec avec une vision érotique de
l'amitié, alors que *Screen Play*, film nominé aux Oscars, fait référence à
l'art théâtral japonais kabuki.

Plutôt que de cantonner l'animation à un domaine précis, Purves ten-
te de la combiner à d'autres arts, notamment au théâtre, qui marque le dé-
but de sa carrière même s'il a rapidement abandonné l'interprétation. Son
idée d'origine : faire que les marionnettes dégagent toute l'expressivité
qu'il ne pourra jamais être capable de posséder. Il a atteint son objectif,
en particulier grâce au langage corporel au détriment des dialogues.

Né en 1955, cet Anglais troque le théâtre contre le monde de l'audio-
visuel en 1978. Il dirige et anime plusieurs longs métrages et séries pour
la chaîne Thames. Sa méthode consiste à recruter des animateurs dif-
férents selon les personnages à créer. Depuis 1986, il a réalisé 70 spots
publicitaires, encarts animés, ouvertures, etc., pour le studio Aardman
d'abord, puis pour Bare Boards, qu'il fonde au début des années 90.

Le cinéma américain l'a contacté pour concevoir les marionnettes
apparaissant dans *Mars Attacks!* Plus récemment, il a participé à la
phase préliminaire d'animation de *King Kong*, de Peter Jackson, ainsi
qu'apporté sa collaboration pour *Le seigneur des anneaux : le retour
du roi*. Le traitement graphique est une nouvelle frontière pour les per-
sonnages de Purves.

Barry Purves hat Büstenhaltern, Pommes frites, tanzenden
Kroketten Leben eingehaucht und Trinkhalme zum Liebesakt verführt
(mit Bläschen in der Limo am Schluss). Aber seine wahre Leidenschaft
gilt den Puppen, denen er unvergessliche Ausdrucksformen zu entlocken
versteht. Shakespeare als Puppe zum Beispiel erlebt Höhepunkte seiner
eigenen Werke in dem preisgekrönten Film *Next*, während in *Rigoletto*
Verdis Figuren die bitteren Momente der Oper durchschreiten und jede
Menge Blut vergießen. *Achilles*, eine erotische Version der Freundschaft,
ist seinerseits eine Hommage an das griechische Theater, und der für
den Oscar nominierte Film *Screen Play* ist eine Referenz an das japani-
sche Kabuki-Theater.

Purves will Animation nicht auf bloß zusammengesetzte Einzel-
zeichnungen beschränkt sehen, sondern sie mit anderen, vor allem mit
den szenischen Künsten verbinden, wo er selbst seine Karriere begann,
obgleich er schnell die Schauspiellaufbahn aufgab.

Der Ausgangsgedanke war, den Puppen mehr Ausdruckskraft ver-
leihen zu können, als es ihm selbst je möglich sein würde – und das ist ihm
gelungen, vor allem dadurch, dass er die Körpersprache auf Kosten des
Dialogs perfektionierte.

Der Engländer Barry Purves, Jahrgang 1955, tauschte 1978 das
Theater gegen die audiovisuelle Welt ein. Er war für Regie und Animation
diverser Spielfilme und Serien für den Fernsehkanal Thames zuständig,
wobei seine Methode darin besteht, verschiedene Animationskünstler
auszusuchen, um ganz bestimmt Figuren zu erschaffen. Seit 1986 hat
er im Studio Aardman und seinem eigenen Anfang der neunziger Jahre
gegründeten Studio Bare Boards siebzig Reklamefilme, animierte
Zwischenwerbungen, Eingangssequenzen und anderes gemacht.

Das amerikanische Kino gewann ihn für die Entwürfe der Puppen, die
in *Mars Attacks!* auftreten, und jüngst in der Vorphase zur Animation von
Peter Jacksons *King Kong*; außerdem zog man ihn für *Der Herr der Ringe:
Die Rückkehr des Königs* zu Rate. Das digitale Grafikdesign ist die neue
Herausforderung für Purves Figuren.

34

BILL PLYMPTON

USA
Plympton Studio
119 W23rd # 206
 New York, NY 10011
Phone: + 1 212 741 5544
Fax: + 1 212 741 5522

Your Face, 1987
How to Kiss, 1989
25 Ways to Quit Smoking, 1989
Plymptoons, 1990
Push Comes to Shove, 1991
The Tune, 1992
Draw!, 1993
I Married a Strange Person, 1997
Eat!, 2001
Mutant Aliens, 2001

Jury Prize, Cannes 1991
World Animation Celebration, 1998
Grand Prix, Annecy 2001
Canal + Award, Cannes 2001

Traditional animation,
drawings on paper

BILL PLYMPTON

www.plymptoons.com

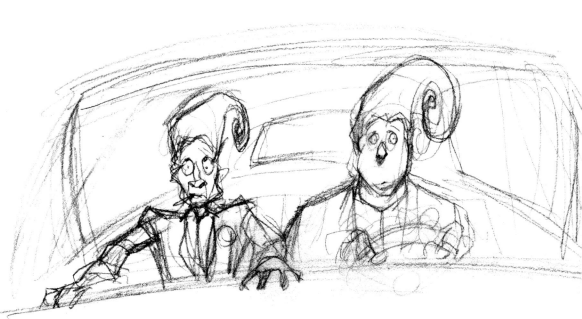

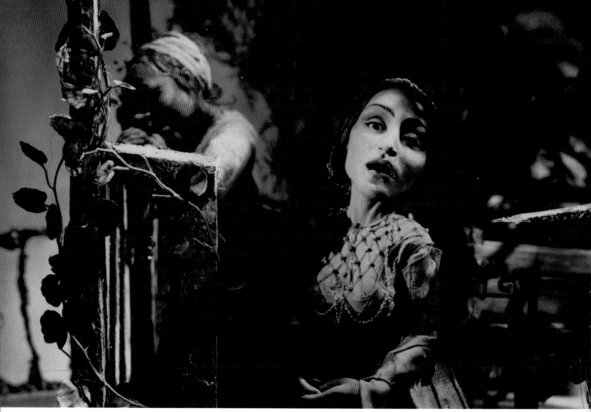

Pg. 35 Gilbert & Sullivan – The
very models, 1998
Puppet animation

Pg. 36–37 Rigoletto, 1993
Puppet animation

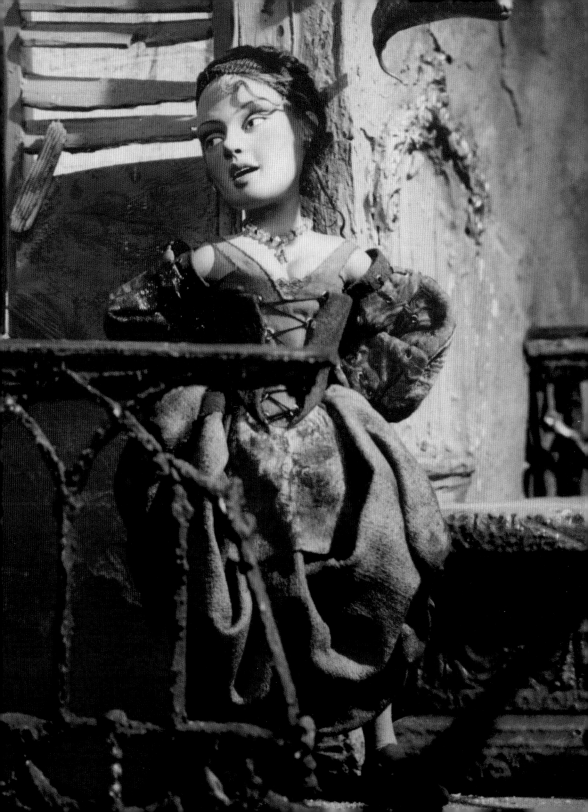

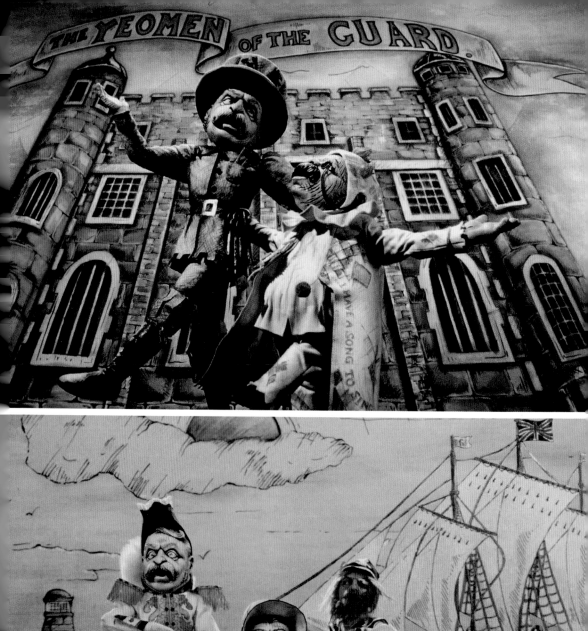
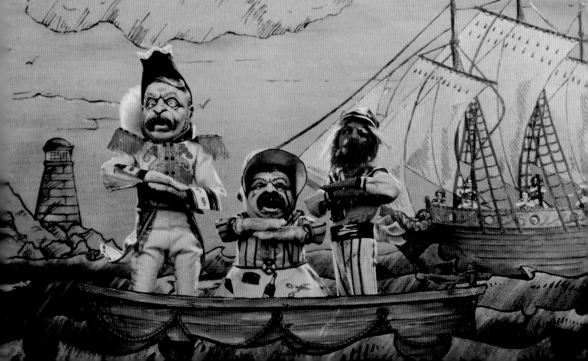

The high level of violence of Bill Plympton's works has lead many animation studios to close their doors to his films and to veto some of his commercials. This fact, however, does not worry this restless American. He is adored in cinema festivals, on the public music channel MTV and by those who love irreverence. The Hollywood Academy even nominated him for an Oscar for his short film *Your Face*.

Plympton's agile stroke and his political incorrectness first appeared in comics and illustrations in publications such as *The New York Times*, *Vogue*, *Vanity Fair*, *Rolling Stone*, *Penthouse* and *National Lampoon*. He made his first animated movie while he was still a student. He shot the whole film upside down, but it got him nowhere. It was not until 1987 that things started to go well for him, and only his ideas seemed upside down.

A great artist, Plympton has chosen to follow an independent career. He prefers to begin the day by drawing the most extravagant and offensive things which come to mind, free of influence by agents and producers or others reminding him about sales statistics or the public's sensitivity. Plympton has financed, produced and directed some of his own feature animation films; such as *I Married a Strange Person*, *The Tune* and *Mutant Aliens*. He recently announced that he is working on a new film, titled *Hair High*, and has installed a *webcam* in his studio so that those interested can watch live as he works.

Plympton's preferred themes include the pathetic aspects of daily life and the attitudes of politicians and those who control the culture industry. In his stories the human body seems to suffer all the vices and hypocrisies of the spirit. Modern society comes under scrutiny beneath the merciless pencil of Bill Plympton.

Bill Plympton s'est vu refuser le droit d'entrée à de nombreux studios d'animation, de même que certains de ses spots pour leur degré de violence. Il en faut toutefois plus pour inquiéter cet Américain agité, car il a déjà conquis festivals de ciné, téléspectateurs de la chaîne musicale MTV et adeptes de la provocation. Sans compter que l'Académie de Hollywood l'a nominé pour l'Oscar du meilleur court métrage avec *Your Face*.

Son talent de dessinateur et son approche politiquement incorrecte s'expriment d'abord dans des bandes dessinées et des illustrations de publications telles que The New York Times, Vogue, Vanity Fair, Rolling Stone, Penthouse et National Lampoon. Son premier film d'animation remonte à ses années universitaires : il tourne les séquences à l'envers et l'aventure se solde par un échec. C'est seulement en 1987 que le vent tourne en sa faveur et que ses idées sont alors reconnues.

Le grand artiste qu'est Plympton a toujours opté pour une carrière indépendante. Il aime commencer la journée en dessinant les thèmes les plus extravagants et décapants qui lui traversent l'esprit : il ne doit

suivre les directives d'aucun agent ou producteur, pas plus qu'obéir à des indicateurs de susceptibilité ou de volumes de ventes. Il a ainsi autofinancé la production et la réalisation de certains longs métrages d'animation, tels que L'impitoyable lune de miel, The Tune et Les mutants de l'espace. Plus récemment, il a annoncé la réalisation de *Hair High*, dessin animé pour lequel une *webcam* montre en direct aux internautes intéressés sa façon de procéder.

Le pathétisme du quotidien, le comportement des hommes politiques et les coulisses de l'industrie culturelle demeurent les sujets favoris du cinéaste. Dans ses histoires exemplaires, le corps humain semble être en proie à tous les vices et hypocrisies de l'esprit. Le crayon sans pitié de Bill Plympton met donc à nu les facettes de la société moderne.

Für Bill Plympton haben sich wegen des hohen Gewaltpotentials seiner Werke und mancher seiner Werbeplakate die Türen etlicher Trickfilmstudios geschlossen. Allerdings kümmert das den ruhelosen US-Amerikaner nicht. Auf Filmfestivals, von den Zuschauern des Musikkanals MTV und denen, die seine Unehrerbietigkeit lieben, wird er angehimmelt. Sein Kurzfilm *Your Face* wurde sogar von der Academy in Hollywood für einen Oscar nominiert.

Plymptons flinker Strich und seine Abwehr gegenüber „Political Correctness" tauchten zuerst in seinen Comics und Illustrationen auf, die er für Zeitschriften und Magazine wie The New York Times, Vogue, Vanity Fair, Rolling Stone, Penthouse und National Lampoon anfertigte. Sein erster Zeichentrickfilm, den er bäuchlings in seiner Studienzeit drehte, glückte überhaupt nicht. Gewissermaßen „auf dem Bauch liegend" blieben nur seine Ideen, aber seit 1987 begannen die Dinge gut zu laufen.

Plympton, ein großer Künstler, hat sich für eine unabhängige Karriere entschieden. Ihm gefällt es, den Tag damit zu beginnen, die ausgefallensten und beleidigendsten Sachen die ihm gerade einfallen, zu zeichnen, ohne dass ihm ein Agent oder Produzent etwas vorschreibt und ohne dass irgend jemand Kontrolle ausübt wegen der Empfindlichkeiten anderer oder mit Blick auf die Verkaufsstatistiken. Die Realisation und Produktion einiger Zeichentrick-Spielfilme hat er sogar selbst finanziert, wie etwa I Married a Strange Person, The Tune und Mutant Aliens. Vor kurzem hat Plympton die Realisierung von *Hair High* angekündigt, wofür er eine Webcam installierte, damit Interessierte seine Arbeit direkt verfolgen können.

Das Pathos des Alltäglichen, das Verhalten der Politiker und die Kulissen der Kulturindustrie sind die Lieblingsthemen des Filmschaffenden. In seinen beispielhaften Geschichten scheint der menschliche Körper alle Laster und geistige Scheinheiligkeit zu erleiden. Der unbarmherzige Stift von Bill Plympton hat die moderne Gesellschaft entlarvt.

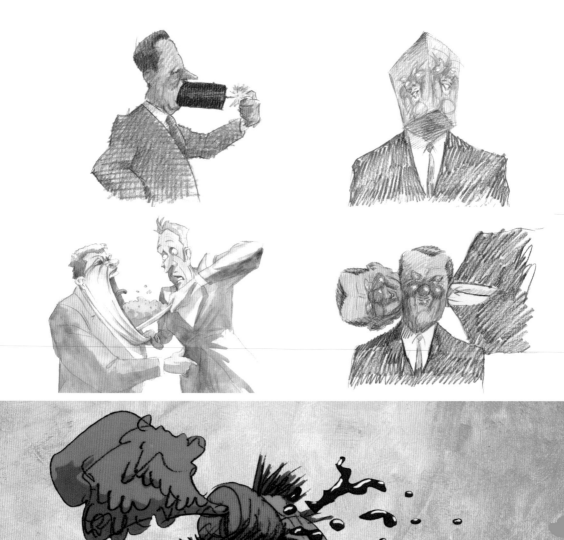
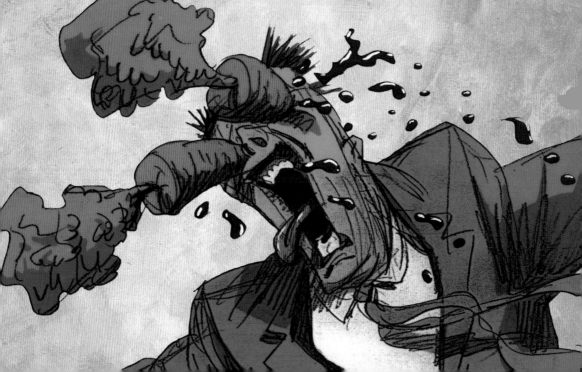

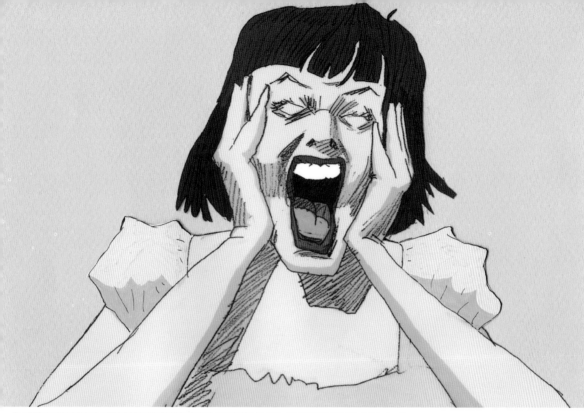

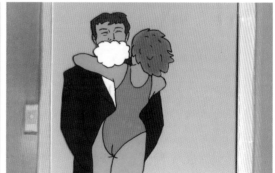

Pg. 38–39 *Hair High*, 2004
Drawings on paper

Pg. 40 (clockwise)
25 Ways to Quit Smoking, 1989
Your Face, 1987
Your Face, 1987
Sex & Violence, 1997
Eat, 2001
Drawings on paper

Pg. 41 (clockwise)
I Married a Strange Person, 1998
Love in fast Lane, 1987
Parking, 2002
Drawings on paper

BLUE SKY STUDIOS, INC.

USA
44 South Broadway, 17th Floor,
 White Plains, NY 10601
E-mail: info@blueskystudios.com
Phone: +1 914 259 6500
Fax: +1 914 259 6499

Joe's Apartment – Funky
 Towel, 1996
Bunny, 1998
Ice Age, 2002
Gone Nutty, 2003

Academy Award, 1999
Children's Prize Oberhausen, 1999
First Prize, Los Angeles Art Film
 Festival 2003

Computer graphics

BLUE SKY

www.blueskystudios.com

Scrat, the bucktoothed squirrel from the animated feature film *Ice Age* has not only managed to captivate a legion of admirers from across the world, he has also earned himself the right to carry on with his pre-historic adventures in the short *Gone Nutty*. Both of these movies were nominated for Oscar Awards and have helped spread the fame of the Blue Sky Studios.

Chris Wedge founded the studio in 1987 and it immediately took on a pioneering role in supplying digital animation to the audiovisual industry. The singing and dancing cockroaches that appeared in the MTV cult classic *Joe's Apartment* illustrate the perfect relationship that can exist between entertainment and technology, and this idea has become Blue Sky's distinguishing principal. In 1997 the company became a leading unit of digital animation and special effects for Fox Filmed Entertainment.

The film *Bunny*, which won an Oscar for best animated short, contributed considerable progress to the simulation of light in digital design. Chris Wedge's studio invested considerable talent in this area by creating exclusive software to simulate how light behaves on digitally created objects and surfaces. With these resources, together with an increased rate of productivity in rendering images, Blue Sky has developed a personal style that is reflected both in their movies and commercials.

The Brazilian animator Carlos Saldanha, a new name in animation film, has been a member of the Blue Sky team since 1993. Saldaña, the co-director of *Ice Age* and director of *Gone Nutty*, attracted Wedge's attention when he produced the award-winning film *Time for Love*, a love story about two wooden dolls that challenge the mechanical routine of a cuckoo clock.

Scrat, le rongeur aux grandes dents du long métrage d'animation *L'âge de glace* ne s'est pas contenté de conquérir une foule d'admirateurs à travers le monde : il a également pu poursuivre ses aventures préhistoriques dans le court *Gone Nutty*. Nominés aux Oscars, ces deux films ont ainsi placé Blue Sky Studios sur le devant de la scène.

Fondé en 1987 par Chris Wedge, le studio joue immédiatement un rôle pionnier dans la création d'animation numérique pour l'industrie audiovisuelle. Les petits cafards qui chantent et dansent dans le si apprécié *Joe's Apartment* de MTV illustrent la combinaison parfaite entre divertissement et technologie, marque de fabrique de Blue Sky. En 1997, la compagnie devient un département phare en animation numérique et effets spéciaux pour la Fox Filmed Entertainment.

Bunny, récompensé par l'Oscar du meilleur court métrage d'animation, suppose une avancée spectaculaire en termes de simulation de la lumière. Après beaucoup d'efforts déployés dans ce domaine, le studio de Chris Wedge développe un logiciel exclusif de simulation du comportement de la lumière sur des objets et des surfaces créés de façon numérique. Grâce à ces ressources et à une productivité accrue pour le rendu d'images, Blue Sky se forge une personnalité propre et détectable dans toutes ses productions.

L'animateur brésilien Carlos Saldanha rejoint l'équipe en 1993 et constitue une nouvelle référence dans le cinéma d'animation. Coréalisateur de *L'âge de glace* et réalisateur de *Gone Nutty*, il est remarqué par Wedge pour son film récompensé *Time for Love*, une histoire d'amour entre deux marionnettes en bois venant perturber la routine mécanique d'une horloge à coucou.

Scrat, das Eichhörnchen mit den großen Zähnen im Animations-Spielfilm *Ice Age*, hat nicht nur unzählige Bewunderer auf der ganzen Welt gefunden, sondern quasi auch das Recht auf weitere prähistorische Abenteuer in dem Kurzfilm *Gone Nutty* erworben. Beide Filme, die jeweils für den Oscar nominiert wurden, haben erheblich zum Ruf der Blue Sky Studios beigetragen.

Das 1987 von Chris Wedge gegründete Filmstudio hat praktisch sofort eine Pionierrolle bei der Versorgung der audiovisuellen Industrie mit digitaler Animation eingenommen. Die kleinen Kakerlaken, die singend und tanzend in dem Kult-Videoclip *Joe's Apartment* auf MTV auftraten, waren Kostproben der perfekten Beziehung, die das Entertainment mit der Technologie eingehen kann, eine Beziehung, die zum Haupterkennungszeichen von Blue Sky wurde. 1997 wurde das Unternehmen zu der Abteilung von Fox Filmed Entertainment, die im Bereich digitaler Animation und Spezialeffekte die Vorhut bildet.

Bunny, der den Oscar für den besten animierten Kurzfilm errang, zeigte die beachtlichen Fortschritte im Bereich der Lichtsimulation in der digitalen Gestaltung. Das Studio von Chris Wedge steckte viel Talent in diesen Bereich und entwickelte Software speziell für die simulierte Lichtführung auf digital geschaffenen Objekten und Oberflächen. Blue Sky hat mit solchen Hilfsmitteln und der Produktivitätssteigerung durch den Einsatz von „Rendering"-Programmen bei Bildern eine eigene Persönlichkeit entwickelt, was sich in seinen Filmen und Werbespots zeigt.

Seit 1993 gehört auch der brasilianische Animationskünstler Carlos Saldanha zur Mannschaft, eine neues Aushängeschild des Animationsfilms. Wedge wurde auf seinen Ko-Regisseur bei *Ice Age* und den Regisseur von *Gone Nutty* aufmerksam, als dieser den später prämierten Film *Time for Love* realisierte, die Liebesgeschichte zweier Holzpuppen, die der mechanischen Routine einer Kuckucksuhr die Stirn bieten.

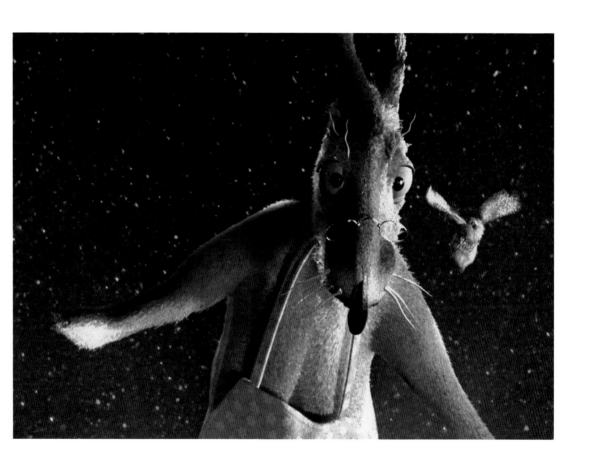

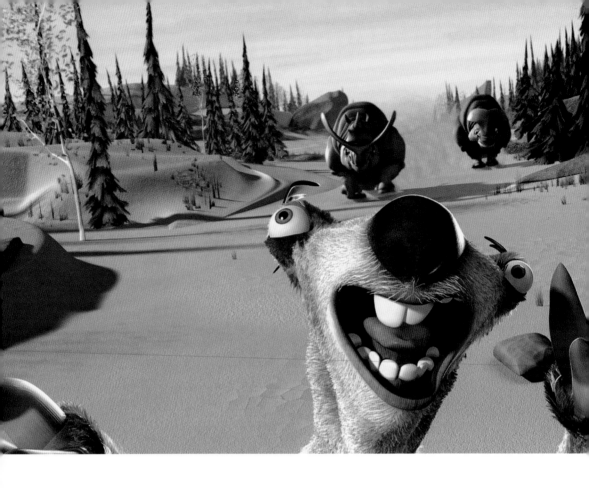

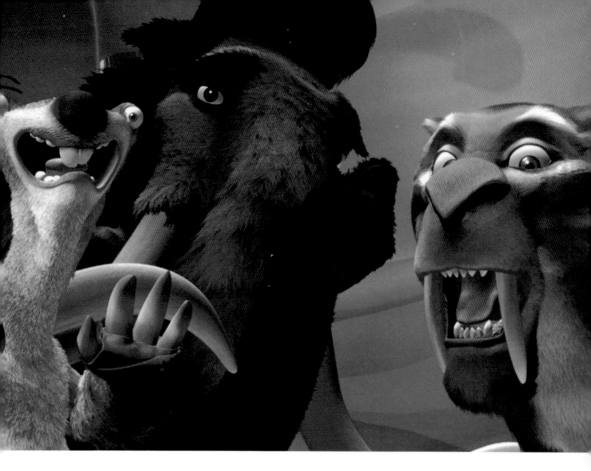

BRUNO BOZZETTO

Italy
Contact: Anita & Irene Bozzetto
Via Corridoni 25b -
24124 Bergamo
E-mail:bozz_bozz@yahoo.com
Phone: + 39 35 369 1905

Tapum! La storia delle armi / Tapum!
 The Weapons' History, 1958
Un Oscar per il Signor Rossi / An
 Award for Mr. Rossi, 1960
Alpha-Omega, 1961
I due castelli / The Two Castles, 1963
West and Soda, 1965
Ego, 1969
Opera, 1973
Allegro non troppo, 1976
Il Signor Rossi cerca la felicità / Mr.
 Rossi Looks for Happiness, 1977
Mister Tao, 1988
Cavallette / Grasshoppers, 1990
Europa & Italia / Europe & Italy, 1999

Critics Prize - Annecy, 1961
First Prize - Venice, 1963/1964
Silver Medal - Montréal, 1967
First Prize - Cannes, 1968
Young People Award - Annecy, 1973
Major Award - Chicago, 1974
Golden Plaque - Chicago, 1976
Best Film for Young People Mifed, 1978
Annie Award to the career, 1982
Golden Bear - Berlin, 1990
Jury Special Prize - Ottawa, 1990
Life Achievement - Zagreb, 1998
Special Jury Prize - Zagreb, 2000
Best Video Short Anima Mundi - São
 Paulo, 2001
Career Award - Bergamo, 2003

Traditional animation
2D computer animation

BRUNO BOZZETTO

www.bozzetto.com

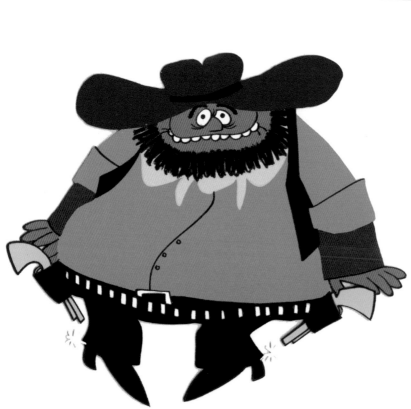

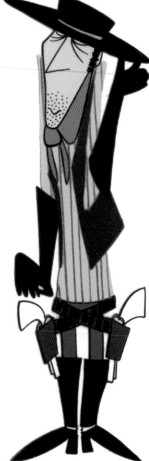

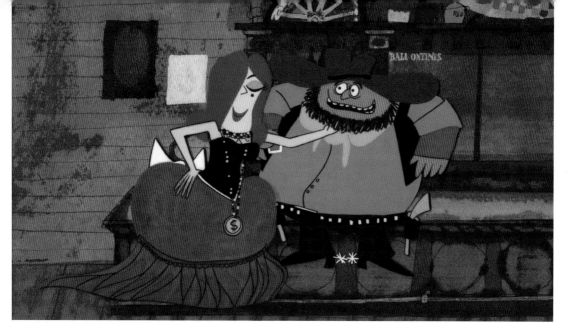

The history of Italian animation and humor of the last forty years cannot be told without mentioning, and stopping to laugh at a moment, the immense filmography of Bruno Bozzetto. This satire superhero chooses his subjects with care: the evolution of man, the search for knowledge and satisfaction, the relativity of things, the meaning of life, vacation travel, a neighbor's parties... All of these topics take on an air of philosophic comedy, while keeping one foot in silent films and the other in surrealism.

Bozzetto was born in Milan in 1938 and he filmed his first professional animation movie at age 20. In 1960 he created the character Sr. Rossi, a common man who cannot find a place for himself in the modern world but who is able to get the public to identify with him. Sr. Rossi starred in several shorts and three feature films. Between 1965 and 1977, Bozzetto filmed six feature-length animated films, one of which is the famous musical *Allegro non troppo*, a humorous response to the Walt Disney film *Fantasia*. The opera and different film genres were not spared either in the film's sharp parody.

With some television series like *La famiglia Spaghetti* and *Quark*, the latter an educational scientific program, the Italian public became familiar with the animated world of Bruno Bozzetto. He has also collaborated with directors who have gained their own recognition, such as Maurizio Nichetti, Guido Manuli and Giuseppe Laganà.

Since 1999, this cartoon veteran dedicates his time to graphic design in 2D. He has also created the series of shorts *Tony & Maria* for the Internet. In 2001, motivated by the new speed of production, he created *Storia del mondo per chi ha fretta*; a typical Bozzetto.

Impossible de parler de l'animation et de l'humour en Italie ces 40 dernières années sans évoquer (et s'arrêter un instant pour rire) l'immense filmographie de Bruno Bozzetto. Le choix des thèmes que ce super héros de la satire traite est bien pensé : évolution de l'homme, quête du savoir et de la satisfaction, relativité des choses, sens de la vie, voyages à l'étranger, fêtes du voisin... Tout prend des allures de comédie philosophique, avec un pied dans le monde du cinéma et l'autre dans le surréalisme.

Né à Milan en 1938, Bozzetto réalise son premier film d'animation professionnel à l'âge de 20 ans. En 1960, il crée le personnage de Monsieur Rossi, un homme banal qui n'arrive pas à se faire une place dans la modernité et incite le public à s'identifier à lui. Il sera la vedette de divers courts et trois longs métrages. Entre 1965 et 1977, Bozzetto tourne six longs d'animation, dont la plus que célèbre comédie musicale

Allegro non troppo, réponse truffée d'humour au film *Fantasia* de Walt Disney. L'opéra et d'autres genres cinématographiques n'échappent pas non plus à son sens aiguisé de la parodie.

Des séries comme *La famille Spaghetti* et *Quark* (de divulgation scientifique) rendent populaire le monde animé de Bruno Bozzetto dans son pays. Il a par ailleurs collaboré avec des artistes eux aussi reconnus, tels que Maurizio Nichetti, Guido Manuli et Giuseppe Laganà. Depuis 1999, le vétéran des dessins animés se consacre au design graphique en 2D. Pour Internet, il crée la série de courts *Tony & Maria* ; et fasciné par la rapidité de production, il réalise en 2001 *Storia del mondo per chi ha fretta*. Du pur Bozzetto.

Ohne das immense filmische Oeuvre von Bruno Bozzetto zu erwähnen (was auch heißt, sich Zeit zu nehmen, um herzhaft zu lachen), lässt sich die Geschichte des Zeichentrickfilms und des italienischen Humors der vergangenen vierzig Jahre kaum erzählen. Dieser großartige Satiriker sucht seine Themen sorgfältig aus: die menschliche Evolution, die (gestillte) Sehnsucht nach Erkenntnis, die Relativität der Dinge, der Sinn des Lebens, aber auch Urlaubsreisen und nachbarschaftliche Feste... All das hat einen Hauch von philosophischer Komödie, die gleichermaßen auf dem Stummfilm wie dem Surrealismus fußt.

Bozzetto, der 1939 in Mailand zur Welt kam, drehte seinen ersten professionellen Zeichentrickfilm mit zwanzig Jahren.1960 entstand mit Herrn Rossi die Figur eines Normalbürgers, dem es nicht gelingt, auf den Zug der Moderne aufzuspringen. Herr Rossi, mit dem sich das Publikum gut identifizieren kann, hatte gleich bei mehreren Kurz- und drei Spielfilmen die Hauptrolle. Zwischen 1965 und 1977 drehte Bozzetto sechs abendfüllende Zeichentrickfilme, darunter das berühmte Musical *Allegro non troppo*, eine humorvolle Antwort auf Walt Disneys *Fantasia*. Weder die Oper noch die verschiedenen Kinogenres entgingen seinem parodistischen Scharfsinn.

TV-Serien wie *La famiglia Spaghetti* und *Quark*, letztere eine allgemeinverständliche Wissenschaftssendung, machte ein breites Publikum in Italien mit der Zeichentrickwelt Bruno Bozzettos vertraut.

Bozzetto arbeitete zeitweise mit inzwischen ebenfalls renommierten Leuten wie Maurizio Nichetti, Guido Manuli und Giuseppe Laganà zusammen. Seit 1999 widmet sich der Zeichentrickveteran dem 2D-Grafikdesign. Für das Netz hat er die Kurzfilm-Reihe *Tony & Maria* gemacht, wobei ihn die rasante Herstellung derart begeisterte, dass er 2001 *Storia del mondo per chi ha fretta* schuf. Ein echter Bozzetto.

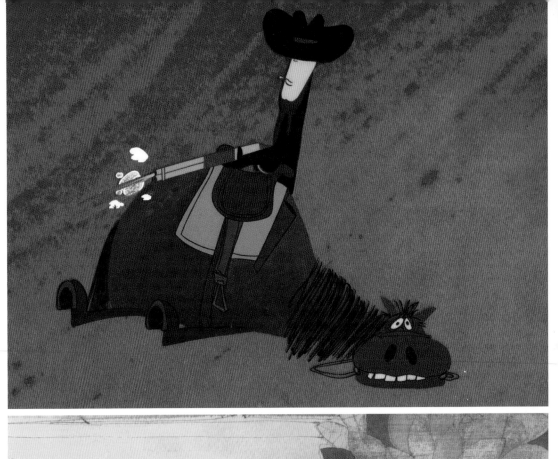

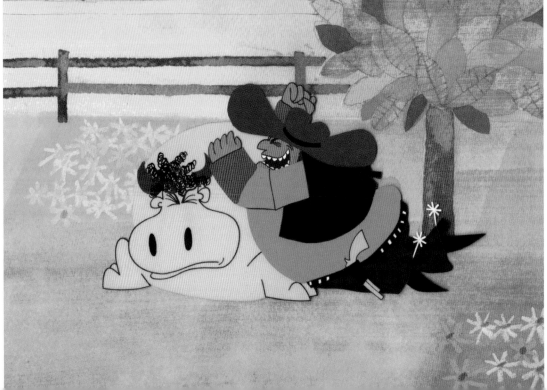

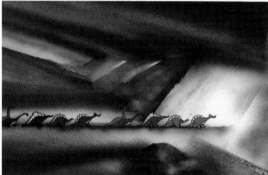

Pg. 46–48 West & Soda, 1965
Traditional animation

Pg. 49 Allegro non Troppo, 1976
Traditional animation

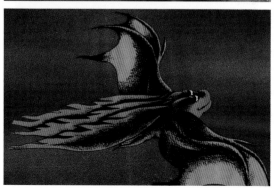

BUZZCO ASSOCIATES

USA
33 Bleecker Street
New York, NY 10012
E-mail: info@buzzzco.com
Phone: (212) 473-8800
Fax: (212) 473-8891

A Warm Reception in L.A., 1987
Snowie and the Seven Dorps, 1990
Fast Food Matador, 1991
We Love It!, 1992
The Ballad of Archie Foley, 1995
KnitWits, 1997
Talking about Sex, 1997
(it was...) nothing at all, 2000
Piscis, 2001
InBetweening America, 1977-2001

Gold Award - Chicago, 1987
First Place Design ASIFA, 1991
Best Educational Film - Annecy, 1997

Traditional animation
Digital scanning and coloring
Flash

BUZZCO ASSOCIATES

www.buzzzco.com

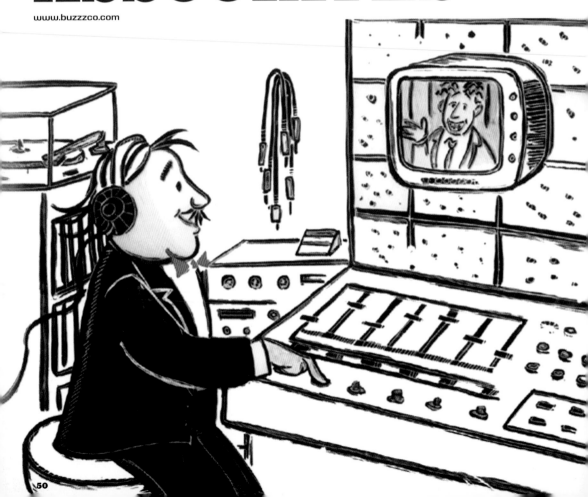

Vincent Cafarelli, Marilyn Kraemer and Candy Kugel are like bees that have been buzzing together in unison since the end of the seventies, when they worked together in the famous New York studio Perpetual Motion Pictures. In 1981 Buzz Potamkin attracted the threesome to the recently created Buzzco Productions, where the team specialized in television programs and vignettes. Candy Kugel also contributed enormously to the creation of MTV's visual identity in its early days.

After Potamkin left the studio in 1984 the trio formed Buzzco Associates and made bees their advertising symbol. They continued to create and produce commercial and public service campaigns, as well as animated material for network and cable television programs. Over the course of the years they have maintained their initial pact of finding more room for making independent films.

Cafarelli and Kugel have created eight of these films, all of them with Lanny Meyers' sound tracks, but each with a very different style. For example, the New York-latino comedy Fast Food Matador makes reference to Pablo Picasso's bullfighting sketches, whereas A Warm Reception in LA is an experimental work that uses neon colors on a black background, and (it was...) nothing at all opens new frontiers for working with computer-created textures.

The team's personal movies also operate, without a doubt, as a laboratory for discovering new ideas that they immediately apply to their commercial productions, thus enriching the Buzzco hive. Finally, the short film Piscis, based on a poem by Giuliana Miuccio, was the company's first production in Flash for the net, and they have since taken on other interactive Internet projects.

Vincent Cafarelli, Marilyn Kraemer et Candy Kugel sont comme des abeilles bourdonnant à l'unisson depuis la fin des années 70, déjà à l'époque collègues au célèbre studio Perpetual Motion Pictures de New York. En 1981, Buzz Potamkin les recrute pour le démarrage de Buzzco Productions, où l'équipe se spécialise en programmes et transitions pour la télévision. De son côté, Candy Kugel participe largement à la création de l'identité visuelle de la chaîne MTV à ses débuts.

En 1984, après le départ de Potamkin, le trio crée Buzzco Associates, justement avec des abeilles comme logo. Ils poursuivent la création et la production de campagnes commerciales et de services publics, outre les animations pour des émissions télévisées tant sur des chaînes gratuites que payantes. Au fil de toutes ces années, ils savent préserver l'accord initial consistant à ouvrir leur porte pour la réalisation de films indépendants.

Cafarelli et Kugel signent cinq de ces créations, toutes accompagnées d'une bande son de Lanny Meyers mais de styles bien différents.

Par exemple, la comédie latino-newyorkaise Fast Food Matador renvoie aux dessins de corridas de Pablo Picasso, alors que A Warm Reception in L.A est une création expérimentale recourant à des néons de couleurs sur fond noir et que (it was...) nothing at all ouvre une nouvelle voie pour la manipulation de textures générées par ordinateur.

En définitive, les films personnels de cette équipe servent de laboratoires pour découvrir des techniques qui sont appliquées dans la foulée aux produits commerciaux, ce qui vient enrichir encore la ruche de Buzzco. Enfin, le court métrage Piscis, inspiré d'un poème de Giuliana Miuccio, est la première réalisation de la compagnie en Flash pour Internet, point de départ d'autres projets interactifs en ligne.

Vincent Cafarelli, Marilyn Kraemer und Candy Kugel sind wie die flei-Bigen Bienchen, die seit Ende der 70er Jahre, als sie noch gemeinsam für das berühmte Filmstudio Perpetual Motion Pictures in New York arbeiteten, zusammen summen. 1981 warb sie Buzz Potamkin für die gerade gegründete Produktionsfirma Buzzco Productions ab, wo das Team sich auf Programme und Comiczeichnungen für das Fernsehen spezialisierte. Candy Kugel ihrerseits war maßgeblich daran beteiligt, in den Anfängen von MTV die visuelle Identität dieses Musiksenders mitzugestalten.

Nachdem Potamkin aus der Firma ausgestiegen war, bildete das Trio die Firma Buzzco Associates und übernahm die Bienen als Label. Es gestaltete und produzierte weiterhin Kampagnen für kommerzielle Zwecke sowie für öffentliche Dienstleister, neben Trickfilmmaterial für das frei zugängliche und das Kabel-Fernsehen. Während all dieser Jahre hat es sein ursprüngliches Abkommen gehalten, nämlich Möglichkeiten für die Realisation von unabhängigen Filmen zu eröffnen.

Cafarelli und Kugel zeichnen verantwortlich für acht solcher Werke, allesamt mit Soundtrack von Lanny Meyers, obgleich in ganz unterschiedlichen Stilen gehalten. So verweist die Komödie Fast Food Matador, die im New Yorker Latinomilieu spielt, auf Pablo Picassos Stierkampfzeichnungen, während es sich bei A Warm Reception in L.A. um eine experimentelle Arbeit handelt, die Neonfarben auf schwarzem Grund einsetzt. (it was...) nothing at all kämpft neue Wege für die Arbeit mit computergeschaffenen Texturen frei.

Die persönlichen Filme des Teams dienen definitiv als Laboratorium für Entdeckungen, die es sofort seinen kommerziellen Produkte anwendet, um so den Bienenstock von Buzzco zu bereichern. Schließlich sei noch der Kurzfilm Piscis, der auf einem Gedicht von Giuliana Miuccio basiert, genannt: von dieser ersten Erfahrung des Unternehmens mit dem Einsatz der Software Flash für das Netz ausgehend, hat man sich auf weitere interaktive Projekte für das Internet gestürzt.

Pg. 50 The Ballad of Archie Foley, 1995
Dir.: Candy Kugel & Vincent Cafarelli
Brush and ink scratched on cell

Pg. 51-52 Talking About Sex, 1997
Dir.: Candy Kugel & Vincent Cafarelli
Traditional animation

Pg. 53 KnitWits, 1997
Dir.: Candy Kugel & Vincent Cafarelli
Traditional animation

CAROLINE LEAF

USA/Canada

Sand or Peter and the Wolf, 1969
Orfeo, 1973
Le Mariage du Hibou / The Owl
 Who Married a Goose, 1974
The Street, 1976
The Metamorphosis of
 Mr. Samsa, 1977
Interview, 1979
A Dog's Tale, 1986
Entre Deux Sœurs /
 Two Sisters, 1990
I Meet a Man, 1991
Odysseus & Olive Tree, 2001

Jury Special - Chicago, 1968
Canadian Film Award, 1975 and 1976
Philip Morris International
 Animation Festival, 1976
Norman McLaren
 Award - Chicago, 1976
Critics and Audience
 Awards - Annecy, 1977
Krakow - Poland, 1978
Jury Award - Montréal, 1979
First Prize - Annecy, 1991
Tampere - Finland, 1991
Life Achievement
 Award - Zagreb, 1996

Manipulating beach sand
 on a lightbox
Fingerpainting on glass
 under the camera lens
Scratching directly into
 film emulsion

CAROLINE LEAF

www.awn.com/leaf/

The destiny of the American animator Caroline Leaf was set with the sole use of sand in her first film, *Sand or Peter and the Wolf*. Since then, this extraordinary artist's career has evolved as a repetition of that totally original experiment. Leaf draws in front of the camera, films her drawing and then destroys it in order to create the next one. In the end all that is left is the movie, which emerges from a process that she calls "one-off performance".

Caroline Leaf exploits rare techniques with refined mastery. In *Two Sisters*, for example, she experimented with the technique of scratching on 70 mm color film. The emotional content of her films also contributes to her having created an original name for herself in the world of animation. Using innovative techniques, she has brought some literary classics to the cinema; for example, Kafka's *The Metamorphosis*, and Mordechai Richler's story *The Street*, a film that earned her an Oscar nomination. She has also adapted ethnic legends, such as *The Owl Who Married a Goose*, to the screen. In her films she expresses her own creative universe, marked by difficult family relationships and her fascination with nature's forces.

Leaf has created most of her films in the liberating environment of the National Film Board of Canada, where she has made some short films in *live action* and has also done several documentaries. She has worked as a professor of animation at Harvard University, and she always encourages the progress of new animators. Her work also includes sculptures and paintings, all of which share the same characteristics of this inquiring author. She currently lives in London.

C'est le sable d'une plage de Boston qui trace le destin de l'animatrice américaine Caroline Leaf : elle en fait à l'époque l'unique matériau de son premier film intitulé *Sand or Peter and the Wolf*. Depuis cet essai totalement artisanal, la carrière de cette remarquable artiste a pris une grande envergure. Elle dessine devant la caméra, filme le dessin puis le détruit avant de passer au suivant. Au final, il ne lui reste que le film, fruit d'un travail qu'elle qualifie de « performance unique ».

Caroline s'est lancée dans des méthodes peu répandues avec un sens parfait de la maîtrise. Dans *Entre deux sœurs* par exemple, elle a utilisé la technique de gravure sur pellicule 70 mm teintée. Le contenu émotionnel de ses films contribue également à créer une personnalité propre dans le monde de l'animation. Elle a porté à l'écran des classiques de la littérature comme *La métamorphose* de Kafka et la nouvelle *La rue* de Mordechai Richler, film qui lui a valu une nomination aux Oscars. Son œuvre offre aussi l'adaptation de légendes ethniques (*Le Mariage du Hibou*) et est à l'image de son propre univers créatif, marqué par des relations familiales difficiles et une fascination pour les forces de la nature.

Leaf a réalisé la plupart de ses films dans le cadre libérateur de l'Office national du film du Canada, dont certains courts métrages en direct et plusieurs documentaires. Elle a enseigné comme professeur d'animation à l'université de Harvard et apporte soutien et encouragements aux nouveaux venus dans le métier. Son œuvre se compose également de sculptures et de peintures qui dénotent la même recherche de maîtrise. Elle a fait de Londres son lieu de résidence.

Die Sanddünen eines Strandes bei Boston wurden für die amerikanische Trickfilmerin Caroline Leaf wegweisend: Auf dieses Material beschränkte sich ihr erster Film *Sand or Peter and the Wolf* . Die Karriere dieser außerordentlichen Künstlerin ist seit damals gleichsam die Entfaltung jenes durch und durch kunsthandwerklichen Experimentes. Sie zeichnet vor der Kamera, filmt und zerstört die Zeichnung, um die nächste zu gestalten. Zum Schluss bleibt nur der Film als Resultat eines Prozesses, den sie „one-off performance" nennt.

Mit ausgesprochen raffiniertem Gespür für ihr kreatives Tun hat sich Caroline Leaf außergewöhnlicher Techniken bedient. So setzte sie in *Two Sisters* Schraffierung auf einem 70 mm Farbfilm ein. Aber auch der emotionale Gehalt ihrer Filme machte aus ihr eine ganz eigene Persönlichkeit in der Welt der Trickfilme. Sie bringt Klassiker der Literatur auf die Leinwand wie *Die Verwandlung* von Franz Kafka oder die Erzählung *The Street* von Mordechai Richler, womit sie sich eine Oscarnominierung verdiente. In ihrem Werk adaptiert sie auch Volkslegenden wie jene von der Gans, die eine Eule heiratete in *Die Hochzeit der Eule*. Leafs eigenes schöpferisches Universum ist von schwierigen Familienbeziehungen und ihrer Faszination für die Kräfte der Natur geprägt.

Den Großteil ihrer Filme hat Leaf in der befreienden Atmosphäre von National Film Board in Kanada geschaffen, wo sie einige Kurzfilme life drehte und mehrere Dokumentarfilme. Als Dozentin für Trickfilm an der Universität von Harvard hat sie junge Trickfilmer enorm angespornt. Ihr Werk umfasst auch Skulpturen und Gemälde, die von dem gleichen schöpferischen Bemühen getragen sind. Leaf lebt zurzeit in London.

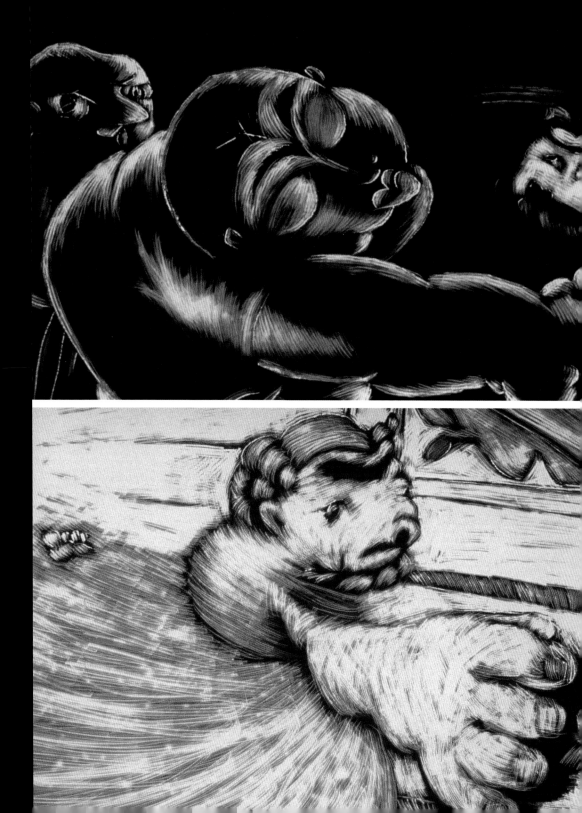

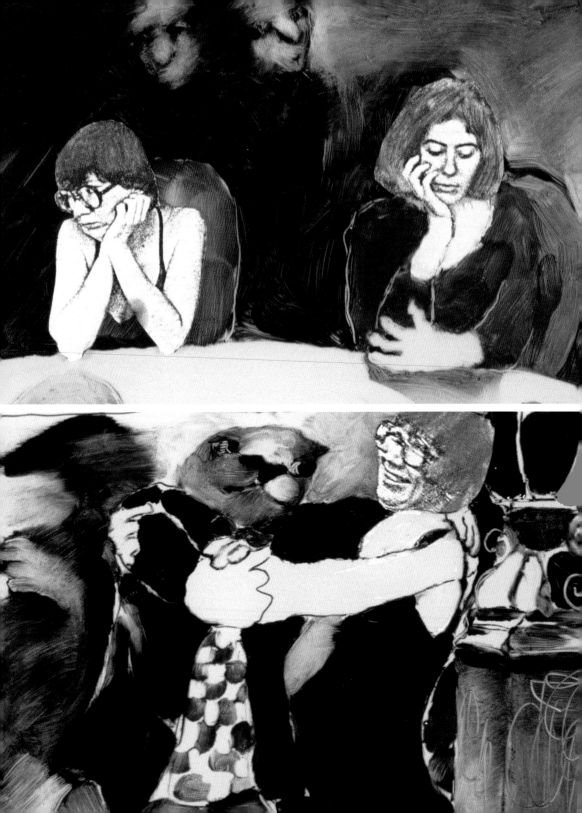

Pg 55 Two Sisters, 1990
Scratching directly into film emulsion

Pg. 56 Interview, 1979
Finger-painting on glass under the
camera lens

Pg 57 The Metamorphosis of
Mr. Samsa, 1977
Manipulating beach sand on a lightbox

DREAMWORKS ANIMATION

USA
1000 Flower Street
Glendale, CA 91201

Antz, 1998
The Prince of Egypt, 1998
The Road to El Dorado, 2000
Chicken Run, 2000
Shrek, 2001
**Spirit: Stallion of the
Cimarron**, 2002
**Sinbad: Legend of the
Seven Seas**, 2003
Shrek 2, 2004

Academy Award for Best
 Original Song, 1999
8 Annie Awards
BAFTA Children's Award, 2002
Academy Award for Best
 Animated Feature, 2002
Kids' Choice Award, 2002
People's Choice Award, 2002

Traditional and digital
 animation
Claymation
3D Computer animation

DREAMWORKS

www.dreamworks.com

DreamWorks SKG was created in 1994, through an association of director Steven Spielberg, record tycoon David Geffen and ex-Walt Disney Studios chairman Jeffrey Katzenberg. Since day one, the studio has been a box-office powerhouse and pioneer in technological developments in animation.

Through successful co-productions with top animation studios such as Aardman and Pacific Data Images (PDI, acquired in 2000), DreamWorks positioned itself as one of the leading studios worldwide. The studio currently runs two campuses in California dedicated to animation, PDI/DreamWorks in Redwood City and DreamWorks Animation in Glendale. Together, they mobilize hundreds of artists in state-of-the-art facilities, often with technologies pioneered by the company.

In 1998, with *The Prince of Egypt* and *Antz*, DreamWorks showed its promise with both traditional animation and cutting-edge digital techniques. Since collaborating on the hit film *Chicken Run* (2000) with Aardman, the studio has added stop-motion animation to its portfolio. The popular film *Shrek* (2002) garnered DreamWorks its first Academy Award® for Best Animated Feature. In 2004, its sequel, *Shrek 2*, has since gone on to become one of the highest grossing films of all time. Scheduled releases for 2004 and 2005, include *Shark Tale, Madagascar* and *The Wallace & Gromit Movie: Tale of the Were-Rabbit*, combine the studio's patented talent for supplementing quality animation with the appeal of top actors providing the voices.

This formula has created an irresistible form of entertainment enjoyed by millions of fans throughout the world. It seems that animation will be more than just a dream at work at this studio for years to come.

DreamWorks voit le jour en 1994 grâce à l'association du réalisateur Steven Spielberg, du producteur millionnaire de disques David Geffen et de l'ancien PDG de Walt Disney Jeffrey Katzenberg. Depuis ses débuts, le studio est une véritable usine à succès commerciaux et il reste pionnier dans les avancées technologiques en matière d'animation.

Grâce à de grandes co-productions avec les meilleurs studios d'animation tels qu'Aardman et Pacific Data Images (PDI, racheté en 2000), DreamWorks s'inscrit comme l'une des compagnies phares de la planète. Deux studios en Californie fonctionnent sous sa coupe pour produire des animations : il s'agit de PDI/DreamWorks à Redwood City et de DreamWorks Animation Studio à Glendale. Ensemble, ils emploient des centaines d'artistes dans des installations de dernier cri, avec des technologies bien souvent mises au point en interne.

En 1998, DreamWorks signe avec *Le Prince d'Égypte* et *Antz* son engagement double envers l'animation traditionnelle et les dernières techniques numériques. Grâce à la co-production avec Aardman du succès *Chicken Run* (2000), le studio complète ses tablettes avec de l'ani-

mation en pâte à modeler. Le célèbre *Shrek* (2002) lui rapporte pour sa part son premier Academy Award pour le meilleur film d'animation. Cette année, la suite intitulée *Shrek 2* est en passe de devenir le film animé aux plus importantes recettes de l'histoire. Les autres sorties prévues pour 2004 et 2005 s'intitulent *Shark Tale, Madagascar* et *The Wallace & Gromit Movie: Tale of the Were-Rabbit* ; elles combinent le talent indéniable du studio pour une animation de qualité et le charme des grands acteurs qui prêtent leur voix.

Cette formule donne un divertissement irrésistible qui compte des millions d'adeptes à travers le monde. Les prochaines années, ce studio continuera visiblement à transformer ses rêves en réalité.

1994 schlossen sich der Regisseur Steven Spielberg, der Platten-Tycoon David Geffen und der ehemalige Walt Disney-Vorstand Jeffrey Katzenberg zu DreamWorks zusammen. Vom ersten Tag an war das Studio so etwas wie ein Kraftwerk für die Kinokassen und Pionier auf dem Gebiet technologischer Entwicklungen bei der Bildanimation.

Durch erfolgreiche Koproduktionen mit Trickfilm-Studios der Spitzenklasse, wie z.B. Aardman oder das im Jahr 2000 erworbene Pacific Data Images (PDI), positionierte sich DreamWorks selbst als eines der weltweit führenden Filmstudios. Das Studio unterhält bekanntlich zwei Niederlassungen in Kalifornien, die sich auf Bildanimation konzentrieren, nämlich PDI/DreamWorks in Redwood City und DreamWorks Animation in Glendale. Zusammen beschäftigen sie Hunderte von Künstlern, wobei das Unternehmen bei den Technologien in den hochmodernen Studioeinrichtungen häufig Neuland betritt.

1998 zeigte DreamWorks mit *The Prince of Egypt* und *Antz* seine Verpflichtung sowohl gegenüber traditionellem Zeichentrick wie auch gegenüber innovativer Digitaltechnik. Seit dem Erfolgsfilms *Chicken Run* (2000), einer Koproduktion mit Aardman, kann das Studio auch Knetfiguren-Animation in seiner Werkliste aufführen. Der populäre Film *Shrek* (2002) brachte DreamWorks seinen ersten Academy Award in der Sparte „Bester animierter Spielfilm" ein. Und 2004 ist der Folgefilm *Skrek 2* dabei, zum Animationsfilm mit dem höchsten Einspielergebnis aller Zeiten zu werden. Für 2004 und 2005 ist der Kinostart von *Shark Tale, Madagascar* und *The Wallace & Gromit Movie: Tale of the Were-Rabbit* geplant; hier wird das offenkundige Talent des Studios für Bildanimation von höchster Qualität mit dem Reiz der Synchronisationsstimmen von Starschauspielern ergänzt.

Dieses Rezept hat eine umwerfende Unterhaltungsform zur Freude von Millionen Fans auf der ganzen Welt geschaffen. Es scheint so, als ob Bildanimation auch in den kommenden Jahren mehr sein wird, als bloß ein Traum, der in diesem Studio geträumt wird.

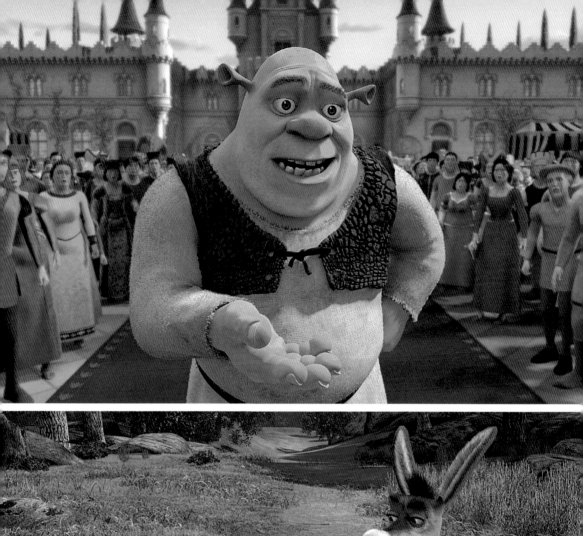
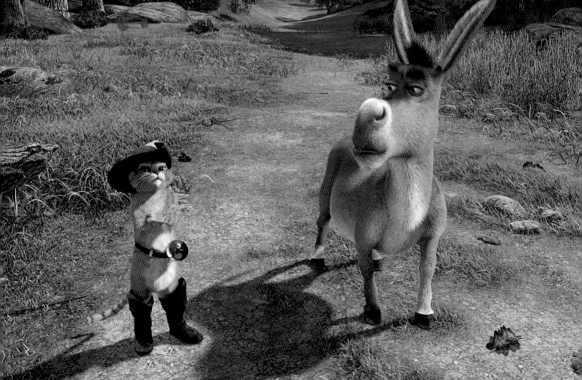

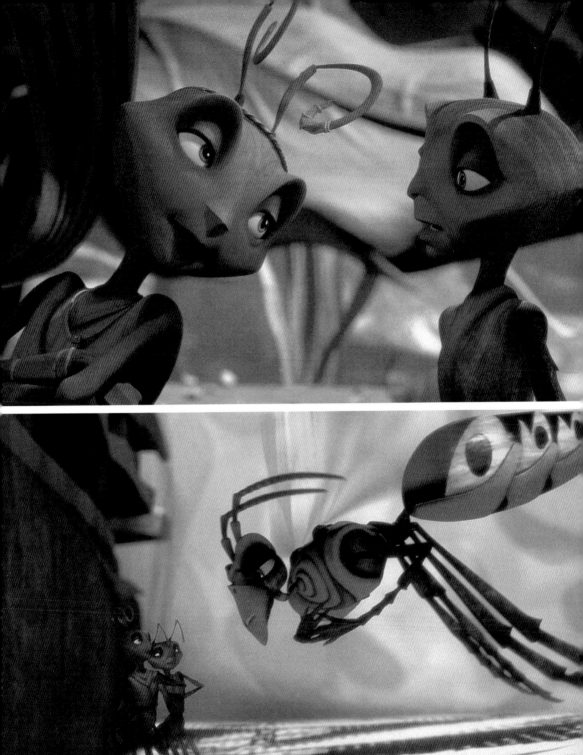

Pg. 59 Shrek 2, 2004

Pg. 60 Antz, 1998

Pg. 61 (top) The Road to
El Dorado, 2000

Pg. 61 (bottom) Spirit: Stallion of
the Cimarron, 2002

Pg. 62 The Prince of Egypt, 1998

Pg. 63 (top) Chicken Run, 2000

Pg. 63 (bottom) Sinbad: Legend of
the Seven Seas, 2003

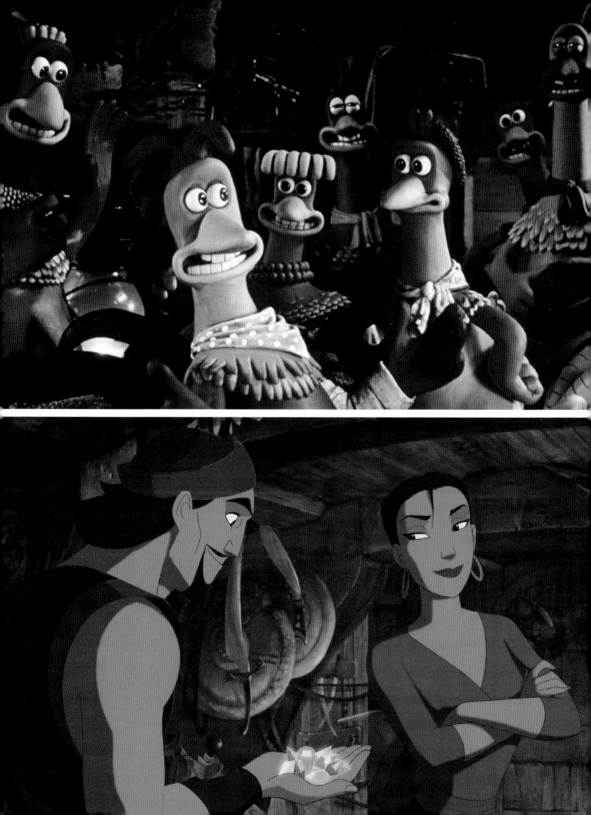

DUCK Studios (a.k.a. Duck
Soup Studios)

USA
Contact: Katie Medernach
2205 Stoner Avenue
Los Angeles, CA 90064
Phone: 310-478-0771
Fax: 310-478-0773

The Snowman, 2001

First Prize Directv-Level13.net - Los
Angeles, 2002
Bronze Award - Kalamazoo, 2002
Best Animation Indie Film Festival -
Hollywood, 2002

Traditional animation
2D and 3D computer graphics
Live action integration

DUCK SOUP

www.duckstudios.com

Imagine a studio capable of transforming any idea into a dynamic, modern and creative animated movie. That is Duck. Formerly known as Duck Soup Studios of Los Angeles, this company produced the highly acclaimed short film *The Snow Man*, and has extensive experience producing commercials, vignettes, title designs, videos, etc.

The group of directors associated with Duck includes award-winning and experienced names like those of Roger Chouinard, John Howley, Paul Vester (*Sunbeam, Picnic, Abductees*) and Graham Morris, as well as innovating new talents from all over the world, such as Niko Meulemans (*The Museum, Chickendales*), Steve Kirklys (*Playing With Blocks*), Erik Deutschman (*Split*), Jeff Drew (*Walk*), Brooke Keesling (*Boobie Girl*), Nicolas Kang, Lane Nakamura and Jeong-A Seong. Amongst them they cover a wide range of technical and artistic skills, including experimental animation. This explains the versatility of Duck's commercial productions, which include clients like Coca-Cola, Levi's, General Motors, McDonald's or Universal Studios, as well as artists such as Mariah Carey and Limp Bizkit.

Traditionally associated with classical animation techniques, since the nineties Duck has evolved towards using digital images. Since this time it has brought writers and animators together in an original content division, designed with the purpose of creating new ideas for film and television. The studio is equipped with the most modern processes of graphic design and digital effects. Among their specialties is the integration of animation with live scenes, a technique that has given many of their recent commercials their characteristic touch of charm and personality.

Si vous imaginez un studio capable de transformer la moindre idée en un film d'animation moderne et créatif, vous faites sans le savoir référence à Duck. Anciennement Duck Soup Studios, cette compagnie de Los Angeles à l'origine du célèbre court métrage *The Snowman* possède à son actif une liste infinie de spots, transitions, ouvertures pour la télévision, clips vidéo, etc.

Les réalisateurs travaillant pour Duck sont aussi bien de grandes pointures telles que Roger Chouinard, John Howley, Paul Vester (*Sunbeam, Picnic, Abductees*) et Graham Morris, que de nouveaux talents internationaux, comme Niko Meulemans (*The Museum, Chickendales*), Steve Kirklys (*Playing With Blocks*), Erik Deutschman (*Split*), Jeff Drew (*Walk*), Brooke Keesling (*Boobie Girl*), Nicolas Kang, Lane Nakamura et Jeong-A Seong. À eux tous, ils couvrent une large gamme de savoirs techniques et artistiques, dont l'animation expérimentale, d'où l'éclectisme des productions commerciales de la maison : entre autres clients

se trouvent Coca-Cola, Levi's, General Motors, McDonald's, Universal Studios, ainsi que des artistes comme Mariah Carey et Limp Bizkit.

D'abord attaché aux techniques d'animation classiques, le studio Duck s'est tourné à partir des années 90 vers l'imagerie numérique. Depuis lors, il réunit des auteurs et des animateurs dans une nouvelle section de contenu pour créer des idées exploitables au cinéma et à la télévision. Il est actuellement équipé des outils dernier cri en matière de design graphique et d'effets numériques. L'une des spécialités de la maison, l'insertion d'animations dans des scènes filmées en direct, apporte la touche amusante et la personnalité ayant marqué ses récentes productions publicitaires.

Man denke an ein Studio, das fähig ist, jedwede Idee in einen dynamischen, modernen und kreativen Animationsfilm zu verwandeln. Duck hat genau dieses Profil. Die seit langem bestehenden Duck Soup Studios von Los Angeles sind ein Unternehmen, das nicht nur den so erfolgreichen Kurzfilm *The Snow Man* hervorbrachte, sondern ein ganzes Spektrum an Reklamen, Einzelzeichnungen, Vorspannen und Eingangssequenzen für das Fernsehen, Videoclips und anderem.

Zum Duck-Umkreis gehören Namen verdienstvoller und sehr erfahrener Regisseure wie Roger Chouinard, John Howley, Paul Vester (*Sunbeam, Picnic, Abductees*) und Graham Morris, genauso wie brandneue Talente aus unterschiedlichen Teilen der Welt wie Niko Meulemans (*The Museum, Chickendales*), Steve Kirklys (*Playing With Blocks*), Erik Deutschman (*Split*), Jeff Drew (*Walk*), Brooke Keesling (*Boobie Girl*), Nicolas Kang, Lane Nakamura und Jeong-A Seong. Allesamt decken sie eine breite Palette an technischen und künstlerischen Fertigkeiten ab, darunter auch die experimentelle Animation. Das erklärt die Wandlungsfähigkeit der kommerziellen Produktion des Unternehmens Duck, zu dessen Kunden Coca-Cola, Levi's, General Motors, McDonald's und Universal Studios zählen, ganz abgesehen von Künstlern wie Mariah Carey und Limp Bizkit.

Aus Tradition den Techniken klassischer Zeichentricks verbunden, hat sich Duck seit den Neunzigerjahren zu digitalen Bildern weiterentwickelt. Seitdem hat das Unternehmen Autoren und Animationskünstler in einer neuen Abteilung für Filminhalte zusammengeführt mit dem Ziel, innovative Ideen für Kino und TV zu entwickeln. Heute ist das Studio für die modernsten Abläufe des digitalen Grafikdesigns und im Bereich Digitaleffekte ausgerüstet. Zu den Spezialitäten des Hauses gehört, in reale Filmszenen Animation zu integrieren; damit hat es vielen seiner jüngsten Reklame-Arbeiten eine besonders charmante Note und eigenen Stil verliehen.

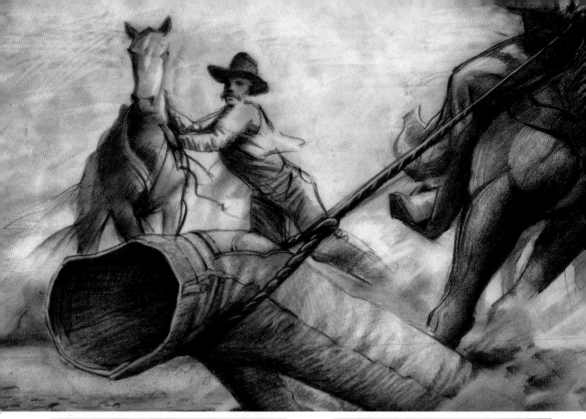

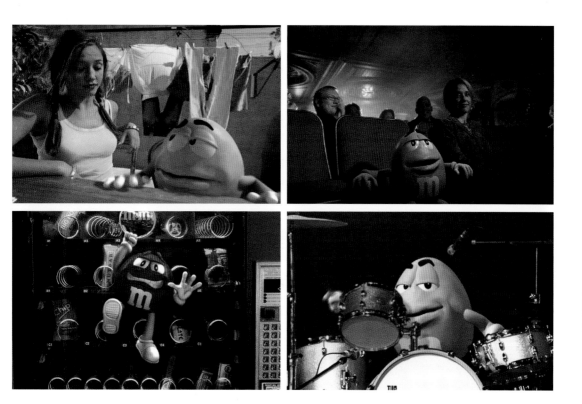

g. 68 Round Up (commercial)
Dir.: Roger Chouinard
Agency: Foote, Cone & Belding/Honig
Client: Levi's

Pg. 69 M&M's series of
commercials, 2003
Dir.: Lane Nakamura
Agency: BBDO
Client: M&M/Mars, Inc.

ERICA RUSSELL

United Kingdom
Gingco
5 Muswell Hill Rd,
 London N10 3JB
E-mail: gingco@blueyonder.co.uk
T: +44 208 883 9689

Feet of Song, 1989
Triangle, 1994
Experimental Dance, 1997
SOMA, 2001

Best British Animated Film, 1989
Best under 15 min BAA, 1995
Clio Award, 1996

Painting and drawing on paper
Cell animation
Cut paper
Digital processing of live action

ERICA RUSSELL

The movies of New Zealand-born Erica Russell reveal the mark of two important experiences in her life: her childhood lived in South Africa and her years as a dancer. The short films that she completed for the English Channel Four, *Feet of Song*, *Triangle* and *SOMA*, make up a trilogy that is dedicated to dance and, at the same time, closely linked to African culture.

The first film celebrates the influences of the African arts, above all dance, in worldwide culture. The second, which earned her an Oscar nomination, is a study of the patterns of movement, done with three-dimensional figures and geometric forms. In both of these films Russell makes use of a brilliant sound track of African and Brazilian rhythms. In the third film a wild and violent dance enters into dialogue with graffiti art inspired in Jean-Michel Basquiat.

Russell also explores the relationship that exists between dance and animation in other experimental works through digital processing of real images. With these films, Erica Russell, who has lived in London since 1971, established herself as one of the most outstanding talents of British animation. Although she has not had academic training, she learned to animate by doing a little bit of everything in the different studios in which she has spent time. She worked as an assistant for Art Babbit, a pioneer of the Disney studios, and for Rocky Morton and Annabel Jankel, creators of the revolutionary character Max Headroom.

In the eighties Russell created the Eyeworks studio and, in 1982, the production company Gingco. Since then, she has won awards for her commercials for women's Levi's jeans and for the chain Virgin Megastore. She has also done videos for stars like Elton John and Tom Tom Club, and created the opening credits for television shows, among other things.

Née en Nouvelle Zélande, Erica Russell laisse dans ses films d'auteur l'empreinte de deux expériences majeures qu'elle a vécues : son enfance en Afrique du Sud et ses années de danse. *Feet of Song*, *Triangle* et *SOMA*, courts réalisés pour la chaîne britannique Channel Four, forment ainsi une trilogie à la fois dédiée à la danse et dévoilant des liens étroits avec la culture africaine.

Le premier est un hommage à l'influence des arts africains, notamment la danse, sur la culture mondiale. Le deuxième, qui lui a valu une nomination aux Oscars, offre une étude des modèles de mouvements avec des figures en 3D et des formes géométriques. Dans ces deux productions, Russell fait appel à une excellente bande son de rythmes africains et brésiliens. Quant au troisième court, il met en scène le dialogue entre une danse sauvage et agressive et l'art du *graffiti* inspiré de Jean-Michel Basquiat.

La relation entre le monde de la danse et l'animation est également dépeinte dans d'autres travaux expérimentaux avec un traitement numérique de l'image. Grâce à ces films, Erica Russell, installée à Londres depuis 1971, s'inscrit parmi les grandes pointures de l'animation britannique. Sans formation académique dans le domaine, elle a appris le métier en touchant un peu à tout dans différents studios. Elle a travaillé comme assistante de Art Babbit, pionnier des studios Disney, ainsi que de Rocky Morton et Annabel Jankel, créateurs du personnage révolutionnaire Max Headroom.

Au cours des années 80, Russell crée le studio Eyeworks et en 1992, la maison de production Gingco. Plus tard, elle obtient des récompenses pour les spots de jeans pour femme Levi's et ceux des magasins Virgin Megastore. Elle a également réalisé des clips vidéo pour de grands noms comme Elton John et Tom Tom Club, ainsi que des génériques pour la télévision, entre autres créations.

Die Filme von Erica Russell, die aus Neuseeland stammt, sind im Wesentlichen von zwei für sie wichtigen Lebenserfahrungen geprägt: ihrer Kindheit in Südafrika und ihrer Zeit als Tänzerin. *Feet of Song*, *Triangle* und *SOMA*, Kurzfilme im Auftrag des britischen Channel Four, bilden eine Trilogie, die dem Tanz gewidmet ist; sie zeigen darüber hinaus enge Bindungen zur afrikanischen Kultur.

Der erste Teil der Trilogie feiert den Einfluss, den die afrikanischen Künste weltweit auf den Tanz haben. Der zweite, der für einen Oscar nominiert wurde, ist eine Studie über Bewegungsmuster mit dreidimensionalen Figuren und geometrischen Formen. In beiden Filmen bedient sich Russell eines brillanten Tonbandes mit afrikanischen und brasilianischen Rhythmen. Im dritten Film tritt ein wilder und brutaler Tanz mit der Kunst der Graffiti, die von Jean-Michel Basquiat angeregt ist, in Zwiesprache.

Die zwischen Tanz und Trickfilm bestehende Beziehung erforscht sie auch in anderen Arbeiten, in denen sie mit der elektronischen Datenverarbeitung des realen Bildes experimentiert. Mit diesen Filmen hat sich Erica Russell, die seit 1971 in London lebt, einen Namen als eine der herausragenden VertreterInnen des britischen Animationsfilmes gemacht. Ohne akademische Ausbildung auf diesem Gebiet lernte sie die Trickfilmkunst, indem sie hier und da in den verschiedenen Studios, in denen sie vorübergehend arbeitete, ein bisschen hineinschnupperte. Sie arbeitete als Assistentin von Art Babbit, dem Pionier der Disney Studios und mit Rocky Morton und Annabel Jankel, den Schöpfern der revolutionären Figur Max Headroom.

In den achtziger Jahren gründete Russell das Eyeworks Studio und 1982 die Produktionsfirma Gingco. Später wurde sie für ihre Jeans-reklame für Frauen, die sie für Levi's gestaltete, und für ihre Werbung für die Virgin Megastore-Kette ausgezeichnet. Auch Videoclips für Stars wie Elton John und Tom Tom Club sowie Vorspannsequenzen für das Fernsehen hat sie gemacht.

FEET OF SONG A-20

FEET OF SONG J36.

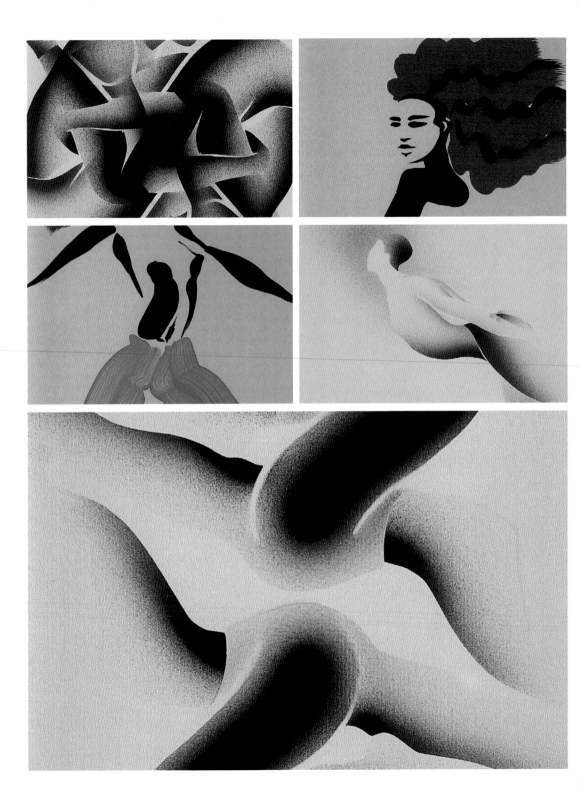

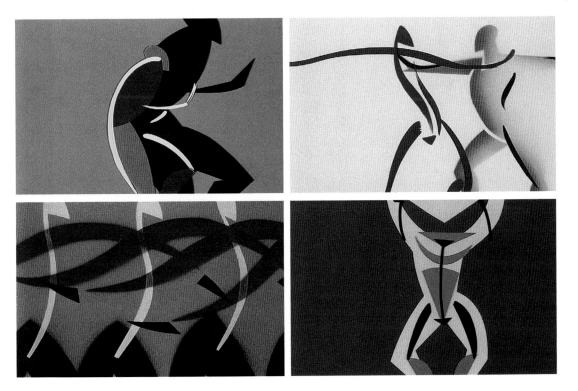

FEDERICO VITALI

EAT AT JOE'S Films Prod.
E-mail: lava.lava@free.fr

Le miracle égyptien / The
 Egyptian Miracle, 1987
Pépère et Mémère / Gran'Pa
 & Gran'Ma, 1987
Guano! series, 1990-1992
Lava-Lava! series, 1995-1997
Signé Furax / Signed
 Furax, pilot, 2001

Best TV series - Annecy, 1995

Traditional animation

FEDERICO VITALI

Federico Vitali's peculiar sense of humor became famous worldwide with the fifty thirty-second episodes of the *Guano!* series that aired on Canal +. In the series several horrible yet, at the same time, pleasant characters lived the noisiest and most foolish of adventures imaginable. Not satisfied yet, Vitali broadened his animated bestiary with the series *Lava-Lava!*, which was produced for the same television channel. This time the show was about animals, farmers and even extraterrestrials that impulsively mingled with one another in a strange vision of the rural world; a world in which it is easy to recognize our own reality.

In spite of his Italian name, Federico Vitali was born in a French village and continues to live in France today. He spent his childhood in the Caribbean islands and became fascinated with animated drawings when he studied Fine Arts in Perpignan. He currently works in his studio-home –called Eat at Joe's– in the town of St. Pierre des Champs. His works include experimental short films, commercials and television programs about animation, such as *La nuit s'anime*, from the Arte channel, and *Trashorama*, a work about independent American animation that he did in collaboration with Bill Plympton.

In 2004, Vitali is preparing the written as well as graphic scripts for the new television series *Farmer farm farm*, and is also continuing to prepare the animated feature film *Ouaaahh!!*, which he wrote with J. Vittiello. On the whole, his work is pure entertainment in the best anarchic cartoon tradition, with nothing unclear about it, and without losing the tone of parody that grants him the title of author; something that not all animation can aspire to.

Le sens de l'humour de Federico Vitali a fait le tour du monde grâce aux 50 épisodes d'une durée de 30 secondes de la série *Guano!* diffusée sur Canal+: y sont mis en scène des personnages aussi terribles qu'avenants et vivant des aventures si mouvementées qu'elles en sont inimaginables. Voulant aller plus loin, Vitali étend ensuite son bestiaire animé avec la série *Lava-lava!* produite par la même chaîne. Il est cette fois question d'animaux, de fermiers, d'extraterrestres même, tous survoltés et se côtoyant dans un étrange monde rural reflétant parfaitement notre réalité.

En dépit de son nom italien, Federico Vitali est né dans un village de l'Hexagone où il réside encore maintenant. Après une enfance sous le soleil des Caraïbes, il développe sa passion pour les dessins animés lors de ses études aux Beaux-arts de Perpignan. À l'heure actuelle, il travaille à St. Pierre des Champs, dans sa maison-studio baptisée Eat at Joe's. Il compte à son actif des courts expérimentaux, des spots publicitaires et des programmes de télévision sur l'animation, tels que *La nuit s'anime*, sur Arte, et *Trashorama*, œuvre réalisée en collaboration avec Bill Plympton sur l'animation indépendante américaine.

Pour 2004, Vitali a des scénarios en préparation, comme les storyboards pour la nouvelle série télévisée *Farmer farm farm*, ainsi que le long métrage animé *Ouaaahh !!*, coécrit avec J. Vittiello. Son œuvre est un divertissement à l'état pur, sans demi-mesures, dans la grande tradition anarchique des dessins animés et attachée à l'approche parodique qui lui vaut le titre d'auteur. Tel n'est pas le cas de la première animation venue.

Man kennt Federico Vitalis besonderen Sinn für Humor weltweit durch die 50 halbminütigen Episoden der Serie *Guano!*, die der Sender Canal + ausstrahlte. Dort erlebte eine Hand voll grauenhafter und gleichzeitig leutseliger Figuren die aufsehenerregendsten und verrücktesten Abenteuer, die man sich überhaupt vorstellen kann. Damit gab sich Vitali aber nicht zufrieden und erweiterte sein Trickfilm-Bestiarium mit der Serie *Lava-lava!*, die er für denselben TV-Sender produzierte. Dabei handelte es sich um Tiere, Farmer und sogar Außerirdische, die auf recht ungestüme Weise miteinander Beziehungen eingingen: in der seltsamen Sichtweise der bäuerlichen Welt kann man leicht unsere Wirklichkeit wieder erkennen.

Er trägt zwar einen italienischen Namen, kam aber in einem Dorf in Frankreich zur Welt, wo er bis heute lebt. Seine Kindheit verbrachte er in der Karibik und begeisterte sich während seines Kunststudiums in Perpignan für Zeichentrick. Zurzeit arbeitet er in seinem „Eat at Joe's" genannten Hausatelier in dem Dorf St. Pierre des Champs. Sein Curriculum beinhaltet experimentelle Kurzfilme, Werbung und Fernsehprogramme über Animation, z.B. *Trick zur Nacht*, das auf Arte lief, oder *Trashorama*, eine Arbeit über den unabhängigen amerikanischen Trickfilm, die er zusammen mit Bill Plympton realisierte.

Für 2004 bereitet Vitali sowohl das Script wie auch die „storyboard" genannten gezeichneten Drehbücher für die neue Fernsehserie *Farmer Farm Farm* vor. Nebenher verfolgt er die Vorbereitung des animierten Spielfilms *Ouaaahh!!* weiter, für den er zusammen mit J. Vittiello den Drehbuch verfasst hat. Tatsächlich ist sein Werk reines Vergnügen, ohne Abstrich, in der besten anarchischen Tradition des Zeichentricks und ohne den parodistischen Ton aufzugeben, dem er die Einstufung als „Autor" verdankt, worauf nicht jede Art von Bildanimation spekulieren kann.

Pg. 74–76 Ouaaahh!!, 2004/2005
Traditional animation

Pg. 77 Lava-lava (TV
series), 1995-1997
Traditional animation

FERENC CAKÓ

Hungary
Apostol utca 21,
 Budapest 1025
E-mail: cako@hu.inter.net
Phone: + 361 326 1094

A Szék / The Chair, 1978
Ad Astra, 1982
Sebajtóbiás / Nevermind Toby,
 series, 1982-1985
Zeno, series, 1985-1988
Ab Ovo, 1987
Hamu / Ashes, 1989
Song of the Sand, 1996
Labirintus / Labyrinth, 1999
Magyar Várak Legendái / Legends of
 the Hungarian Castles, series, 2000
The Four Seasons, series, 2000

Fipresci Prize - Annecy, 1983
Category Prize - Espinho, 1983
Silver Dragon - Krakow, 1983
Best Animation - Cannes, 1988
Best Short - Annecy, 1989
Golden Gate Award - San Francisco, 1991
Golden Bear - Berlin, 1994
City of Espinho Prize, 1996
Special Prize - Zagreb, 1999
Outstanding Artist - Hungary, 1999

Objects, puppet, clay
Paper-cut
Sand animation

FERENC CAKÓ

www.cakostudio.hu

Ferenc Cakó is one of the few animation artists to exhibit his work in performances all over the world. On stage, seated at a table and surrounded by musicians or speakers, he "paints" marvellous sand pictures, then immediately wipes them away while the audience follows the process, one step at a time, on a movie screen.

Cakó was born in Budapest in 1950 and began animating with puppets, clay and paper cutouts at the beginning of the seventies; first at the School of Fine Arts and later, from 1973 to 1991, at the Pannonia Film Studio. In 1982 he began to animate his own scripts. Nonetheless, it was not until 1987, after receiving an award at the Cannes Festival for his short film Ab Ovo, when he definitively adopted the use of sand. When the sand comes in contact with his hands the fine grains flow with the magic of the best storytellers. In addition to this, Cakó continues to combine diverse materials and techniques. Sometimes he is interested in contrasting them, and other times in complementing them.

This pride of modern Hungarian culture is also a drawer and painter—with works exhibited in several countries—, a distinguished illustrator of children's and adolescent's books, and a professor of 3D animation. Fables, television series for children, small comedies of the absurd and dense essays, at times terrifying and always visually impeccable, stand out in his filmography. In his most ambitious short films, themes of his own past surface –Ashes–, as well as the workings of Hungarian society –Nest–, the anguish of the future –Labyrinth– and the relative impotence of desire –Vision–.

Ferenc Cakó est l'un des rares artistes en animation effectuant des performances à travers le monde. Sur scène, devant une table et entouré de musiciens ou de haut-parleurs, il « peint » de magnifiques tableaux de sable pour les détruire immédiatement. Dans la salle, le public suit chaque étape du processus sur écran géant.

Né à Budapest en 1950, Cakó débute dans l'animation au début des années 70 avec des marionnettes, de la plastiline et des découpages de papier. Il passe d'abord par l'École des beaux-arts puis, entre 1973 et 1991, il travaille pour le Pannonia Film Studio. Dès 1982, il commence à animer ses propres scénarios mais ce n'est qu'en 1987, lorsqu'il reçoit le prix du Festival de Cannes pour son court Ab Ovo, qu'il adopte définitivement la technique du sable. Au contact de ses doigts, les grains fins glissent et transmettent la magie des meilleurs conteurs. En parallèle, Cakó poursuit l'association de divers matériaux et procédés qu'il ne semble

Cet orgueil de la culture hongroise moderne exerce également comme dessinateur et peintre (ses œuvres sont exposées dans divers pays), illustrateur vedette de livres pour enfants et adolescents, mais aussi comme professeur d'animation en 3D. Sa filmographie renferme des fables et séries télévisées pour enfants, de petites comédies sur l'absurde et des essais poussés, parfois effrayants mais toujours impeccables sur le plan visuel. Ses courts d'auteur les plus ambitieux abordent des thèmes propres à son passé dans Cendres, le fonctionnement de la société hongroise dans Nid, l'angoisse face à l'avenir dans Labyrinthe et la relative impuissance du désir dans Vision.

Ferenc Cakó gehört zu den wenigen Trickfilmern, die ihre Arbeit in Form von Performances auf der ganzen Welt vorführen. Umgeben von Musikern oder Lautsprechern „malt" er auf der Bühne auf einem Tisch wunderbare Sandbilder, um sie sofort wieder zu zerstören, während die Zuschauer diesen Prozess Schritt für Schritt auf einer Kinoleinwand verfolgen.

Cakó, der 1950 in Budapest zur Welt kam, begann Anfang der siebziger Jahre mit dem Trickfilm – zunächst mit Puppen, Plastilin und Scherenschnitt – und zwar zuerst an der Kunstakademie, dann von 1973 bis 1991 im Pannonia-Filmstudio. Seit 1982 verwendete er seine eigenen Trickfilm-Drehbücher. Aber erst 1987 entschied er sich definitiv für Sand als den Stoff seiner Wahl, nachdem sein Kurzfilm Ab Ovo auf dem Festival von Cannes ausgezeichnet worden war. Unter seiner Berührung fließen die feinen Körnchen mit dem Zauber der besten Märchenerzähler. Cakó kombiniert aber auch weiterhin verschiedene Materialien und Techniken, einmal daran interessiert, sie zu kontrastieren, ein anderes Mal, sie gegenseitig zu ergänzen.

Er, der ganze Stolz der modernen ungarischen Kultur, ist auch Zeichner und Maler, der in verschiedenen Ländern ausstellte, vortrefflicher Kinder- und Jugendbuch-Illustrator und Professor für 3D-Animation. In seinem filmischen Oeuvre ragen Fabeln und Kinderprogramme für das Fernsehen heraus, kleine Komödien über Absurditäten und dann wiederum bedrückende, zuweilen erschreckende Studien – das alles immer visuell makellos. In seinen eher anspruchsvollen kurzen Autorenfilmen tauchen Themen aus seiner persönlichen Vergangenheit auf (Ashes). Es geht auch um das Funktionieren der ungarischen Gesellschaft (Nest), um Zukunftsangst (Labyrinth) und die relative

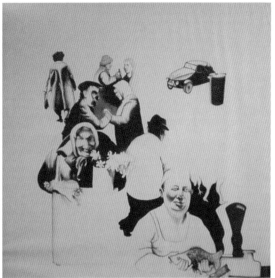

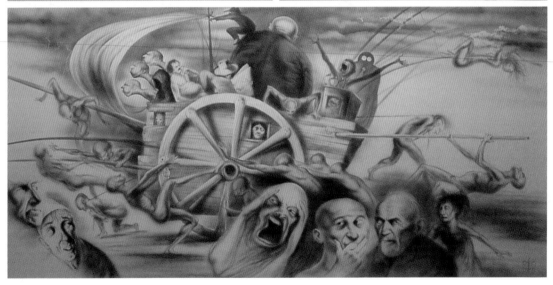

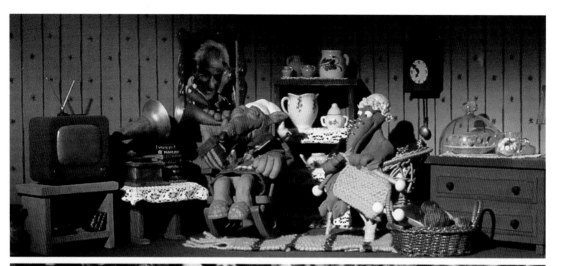

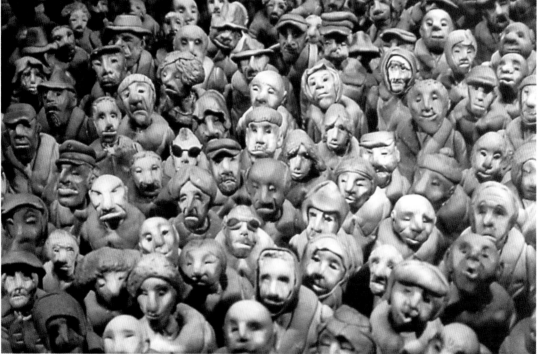

Pg. 81
Caravan, 2000
Puppet animation

Labirintus, 1999
Puppet animation

FILMÓGRAFO

Portugal
Contact: Abi Feijó
Rua Dr. António Macedo 309
r/c Dº 4420-430 Valbom
Gondomar
E-mail: ciclope@ciclopefilmes.com
Phone: + 351 93 627 5674

Oh que calma / How Calm It Is, 1985
Os salteadores / The Outlaws, 1993
Ovo / Egg, 1994
Estória do gato e da lua / The Cat
 and the Moon, 1995
Fado lusitano / Fado, the Lusitanian
 Lament, 1995
Gatofone / Catphone, 1996
Jogos olimpicos / Olympic Games, 1996
A casa do João / João's House, 1998
A noite / The Night, 1999
Clandestino / Stowaway, 2000

Special Jury Prize - Espinho, 1993
Cartoon Portugal and Best
 Portuguese script - Espinho, 2000
Grand Prix T_ebo_ - Czech
 Republic, 2003

Traditional animation
Cut out, clay, sand and
puppet animation
Computer graphics

FILMÓGRAFO

http://awn.com/filmografo

"Portugal has a roving heart, an adventurer's spirit, a grieved soul and an obedient body"; this is a synopsis of the short film *Fado lusitano*. The director of this film, Abi Feijó, the producer Filmógrafo, and the film itself have all contributed to endowing Portugal with a powerful new generation of artists anxious to do away with the country's long lull in the area of animation. The movement began at the beginning of the nineties, motivated by the growth of the Cinanima Festival which, since 1977, brings the international community of animation together every year in the Portuguese city of Espinho.

Abi Feijó was born in Braga in 1956 and studied at Porto's School of Fine Arts. In 1984 he collaborated with the National Film Board of Canada, where he reaffirmed his conviction to dedicate himself to animation. Upon returning to his country he founded Filmógrafo, today a center of attraction for audacious filmmakers who practice the most diverse techniques. Manuela Bacelar, Daniela Duarte Rui, Graça Gomes, Clídio Nóbio, André Marques, Pedro Serrazina, Regina Pessoa and José Miguel Ribeiro are among the directors who have been recognized at the most important international festivals.

Apart from some of the educational films that Filmógrafo creates, their productions offer a series of profoundly Portuguese subjects—songs, ghosts from popular culture, traumas from history, etc—and, at the same time, universal themes. As with the rest of contemporary Portuguese cinema, these animators understand film to be an individual and subjective reflection with political content and humanistic meaning.

Abi Feijó has also had strategic importance as a professor of animation, a workshop advisor and as ex-President of ASIFA.

« Le Portugal possède un cœur vagabond, un esprit aventurier, une âme en peine et un corps obéissant » : tel est la synopsis du court métrage *Fado lusitano* du réalisateur Abi Feijó et de la maison de production Filmógrafo. Avec ce film, le pays s'est doté d'une nouvelle génération active d'artistes disposés à rompre la longue absence nationale dans le domaine de l'animation. Le mouvement a commencé au début des années 90 grâce à l'importance croissante du Festival Cinanima qui réunit chaque année depuis 1977 la communauté internationale de l'animation dans la ville de Espinho.

Abi Feijó naît à Prague en 1956 et étudie à l'École des beaux-arts de Porto. En 1984, il collabore avec l'Office national du film du Canada où il réaffirme sa volonté de réaliser des animations d'auteur. De retour au pays, il fonde Filmógrafo, aujourd'hui centre d'attractions pour les créateurs intrépides se prêtant aux mêmes techniques. Le talent des réalisateurs Manuela Bacelar, Daniela Duarte Rui, Graça Gomes, Clídio Nóbio,

André Marques, Pedro Serrazina, Regina Pessoa et José Miguel Ribeiro a été reconnu dans les grands festivals internationaux.

À l'exception de quelques films éducatifs, la production de Filmógrafo se caractérise par une thématique tant indéniablement portugaise (chansons, légendes de la culture populaire, traumatismes de l'histoire, etc.) qu'universelle. À l'instar des intervenants du reste du cinéma portugais contemporain, ces animateurs considèrent les films comme une réflexion individuelle et subjective, avec une base politique et un sens humaniste.

Abi Feijó joue également un rôle déterminant comme professeur d'animation, dirigeant d'ateliers et ex-président d'ASIFA.

"Portugal hat ein schweifendes Herz, Abenteuergeist, eine bekümmerte Seele und einen gefügigen Körper" – so etwa lässt sich der Kurzfilm *Fado lusitano* zusammenfassen. Dieser Film, sein Regisseur Abi Feijó und die Produktionsfirma Filmógrafo haben dazu beigetragen, dass in Portugal eine neue, starke Künstlergeneration auftauchte, dazu bereit, das lange Schweigen des Landes zum gesamten Spektrum der Animation zu brechen. Die Bewegung begann zu Beginn der 90er Jahre mit der wachsenden Bedeutung des Festivals Cinanima, das bereits seit 1977 alljährlich die internationale Gemeinschaft der Trickfilmer in der portugiesischen Stadt Espinho versammelt.

Abi Feijó wurde 1956 in Braga geboren und studierte an der Hochschule der Schönen Künste in Porto. 1984 arbeitete er am National Film Board in Kanada. Dort festigte sich sein Wunsch, sich dem animierten Autorenfilm zu widmen. Nach seiner Rückkehr gründete er in Portugal Filmógrafo, heute Anziehungspunkt für kühne Regisseure, die die verschiedensten Techniken benutzen. Manuela Bacelar, Daniela Duarte Rui, Graça Gomes, Clídio Nóbio, André Marques, Pedro Serrazina, Regina Pessoa und José Miguel Ribeiro, die bei den großen internationalen Festivals herausragten, gehören zu ihnen.

Abgesehen von einigen didaktischen Filmen zeigt die Produktion von Filmógrafo – etwa mit Liedern, Gespensterfiguren aus der Volkskultur, geschichtlichen Traumata – eine zutiefst portugiesische und gleichzeitig allgemein gültige Thematik. Wie im gesamten übrigen zeitgenössischen Kino Portugals verstehen die Trickfilmer ihre Arbeiten als persönliche und subjektive Reflexion mit politischem Hintergrund und humanistischer Ausrichtung.

Als Professor für Animation, Workshop-Leiter und ehemaliger Präsident der Interessenvertretung für unabhängigkünstlerisch arbeitende Animationsfilmer ASIFA hatte Abi Feijó auch eine strategisch wichtige Rolle.

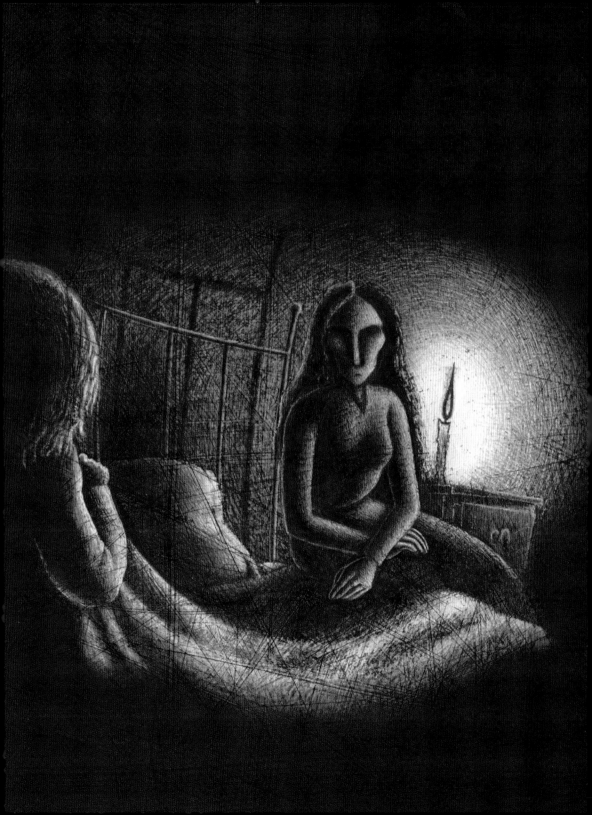

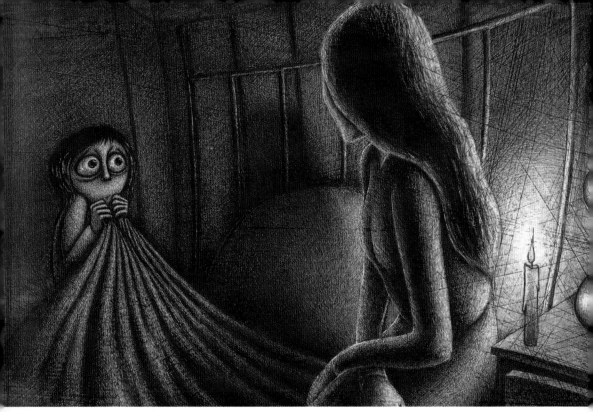

Pg. 83-84 A Noite, 1999
Painting and carving on plaster plates
Dir.: Regina Pessoa

**FILMTECKNARNA
ANIMATION**

Sweden
Contact: Lars Ohlson
Malmgårdsvägen 16-18,
 11638 Stockholm
Phone: + 46 8 442 7300
Fax: + 46 8 442 7319
E-mail: ft@filmtecknarna.com

OThe Man Who Thought With His
 Hat, 1984
Dawning, 1985
Pesce Pesce, 1988
Exit, 1989
Alice in Plasmaland, 1993
Revolver, 1993
Body Parts, 1995
Ebbe & Sten, 1995
Otto, 1997
Family & Friends, 2002

First Prize - Chicago, 1988
Best Script - Ottawa, 1990
Best Production Under 10 min -
 Ottawa, 1994
Special Jury Prize - Hiroshima, 1994
Golden Gate Award - San Francisco,
 1994
Nordisk Panorama, 1995
Jury's Special Prize - Oslo, 1997
Unicef Award - Berlin, 1998
Bronze Clio, 2001
Best Showreel Anima Mundi - Rio de
 Janeiro, 2002
Public Award - Ottawa, 2002

Traditional animation
Cut out
Claymation
Computer graphics

FILM-
TECKNARNA

www.filmtecknarna.com

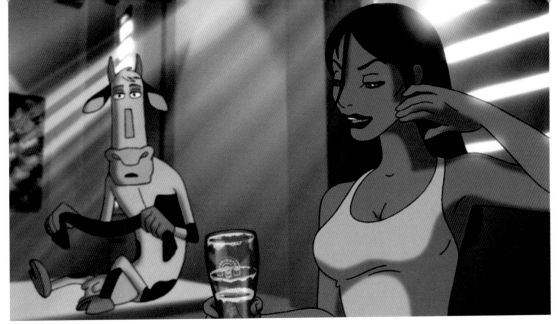

Lars Ohlson, Jonas Odell and Stig Bergqvist were just three students in Stockholm fascinated with drawing and animation until, in the seventies, they joined together to make small Super 8 films. Going professional was a natural consequence of this endeavor. In 1981, with their first commissioned work from the Swedish Film Institute, the trio founded FilmTecknarna. In the nineties Jonas Dahlbeck and the Swiss director Boris Nawratil joined the company.

The company benefits from each director's different experiences, which include design, engineering and architecture, and can thus cover a wide range of techniques, styles and applications of the animated image. Lars Ohlson co-directed some of the studios' first short films, but then decided to take over the administration of the company as executive producer and general director. Jonas Odell is responsible for most of FilmTecknarna's short films, as well as its television series, openings and vignettes, and the most highly praised sequence of Madonna's video, *Music*.

A resident of California, in the United States, Stig Bergqvist has also filmed television episodes and the feature film *Rugrats in Paris* (2001). The youngest of the five, John Dahlbeck's work includes the short film *Do Nothing 'Till You Hear From Me*, a work in which he demonstrates his perfect knowledge of how to combine new and old techniques. For his part, the Swiss animator Boris Nwratil directed the project *Smoking Mummies*, an adventure movie that is completely animated in 3D.

This eclectic quintet from Stockholm has important clients in the production, service and show industry. In addition to their own artists, they also employ freelancers from around the world.

Lars Ohlson, Jonas Odell et Stig Bergqvist étaient trois étudiants de Stockholm attirés par le monde du dessin et de l'animation. Dans les années 70, ils mettent leurs efforts en commun pour tourner des petits films en Super 8. De cette rencontre a tout naturellement découlé une aventure professionnelle. En 1981, avec les premières commandes du Swedish Film Institute, le trio fonde FilmTecknarna. Au cours des années 90, Jonas Dahlbeck et le Suisse Boris Nawratil les rejoignent.

La compagnie exploite la variété d'expériences de ses dirigeants, en matière de design, d'ingénierie et d'architecture, afin de proposer toute une gamme de techniques, styles et applications de l'image animée. Lars Ohlson codirige certains des premiers courts métrages du studio, avant de se consacrer uniquement à la gestion de la compagnie comme producteur exécutif et directeur général. Jonas Odell signe la majorité des courts métrages de FilmTecknarna, de même que des séries, génériques et transitions pour la télévision, sans oublier la célèbre séquence du clip vidéo *Music* de Madonna.

Installé en Californie, Stig Bergqvist a également réalisé des téléfilms et le long métrage *Les Razmokets à Paris* (2001). Parmi les œuvres de Jonas Dahlbeck, le plus jeune des cinq, se distingue le court métrage *Ne bouge pas tant que tu n'as pas entendu parler de moi*, dans lequel il combine à la perfection des techniques anciennes et récentes. Pour sa part, le Suisse Boris Nawratil a mis au point le projet *Smoking Mummies*, un film d'aventure totalement animé en 3D.

Ce groupe suédois plutôt éclectique travaille avec des clients de poids de l'industrie, des services et du monde du spectacle. Outre ces cinq artistes permanents, d'autres interviennent ponctuellement depuis les quatre coins de la planète.

Lars Ohlson, Jonas Odell und Stig Bergqvist studierten in den siebziger Jahren in Stockholm, als sie, fasziniert von Zeichnung und Trickfilm, begannen, ihre Kräfte zu bündeln, um gemeinsam kleine Super 8-Filme zu drehen. Die natürliche Folge dieser Begegnung war eine wachsende Professionalität. 1981 erhielt das Trio seine ersten Aufträge vom Schwedischen Film Institut und gründete das Unternehmen FilmTecknarna. In den neunziger Jahren traten Jonas Dahlbeck und der Schweizer Boris Nawratil bei.

Das Unternehmen zieht Vorteile aus den unterschiedlichen Erfahrungen seiner Leiter, die Design, Ingenieurtechnik und Architektur umfassen und so ein breites Spektrum an Techniken, Stilen und Anwendungen des Trick-Bildes abdecken. Lars Ohlson war bei den ersten Kurzfilmen des Studios Co-Regisseur, entschied sich aber dann für die administrative Aufgabe als ausführender Produzent und Generaldirektor des Unternehmens. Jonas Odell zeichnet für den Großteil der Kurzfilme von FilmTecknarna, außerdem für Serien, Vorspanne und Einzelzeichnungen im Fernsehen; für die Sequenz des Videoclips *Music* von Madonna erntete er am meisten Beifall.

Auch Stig Bergqvist, ansässig in Kalifornien, USA, hat Episoden fürs Fernsehen und den Spielfilm *Rugrats in Paris* (2001) gedreht. In seinem knappen *Do Nothing' Till You Hear From Me* stellt Jonas Dahlbeck, der jüngste unter den fünf, unter Beweis, dass er neue und alte Techniken perfekt zu kombinieren weiß. Der Schweizer Boris Nawratil seinerseits hat das Projekt *Smoking Mummies* entwickelt, einen kompletten 3D Abenteuer-Trickfilm.

Das Quintett aus Stockholm, das sich verschiedener Stilelemente und Schulen bedient, hat wichtige Kunden in der Produkt-, Dienstleistungs- und Event-Industrie. Neben fest angestellten beschäftigt es auch unabhängige Künstler an verschiedenen Orten der Welt.

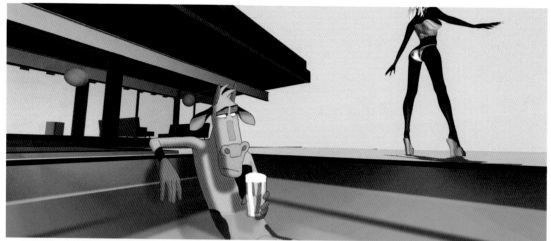

Pg. 86-88 Boddington "Cream of
playboy", 1999
Cell animation & CGI
Dir.: Jonas Dahlbeck
Agency: BBH, London

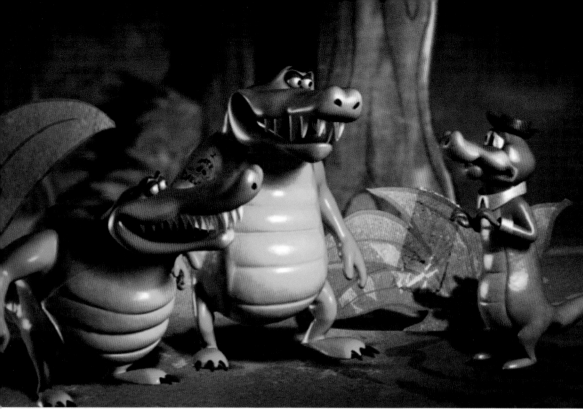

Pg. 89 Aligation liberation, 1999
Dir.: Jonas Dahlbeck
Cell animation, 3D, photography
Agency: Cartoon Network

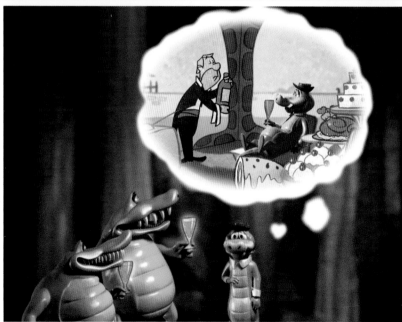

 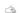

FOLIMAGE

France
Contact: Jacques Remy-Girerd
E-mail: folimage@wanadoo.fr
Phone: + 33 475 78 48 68
Fax: + 33 475 43 06 92 ms

Le Moine et le Poisson / The
Monk and the Fish, 1994
La Grande Migration / The Great
Migration, 1995
Paroles en l'Air / Winged
Words, 1995
Ferrailles / Scrapmetal, 1996
La Bouche Cousue / The Sewn
Mouth, 1998
L'Enfant au Grelot / Charlie's
Christmas, 1998
Au Bout du Monde / At the End
of the Earth, 1999
Hilltop Hospital, 2000
La Prophétie des Grenouilles /
Frog's Prophecy, 2003

Cartoon d'Or, 1995/1998
César Prize, 1996
Grand Prix, Stuttgart 1998
Special TV Prize, Annecy 1998
Special Jury Prize, Hiroshima
1998/2000
Best TV Series Anima Mundi, Rio de
Janeiro 2001
Grand Prix, Seoul 2001
Cinanima Prize, Espinho 2002
International Special Jury Prize,
Hiroshima 2002

Traditional animation
Stop motion
Clay animation
Computer graphics

FOLIMAGE

www.folimage.com

Contrary to current tendencies in France, the Folimage studio has not moved its production to Eastern countries or to Asia, but rather continues to make its own films, from their initial outlines to their final digitalization and distribution. All of this is done in the studio's facilities in Valence, in the region of Rhône-Alpes, the same area where the Lumière brothers were born.

The work of Folimage goes beyond the mere showing of films in television, cinema, festivals or institutions. Ever since Jacques-Rémy Girerd, Pascal le Notre and Serge Besset founded the studio in 1984, it has gradually strengthened its role as a bastion of auteur cinema in France. In addition to producing shorts and television series with their own personnel, the studio has been welcoming European artists since 1993 as interns, people like Michael Dudok de Wit (*The Monk and the Fish*) and Konstantin Bronzit (*At the End of the Earth*). In 1999, the studio founded a school of animation, La Poudrière.

In their archive of more than 100 films one perceives, on the one hand, a great difference with respect to American and Japanese standards and, on the other, constant references to the world of fine arts. It is also possible to find many movies with intellectual content aimed at an adult public, as well as stimulating productions for children and youth. It is evident that the interest in invention is larger than the commercial one.

In December of 2003, Jacques-Rémy Girerd launched Folimage's first feature film, *Frog's Prophecy*. This fascinating story, based on a modern Noah's Arc that experiences a new flood, attracted more than 800,000 French film viewers to the big screen in its first three months in cinemas.

Contrairement à la tendance du moment en France, le studio Folimage n'a pas délocalisé sa production dans les pays de l'Est ou en Asie. Il continue à produire ses films, des premiers tracés au fini numérique et à la phase de distribution, dans ses installations de Valence, dans cette même région Rhône-Alpes qui a vu naître le cinématographe des frères Lumière.

Les travaux de Folimage vont bien au-delà de la simple diffusion de films à la télévision, au cinéma, dans les festivals ou dans des institutions. Depuis sa création en 1984 par Jacques-Rémy Girerd, Pascal le Notre et Serge Besset, le studio n'a cessé de consolider son rôle de bastion de l'animation d'auteur dans l'hexagone. Outre la production de courts et de séries télévisées à base d'œuvres d'employés de la maison, le studio offre depuis 1993 des stages à des artistes européens, tels que Michael Dudok de Wit (*Le moine et le poisson*) et Konstantin Bronzit (*Au bout du monde*). En 1999, il ouvre l'école d'animation La Poudrière.

Ses archives riches de plus de 100 films révèlent d'une part la volonté de distinction par rapport aux standards américains et japonais et, d'autre part, une référence constante au monde des beaux-arts. Elles renferment aussi bien des films dont le contenu intellectuel s'adresse à un public adulte que des productions dynamiques destinées aux enfants. Il va sans dire que l'imagination l'emporte sur toute logique commerciale.

En décembre 2003, Jacques-Rémy Girerd lance le premier long métrage de Folimage, intitulé *La prophétie des grenouilles*. Basée sur une Arche de Noé moderne affrontant un nouveau déluge, cette histoire a attiré plus de 800 000 spectateurs dans les trois premiers mois ayant suivi sa sortie en salles.

Das Studio Folimage hat entgegen der zur Zeit in Frankreich herrschenden Tendenz seine Filmproduktion nicht nach Osteuropa oder Asien verlegt. Von den ersten Strichen über die digitale Fertigstellung bis zum Verleih werden die Filme nach wie vor in den eigenen Niederlassungen in Valence im französischen Verwaltungsgebiet Rhône-Alpes hergestellt, also dort, wo auch die Lichtspielkunst der Gebrüder Lumière entstand.

Die Arbeit von Folimage geht weit über die bloße Filmvorführung im Fernsehen, im Kino, auf Festivals oder in sonstigen Einrichtungen hinaus. Seit Jacques-Rémy Girerd, Pascal le Notre und Serge Besset das Studio 1984 gründeten, hat es innerhalb Frankreichs für die Bildanimation eine immer stärkere Rolle als Bastion des Autorenfilms gespielt. Neben der Produktion von Kurzfilmen und Fernsehserien mit eigenem Personal bietet das Studio seit 1993 europäischen Künstlern auch Langzeit-Praktika an, die zum Beispiel Michael Dudok de Wit (*Der Mönch und der Fisch*) und Konstantin Bronzit (*Am Ende der Welt*) annahmen. 1999 gründete Folimage die Schule für Bildanimation La Poudrière.

Die Gesamtproduktion umfasst mehr als hundert Filme, in denen man einerseits einen deutlichen Unterschied im Vergleich zu den US-amerikanischen und japanischen Gepflogenheiten und andererseits eine beständige Bezugnahme auf die Welt der bildenden Kunst wahrnimmt. Man findet viele Filme von ausgeprägt intellektuellem Gehalt, die sich an Erwachsene richten, genauso wie anregende Produktionen für Kinder und jugendliche Zuschauer. Es ist offensichtlich, dass der Erfindergeist weiterhin über der Logik des Kommerzes steht.

Im Dezember 2003 brachte Jacques-Rémy Girerd mit *La prophétie des grenouilles* den ersten Spielfilm von Folimage auf den Markt. Die faszinierende Geschichte einer modernen Arche Noah, die eine neue Sintflut erlebt, zog allein in den ersten drei Monaten mehr als 800.000 Franzosen vor die Leinwand.

Pg. 91 La prophétie des grenouilles/
Raining Cats and Frogs, 2003
Dir.: Jacques-Rémy Girerd

Pg. 92 Les tragédies minuscules/
Minuscule tragedies, 1999
Dir.: Alain Gagnol and Jean-
Loup Felicioli

Pg. 93 Top Hôpital Hilltop/
Hilltop Hospital, 1999
Dir.: Pascal Le Nôtre

Pg. 93 Bottom Casa, 2003
Dir.: Sylvie Léonard

FRÉDÉRIC BACK

Canada

Radio-Canada French
 Program Sales
Colette Forest, Manager
1400 Rene-Levesque Blvd East,
 B45-1, Montreal - QC H2L 2M2
Phone: (514) 597-7826
Fax: (514) 597-7862
colette_forest@radio-canada.ca

Abracadabra, 1970
Inon ou la Conquète du Feu /
 Inon or The Conquest of Fire, 1971
La Création des Oiseaux /
 The Creation of the Birds, 1973
Illusion, 1974
Taratata la Parade, 1977
Tout Rien / All Nothing, 1978
Crac, 1981
L'Homme qui Plantait des Arbres /
 The Man Who Planted Trees, 1987
 Le Fleuve aux Grandes Eaux / The
 Mighty River, 1993

Oscar, 1982 and 1988
Clermont-Ferrand and
 Tampere, 1988
Annecy, 1991 and 1993
Hiroshima, 1987 and 1994

Traditional animation
Colored pencil
Frosted cell

FRÉDÉRIC BACK

www.radio-canada.ca

They say that he was born with a pencil in his hand. Some call him "the pencil missionary." Frédéric Back is an old-fashioned animator, the kind who could spend a whole month creating just one shot. In addition, he is among those who draw in defense of his ideals.

Back's ideals include defending collective memory and the protection of the environment. The cinema, according to Back, is an excellent resource for promoting ecology. He strives to use the success of his movies to motivate artists and producers to make more films about the relationship between man and nature.

Back, an animal-lover and enthusiastic animal-drawer, was born in Germany in 1924 and immigrated to Canada with his family during World War II. In the first days of television he developed a painting on glass technique that solved scenographic problems for television. In 1967 he created the stained-glass window of the Place des Arts metro station in Montreal. In 1970 he began to work in the Societé Radio-Canada animation studios. There, together with Hubert Tison, he spent 20 years at the head of a project producing educational films that have been shown around the world.

However, good intentions are not his only virtue. Frédéric Back is a master drawer whose talent can be compared to that of the greatest painters. His stroke is fragile but it contains the power to evoke the public's emotions. *Crac*, an ironic story about a rocking chair that becomes a main attraction in a modern art museum, and *The Man Who Planted Trees*, a fable about a forest that emerges in the middle of the desert, both won Academy awards. *The Mighty River*, another animated epic poem, also received an Oscar nomination.

Il a pour habitude de dire qu'il est né avec un crayon à la main; certains le surnomment même « le missionnaire du crayon ». Frédéric Back est un animateur de la vieille école, capable de passer un mois sur un seul plan et dessinant pour servir des idéaux.

Sa lutte concerne la défense de la mémoire collective et la protection de l'environnement. À ses yeux, le cinéma est un vecteur remarquable pour promouvoir l'écologie. Il espère que le succès de ses films motivera d'autres artistes et producteurs à créer plus d'œuvres traitant de la relation entre l'homme et la nature.

Né en Allemagne en 1924, amoureux du monde animalier qu'il adore dessiner, Back émigre au Canada avec sa famille lors de la Seconde Guerre mondiale. Aux débuts de la télévision, il développe une technique de peinture sur verre pour résoudre les problèmes de scénographie. En 1967, il réalise la verrière de la station de métro Place des Arts de Montréal. En 1970, il s'installe dans les studios d'animation de la Société

Radio-Canada. En compagnie de Hubert Tison, il constitue pendant 20 ans le noyau dur d'un projet de production de films pédagogiques qui ont fait le tour du monde.

Cependant, il ne s'en tient pas aux bonnes intentions. Frédéric Back est un maître du dessin, comparable aux grands génies de la peinture. Bien que délicat, son tracé possède un pouvoir évocateur suscitant des émotions dans le public. Tant *Crac*, histoire pleine d'ironie d'un fauteuil à bascule qui devient l'attraction d'un musée d'art moderne, que *L'homme qui plantait des arbres*, fable sur les efforts d'un homme pour reboiser une zone aride, ont été « oscarisés ». Son film *Le fleuve aux grandes eaux*, autre épopée en dessin animé, a également été nominé dans cette catégorie.

Er sei mit dem Bleistift in der Hand geboren, pflegt er zu sagen. Einige nennen ihn den „Missionar des Bleistiftes". Frédéric Back gehört zu den Trickzeichnern vom alten Schlag, die der Herstellung eines einzigen Planes noch einen ganzen Monat widmen können. Und die noch für ein paar Ideale zeichnen.

Backs Ideale sind sie Verteidigung des kollektiven Gedächtnisses und der Umweltschutz. Kino, wie er es auffasst, ist ein gutes Medium, um die Ökologie zu unterstützen. Mit dem Erfolg seiner Filme hofft er, Künstler und Produzenten anzuspornen, mehr Filme über das Verhältnis von Mensch und Natur zu machen.

1924 in Deutschland geboren, Tierliebhaber und passionierter Tierzeichner, emigrierte Back mit seiner Familie während des Zweiten Weltkrieges nach Kanada. Er entwickelte eine Maltechnik auf Glas zur Lösung bühnenbildnerischer Probleme in der Urstunde des Fernsehens. 1967 schuf er die Glasfenster in der Metrostation Place des Arts von Montreal. 1970 richtete er sich dann in den Trickfilmstudios der Societé Radio-Canada ein. Zusammen mit Hubert Tison war er dort zwanzig Jahre lang der harte Kern eines Projektes zur Produktion von didaktischen Filmen, die um die ganze Welt gegangen sind.

Die guten Absichten sind allerdings nicht seine einzige Tugend. Frédéric Back ist ein Meister der Zeichnung, vergleichbar mit den großen Genies der Malerei. Sein Strich ist zart, obgleich mit suggestiver Kraft, die beim Publikum Gefühle wachruft. *Crac*, einer ironischen Geschichte über einen Schaukelstuhl, der zur Attraktion in einem Museum für moderne Kunst wird, und *Der Mann, der Bäume pflanzte* (1987), einer Fabel über das Auftauchen eines Waldes inmitten einer Wüste, wurde von der Academy der Oscarzugesprochen. *The Mighty River*, ein anderes Zeichentrick-Epos, wurde für diese Auszeichnung nominiert.

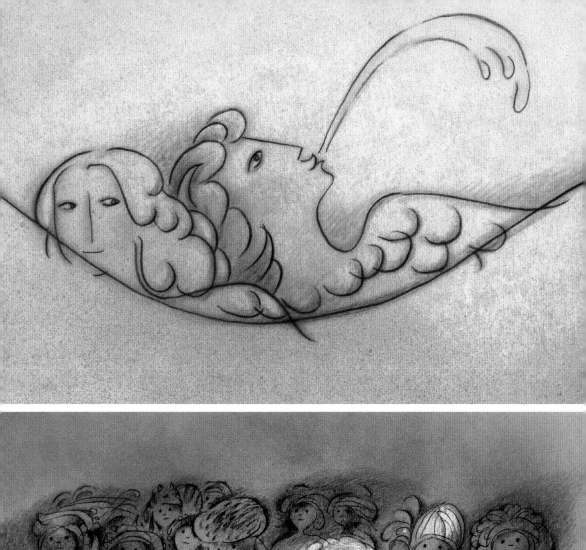
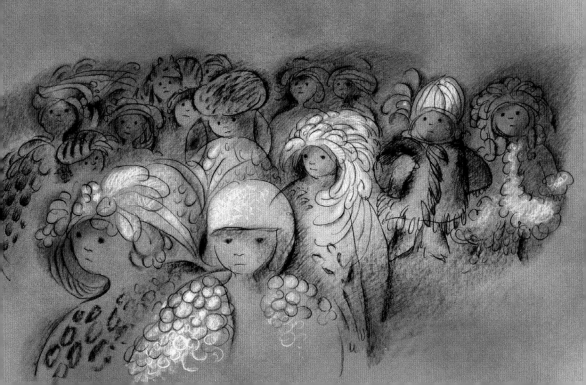

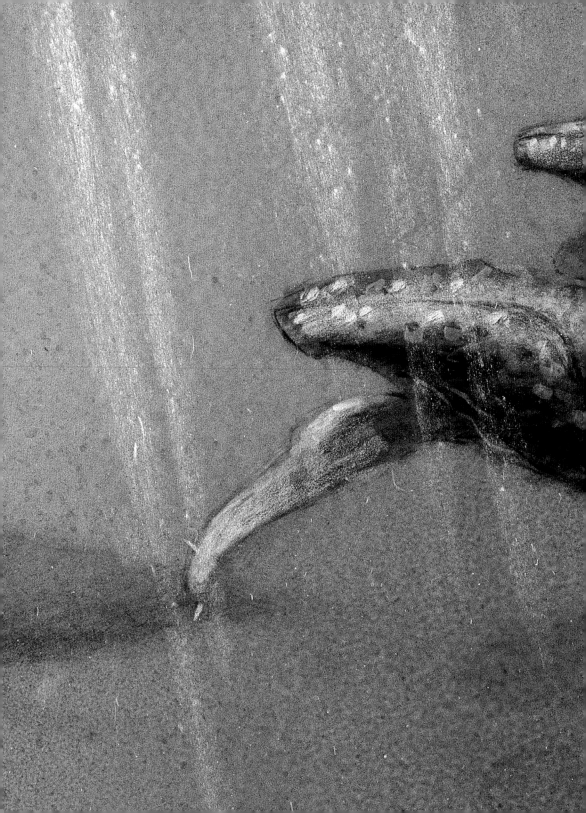

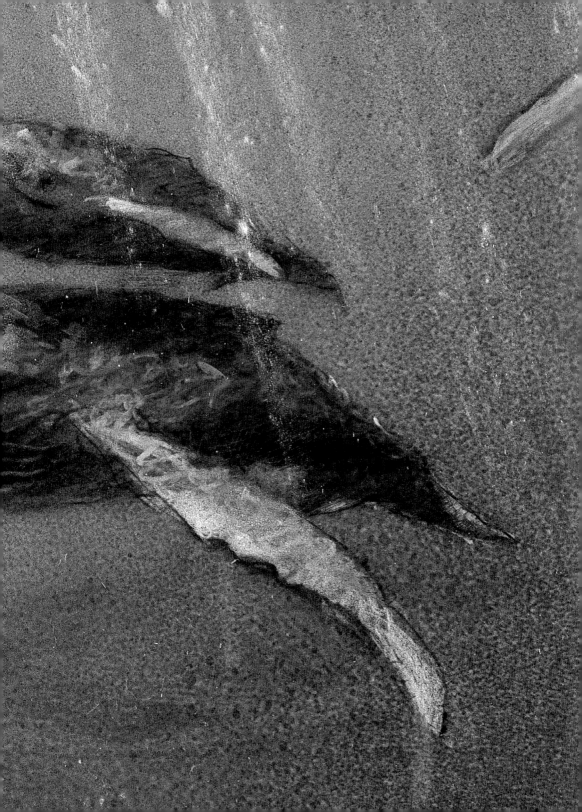

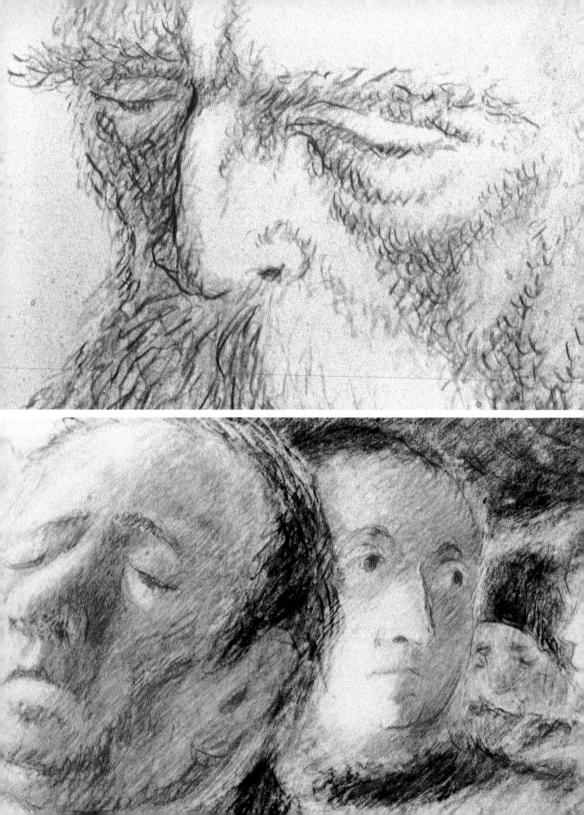

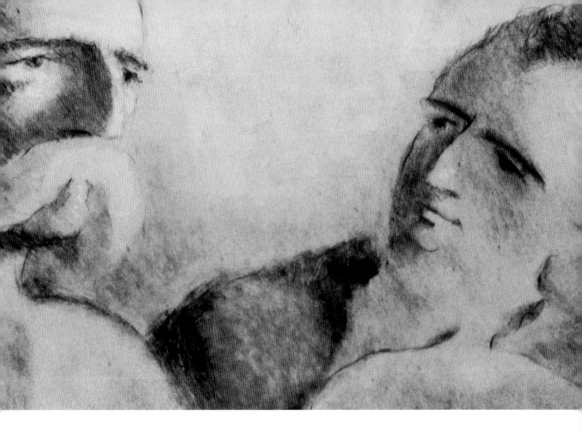

Pg. 102–103 The Man Who
Planted Trees, 1987
Colored pencil on frosted cell and paper
© Radio-Canada 1987

GEORGES SCHWIZGEBEL

Switzerland
Studio GDS
Vibert 15, Carouge
CH-1227
Phone: 41 22 342 72 36
E-mail: gschwiz@worldcom.ch

Le Vol d'Icare / The Flight of Icarus, 1974
Hors-jeu / Off-Side, 1977
Le Ravissement de Frank N. Stein /
 The Ravishing of Frank N. Stein, 1982
78 Tours / 78 R.P.M., 1985
Nakounine, 1986
Le Sujet du Tableau / The
 Subject of the Picture, 1989
La Course à l'Abîme / The
 Ride to the Abyss, 1992
L'Année du Daim / The
 Year of the Deer, 1995
Fugue, 1998
La Jeune Fille et les Nuages / The
 Young Girl and the Clouds, 2000

First Prize - *Valladolid*, 1985
Grand Prize - *Stuttgart and
 Treviso*, 1985
First Prize - *Zagreb*, 1995
Grand Prize - *Espinho*, 1995
Best Swiss - *Short Film*, 2002

Traditional animation
Acrylic painting
Crayon
Gouache and pastel

GEORGES SCHWIZGEBEL

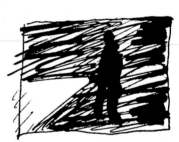

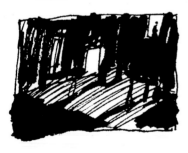
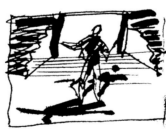
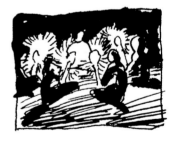

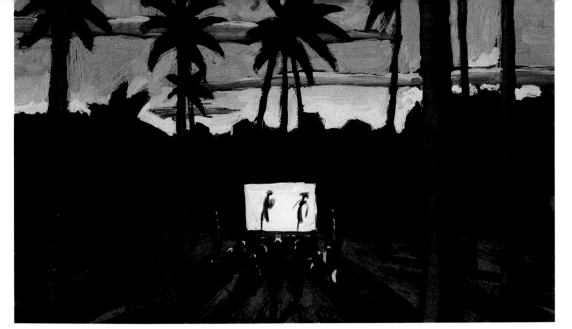

As a result of having studied in Geneva's Art School and College of Decorative Arts, Georges Schwizgebel is known in Switzerland both as a painter and as an animation film director. His two talents actually come together in his work when his paintings take on movement. His work with acrylic ink, pencil, gouache and pastel stands out for his precise suggestion of light and his economical and decisive use of lines.

Schwizgebel prefers to use his hands and paper over any other kind of machine—especially computers, as he does not consider their results to be at all attractive. His dedication to traditional techniques is evident in the fact that he continues to use an old Mitchell camera that reputedly belonged to Charlie Chaplin.

However, there is nothing conventional about him. Like most animators, Schwizgebel has combined for years his purely commercial work with his own projects as an artist. Currently, in his GDS Studios, he is able to dedicate himself exclusively to his short films. In these rather experimental films meaning and form cannot be separated. One of Schwizgebel's favorite themes is movement itself, which he brilliantly combines with the film's sound track.

His films have already been the focus of retrospectives in Paris, Annecy, Rome, New York, Tokyo and Taipei, among other cities. Alongside his career as a filmmaker, Schwizgebel also draws theater sets and frescos, works with interior design and exhibits his paintings throughout Europe.

Ancien élève de l'École des arts décoratifs et du Collège d'arts plastiques de Genève, Georges Schwizgebel s'est fait une place en Suisse tant pour ses peintures que pour la direction de films d'animation. En fait, ces deux disciplines se marient au sein de son œuvre où la peinture prend vie. Son travail à base d'acrylique, de crayon, de gouache et de pastel se distingue par l'exploitation de la lumière et l'économie efficace du trait.

Schwizgebel préfère le papier et la manipulation manuelle aux machines ou, pire encore, aux ordinateurs dont il considère le résultat peu attrayant. Son attachement aux méthodes traditionnelles est incontestable : preuve en est de sa vieille caméra Mitchell qui aurait selon la légende appartenu à Charles Chaplin et dont il se sert toujours.

Pourtant, il ne cède pas au conventionnalisme. À l'instar de la majorité des animateurs, Schwizgebel a su concilier pendant de nombreuses années un travail purement commercial et des projets d'auteur. Maintenant à la tête du studio GDS, il peut se consacrer exclusivement à ses courts métrages un rien expérimentaux et dont forme et message sont indissociables. L'un de ses thèmes favoris reste son propre mouvement, sans compter la surprenante utilisation qu'il fait de la bande-son.

Ses films ont déjà fait l'objet de rétrospectives à Paris, Annecy, Rome, New York, Tokyo et Taipei, entre autres. En parallèle à sa carrière de cinéaste, Schwizgebel dessine des décors de théâtre et des fresques, réalise la décoration de meubles et expose ses tableaux à travers l'Europe.

Georges Schwizgebel, der in Genf an der Kunstschule und der Ecole Supérieure des Beaux Arts (ESBA) studierte, ist in der Schweiz sowohl als Maler wie als Regisseur von Zeichentrickfilmen bekannt. Im Grunde genommen vermischen sich beide Facetten in seinem Werk, wo sich die Malerei in Bewegung setzt. Merkmale seiner Arbeit mit Acrylfarbe, Bleistift, Gouache und Pastellkreiden sind der präzise Einsatz von Licht und die Ökonomie und Bestimmtheit seines Striches.

Schwizgebel zieht Papier und Handarbeit jeder Art von Maschine, v.a. Computern, vor, deren Ergebnisse er wenig überzeugend findet. Wie sehr er traditionellen Vorgehensweisen anhängt, kann man gut daran ermessen, dass er nach wie vor eine alte Mitchell-Kamera benutzt, die angeblich Charles Chaplin gehörte.

Dennoch gleitet er nicht ins Konventionelle ab. Wie die Mehrzahl der Trickzeichner hat auch Schwizgebel während vieler Jahre die rein kommerzielle Arbeit mit seinen Projekten als Autor in Einklang bringen müssen. Heute kann er sich mit seinem Studio GDS ganz und gar seinen durchaus experimentellen Kurzfilmen widmen, in denen Sinn und Form untrennbar sind. Zu Schwizgebels Lieblingsthemen gehört die eigene Bewegung, die mit einem außergewöhnlichen Einsatz des Tonbandes verknüpft wird.

Seine Filme waren bereits in Paris, Annecy, Rom, New York, Tokio, Taipeh und anderen Städten Gegenstand von Retrospektiven. Parallel zu seiner Karriere als Filmschaffender entwirft Schwizgebel Bühnenbilder fürs Theater sowie Fresken und ersinnt Innenausstattungen. Seine Bilder stellt er in ganz Europa aus.

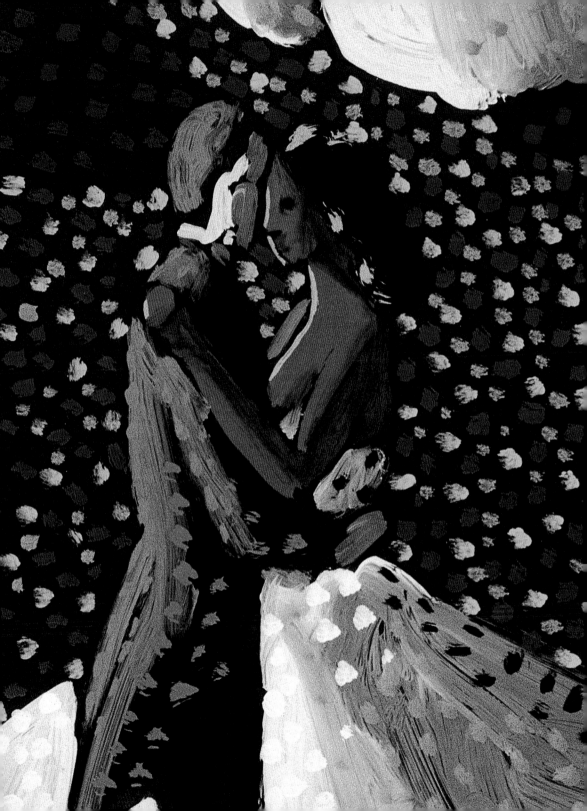

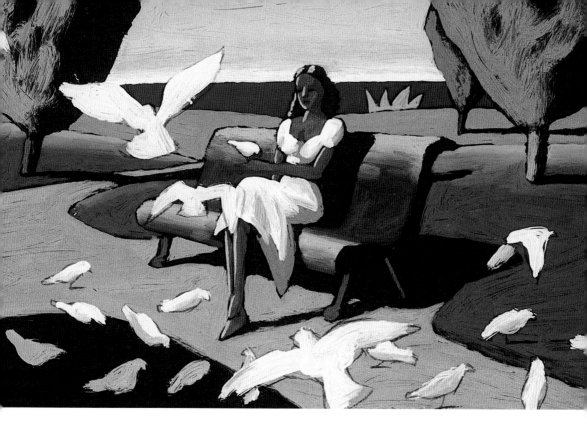

Pg. 104 Sketches

Pg. 105-107 The Young Girl and the Clouds, 2000
Acrylic painting on cell and pastel

 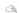

GIL ALKABETZ

Israel/Germany
Sweet Home Studio
Bebelstr. 58 70193
Stuttgart, Germany
Phone/Фах: + 49 711 6361735
E-mail: gil@alkabetz.com

Bitzbutz, 1984
Swamp, 1991
Yankale, 1995
Ecstazoo, 1996
Rubicon, 1997
Lucky Stars - pilot, 2000
Trim Time, 2002
Travel to China, 2002

Best First Film - *Annecy*, 1985
First Prize Animation - *Melbourne*, 1985
Best German Short Film, 1992
Special Jury Prize - *Ottawa*, 1992
Critics Prize - *Oberhausen*, 1996
First Prize Animation - *Krakow*, 1996
Art Academy Students Award -
 Zagreb, 1996
Funniest Film - *Annecy*, 1997
Silver Plaque - *Chicago*, 1997
Jury and Audience Prizes - *Castelli
 Animati, Rome*, 1997
Best Animation Film - *Mediawave*, 1998

Plasticine on glass
Painting on cell
Hand drawing
Computer compositing

GIL ALKABETZ

www.alkabetz.com

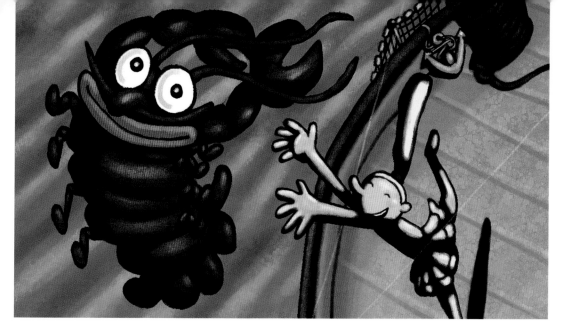

Excellent screenplays, an innovative language and basically simple drawings that spare details and emphasize the essential; these qualities have turned Gil Alkabetz into one of the most important names of contemporary German animation. Born in an Israeli *kibutz* in 1957, Alkabetz studied graphic design in Jerusalem and started his career as an animator in the Frame by Frame studio. Between 1985 and 1995 he worked as an independent animator and illustrator, as well as a professor of these subjects in Haifa and at the Jerusalem Cinema Library. Upon receiving a grant in 1995, Alkabetz moved to the German city of Stuttgart, where in 2001 he founded the Sweet Home Studio with his wife and collaborator, Nurit Israel.

Alkabetz's Israeli roots continue to fuel his films, although not in an explicit way. The recurring themes of territorial disputes and of the difficult challenge of dealing with conflicts suggest a political reading of complex fables full of dark humor, such as *Bitzbutz*, *Swamp* and *Rubicon*, the last of which was selected for the Cannes Festival.

The images of Gil Alkabetz that are most known around the world are perhaps the opening credits of Tom Tykwer's feature film *Run Lola Run*, as well as the sequence in which an animated clone of the actress Franka Potente appears running around the television. The independent shorts of this incisive animator have also received recognition in the animation circuit.

Alkabetz's most recent production points towards healthy diversification. In 2002 his studio created the experimental film *Travel to China*—where just one photograph tells a man's story of desire and evasion—and the children's short *Trim Time*, which narrates the tough life of a tree over the course of a year.

Des scénarios solides, un langage innovant et des dessins minimalistes s'en tenant à l'essentiel ont fait de Gil Alkabetz l'un des grands noms de l'animation allemande contemporaine. Né dans un *kibboutz* israélien en 1957, il étudie l'infographie à Jérusalem et débute comme animateur au studio Frame by Frame. Entre 1985 et 1995, il travaille comme animateur et illustrateur indépendant et enseigne ces disciplines à Haifa et à la cinémathèque de Jérusalem. En 1995, il décroche une bourse et s'installe à Stuttgart où, en 2001, il fonde Sweet Home Studio avec son épouse et collaboratrice Nurit Israel.

Les racines israéliennes d'Alkabetz continuent à alimenter ses films de façon implicite. Des thèmes récurrents comme la dispute du territoire et la difficulté de gérer les conflits offrent une lecture politique de fables élaborées et remplies d'humour noir comme *Bitzbutz*, *Swamp* et *Rubicon* (sélectionnée au Festival de Cannes).

Sans doutes les images de Gil Alkabetz ayant fait le tour de la planète sont les crédits au début du long métrage de Tom Tykwer intitulé *Cours Lola cours*, ainsi que la séquence où un clone animé de l'actrice Franka Potente apparaît à la télévision en train de courir. Cependant, les courts indépendants de cet animateur acerbe ont également su se faire apprécier dans le monde de l'animation.

Sa dernière production en date tente une diversification bienvenue. En 2002, son studio crée l'œuvre expérimentale *Travel to China*, contant l'histoire du désir d'évasion d'un homme à partir d'une seule photo, et le court pour enfants *Trim Time*, narrant la dure vie d'un arbre au fil des quatre saisons.

Seinen ausgezeichneten Drehbüchern, seiner innovativen Sprache und seinem im Grunde genommen einfachen Zeichenstil, der auf Details zugunsten des Wesentlichen verzichtet, verdankt Gil Alkabetz seinen Ruf als starker zeitgenössischer Trickfilmer in Deutschland. Er wurde 1957 in einem Kibbuz in Israel geboren, studierte später in Jerusalem Grafikdesign und machte sich im Studio Frame by Frame mit Bildanimation vertraut. Von 1985 bis 1995 arbeitete er als unabhängiger Trickfilmkünstler und Illustrator und unterrichtete diese Fächer auch in Haifa und an der Kinemathek in Jerusalem. 1995 führte ihn ein Stipendium nach Stuttgart, wo er 2001 zusammen mit seiner Frau und Mitarbeiterin Nurit Israel das Sweet Home Studio gründete.

Seine israelischen Wurzeln sind noch immer, wenngleich nicht offenkundig, der Nährboden von Alkabetz' Filmen. Territoriale Streitigkeiten und die schwierige Herausforderung, mit Konflikten umzugehen, sind Themen, auf die er immer wieder zurückgreift. Das legt eine politische Lesart seiner komplexen und mit schwarzem Humor gespickten Geschichten in Art von *Bitzbutz*, *Swamp* und *Rubicon* nahe (*Rubicon* wurde übrigens für Cannes ausgewählt.)

Der Vorspann zu Tom Tykwers Spielfilm *Lola rennt* so wie die Sequenz, in der eine Zeichentrick-Doppelgängerin der Schauspielerin Franke Potente innerhalb des Filmes auf einem Fernsehbildschirm zu sehen sind, sind wohl die Bilder, die am meisten um die Welt gingen. Aber auch die nicht als Auftragsarbeiten entstandenen Kurzfilme haben Anerkennung in der Szene der Trickfilmer gefunden.

An seiner jüngsten Produktion sieht man die gesunde Tendenz zur Mannigfaltigkeit. 2002 schuf sein Studio sowohl den Experimentalfilm *Travel to China*, in dem er mit einem einzigen Foto die gesamte Geschichte eines Mannes erzählt, der der Realität zu entfliehen wünscht, als auch den Kurzfilm *Schnipp Schnapp*, der das harte Leben eines Baumes im Verlauf eines Jahres erzählt.

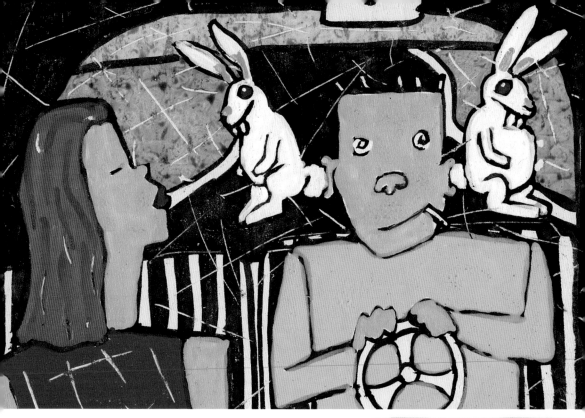

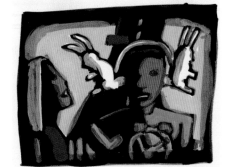

Pg. 108–109 Lobster tale, 2004
Traditional animation

Pg. 110 Ecstazoo, 1996
Ink on paper

Pg. 110 (right) Ecstazoo
(visual development), 1996
Ink on paper

Pg. 111 Run Lola Run (opening
sequence), 1999
Traditional animation

Run Lola Run (opening
sequence), 1999
Storyboard

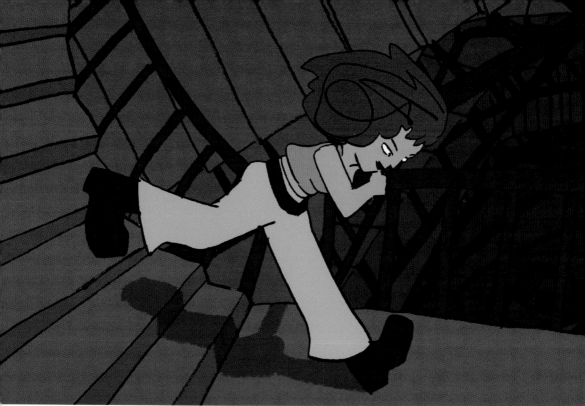

HI TOM
I THOUGHT SHE
COULD ALSO MAKE
A RUDE GESTURE
WITH HER FINGERS.
DO YOU THINK IT'S
GOOD? BYE
GIL ALKABETZ

IGOR KOVALIOV	Yego Zhena Kuritsa / Hen, His Wife, 1989	Grand Prize - Ottawa, 1990/1996	Traditional animation
Ukrania / USA	Andrei Svislotski, 1991	Special Jury Prize - Shanghai, 1992	2D computer graphics
Klaskycsupo	Rugrats TV series, 1991	Best Experimental Film - Oberhausen, 1992	
	Duckman TV series, 1994	Best part of TV Show - Ottawa, 1994	
	Raahh!!! Real Monsters! TV series, 1994	Special Prize - Annecy, 1995	
	Bird in the Window, 1996	Best Animation - Short Sitges, 1996	
	The Rugrats movie, 1998	Special Jury Prize - WAC, USA, 2000	
	Flying Nansen, 2000	Special Prize - Hirsohima, 2000	
		Grand Prize - Castelli Animati, Rome, 2000	

IGOR KOVALIOV

If destiny were capable of capriciously drawing life's paths, Igor Kovaliov's case would be exemplary.

Born in Kiev in 1954, Kovaliov failed art school entrance exams because he did not know how to draw. Instead of becoming discouraged, at the age of 18 he began to work as an animator at the Kiev Studio under the influence of the Estonian director Priit Pärn. As perestroika became evident, he and Alexander Tartarsky founded Pilot, the first independent animation studio of the disappeared Soviet Union, which they set up in the buildings of what had been an Orthodox church.

The impact of his first film, Hen, His Wife, selected for the Cannes Film Festival, caught the eye of the Hungarian producer Gabor Csupo, who proposed that Kovaliov work at the Klasky-Csupo studio of Hollywood. The rest of this success story consists of a constant moving back and forth between typically commercial projects, like the TV series and first feature film of the Rugrats, and his own personal films, such as Bird in the Window and Flying Nansen. In both cases, Kovaliov's talent has been widely recognized and prized.

His shorts make up one of the most consistent collections in the world of animation. In them, his characters experience loneliness, paranoia, madness and reclusion. Autobiographical traces coexist with a rich symbolism in which past and present, memory and imagination blend together and are taken beyond any distinction. His graphic style is dense, full of brown tones and intense shadings, undoubtedly of Russian inspiration. In spite of it all, destiny has wished that Kovaliov become an artist without any limitations.

Si le destin peut à sa guise tracer le parcours d'une vie, le cas d'Igor Kovaliov est un parfait exemple du genre.

Né à Kiev en 1954, Kovaliov est recalé à l'examen d'admission d'une école d'art car il ne sait pas dessiner. À 18 ans, au lieu de se décourager, il débute comme animateur au Kiev Studio, influencé par l'œuvre de l'Estonien Priit Parn. Avec l'avènement de la perestroika, il fonde avec Alexander Tartarsky le premier studio d'animation indépendant de l'ex-Union soviétique : Pilot installe alors ses locaux dans une ancienne église orthodoxe.

La répercussion de son premier film d'auteur intitulé Sa femme la poule (sélection du Festival de Cannes) attire l'attention du Hongrois Gabor Csupo, lequel lui propose de travailler pour le studio Klasky-Csupo de Hollywood. La suite de cette histoire n'est qu'une alternance de projets purement commerciaux, tels que la série télévisée et le premier long métrage des Razmoket, et de films en tous points personnels comme Bird in the window ou Flying Nansen. Sur les deux plans, Kovaliov reçoit une large reconnaissance et voit son talent récompensé.

Ses courts d'auteur composent l'une des œuvres les plus cohérentes de l'animation mondiale, dans lesquels les personnages vivent des expériences de solitude, de paranoïa, de folie et de réclusion. Des aperçus autobiographiques se marient à un symbolisme très marqué dans un contexte où passé et présent, mémoire et imagination ne fond qu'un. Le style graphique est dense, avec une dominante de marrons et de clairs-obscurs intenses, sans conteste d'inspiration russe. Malgré cela, le destin a voulu que Kovaliov devienne un artiste sans frontières.

Wenn das Schicksal ganz nach Lust und Laune die Linien, nach denen ein Leben verläuft, zeichnen könnte, dann wäre der Fall von Igor Kovaliov exemplarisch.

Kovaliov, der 1954 in Kiew geboren wurde, bestand die Aufnahmeprüfung einer Kunstschule nicht, weil er angeblich nicht zeichnen konnte. Anstatt zu verzagen begann er mit 18 Jahren als Animations-Künstler im staatlichen Kiew Studio unter dem Einfluss des Estländers Priit Parn zu arbeiten. Im Zuge der beginnenden Perestroika gründete er zusammen mit Alexander Tartarsky das Trickfilm-Studio Pilot, das erste unabhängige der ehemaligen Sowjet Union, das in den Nebengebäuden einer alten orthodoxen Kirche untergebracht war.

Die Resonanz auf seinen ersten Autorenfilm namens Hen, His Wife, der es schaffte, für das Festival von Cannes ausgesucht zu werden, weckte das Interesse des Ungarn Gabor Csupo, der ihn einlud, für das Klasky-Csupo-Studio in Hollywood zu arbeiten. Der Rest dieser Erfolgsgeschichte ist ein beständiges Pendeln zwischen typisch kommerziellen Projekten, wie die TV-Serie und der erste Spielfilm zu den Rugrats, und absolut persönlichen Filmen wie Bird in the Window oder Flying Nansen. In beiden Fällen erfuhr Kovaliov große Anerkennung und wurde für sein Talent ausgezeichnet.

Seine kurzen Autorenfilme bilden eines der in sich schlüssigsten Ensembles in der Welt der Animation. Darin machen seine Figuren die Erfahrung von Einsamkeit, Paranoia, Irrsinn und Eingeschlossensein. Die autobiografischen Spuren verbinden sich mit einer reichhaltigen Symbolik in einem Ambiente, in dem sich Vergangenheit und Gegenwart, Erinnerung und Vorstellung bis zur Ununterscheidbarkeit miteinander vermischen. Sein grafischer Stil ist schwer, voller Brauntöne und intensiver Helldunkel-Kontraste von unzweifelhaft russischer Inspiration. Trotz alledem wollte das Schicksal, dass Kovaliov sich zu einem Künstler jenseits aller Grenzen wandelte.

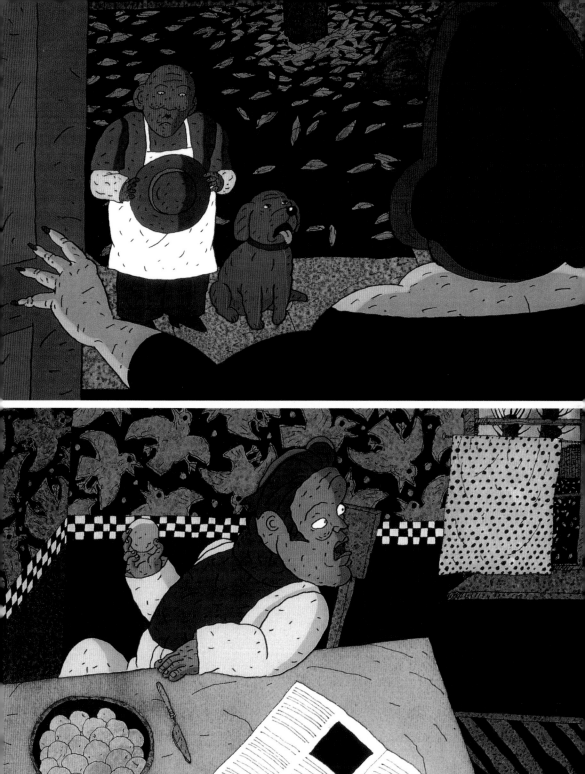

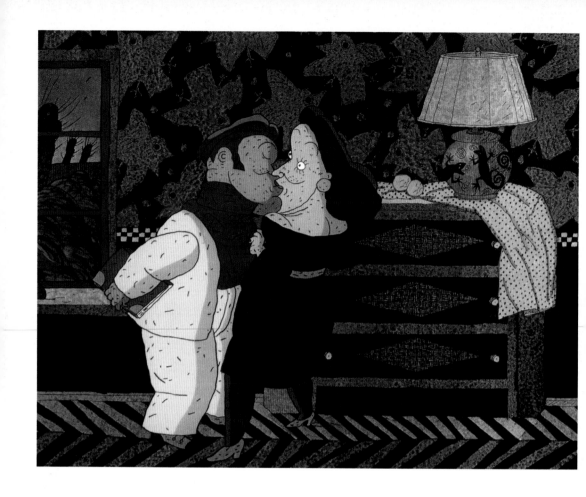

Pg. 113–114 *Bird in the Window*, 1996
Traditional animation

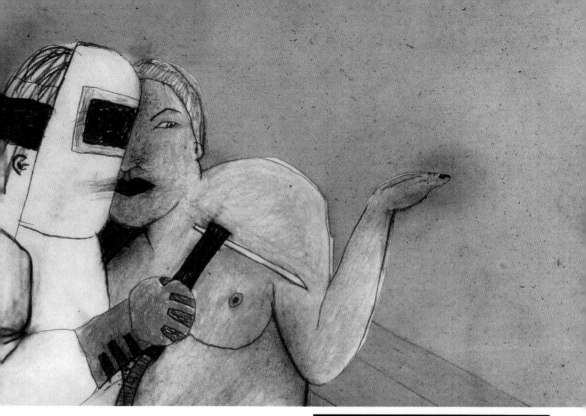

Pg. 115 Inspirational paintings

**THE ILLUMINATED
FILM COMPANY LTD**

United Kingdom
115 Gunnersbury Lane,
London W3 8HQ
United Kingdom
Phone: +44 20 8896 1666
Fax: +44 20 8896 1669
E-mail: info@illuminatedfilms.com

The Very Hungry Caterpillar & Other
 Stories, 1993
T.R.A.N.S.I.T., 1997
Christmas Carol – The Movie, 2001
War Game, 2002
War Boy, 2003

Grand Prix and Best in category -
 WAC, Los Angeles, 1998
Grand Prix and Audience Prize -
 Espinho, 1998
Children's Choice - *BAA London*, 2002
Best TV Special - *Annecy*, 2002
Winner Animation - *Tokyo Kinder Film
 Festival*, 2002

2D animation
3D CGI
Cut out

ILLUMINATED FILMS

www.illuminatedfilms.com

SCROOGE:but make yourself known.

GHOST II V.O. : Come in and know me better.
Scrooge walks into golden light

SCROOGE : What HAVE you DONE

TO MY HOUSE?

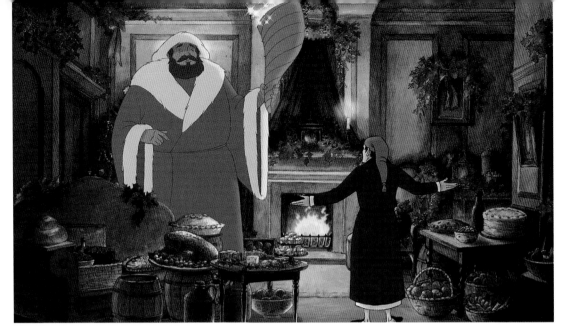

The Illuminated Film Company is the small kingdom of Iain Harvey, whose name confirms the important role a producer plays in animated films. Before starting this company in 1993, Harvey already had an impressive résumé. Having come from the publishing sector and with a particular interest for children's books, he produced Dianne Jackson's classic *The Snowman* (nominated for an Oscar in 1982), *Prince Cinders* (1993) and the famous television special *Father Christmas* (1991). He was also the executive producer of Jimmy Murakami's *When the Wind Blows* (1987), which was given an award at the Annecy festival, and the series *Spider!* (BBC, 1991).

The adaptation of beautiful children's books to the screen is a constant feature of Iain Harvey's career. The first production of The Illuminated Film Company, *The Very Hungry Caterpillar & Other Stories*, a series of five episodes directed by Andrew Goff, brought the narrative and graphic creativity of American writer Eric Carle to the big screen. With *T.R.A.N.S.I.T.*, by Piet Kroon, a sophisticated tribute to *art deco* and the luxurious tourism of the past, the producer captivated the adult public and won top awards at different festivals. The feature film *A Christmas Carol* by Charles Dickens reintroduced children's themes, as did the short *War Game* and its sequel *War Boy*.

Iain Harvey's company distributes movies all over the world through Disney and MGM. In 2003, it pre-produced the animated sit-com *Village People*, written by Oliver Lansley and directed by Edward Foster. Currently, Harvey is vice-president of the European Association of Animated Film (Cartoon).

Illuminated Film Company est le petit royaume de Iain Harvey, un nom prouvant que le rôle du producteur est crucial dans le cinéma d'animation. Avant de fonder cette compagnie en 1993, Harvey a déjà en main un CV respectable. Issu du monde de l'édition et surtout intéressé par les livres pour enfants, il produit *The Snowman*, un classique de Dianne Jackson nominé aux Oscars en 1982, *Prince Cinders* (1993) et la célèbre création télévisée *Sacré Père Noël* (1991). Il est également producteur exécutif de *Quand souffle le vent* de Jimmy Murakami (1987), primé à Annecy, et de la série *Spider!* (BBC, 1991).

L'adaptation de beaux livres pour enfants semble une constante dans la carrière de Iain Harvey. Illuminated Film Company débute avec la production de *The Very Hungry Caterpillar & Other Stories*, une série en cinq épisodes dirigée par Andrew Goff, et porte ainsi à l'écran la créativité narrative et graphique de l'écrivain américain Eric Carle. Avec *T.R.A.N.S.I.T.* de Piet Kroon, hommage sophistiqué à l'art déco et au tourisme luxueux d'antan, la maison de production capte le public adulte et récolte d'importants prix dans des festivals. Le retour à la thématique pour enfants se fait avec le long métrage *Un chant de Noël* de Charles Dickens, le court *Jeu de guerre* et sa suite *War Boy*.

La société de Iain Harvey distribue des films dans le monde entier via Disney et la MGM. En 2003, il préproduit la comédie animée *Village People*, écrite par Oliver Lansley et dirigée par Edward Foster. Actuellement, Harvey est vice-président de l'Association européenne du film d'animation (prix Cartoon).

Das von Iain Harvey regierte kleine Königreich Illuminated Film Company beweist, dass die Rolle des Produzenten beim Trickfilm nicht zu unterschätzen ist. Bereits vor der Firmengründung 1993 konnte Harvey auf ein beachtliches Curriculum zurückblicken. Ursprünglich aus dem Verlagsgeschäft kommend, wo sein Interessenschwerpunkt auf Kinderbüchern lag, produzierte er außer dem Klassiker von Dianne Jackson *Der Schneemann*, der 1982 für den Oscar nominiert wurde, auch das beliebte TV-Special *Father Christmas* (1991) und *Prince Cinders* (1993). Darüber hinaus war er geschäftsführender Produzent bei dem in Annecy prämierten Film *Wenn der Wind weht* von Jimmy Murakami (1987) und bei der BBC-Reihe *Spider!* (1991).

Die Adaptierung von schönen Kinderbüchern kann man wohl als Konstante in der beruflichen Laufbahn von Iain Harvey ansehen. Die erste Produktion von Illuminated Film Company war *Die Raupe Nimmersatt und andere Geschichten*, eine fünfteilige Reihe unter der Regie von Andrew Goff, die die erzählerische und grafische Kreativität des amerikanischen Autors Eric Carle auf die Leinwand brachte. Mit Piet Kroons *T.R.A.N.S.I.T.*, einem raffinierten Tribut an den Jugendstil und an einen Luxustourismus, der der Vergangenheit angehört, zog die Produktionsfirma das erwachsene Publikum in ihren Bann und errang große Preise bei verschiedenen Festivals. Die kindgerechte Thematik nahm Harvey mit dem Spielfilm *Eine Weihnachtsgeschichte* nach Charles Dickens, mit dem Kurzfilm *Kriegsspiel (War Game)* und seinem Folgefilm *War Boy* wieder auf.

Iain Harveys Unternehmen verleiht seine Filme weltweit über Disney und MGM. Im Jahr 2003 produzierte es im Vorlauf die animierte Sitcom *Village People* nach einem Drehbuch von Oliver Lansley und unter der Regie von Edward Foster. Zurzeit bekleidet Harvey das Amt des Vizepräsidenten der European Association of Animated Film (Cartoon).

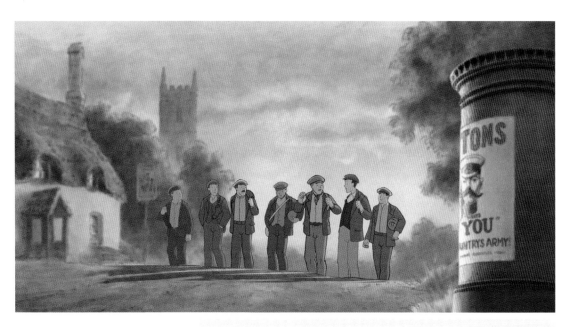

Seq ③ Sc ㉟ PANEL № (82)

ACTION (CUT) TO SHOT OF PLAYERS APPROACHING CAMERA
DIALOGUE LACEY — : "IT'S NOT FOOTBALL. WE HAVE TO WORK. WE HAVE TO LOOK AFTER
THE FIELDS."
FREDDIE — : THEY'RE GOING TO BE SOLDIERS!..."

B/G

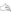 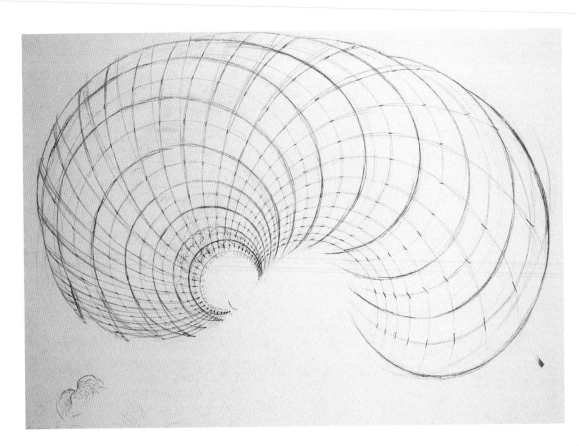

ISHU PATEL

Canada/India

How Death Came to Earth, 1972
Perspectrum, 1975
Bead Game, 1977
Afterlife, 1978
Top Priority, 1981
Paradise, 1985
Divine Fate, 1994

Best Film - *BAA*, 1978
Grand Prix - *Annecy*, 1978
Canadian Film Award, 1978
Silver Bear - *Berlin*, 1985
First Prize - *Los Angeles*, 1985
Unicef Prize - *Ottawa*, 1994

Traditional animation with
backlight and multiples
exposures

ISHU PATEL

www.nfb.ca

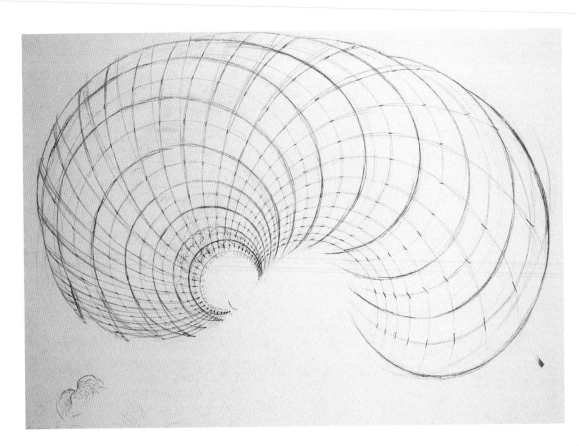

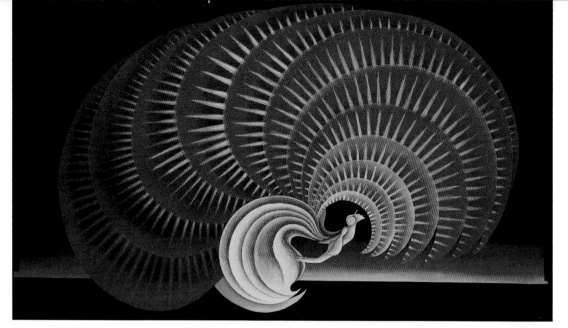

The sacred dimension of Indian culture runs through Ishu Patel's movies. His scripts emanate ancestral wisdom in the form of short moral stories that take a stand against excessive ambition, the predation of nature and the destructive impulse that assails the human species. This animator usually begins with a concept and then looks for a way to give it expression with audiovisuals. His clay animations, which use a sophisticated process of illumination from below, perfectly transmit the mysterious and variable character that distinguishes his fables. Among the various techniques that Patel investigates, the animation of colored beads in *Bead Game* is worth noting. This was one of his first films, and it was inspired by the decorative works of Inuit women. The simple material was seen as an impressive plea against nuclear weapons and the growing bellicosity that goes hand in hand with human evolution.

La dimension sacrée de la culture indienne habite les films d'Ishu Patel. Ses scénarios distillent une sagesse ancestrale sous forme de petits contes moraux contre l'ambition démesurée, les prédateurs dans la nature et l'approche destructrice du genre humain. En général, cet animateur part d'un concept et cherche la façon de l'exprimer sous forme audiovisuelle. Ses animations en plastiline, dénotant un processus sophistiqué d'éclairage par le bas, transmettent à la perfection le caractère mystérieux et changeant propre à ses fables. Parmi les différentes

techniques expérimentées par Patel se démarque l'animation de perles de couleurs dans l'un des ses premiers films, *Histoire de perles*, inspiré des travaux de décoration des femmes inuits. Le matériel de grande simplicité y apparaît comme un impressionnant pamphlet contre l'énergie nucléaire et le caractère belliqueux allant croissant avec l'évolution de l'homme.

Die Dimension des Heiligen, wie man es in der indischen Kultur findet, durchzieht die Filme von Ishu Patel. Seine Drehbücher destillieren eine uralte Weisheit in Form kleiner moralischer Geschichten, die sich gegen maßlose Ansprüche, gegen die Plünderung der Natur und das destruktive Element der menschlichen Rasse richten. Dieser Trickfilmer geht für gewöhnlich von einem Begriff aus, um dann eine audiovisuelle Gestaltungsform als Entsprechung zu suchen. Seine Animationen mit Knetfiguren, die raffiniert von unten ausgeleuchtet werden, bringen den geheimnisvollen und wechselhaften Charakter, der seine Fabeln auszeichnet, zur Perfektion. Zu den verschiedenen Techniken, die Patel erprobt hat, gehört die Bildanimation mit bunten Perlen in *Bead Game*, einem seiner ersten Filme, der von den Schmuckarbeiten der Inuit-Frauen angeregt war. Der einfache Stoff kam als beeindruckendes Pamphlet daher, das sich gegen die atomare Bedrohung und wachsende Kriegsbereitschaft, die mit der Entwicklung des Menschheit einhergeht, richtete.

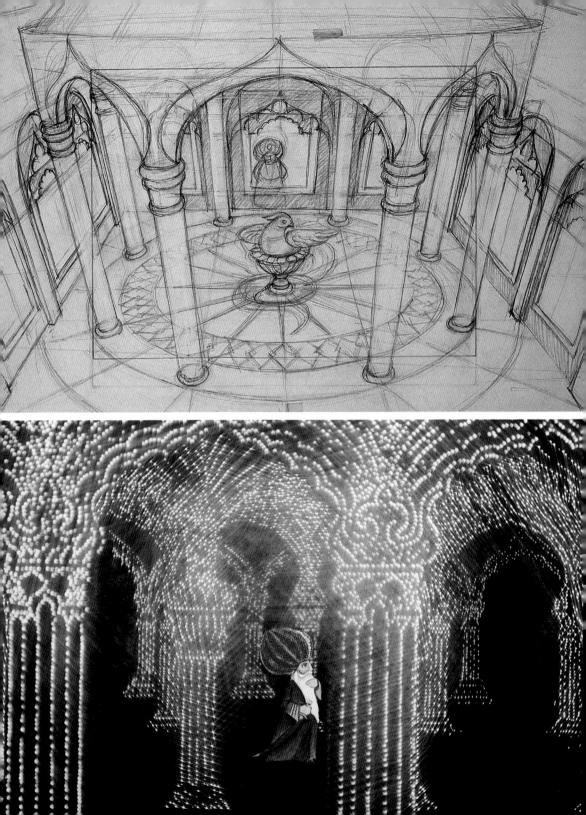

Pg. 122 Paradise (scene planning), 1985

Pg. 123-124 Paradise, 1985
Traditional animation with backlight
and multiples exposures.

Pg. 125 Top Priority, 1981
Paint on glass

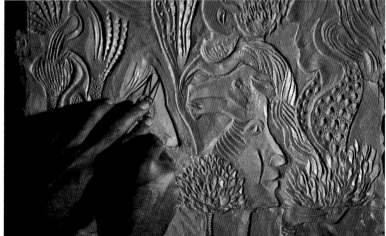

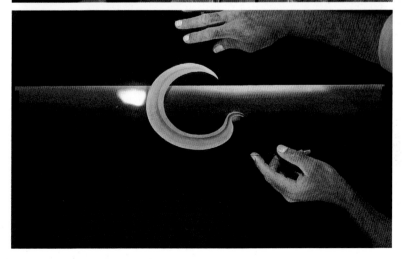

J. J. SEDELMAIER PRODUCTIONS, INC.

USA
199 Main Street, White Plains, New York 10601
Phone: 914 949 7979
Fax: 914 949 7989
E-mail: sedelmaier@aol.com

Beavis and Butthead, 1993
Schoolhouse Rock, 1993
The X-Presidents, Fun with Real Audio, Animated Outtakes, The Ambiguously Gay Duo, 1996-2000
Third Leg of Justice, 2002
Captain Linger, Harvey Birdman Attorney at Law - pilot

Telly Awards, 1993/1994/1995
First Place - *ASIFA/East*, 1994
First Place - *Campaign Mobius Award*, 1995
Best Educational Film - *Annecy*, 1995
Best Film - *ASIFA/East*, 1996
Annie Award, 1996
Best Short in Video - *Anima Mundi/Rio de Janeiro*, 2002

Traditional animation
Stop-motion photography
Digitally drawn animation

J. J. SEDELMAIER PRODUCTIONS

www.jjsedelmaier.com

His mother works in graphic design and his father is Joe Sedelmaier, the director of commercial advertisements. Given this fact, anyone interested in psychology will understand why young J. J. Sedelmaier lived surrounded by comics and selected some of these stories to animate in *stop motion* with a Super 8 camera. Once he grew older, he immediately tried to turn this game into a profession and, in fact, in the eighties started to get involved in the world of cartoons.

As an independent animator he spent time in the studios of Tony Eastman and R. O. Blechman, among others, until he established himself as a producer and director. In 1991 he founded J. J. Sedelmaier Productions, where he continues supervising the creation of projects and, in many cases, himself picks up a pencil or works at a keyboard.

Sedelmaier is responsible for the animation of well-known television programs such as MTV's *Beavis and Butthead* and the irreverent shorts of *Saturday TV Funhouse* on NBC's program *Saturday Night Live*. He has also collaborated with illustrators like Al Hirschfeld, George Booth and Garry Trudeau.

J. J. Sedelmaier Productions' list of commercial clients could be confused with a telephone book. The variety of styles they use spans from the delicate commercials of Northern Quilts toilet paper to the *anime-retro* touch of the famous Volkswagen *Speed Racer* campaign. As far as technology is concerned, the studio has been one of the last to introduce digital production, as they have stayed faithful to the notion of traditional drawing. Together with their works in animation, J. J. Sedelmaier Productions also operates in the area of graphic design, package design, printed advertising, billboards, Flip Books, illustrations, etc., very much in line with the Sedelmaier family tradition.

Sa mère s'adonne au design graphique et son père, Joe Sedelmaier, est réalisateur de spots publicitaires. N'importe quel psychologue averti comprendra pourquoi le petit J. J. Sedelmaier a vécu entouré de bandes dessinées, desquelles il s'est inspiré pour inventer des histoires à animer en *stop motion* avec une caméra Super 8. En grandissant, il a essayé de transformer le jeu en un métier ; dans les années 80, il se lance alors dans le monde des dessins animés.

Entre autres, il travaille comme animateur indépendant pour les studios de Tony Eastman et R. O. Blechman, avant de s'installer comme producteur et réalisateur. En 1991, il fonde J. J. Sedelmaier Productions, où il continue à superviser la création de projets et, très souvent, à manipuler lui-même crayon ou clavier.

Sedelmaier est à l'origine de l'animation de programmes télévisés comme *Beavis et Butthead* de la MTV et de la série provocatrice *Saturday TV Funhouse* de l'émission *Saturday Night Live* sur la NBC. Il a par ailleurs collaboré avec des illustrateurs comme Al Hirschfeld, George Booth et Garry Trudeau.

Le portefeuille de clients commerciaux de J. J. Sedelmaier Productions est comparable à un annuaire téléphonique, sachant la variété de styles que le studio offre, des spots publicitaires tranquilles pour le papier hygiénique Northern Quilters au look dessin animé rétro de la célèbre campagne *Speed Racer* pour Volkswagen. Sur le plan technologique, le studio a été dans les derniers à adopter la production numérique et est ainsi rester fidèle au dessin traditionnel.

À côté des travaux d'animation, J. J. Sedelmaier Productions interviennent dans une foule de domaines : design graphique, conception d'emballages, publicités sur papier, affiches, brochures, illustrations, etc. Il va sans dire que l'ensemble évolue dans le respect de la tradition de la famille Sedelmaier.

Seine Mutter: Grafikdesignerin, sein Vater Joe Sedelmaier: bekannt für seine Werbekampagnen. So kann jeder Laienpsychologe wohl verstehen, warum der kleine J. J. Sedelmaier von Comics umgeben aufwuchs, von denen er Geschichten aufnahm, um sie dann mit einer Super 8-Kamera in Stop motion in Zeichentrickfilme umzusetzen. Kaum herangewachsen versuchte er, das Hobby zum Beruf zu machen und begann in den 80er Jahren, sich in der Trickfilmwelt einzuführen.

Als unabhängiger Trickfilmkünstler arbeitete er auch für die Studios von Tony Eastman und R. O. Blechman, bis er sich als Produzent und Regisseur selbstständig machte. 1991 gründete er J. J. Sedelmaier Productions, wo er bis heute die neu entstehenden Projekte überwacht und oftmals selbst den Zeichenstift zur Hand nimmt oder die Tastatur bedient.

Sedelmaier zeichnet verantwortlich für bekannte Fernseh-Zeichentrickprogramme wie *Beavis and Butthead*, das auf MTV lief, oder die frechen Kurzfilme *Saturday TV Funhouse* des NBC-Programms *Saturday Night Live*. Mit Illustratoren wie Al Hirschfeld, George Booth und Garry Trudeau hat er ebenfalls zusammengearbeitet. Die Liste kommerzieller Auftraggeber von J. J. Sedelmaier Productions hat fast die Ausmaße eines Telefonbuchs, da die Stilvarianten, die er benutzt, von der taktvollen Reklame für Toilettenpapier der Marke Northern Quilters bis hin zum Retro-Look der berühmten Volkswagen-Kampagne Speed Racer reichen. Was die Technologie betrifft, so gehört das Studio zu den letzten, die die digitale Herstellung eingeführt haben, obgleich es auch weiterhin dem traditionellen zeichnerischen Entwurf treu bleibt.

Neben den Arbeiten im Bereich des Trickfilms betätigt sich J. J. Sedelmaier Productions auch im Bereich des Grafikdesigns, der Gestaltung von Verpackungen, gedruckten Werbeanzeigen, Plakaten, Daumenkinos, Illustrationen usw., ganz in der Tradition der Familie Sedelmaier.

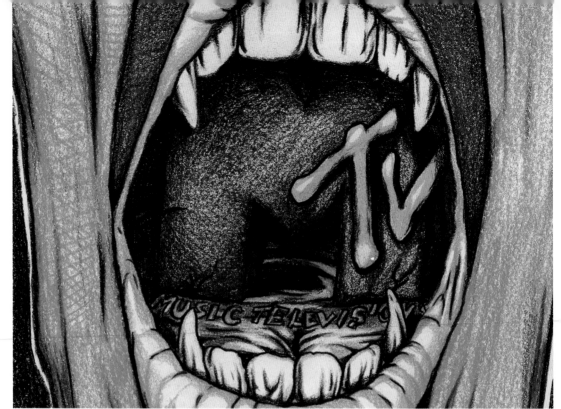

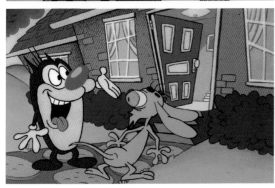
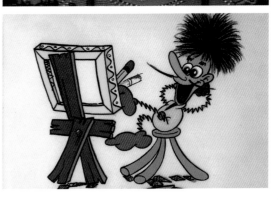

JEAN-FRANÇOIS LAGUIONIE

France
30 Rue Yuonne Le Tac
75018 Paris
Phone: 33 1 4606 7027
Fax: 33 1 4254 2109
E-mail: laguionie.jf@wanadoo.fr

La demoiselle et le violoncelliste /
The Damsel and the Cellist, 1965
L'Arche de Noé / Noah's Ark, 1967
Une bombe par Hasard / A Bomb by
Chance, 1969
Le masque du diable / The Mask of
the Devil, 1975
L'acteur / The Actor, 1976
La traversée de l'Atlantique à la rame
/ Rowing Across the Atlantic, 1978
Gwen ou le livre des sables / Gwen
or the Book of Sand, 1984
Le château des singes / A Monkey's
Tale, 1999
L'Île de Black Mór / The Island of
Black Mór, 2004

Grand Prix - *Annecy*, 1965
Silver Dragon - *Krakow*, 1967
Golden Dragon - *Krakow*, 1969
Golden Palm - *Cannes*, 1978
César Prize - *France*, 1978
First Prize - *Ottawa*, 1978
Critics Prize - *Annecy*, 1984
Feature Film Prize - *Los Angeles*, 1990

2D animation
Cut out

JEAN-FRANÇOIS LAGUIONIE

2

85 Il s'arrête, affolé.

86 Gina s'amuse beaucoup.

87 Elle fait le tour du lit - le Singe repart de l'autre côté.

88 Contreplongée : L'armoire. Le Singe entre en 1er plan ...

... et bondit de justesse sur son refuge.

89 Plongée sur Gina dépitée qui lui montre le costume.

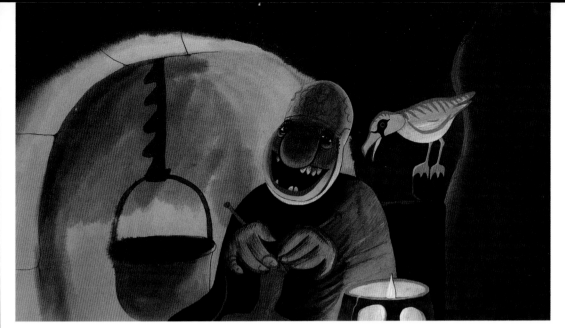

Too timid to act in front of an audience, young Jean-François Laguionie preferred to build stage sets and put on small shadow play shows for his classmates at the School of Dramatic Art. One day Paul Grimault, the great master of French animation, observed his work and proposed they join forces. Thus a new genius of animation was born.

Through animation movies Laguionie found a way to reconcile his two great passions, the theater and graphics. A talented writer, he adapts his own stories to a series of sketches and thus narrates the script through images. Using his great theatrical sense, he adjusts the scenery and illumination and, finally, rolls the camera.

His first short, *La demoiselle et le violoncelliste*, a film made with figures cut out of paper, won the Grand Prix at the Annecy Festival, while his classic *La traversée de l'Atlantique à la rame* won the Golden Palm Award in Cannes and the César Prize for the best short animation film of the year in France. Laguionie started his own studio, La Fabrique, in 1979, and began to produce feature films. However, he has never abandoned his method of using cut out figures, nor adopted digital animation techniques.

The evolution of Jean-François Laguionie's work—or Jef, as everyone calls him—is an excellent example of someone who adapts to the market without betraying the principles that have made him a source of inspiration for animators all over the world. His films range from the most intimate stories to large-scale, multinational productions of adventures. Beneath the apparent simplicity of his micro-stories hide drastic expectations and threats of the Apocalypses. Things are not exactly as they seem.

Bien trop timide pour se produire en public, le jeune Jean-François Laguionie préfère monter des décors et de petits spectacles d'ombres chinoises pour ses camarades de l'École d'art dramatique. Un jour pourtant, Paul Grimault, grand maître de l'animation dans l'Hexagone, voit son travail et lui offre une collaboration. Naît alors un nouveau génie dans cette discipline.

Dans ses films d'animation, ce cinéaste parvient à concilier deux grandes passions que sont le théâtre et le graphisme. En outre, en tant qu'écrivain de grand talent, il adapte ses propres histoires en une série de croquis et fait de la trame une suite d'images. Sa sensibilité théâtrale lui permet de peaufiner la mise en scène et l'éclairage avant de passer derrière la caméra.

Son premier court métrage, intitulé *La demoiselle et le violoncelliste*, donne vie à des personnages en papier découpé et remporte le grand prix du Festival d'Annecy. Ce qui est en revanche devenu son classique, *La traversée de l'Atlantique à la rame*, décroche la Palme d'or à Cannes

et le César du meilleur court d'animation français de l'année. C'est en 1979 que Laguionie fonde La Fabrique, son propre studio où il passe à la production de longs métrages, sans pour autant abandonner la technique de personnages en papier découpé et passer au numérique.

La trajectoire de Jean-François Laguionie (ou simplement Jef, comme tout le monde le surnomme) est le parfait exemple d'adaptation au marché sans trahir les principes qui ont fait de lui la source d'inspiration d'animateurs de toute la planète. Ses films traitent tant d'histoires intimes que d'aventures à grande échelle et de créations internationales. Derrière la simplicité perçue de ces petits contes se cachent des projections radicales et des menaces d'apocalypse. Les apparences sont parfois trompeuses…

Der junge Jean-François Laguionie war zu schüchtern, um vor Publikum zu spielen. Er baute lieber Bühnenbilder und bot seinen Kommilitonen an der Schauspielschule kleine Schattenspieldarbietungen chinesischer Tradition bis eines Tages Paul Grimault, der Altmeister der französischen Animation, seine Arbeit sah und ihm die Zusammenarbeit anbot. Das war die Geburtsstunde eines neuen genialen Trickfilmers.

In seinen Trickfilmen hat der Filmkünstler seine beiden großen Leidenschaften unter einen Hut gebracht: das Theater und die Grafik. Als außergewöhnlich talentierter Schriftsteller formt er zudem seine eigenen Geschichten passgerecht für Skizzenreihen um und verwandelt Drehbücher in Bilder. Mit Hilfe seines feinen Gespürs für die dramatischen Künste sorgt er für eine geeignete Inszenierung und Ausleuchtung, bevor er schließlich die Kamera betätigt.

Mit seinem ersten Kurzfilm *The Damsel and the Cellist*, einem kleinen Meisterwerk mit Scherenschnittfiguren, errang er den Großen Preis des Festivals von Annecy, und mit dem Klassiker *Rowing Across the Atlantic* die Goldene Palme von Cannes und den César für den besten französischen Beitrag des Jahres in der Sparte Animierter Kurzfilm. 1979 gründete Laguionie La fabrique, sein erstes eigenes Studio, womit er zur Herstellung ganzer Spielfilme überging, ohne etwa deshalb die Scherenschnitttechnik zugunsten der digitalen Animation ad acta zu legen.

Der Werdegang von Jean-François Laguionie, kurz Jef genannt, ist ein gutes Beispiel dafür, wie Marktanpassung gelingt ohne die eigenen Anfänge, welche ihn zur Inspirationsquelle für Animationskünstler in aller Welt machten, zu verleugnen. Seine Filme reichen von Gefühls- und Bekenntnisgeschichten bis zu groß angelegten Abenteuerfilmen, die als multinationale Produktionen laufen. Unter der scheinbar einfachen Oberfläche seiner winzigen Erzählungen verbergen sich drastische Vorahnungen und apokalyptische Drohungen. Die Dinge sind nicht immer das, was sie zu sein scheinen.

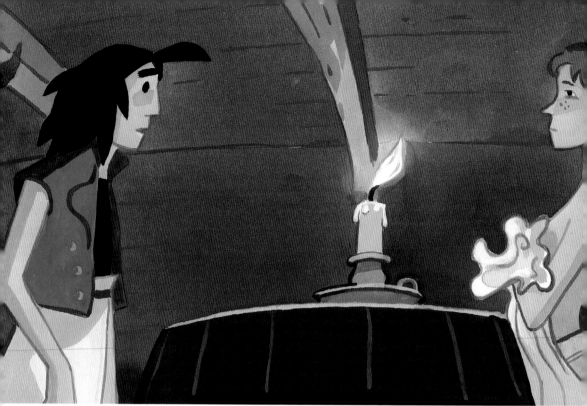

Pg. 132–133 L'Île de Black Mór / The Island of Black Mór (storyboard), 2004

Pg. 134 L'Île de Black Mór / The Island of Black Mór, 2004
Traditional animation

L'Île de Black Mór / The Island of Black Mór (storyboard), 2004

Pg. 135 La Traversée de l'Atlantique à la Rame / Rowing Across the Atlantic, 1978
Traditional animation

JERZY KUCIA

Poland
31-428 Krakow
Ul. Chrobrego 29/33
Phone/Fax: + 48 12 411 7961
E-mail: jkucia@interia.pl

Powrót / Return, 1972
Winda / The Elevator, 1974
Szlaban / The Barrier, 1977
Krag / The Circle, 1978
Refleksky / Reflections, 1979
Wiosna / The Spring, 1980
Odpryski / Chips, 1984
Parada / Parade, 1986
Przez Pole / Across the Fields, 1992
**Strojenie Instrumentów / Tuning
 Instruments,** 2000

Grand Prix - *Grenoble,* 1973
International Prize - *Oberhausen,* 1974
ASIFA Prize, 1978
Special Prize - *Annecy,* 1979
State of Krakow Prize, 1983
Grand Prize - *Toronto,* 1984
First Prize - *Oberhausen,* 1987
Utrecht Prize, 1996
Prize - *Ottawa,* 2000
Special Jury Award - *World Festival
 of Animated Films,* 2002
International Short Film Award -
 BAR, 2002
**Award of the Land of Baden-
 Württemberg** - *Stuttgart,* 2002
Jury Special Prize - *Zagreb,* 2002

Drawing
Painting
Manipulated live-action
Traditional animation
Cut-out

JERZY KUCIA

Jerzy Kucia, a plastic and graphic artist and professor at Krakow's Academy of Fine Arts, is known as a master of animation in Poland, a country with a renowned tradition in this area. His work is often compared to that of other artists of introspection and the sublime, such as the French filmmaker Robert Bresson.

In fact, Kucia's short films comprise a compendium of the subtleties of human emotion. In his movies, story telling tends to give way to the careful observation of mental processes and the effects that the passing of time has on the human psyche. The graphic or plastic intervention techniques of his movies, made one frame at a time, are varied and always surprising. It took Kucia five years to finish the film *Across the Fields*; he and his wife Ewa created 16,000 paintings for this movie that was just 18 minutes long.

Even so, technique does not take over the creative process of the filmmaker, but rather helps him in his search for what he considers most important: the perception of life's mechanisms. Kucia likes to call his films "emotional documentaries". Instead of telling stories, his films present "problems": the idle pursuits of a man traveling on a train, an insect's inglorious fight to survive, the hopes generated by the arrival of spring. Personal memory, the traditions of his country and the great historical disasters experienced in Europe and the East all have a prominent place in his work, which rejects cartoon characters and conventional narrative.

Jerzy Kucia is an audiovisual poet whose work captures small moments and does not shrink away from facing up to the toughest dimensions of reality.

Artiste plasticien et professeur de l'Académie de Beaux-arts de Cracovie, Jerzy Kucia est considéré comme le maître de l'animation en Pologne, un pays avec une tradition de longue date dans le domaine. Son œuvre est souvent comparée à celle d'autres artistes de l'introspection et du sublime, tels que le cinéaste Robert Bresson.

Ses courts métrages constituent de véritables recueils détaillés sur les émotions. Chez Kucia, la narration d'histoires laisse généralement place à une observation poussée des processus mentaux et des effets du temps sur la psyché. Ses techniques de manipulation graphique ou plastique de la pellicule, image par image, sont aussi diverses que surprenantes. Il lui aura fallu cinq ans pour achever *Dans les champs*, œuvre qui ne compte pas moins de 16 000 peintures créées par Kucia et sa femme Ewa, pour un résultat final de 18 minutes.

Plus que des obstacles au processus créatif, ces techniques permettent au réalisateur d'aller à l'essentiel, à la perception des méca-nismes de la vie. Kucia aime qualifier ses films de « documentaires émotionnels » : au lieu de raconter des histoires, il expose des problèmes, allant des pensées d'un homme lors d'un voyage en train à la lutte sans gloire d'un insecte pour survivre et aux espoirs qui naissent avec l'arrivée du printemps. La mémoire personnelle, les traditions de son pays et les grands bouleversements vécus en Europe occupent une place de choix dans son œuvre, loin des personnages de bandes dessinées et des histoires conventionnelles.

Jerzy Kucia est un poète audiovisuel qui s'attache à de courts instants et n'hésite pas à affronter la dimension la plus difficile de la réalité.

Der bildende Künstler Jerzy Kucia, der an der Kunstakademie von Krakau lehrt, ist in Polen als Meister des Trickfilms anerkannt, einem Land mit einer beachtlichen Tradition auf diesem Gebiet. Er wird gemeinhin mit solchen Künstlern verglichen, deren Werk für das Sublime und Verinnerlichung steht, beispielsweise mit dem französischen Filmkünstler Robert Bresson.

Tatsächlich bilden seine Kurzfilme ein scharfsinniges Kompendium der menschlichen Gemütsbewegungen. Kucia drängt das bloße Erzählen von Geschichten hinter die sorgfältige Beobachtung von mentalen Abläufen und den Auswirkungen, welche die Zeit auf die Psyche der Personen hat, zurück. Seine Techniken des grafischen oder bildnerischen Eingriffs in den Film, Einzelaufnahme für Einzelaufnahme, sind vielfältig und überraschen immer. Für *Quer übers Feld* (1992) brauchte er fünf Jahre, und für einen nur 18 Minuten langen Film schufen er und seine Ehefrau Ewa sechzehntausend Bilder.

Trotzdem dominiert die Technik nicht den kreativen Prozess des Regisseurs, sondern hilft ihm lediglich bei seiner Suche nach der für ihn ganz wesentlichen Wahrnehmung der Mechanismen des Lebens. Kucia nennt seine Filme gerne „emotionale Dokumentationen". Er präsentiert „Probleme" anstatt Geschichten zu erzählen: die Hirngespinste eines Mannes auf einer Zugreise, der ruhmlose Überlebenskampf eines Insekts, die Hoffnungen, die mit dem Frühling aufbrechen. Die persönliche Erinnerung, die Traditionen seines Landes und die großen geschichtliche Erschütterungen, die Osteuropa erlebte, haben eine tragende Rolle in seinem Werk, das Comicfiguren und konventionelle Erzählweise ablehnt.

Jerzy Kucia ist ein Poet des Audiovisuellen, der die kleinen Momente aufgreift und der nicht davor zurückschreckt, noch der härtesten Seite des Lebens die Stirn zu bieten.

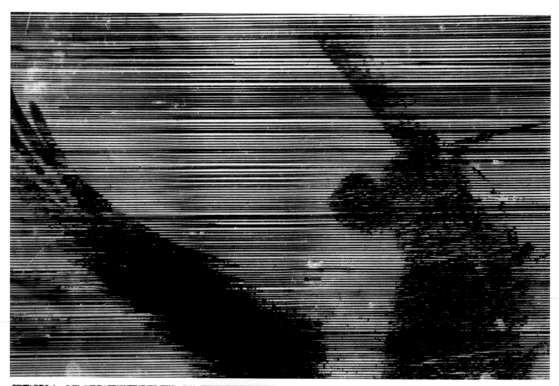

Pg. 137–138 Across the Fields, 1992
Pg. 139 The Spring, 1980

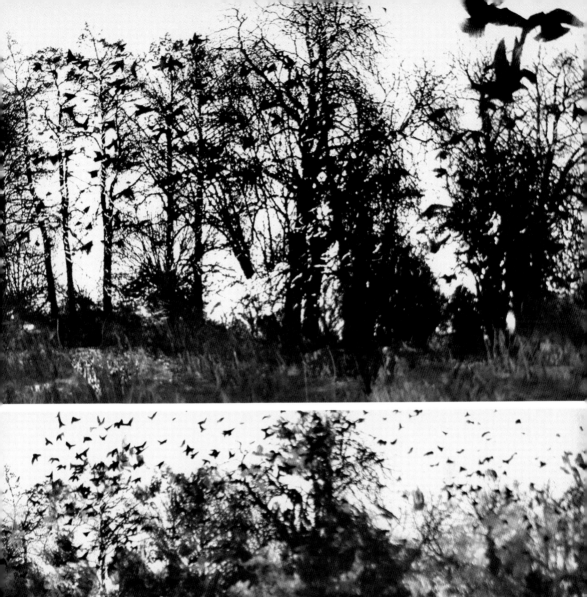

JOAN C. GRATZ

USA
GRATZFILM
1801 NW Upshur
Suite 610
Portland, Oregon 97209
Phone: + 1 503 289 5145
E-mail: gratz@spiritone.com

Candyjam, 1988
Mona Lisa Descending a Staircase,
 1992
Pro and Con, 1992
Dowager's Feast, 1996
Innerplay, 2000
Dowager's Idyll, 2001

Academy Award - *Best Animated
 Short*, 1993
Special Jury Prize - *Ottawa*, 1993
Golden Conch - *Bombay*, 1994
Gold Award - *WorldFest*, 1993
Best Experimental Film - *WAC USA*,
 1996

Clay
Painting

JOAN C. GRATZ

www.gratzfilm.com

Cinema and painting have discovered an original form of dialogue in the techniques of Joan Gratz's exceptional short films. This animator uses colored clay as if it were ink, mixing tones and organizing the flow of images with delicate lines. Her objective is to endow painting with movement, sequence and rhythm and, at the same time, enrich the cinematographic image with abstraction and style.

Her first work, *Mona Lisa Descending a Staircase*, perfectly illustrates the method of metamorphoses in cascade, which is not exhausted in the mere formal achievement, but rather broadens the meaning of what is projected onto the screen. In this Oscar award-winning short, Gratz explores the human face in 20th-century painting and makes her "visual onomatopoeia" communicate the graphic style and emotional content of the works of 35 great artists.

The professional career of Joan C. Gratz began in the studios of Will Winton, where she worked as an animator and designed scenes and effects for the most important shorts that the company produced. Her excellent work with clay painting can also be seen in the videos of John Fogerty (*Vanz can't Danz*) and Peter Gabriel (*Digging in the Dirt*), as well as in dozens of commercials that she herself has produced since 1986.

It is through her artistic films, however, that the international public has most recognized Gratz's sublime cultural style. Her three most recent shorts are experiments in the area of abstraction and kaleidoscope, and in them clay painting seems to pursue the absolute fluidity of musical language.

Le cinéma et la peinture ont trouvé dans la technique de Joan C. Gratz un mode de dialogue original. Dans ses prodigieux courts métrages, l'animatrice manipule la plastiline de couleur comme s'il s'agissait d'encre : elle mélange des tons et génère le flux d'images au travers de lignes fines. L'idée est de procurer mouvement, séquence et rythme à la peinture, tout en dotant l'image cinématographique d'abstraction et de stylisation.

Son œuvre majeure, *Mona Lisa Descending a Staircase*, illustre à la perfection la technique de métamorphose en cascade qui, au-delà du simple exploit, augmente le sentiment de perception à l'écran. Dans ce court récompensé par un Oscar, Gratz explore le visage humain dans la peinture du 20e siècle et parvient par son « onomatopée visuelle » à transmette le style graphique et le contenu émotionnel du travail de 35 grands artistes.

La carrière professionnelle de Joan C. Gratz débute dans les studios de Will Winton, où elle exerce comme animatrice et dessine des scènes et des effets pour les principaux courts métrages qui y sont produits. La maîtrise absolue de la manipulation de la plastiline se dénote également dans les clips vidéo de John Fogerty (*Vanz can't Danz*) et Peter Gabriel (*Digging in the Dirt*), ainsi que dans des dizaines de spots publicitaires dont elle assure depuis 1986 la production.

Toutefois, le public international consacre surtout l'empreinte culturelle de Gratz pour ses films artistiques. Ses trois derniers courts illustrent des essais d'abstraction et de kaléidoscope où la peinture avec plastiline semble rechercher la fluidité parfaite du langage musical.

Film und Malerei haben eine originelle Form des Dialogs in der Technik gefunden, die Joan C. Gratz in ihren wunderbaren Kurzfilmen einsetzt. Die Trickfilmerin benutzt farbiges Plastilin als wäre es Tinte, indem sie Töne mischt und den Bildfluss durch zarte Linien organisiert. Ihr Ziel ist es, der Malerei Bewegung, Abfolge und Rhythmus zu verleihen und gleichzeitig, das Filmbild zu abstrahieren und zu stilisieren.

Ihr bisheriges Meisterstück *Mona Lisa Descending a Staircase* zeigt in Perfektion die Methode der kaskadenartigen Metamorphosen , die sich nicht im rein formalen Kunststück erschöpfen, sondern den Sinngehalt dessen, was man auf der Leinwand sieht, erweitern. In diesem Kurzfilm, der mit einem Oscar prämiert wurde, erforscht Gratz das menschliche Gesicht in der Malerei des 20. Jahrhunderts und schafft es, dass ihre „visuelle Lautmalerei" den Zeichenstil und den emotionalen Gehalt der Arbeit von 35 großen Künstlern vermittelt.

Die professionelle Laufbahn von Joan C. Gratz begann in den Studios von Will Winton, wo sie als Trickfilmerin arbeitete und Szenen und Effekte für die wichtigsten der dort produzierten Kurzfilme entwarf. Die Vorzüglichkeit ihrer Arbeit mit Plastilin kann man auch in den Videoclips von John Fogerty (*Vanz Can't Danz*) und Peter Gabriel (*Digging in the Dirt*) sehen, ebenso in Dutzenden von Werbespots, die sie seit 1986 in eigener Produktion machte.

Allerdings sind es eher die künstlerischen Filme, in denen das internationale Publikum die kulturell raffinierte Handschrift von Gratz erkennen kann. Ihre drei jüngsten Filme experimentieren im Bereich der Abstraktion und des Kaleidoskops, wo das Malen mit Plastilin das absolute Fließen der musikalischen Sprache zu verfolgen scheint.

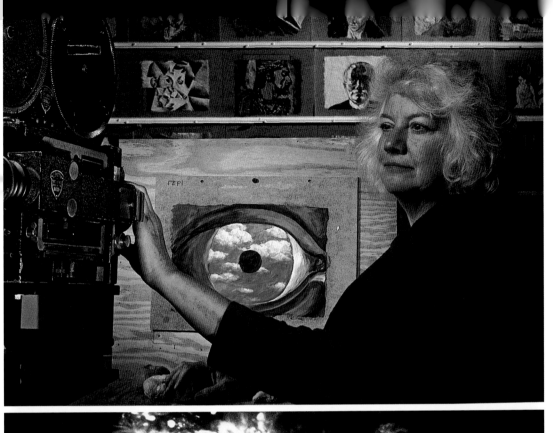

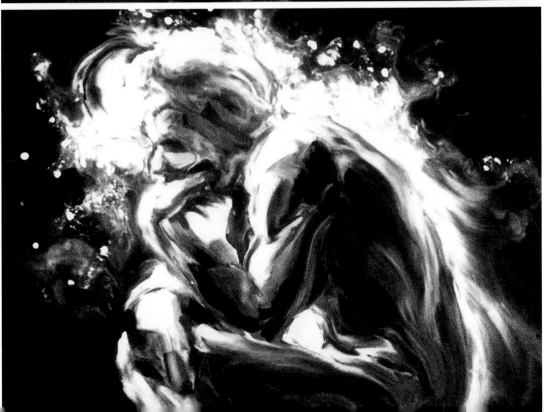

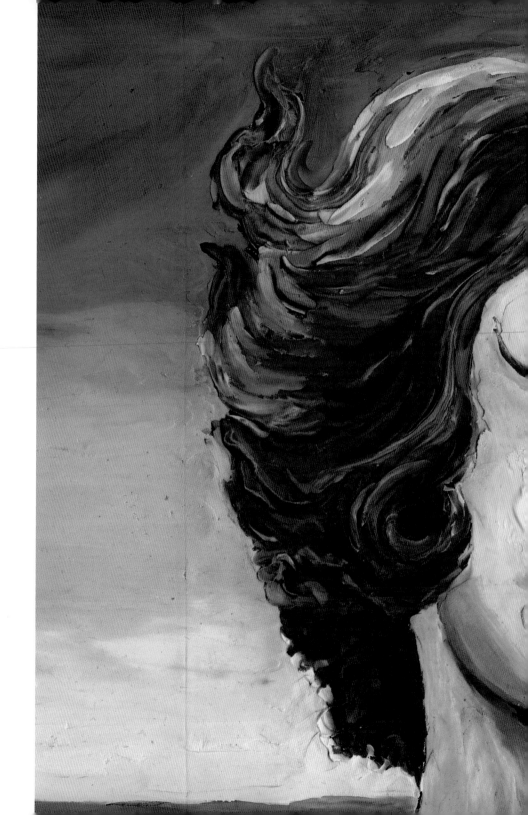

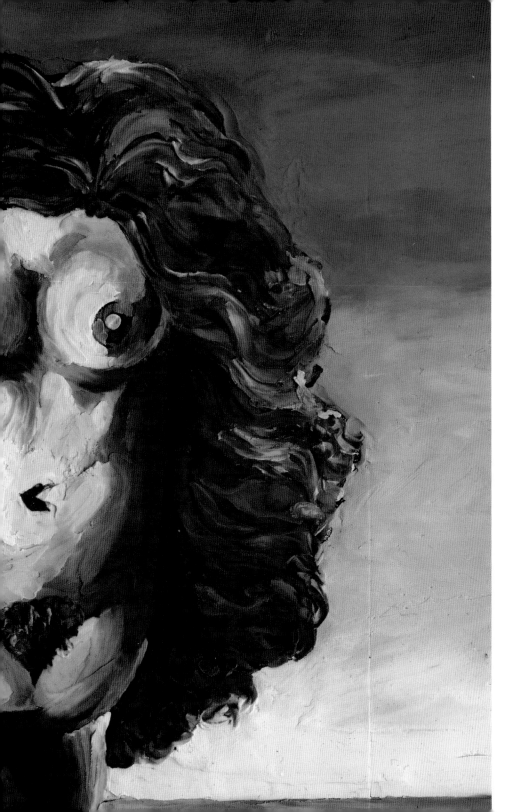

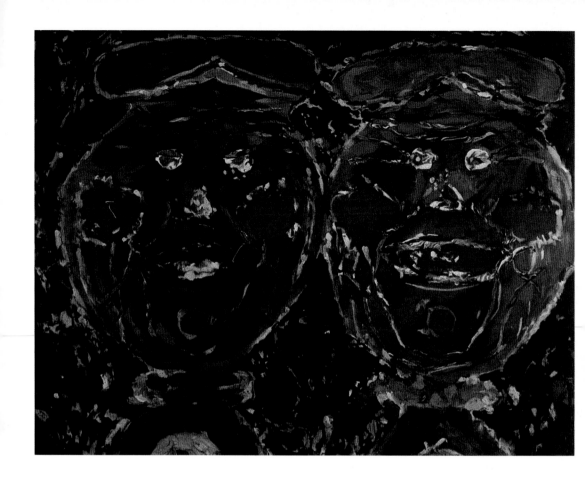

Pg. 140 The shooting of "Mona Lisa
Descending a Staircase".

The Creation, 1981
Clay painting.

Pg 141–144 Mona Lisa Descending
a Staircase, 1992
Clay painting.

Pg. 145 Pro and Con, 1992
Mixed media

Pg. 145 (bottom left) Pro and
Con, 1992
Mixed media

JOANNA QUINN

United kingdom
Beryl Productions
 International Ltd.
c/o Chapter, Market Road,
 Canton, Cardiff, CF5 1QE
United Kingdom
Phone: 029 20 396 775 (Office),
Phone: 029 20 226 225 (Studio)
E-mail: studio.beryl@fut.net

Girls Night Out, 1986
Moo Glue, 1987
Tea at Number 10, 1987
Castell Cant, 1988
Body Beautiful, 1990
Elles, 1992
Britannia, 1993
Famous Fred, 1996
Wife of Bath/The
 Canterbury Tales, 1998

Special Jury, Ufoleis and Mellow
 Manor Prizes - *Annecy,* 1987
Silver Dragon - *Krakow,* 1988
Cymru Award - *BAFTA,* 1991 and 2000
Silver Hugo - *Chicago,* 1992
Special Jury Prize for Best
 Humour - *Zagreb,* 1992
Best under 5 min - *Espinho,*
 1993 *and Zagreb,* 1994
Audience Prize - *Zagreb,* 1994
Best Film category E - *Hiroshima,* 1994
Golden Hugo - *Chicago,* 1994
Best Childrens Animation - *BAFTA,* 1997
Grand Prix TV - *Annecy,* 1997
Best between 13-26 min - *Espinho,* 1997
Best Animated Film - *BAFTA,* 1999
Emmy Awards, 1999

Hand drawing
Traditional animation

JOANNA QUINN

British animator Joanna Quinn's greatest source of inspiration comes from watching people; she often asks her friends to repeat the same action over and over again while she analyzes the body's movements, identifies its key positions and sketches a quick draft. Her drawings develop from these drafts, and in them one can already make out the final product.

This is the method that she has used since her first movie, *Girls Night Out,* which she filmed while still a student of Graphic Design at Middlesex University in London. In this movie Beryl came to life, a character that would appear in future works and give name to the company that Quinn founded in Cardiff in 1987 with the producer and writer Les Mills: Beryl Productions International.

Beryl personifies Joanna Quinn's intentions as she explores women's identity in a world dominated by the laws of beauty and a good physical figure. Quinn believes that female filmmakers have a great responsibility as creators of a positive image of women.

Born in Birmingham, England, in 1962, Quinn has dedicated herself to encouraging young new talents, whether that is by working as an animation professor with a busy agenda in both Europe and the United States, or by opening her Cardiff studio to recent graduates.

Beryl Productions has an important list of commercial clients, while Joanna Quinn's own movies are a guaranteed attraction at the major film festivals. *Famous Fred,* a 30-minute musical about a feline rock star, and *Wife of Bath,* a segment from *The Canterbury Tales,* received Oscar nominations for the best animated short film.

C'est en observant son entourage que Joanna Quinn trouve le plus d'inspiration pour ses animations. Bien souvent, elle demande en effet à ses amis de répéter plusieurs fois une action pour étudier les mouvements du corps, identifier les positions clés et en faire une ébauche. Tel est le point de départ de ses dessins, où les traits esquissés adoptent peu à peu la forme définitive.

Elle applique cette méthode depuis son premier film intitulé *Girls Night Out* et réalisé alors qu'elle étudiait encore l'infographie à l'université de Middlesex, à Londres. Avec cette production naît Beryl, personnage qui interviendra dans des travaux ultérieurs et qui donne le nom à l'entreprise fondée à Cardiff en 1987 avec le producteur et écrivain Les Mills, la Beryl Productions International.

Beryl symbolise les intentions de Joanna Quinn en analysant l'identité de la femme dans un monde régi par une dictature de la beauté et de

l'apparence physique. Quinn croit les femmes cinéastes capables d'assumer la diffusion d'une image positive du genre féminin.

Né en 1962 à Birmingham (Angleterre), elle s'efforce d'encourager de nouveaux talents, aussi bien comme professeur d'animation à l'agenda chargé en Europe et aux États-Unis, qu'en accueillant dans son studio des jeunes fraîchement sortis de l'université.

Beryl Productions possède un portefeuille bien garni de clients et les films personnels de Joanna Quinn sont toujours très prisés dans les grands festivals. *Famous Fred,* comédie musicale de 30 minutes sur un félin star du rock, et *Wife of Bath,* extrait de *The Canterbury Tales,* ont été nominés pour l'Oscar du meilleur court métrage d'animation.

Menschen zu beobachten ist für die britische Trickzeichnerin Joanna Quinn die reichste Inspirationsquelle. Sie pflegt ihre Freunde darum zu bitten, eine Handlung mehrmals zu wiederholen, damit sie die Körperbewegungen analysieren, Grundpositionen feststellen und eine Skizze anfertigen kann. Diese wiederum dient ihr als Grundlage für ihre Zeichnungen, in denen bereits die endgültige Form festgelegt wird.

Diese Methode wendet sie seit ihrem Erstling *Girls Night Out* an, den sie noch während ihres Grafikdesign-Studiums an der Londoner Middlesex University drehte. Das war auch die Geburtsstunde der Figur Beryl, die sie in späteren Arbeiten wieder aufnahm und die dem Unternehmen, das sie1987 zusammen mit dem Produzenten und Autor Les Mills in Cardiff gründete, den Beryl Productions International, seinen Namen gab.

Beryl verkörpert Joanna Quinns Intentionen, die weibliche Identität in einer Welt zu erforschen, in der das Diktat körperlicher Fitness und Schönheit herrscht. Quinn misst den Frauen unter den Filmemachern große Verantwortung bei der Prägung eines positiven Frauenbildes zu.

Die 1962 im britischen Birmingham geborene Quinn widmet sich der Aufgabe, neue Talente anzuspornen, sei es durch ihre ausgesprochen intensive Dozententätigkeit, die sie in Europa und den Vereinigten Staaten im Fachbereich Animation ausübt, sei es dadurch, dass sie jungen Hochschulabsolventen Zugang zu ihrem Studio in Cardiff gewährt.

Beryl Productions hat einen wichtigen Bestand an Geschäftskunden, und die persönlichen Filme von Joanna Quinn ziehen auf den großen Festivals garantiert Kunden an. *Famous Fred,* ein halbstündiges Musical über einen rockenden Kater, und *Wife of Bath,* Teil aus Chaucers *The Canterbury Tales,* wurden in der Sparte „Bester animierter Kurzfilm" für einen Oscar nominiert.

Pg. 147 Charmin, 1999/2003
Commercial spots
Studio/client: Acme Filmworks
Agency: D'Arcy, London/New York

Pg. 148 Body Beautiful, 1990
Traditional animation

Body Beautiful, 1990
Storyboard

Pg. 149 Body Beautiful, 1990
Traditional animation

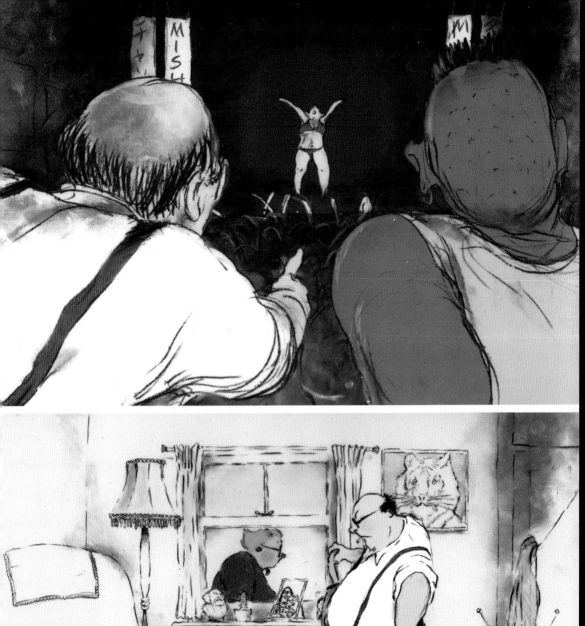
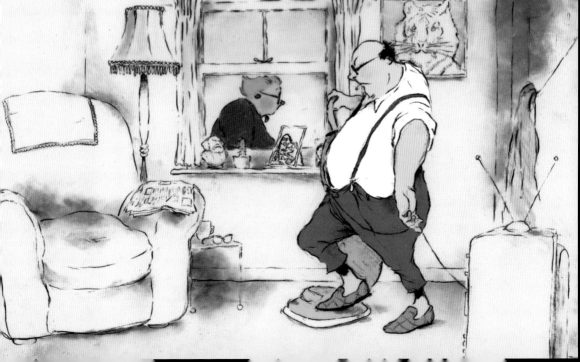

Pg. 150 Body Beautiful, 1990
Traditional animation.

Body Beautiful, 1990
Visual development.

Pg. 151 Elles, 1992
Animation key-frames
Pencil on paper

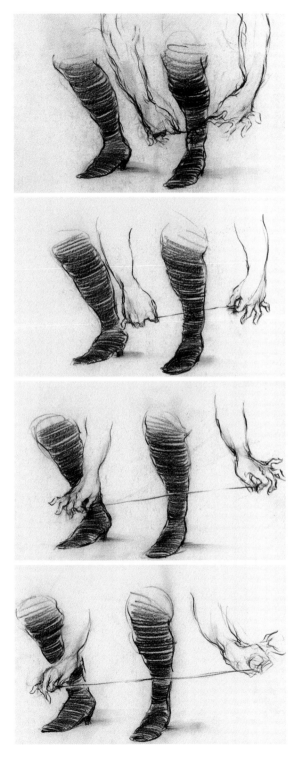

JONATHAN HODGSON

United Kingdom
Contact: Jane Colling,
Sherbet/Jonathan Hodgson
112-114 Great Portland
 Street, London W1N 5PE
Phone: +44 (0)20 7636 6435
Fax : +44 (0)20 7436 3221
E-mail: jane@sherbet.co.uk /
 jh@junkyard.uk.com

Dogs, 1981
Night Club, 1983
Menagerie, 1984
Train of Thought, 1985
The Doomsday Clock, 1987
Feeling My Way, 1997
The Man with the
 Beautiful Eyes, 1999
Camouflage, 2001

Best Student Film - *Stuttgart
 and Cambridge,* 1981
Jury Special Prize - *Annecy,* 1983
Mari Kuttna Award - *London,* 1983
Grand Jury Prize - *Ottawa,* 1998
Best Under 7 min - *BAA,* 2000
Best Short Animation - *BAFTA,* 2000
Best Animation - *Dresden,* 2000
UNICEF Prize - *WAC/USA,* 2001
Main Prize - *Dresden,* 2001
Jury Prize - *Oberhausen,* 2001

**Traditional animation
Moving collages
Digitally manipulated
 live action**

JONATHAN HODGSON

www.sherbet.co.uk

For Jonathan Hodgson, there is nothing so complex or delicate that it cannot be used as a theme for creating an animated film. He has worked with the memories of people who spent their childhood living with schizophrenic parents—in the documentary *Camouflage*—, with the subconscience of a man going from his home to work—in *Feeling My Way*—and with children who discover another dimension of reality through a poem by Charles Bukowski—in *The Man with the Beautiful Eyes*. The inspiration of this notable animator, born in Oxford in 1960, comes from the observation of life in its multiple facets.

In the area of technique, Hodgson likes to try ambitious combinations. At the beginning of his career he mainly focused on pure and simple drawings, although these were already fairly sophisticated, as can be seen in *Dogs*, a work about his student years, and in *Night Club*, his first professional short about the loneliness of a Liverpool night. With time, this filmmaker has developed a particular style of animated *collage* as well as a personal way of digitally working real images and mixing them with animation in order to obtain extremely dramatic effects.

A graduate of the Royal College of Art, Hodgson, one of the founders of the production company Bermuda Shorts, has directed commercials, videos and opening credits for television since 1985. In 1996, he and the producer Jonathan Bairstow created Sherbet in London, a company that usually receives many awards in the international film festivals. At Sherbet, Hodgson continues his long-time collaboration with the animator Susan Young, while he at the same time produces works by Sandra Ensby and Ruth Lingford, among others.

Aux dires de Jonathan Hodgson, rien n'est trop complexe ou délicat pour ne pas servir de base à un film d'animation. Aussi s'est-il inspiré des souvenirs de personnes dont l'enfance s'est déroulée aux côtés de parents schizophrènes (documentaire *Camouflage*), du subconscient d'un homme se rendant de chez lui au travail (dans *Feeling My Way*) et d'enfants découvrant une autre dimension de la réalité d'après un poème du « maudit » Charles Bukowski (dans *The Man with the Beautiful Eyes*). Né à Oxford en 1960, l'inspiration vient à ce remarquable animateur en observant la vie sous de multiples facettes.

Sur le plan technique, Hodgson aime se lancer dans des combinaisons audacieuses. Au début de sa carrière, il préférait le dessin épuré, bien que déjà fort sophistiqué, comme le prouve *Dogs*, un travail effectué pendant ses études. Tel est également le cas dans *Night Club*, son premier court professionnel traitant de la solitude de la nuit à Liverpool.

Avec le temps, le réalisateur s'est forgé un style bien à lui de collage animé, avec un traitement numérique particulier de l'image qu'il mélange à l'animation et produisant des effets très percutants.

Diplômé du Royal College of Art, Hodgson est l'un des fondateurs de la maison de production Bermuda Shorts et réalisateur depuis 1985 de spots publicitaires, de génériques pour la télévision et de clips vidéo. En 1996, il crée à Londres, avec le producteur Jonathan Bairstow, la compagnie Sherbet, souvent récompensée dans les festivals internationaux. Chez Sherbet, Hodgson poursuit une longue collaboration avec l'animatrice Susan Young et produit aussi des œuvres de Sandra Ensby et Ruth Lingford, entre autres artistes.

Für Jonathan Hodgson gibt es nichts, was als Thema für einen Trickfilm zu komplex oder heikel wäre. In seinem Dokumentarfilm *Camouflage* hat er die Erinnerungen von Personen behandelt, die ihre Kindheit mit schizophrenen Eltern verbringen musstenund in *Feeling My Way* das Unterbewusste eines Mannes auf dem Weg zur Arbeit. In *Der Mann mit den schönen Augen* nach einer Erzählung des verpönten Charles Bukowski waren Kinder, die eine andere Dimension der Realität entdecken, sein Thema. Anregungen erhält dieser bemerkenswerte Animationskünstler, der 1960 in Oxford geboren wurde, vom Leben selbst, das er in seinen vielseitigen Facetten beobachtet.

Auch im Bereich der Technik erprobt Hodgson gerne die anspruchsvollsten Kombinationen. Am Anfang seiner Laufbahn herrschte noch die reine und schlichte, wenngleich durchaus raffinierte Zeichnung vor, wie man in *Dogs* feststellen kann, einer Arbeit aus seinen Studienzeiten, genauso wie in *Night Club*, seinem ersten professionellen Kurzfilm, der die Einsamkeit der Nacht in Liverpool behandelte. Mit der Zeit entwickelte der Regisseur dann mit animierten Collagen einen einzigartigen Stil und auch eine sehr persönliche Art, das real gefilmte Bild digital zu bearbeiten und es mit animierten Passagen zu mischen, womit er große dramatische Effekte erzielt.

Hodgson, Absolvent des Royal College of Arts und einer der Gründer der Produktionsfirma Bermuda Shorts, macht seit 1985 Werbespots, Fernsehvorspanne und Videoclips. 1996 gründete er zusammen mit dem Produzenten Jonathan Bairstow in London das Unternehmen Sherbet, für das Preisverleihungen bei internationalen Festivals schon zur Gewohnheit geworden sind. Bei Sherbet führt Hodgson seine schon lange währende Zusammenarbeit mit Susan Young fort, gleichzeitig realisiert er auch Arbeiten mit Sandra Ensby, Ruth Lingford und anderen.

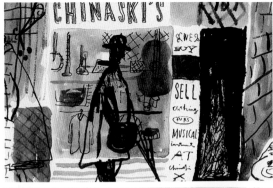

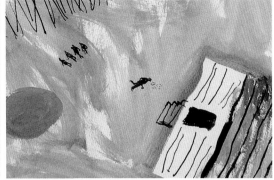

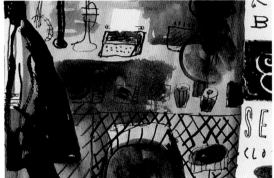

Pg. 153–155 The Man With the
Beautiful Eyes, 1999
Traditional animation

Pg. 155 (right) Menagerie, 1984
Traditional animation

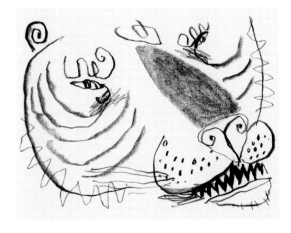

JOSÉ MIGUEL RIBEIRO

Portugal
Zeppelin Filmes, Lda.
Contact: Luís da Matta Almeida
Av. de Portugal, 66 1o DTO,
2795-554 Carnaxide
Phone: + 351 21 425 1980
Fax: + 351 21 425 1989
E-mail: info@zeppelin-filmes.pt

Representações /
Representations, 1988
Ovo / Egg, 1994
O banquete da rainha / The
Queen's Feast, 1996
A suspeita / The Suspect, 1999
Timor Lorosae, 1999
As coisas lá de casa / Home
Things (series), 2001-2002

Special Prize - *Valencia*, 1995
Best Didactic Film - *Espinho*, 1996
Quality Prize - *CNC/France*, 1997
Best Film - *Anima Mundi/Rio de Janeiro*,
2000
Cartoon d'Or, 2000
Fipresci Prize - *Tróia/Portugal*, 2001
Best Script and Best Portuguese
Film - *Espinho*, 2002

Puppet
Clay animation

JOSÉ MIGUEL RIBEIRO

www.zeppelin-filmes.pt

The short film *The Suspect* made history in Portuguese animation cinema in 2000 when it became the first film of the country to win the Cartoon d'Or prize for the best film of European animation, as well as 20 other international awards. In the short, suspense and humor travel together in a train car in which four people share the feeling that a dangerous murderer is among them.

The young director José Miguel Ribeiro, born in 1966, was inspired by the train trips that he had taken between Lisbon and Porto while attending an animation course offered by the Filmógrafo studio of Porto. Ribeiro also studied painting at Lisbon's School of Fine Arts, participated in the Calouste Gulbenkian Foundation's videoart workshop—where he would later teach classes on 3D animation—and completed a nine month long internship at the Lazennec Bretagne studio in Rennes, France.

This eclectic education has given him an excellent command of narrative and an ability to manipulate puppets and clay figures. As a result of his work in France, he filmed the short *Egg* with Pierre Bouchon, a movie that received important awards. Ribeiro has also participated in productions of the Filmógrafo studio, such as *Os salteadores* by Abi Feijó, and he forms part of a special generation of Portuguese animators that emerged in the eighties and is beginning to conquer territory in a country that still does not have a tradition of animation. Evidence of their success is the broadcasting of the children's series *Home Things*, a show that was made completely out of clay.

José Miguel Ribeiro is one of the most highly awarded filmmakers of Portuguese animation cinema to date, and no less important is his reputation as an illustrator of books, magazines and newspapers.

Le court métrage *A suspeita* a marqué l'histoire du cinéma d'animation portugais en 2000 : il s'agit du premier film de ce pays remportant le Cartoon d'Or du meilleur film d'animation européen et plus de 20 prix internationaux. Dans ce court, suspense et humour vont de pair dans un wagon de train où quatre personnes partagent le sentiment qu'un dangereux assassin se trouve parmi elles.

Né en 1966, le jeune réalisateur José Miguel Ribeiro s'inspire des voyages en train entre Lisbonne et Porto qu'il effectue pour assister au cours d'animation du studio Filmógrafo de Porto. Ribeiro étudie aussi la peinture à l'École supérieure des beaux-arts de Lisbonne, participe à l'atelier d'art vidéo de la Fondation Calouste Gulbenkian (où il donnera par la suite des cours d'animation en 3D) et réalise un stage de neuf mois au studio Lazennec Bretagne de Rennes. Cette formation éclectique lui a conféré une grande maîtrise de la narration, ainsi que de la manipulation

de marionnettes et de figures en plastiline. Par ailleurs, au terme de son stage en France, il réalise avec Pierre Bouchon le court *Ovo* qui rafle d'importants prix. Ribeiro participe également à des productions du studio Filmógrafo, tels que *Os salteadores* d'Abi Feijó; il appartient à une génération d'animateurs portugais qui a vu le jour dans les années 80 et commence à se faire une place dans un pays encore dépourvu de tradition dans le domaine de l'animation. Preuve en est de la diffusion sur le petit écran de sa série pour enfants *As coisas lá de casa*, exclusivement réalisée à base de plastiline.

À l'heure actuelle, José Miguel Ribeiro est l'un des réalisateurs les plus récompensés du cinéma d'animation portugais, sans compter sa grande renommée comme illustrateur de livres, revues et journaux.

Der portugiesische Kurzfilm *A suspeita* hat 2000 Geschichte geschrieben, insofern er der erste Film des Landes überhaupt war, der den Cartoon d'Or für den besten europäischen Animationsfilm errang, neben über zwanzig weiteren Auszeichnungen. In dem Kurzfilm reisen Spannung und Humor in einem Zug mit, in dem vier Leute das Gefühl teilen, es befände sich ein gefährlicher Mörder unter ihnen.

Der junge Regisseur José Miguel Ribeiro, Jahrgang 1966, ließ sich dafür von seinen Zugreisen zwischen Lissabon und Porto anregen, die er zu Zeiten machte, als das Studio Filmógrafo in Porto ihm den Besuch eines Trickfilmkurses ermöglichte. Ribeiro studierte auch Malerei an der Hochschule der Schönen Künste in Lissabon, nahm an Videokunst-Workshops der Calouste Gulbenkian-Stiftung teil, wo er später selbst Unterricht in 3D-Animation erteilte, und absolvierte ein neunmonatiges Praktikum im Studio Lazennec Bretagne im französischen Rennes.

Diese heterogene Ausbildung wurde sein Rüstzeug für die vorzügliche Beherrschung der Erzählkunst und der Handhabung von Puppen und Knetfiguren. Als ein Resultat seines Praktikums in Frankreich machte er mit Pierre Bouchon den Kurzfilm *Ovo*, der wichtige Preise erhielt. Ribeiro, der auch an Produktionen des Studios Filmógrafo beteiligt war, etwa an *Os salteadores* von Abi Feijó, gehört der besonderen Generation portugiesischer Trickfilmer an, die in den 80er Jahren auftritt und in einem Land ohne jegliche Trickfilmtradition Raum zu erobern beginnt. Eine Kostprobe davon gibt die Fernsehausstrahlung der Kinderserie *As coisas lá de casa*, die komplett mit Knetfiguren gemacht wurde.

José Miguel Ribeiro ist bis heute einer der meist prämierten Regisseure des portugiesischen Trickfilms, und sein Ruf als Illustrator von Büchern, Zeitschriften und Tageszeitungen ist dem fast ebenbürtig.

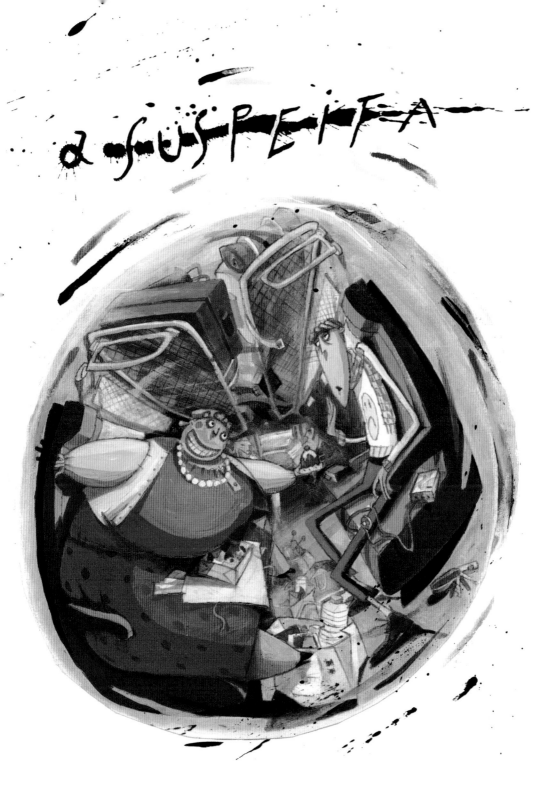

Pg. 157 A Suspeita / The Suspect
(poster), 1999.
Stop motion.

Pg. 158 Making of "A Suspeita"

Pg. 159 A Suspeita / The Suspect, 1999
Visual developments

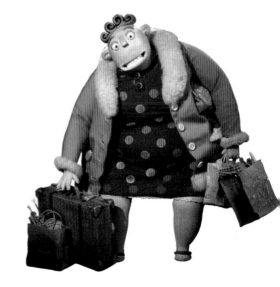

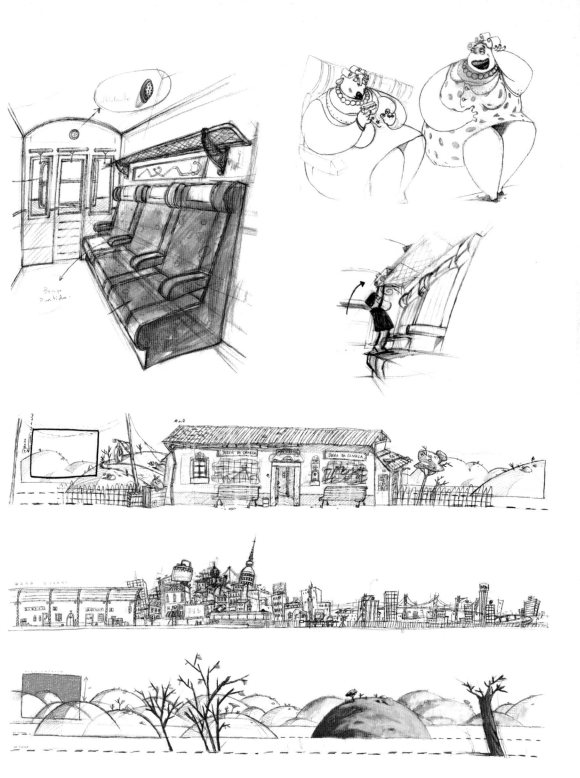

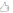

KATHY SMITH

Australia/USA
School Of Cinema Television
Animation & Digital Arts
University of Southern California
Phone: + 1 213 821 1348
E-mail: kathy@imoods.org
 kates@usc.edu

Power & Passion, 1983
Designed Nightmare, 1983
A Figure in Front of a Painting, 1984
Ayers Rock Animation, 1985
Change of Place, 1985
Delirium (installation), 1987
Living on the Comet, 1993
Indefinable Moods, 2001

Bronze Award - *New York EXPO*, 1994
International Digital Media
 Art Track Award - *Hong Kong*, 2001
Silver Award - *Leonardo Prix/Italy*, 2001
Jury Award - *New York EXPO*, 2001
Best Animated Short - *USA Film
 Festival*, 2002

Oil painting
Mixed media
Traditional animation
Pixilation
Stop motion
2D and 3D CGI

KATHY SMITH

www.kathymoods.org

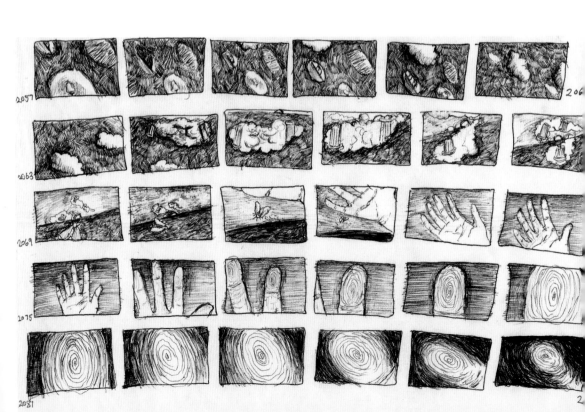

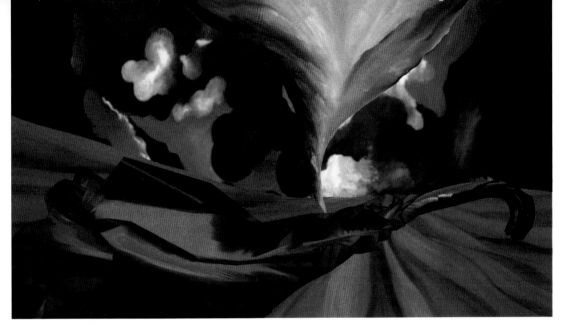

While watching Kathy Smith's movies spectators may wonder, for a few moments, if they are asleep or awake. Her films' flowing images and sound tracks allude to dream experiences. Smith defines her work as an attempt to express the mystery of existence through the non-linear narrative of dreams. The themes of her films include spirituality, death and the lack of control we have over our environment.

Although she is currently based in the U.S., Kathy Smith was born in Taree, Australia in 1963, and has been working with paintings, installations and animation films since 1982. She is extremely adept at fusing traditional techniques with digital media. She often reorders her paintings and drawings into new collages with broader meanings, and animates them in a totally personal process. In Indefinable Moods, she animated oil paintings by applying animated three-dimensional virtual objects to them.

Kathy is fascinated by the works of the renaissance painters, especially in their quest to transcend the still image through perspective, experimenting with light and their "desire for movement". She considers animation to be the ideal vehicle for carrying out this objective and for expressing complex ideals, mental processes and emotions.

The Jungian film Living on the Comet explores archetypes from life's cycle. The movie-installation Delirium starts with the news of an accident and examines the psychosomatic aftereffects of the event, taking the spectator through a journey of images, sounds and movements. For Kathy Smith, advanced technology is neither a fetish nor an end in itself, but rather a tool at the service of different forms of communication.

Pendant un instant, le spectateur de films de Kathy Smith peut douter s'il est ou non réveillé, tant l'enchaînement des images et la construction de la bande-son créent un cadre onirique. Smith voit son travail comme l'expression du mystère de l'existence via une narration non linéaire des rêves. La spiritualité, la mort et le manque de contrôle sur l'environnement sont certains des thèmes clés.

Née en 1963 à Taree, Australie, mais actuellement installée aux États-Unis, Kathy Smith se consacre depuis 1982 à la peinture, au montage d'installations et aux films d'animation. Douée pour marier techniques traditionnelles et moyens numériques, elle fait souvent de ses peintures et dessins de nouveaux collages plus génériques qu'elle anime ensuite à son gré. Dans Indefinable Moods par exemple, l'animation porte sur des peintures à l'huile grâce à des objets virtuels en 3D.

Kathy est fascinée par les œuvres des peintres de la Renaissance et leurs efforts pour dépasser l'image statique grâce à la perspective, aux jeux de lumière et au « désir de mouvement ». À ses yeux, l'animation constitue le vecteur idéal pour atteindre cet objectif et transmettre des idées complexes, des processus mentaux et des émotions.

Son film de teneur jungienne Living on the Comet met en scène des prototypes de cycles de vie. Le film-installation Delirium part, quant à lui, de l'annonce d'un accident pour en rechercher les échos psychosomatiques, ce qui plonge le spectateur dans un univers d'images, de sons et de mouvements. Selon Kathy Smith, la technologie avancée n'est pas plus un fétiche qu'une fin en soi : elle est juste un outil au service de la communication.

Angesichts von Kathy Smiths Filmen könnte sich der Zuschauer für Augenblicke im Traum wägen. Der Bilderstrom und der Einsatz der Tonbänder verweisen auf eine traumhafte Erfahrung. Smith definiert ihre Arbeit als einen Versuch, das Geheimnis des Daseins durch die nicht lineare Erzählweise der Träume auszudrücken. Das geistige Leben, der Tod und die Unbeherrschbarkeit der Umwelt sind nur einige ihrer Themen.

Kathy Smith, die 1963 in Taree, Australien zur Welt kam und in den Staaten ansässig ist, arbeitet seit 1982 mit Malerei, Installationen und Zeichentrickfilm. Sie verschmilzt außerordentlich geschickt traditionelle Techniken mit dem digitalen Medium. Oft ordnet sie ihre Gemälde und Zeichnungen zu neuen Collagen mit erweitertem Sinngehalt um und erweckt sie in einem ganz persönlichen Prozess zum Leben. In Indefinable Moods belebt sie Ölbilder, indem sie dreidimensionale, virtuell animierte Gegenstände verwendet.

Die Werke der Renaissancekünstler faszinieren Smith bei ihrem Bemühen darum, das statische Bild mittels der Perspektive, des Lichtspiels und des „Bewegungswunsches" zu ergründen. Der Trickfilm scheint ihr das ideale Mittel zur Umsetzung dieses Vorhabens und auch dafür zu sein, komplexe Ideen, mentale Prozesse und Gefühle auszudrücken.

Living on the Comet, erforscht, ganz in der Traditon C.G. Jungs, Archetypen des Lebenskreislaufs. Ausgangspunkt der Film-Installation Delirium ist die Nachricht von einem Unfall, um den psychosomatischen Nachhall zu untersuchen, indem der Zuschauer auf eine Reise aus Bildern, Geräuschen und Bewegungen mitgenommen wird. Für Kathy Smith ist Hightech weder Fetisch noch um ihrer selbst willen da, sondern Werkzeug im Dienste der Kommunikation.

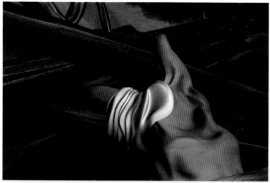

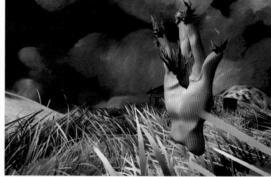

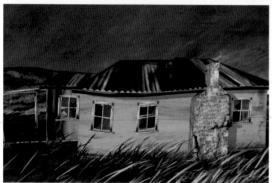

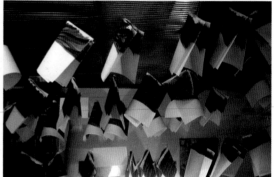

Pg. 160 Living on the Comet, 1993
Storyboard

Pg. 161 Indefinable Moods, 2001
Mixed media

Pg. 162 (top) Indefinable Moods, 2001
Mixed media.

Indefinable Moods, 2001
Animation hanging to dry

Pg. 162 (bottom) Indefinable
Moods, 2001
3D planning chart created for the film

The artist in her studio

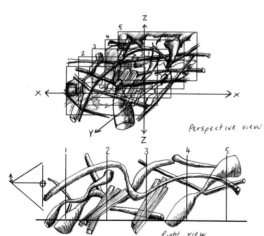

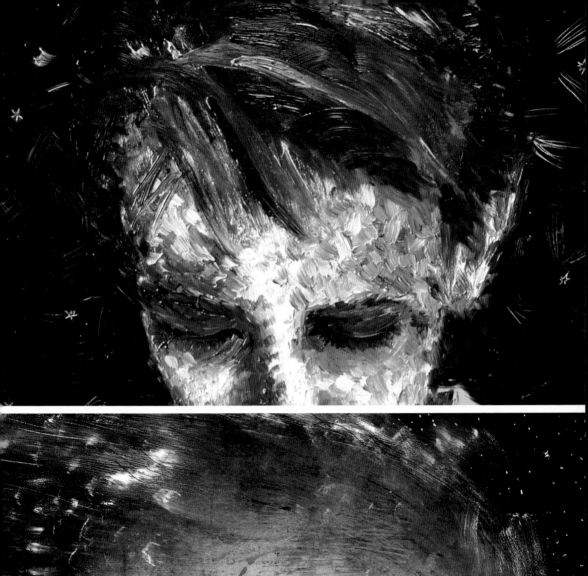
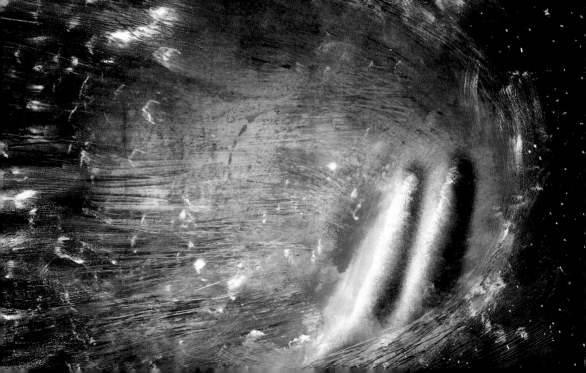

KECSKEMÉTFILM LTD.

Hungary
6000 Kecskemét,
Liszt Ferenc u. 21
Phone: + 36 76 481 711
Fax: (36) 76 481787
E-mail: kfilm@kecskemetfilm.hu

Hé, te! / Hey, You!, 1976
Gordiuszi csomó / Gordian
 Knot, 1980
Aréna / Arena, 1982
Az éjszaka csodái / The
 Miracles of the Night, 1982
Vízipók-Csodapók / Water-Spider,
 Wonder-Spider, 1985
Leo és Fred / Leo and Fred, 1986
Western, 1990
Zöldfa u.66. / Greentree
 Street 66, 1992
Éjszakai kultúrtörténeti
 hadgyakorlat / Culturhistorical
 Manoeuvre at Night, 1992
A Monkey's Tale, 1998

Bronze Hugo - *Chicago*, 1977
Silver Pigeon - *Leipzig*, 1978
Opera Prima Prize - *Zagreb*, 1980
Silver Prize - *Espinho*, 1980 and 1982,
Special Award - *Zagreb*, 1982
Special Prize of the Jury -
 Mediawave, 1990

Multiple techniques

KECSKEMÉT-
FILM

www.kecskemetfilm.hu

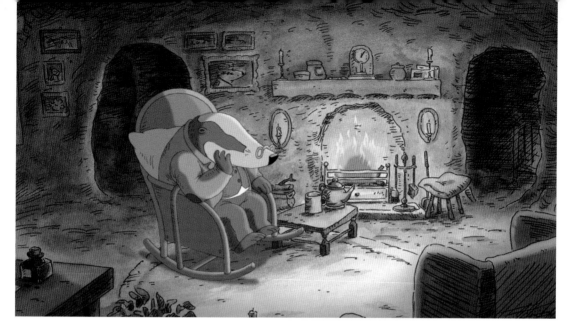

The family-like environment and close-knit team of Kecskemétfilm are among the factors that have helped this production company maintain, since its foundation in 1971, its position as one of the leaders of Hungarian animation. After the successful privatization of the company in 1995, the studio was placed in the hands of its 20 employees. The company also works with between 100 and 150 freelance artists.

Kecskemétfilm produces all kinds of animation movies, from short artistic films to feature films and television series, as well as commercials and educational movies. The company's biggest hit was the series *Water-Spider, Wonder-Spider*, which explored marine life and was watched by more than 1 million people in Hungary alone. The series *Leo and Fred* and *Hungarian Folk-Tales* were also a success among the television public.

In their productions, Kecskemétfilm develops an enormous variety of techniques and themes that are intended for adults as well as children. The history and legends of Hungary are among the main subjects of their scripts, together with cinematographic poetry and political satires which, are closely followed by the public.

More than 250 movies have come off the drawing boards of directors like Mária Horváth, Lajos Nagy, Péter Szoboszlay, Zoltán Szilágyi Varga, Árpád Miklós and Gizella Neuberger. Among their various international co-productions, the studio participated in the multinational project, *A Monkey's Tale*, by Jean-François Laguionie.

Kecskemétfilm sponsors a large annual animation film festival, maintains a foundation for the development of this art, and created Hungary's first School of Animation.

Depuis sa création en 1971, la maison de production hongroise Kecskemétfilm jouit d'une grande cohésion et d'un esprit presque familial entre ses collaborateurs, d'où sa place parmi l'élite du marché. Après une privatisation réussie en 1995, la direction est passée dans les mains de ses 20 employés permanents, auxquels s'ajoutent entre 100 et 150 artistes indépendants.

Kecskemétfilm produit tous types de films d'animation, des courts artistiques aux longs métrages et séries télévisées, en passant par des spots publicitaires et des films pédagogiques. Son plus grand succès, la série *Water-Spider, Wonder-Spider*, raconte la vie des animaux marins ; rien qu'en Hongrie, pas moins d'un million de personnes l'ont suivie. Les séries *Leo and Fred* et *Hungarian Folk-Tales* ont également conquis les téléspectateurs.

Les productions de Kecskemétfilm ont recours à une large gamme de techniques et de thèmes et visent tant le public adulte que le monde des enfants. L'histoire et les légendes de Hongrie occupent une place importante dans la plupart des scénarios, de même que les poèmes visuels et les satires politiques d'impact national.

À ce jour, plus de 250 films sont sortis des tables à dessin de réalisateurs comme Mária Horváth, Lajos Nagy, Péter Szoboszlay, Zoltán Szilágyi Varga, Árpád Miklós et Gizella Neuberger. Le studio a par ailleurs participé à des coproductions internationales, telles que *Le château des singes*, de Jean-François Laguionie.

Kecskemétfilm organise un festival annuel de longs métrages d'animation, gère une fondation pour la promotion de cet art et a créé la première école d'animation de Hongrie.

Der Zusammenhalt des Teams in fast familiärer Atmosphäre ist einer der Triumphe, auf den die Produktionsfirma Kecskemétfilm bauen kann, um seit ihrer Gründung 1971 die Federführung im ungarischen Trickfilm zu behalten. Nach der erfolgreichen Privatisierung 1995 ging das Studio in die Hände seiner zwanzig fest Angestellten über, denen man üblicherweise 100 bis 150 freischaffende Künstler hinzuzählt.

Kecskemétfilm produziert jede Art von Trickfilmen, angefangen beim künstlerischen Kurzfilm über Werbefilme und pädagogische Filme bis hin zum langen Spielfilm und ganzen Fernsehserien. Den größten Erfolg bislang erzielte das Unternehmen mit der Serie *Water-Spider, Wonder-Spider*, die das Leben von Meeresgetier erforschte und die allein in Ungarn mehr als eine Million Zuschauer sahen. Die Serien *Leo and Fred* und *Hungarian Folk-Tales* eroberten ebenfalls das Fernsehpublikum.

Die Produktionen von Kecskemétfilm wenden ein enormes technisches und inhaltliches Spektrum an und richten sich sowohl an ein erwachsenes wie kindliches Publikum. Die Geschichte Ungarns und seine Legenden nehmen in einem Großteil der Drehbücher einen wichtigen Raum ein genauso wie filmkünstlerische Dichtung und politische Satire, die im Land großen Widerhall finden.

Mehr als 250 Filme wurden bereits auf den Zeichenbrettern von Regisseuren wie Mária Horváth, Lajos Nagy, Péter Szoboszlay, Zoltán Szilágyi Varga, Árpád Miklós und Gizella Neuberger entworfen. Es gab diverse internationale Koproduktionen, darunter die Teilname an dem multinationalen Projekt *Kwom und der König der Affen* (1999) von Jean-François Laguionie.

Kecskemétfilm fördert ein alljährlich stattfindendes Festival des Zeichentrick-Spielfilms, unterhält eine Stiftung für die Entwicklung dieser Kunst und hat in Ungarn die erste Fakultät für Trickfilm ins Leben gerufen.

Pg. **164** Arcra Arc / Face to Face, 1994
2D animation
© KECSKEMÉTFILM LTD.

Pg. **165** Leb Wohl Lieber Dachs /
Badger's Parting Gifts, 2002
2D Animation
© JÜRGEN EGENOLF PRODUCTIONS

Pg. **166** Angyalbárányok / The Angel
Sleeps, 2002
2D animation
© KECSKEMÉTFILM LTD.

Pg. **167** Voyaga au centre de la terre /
Journey to the Centre of the Earth, 2000
2D animation
© LA FABRIQUE, TELE IMAGES CREATION,
FRANCE3, EM.TV & MERCHANDISING AG

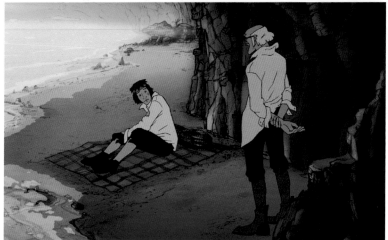

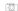

KOJI YAMAMURA

Japan
Yamamura Animation Inc.
4-14-4-205 Kasuya,
 Setagaya-ku, Tokyo 157-0063
E-mail: yam@jane.dti.ne.jp

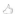

**Hyakka zukan / Japanese-
 English Pictionary,** 1989
Fushigina Elevator, 1991
Ouchi / A House, 1993
Sandoicchi / The Sandwiches, 1993
Ame no hi / Imagination, 1993
Kipling Jr., 1995
Kid's Castle, 1995
Bavel no Hon / Bavel's Book, 1996
Dottini suru! / Your Choice!, 1999
Atama Yama / Mt. Head, 2002

First Prize - *Hiroshima,* 1992
Best Director Animation -
 Chicago, 1993
First Prize Animation - *Chicago,*
 1996 and 1999
Grand Prix - *Annecy,* 2003
Grand Prix - *Mediawave,* 2003
Jury Special Prize - *Leipzig,* 2003

Traditional animation
Animation with photos
3-D animation with clay
Computer graphics

KOJI
YAMAMURA

www.jade.dti.ne.jp/~yam/

Koji Yamamura was 13 years old when he made his first animation movie. At age 40 he still retains his love for children's fantasies, although his command of different techniques has made him one of the leading names in the animation world. Yamamura searches for the essence of life in life's small moments; the moments that children know how to value so well.

The great success and the Oscar nomination that Yamamura received for *Mt. Head*, a rather cruel fable about a cherry tree that grows out of a poor man's head, marked the zenith of this filmmaker's career; a career in which he has successfully combined childhood sentiments with a critical adult perspective.

Yamamura's movies do not follow any established models. In the Japanese animation context, they stand out for their poetic quality and their capacity to provoke reflection through humor. Visually, they are infinite sources of pleasure.

As far as technique is concerned, the productions of Yamamura Animation, which was created in 1993, defy all classification. Their work includes short films for children, publicity movies and videos made with play-dough, photos, colored pencil, ink, etc. These days, Yamamura finishes his movies on the computer, even though he always tries to maintain a large variety of analogue processing.

A love for metamorphosis characterizes Yamamura's creations. With them he has raised the capabilities of animation film to a high level, as he creates a constant flux of images that transform themselves in the blink of an eye. Trees grow out of heads, fish fly under the rain, alligators go to the barber, buildings look surprised... Everything entertains and satirizes and, at the same time, works as a subtle educational tool.

Koji Yamamura a 13 ans lorsqu'il réalise son premier film d'animation ; maintenant âgé de 40 ans, son goût pour les histoires pour enfants est resté intact et les techniques qu'il maîtrise ont fait de lui l'un des animateurs les plus expérimentés au monde. Yamamura recherche l'essence de la vie dans chaque instant, ce que les enfants apprécient grandement.

Le mont chef, son grand succès et par là même un droit de nomination aux Oscars, est une fable un tantinet cruelle dans laquelle un cerisier pousse sur la tête d'un homme. Il s'agit sans conteste du point culminant d'une carrière faite d'un mélange de sentiments de l'enfance et d'un regard adulte critique.

Les films de Yamamura n'obéissent à aucun modèle. Dans le cadre de l'animation japonaise, ils se distinguent par leur approche poétique et par la réflexion qu'ils provoquent via l'humour. Sur le plan visuel en outre, ils sont une véritable merveille.

Les productions de Yamamura Animation (studio créé en 1993) ne répondent pas non plus à un genre précis en matière technique. Elles englobent des courts métrages pour enfants, des films publicitaires et des vidéos qui font intervenir pâte à modeler, photos, crayons de couleur, encre, etc. Aujourd'hui, Yamamura peaufine ses films sur ordinateur, tout en recourant autant que possible à diverses méthodes analogiques.

Toutes les créations traitent de métamorphoses : il s'agit d'animations de haut niveau, avec un enchaînement continu et fort rapide d'images : des arbres poussent sur les têtes, des poissons volent sous la pluie, des caïmans vont chez le coiffeur, le tout sous le regard étonné des bâtiments... Tout est divertissant et satire, mais aussi un outil pédagogique raffiné.

Koji Yamamura war erst dreizehn, als er seinen ersten Zeichentrickfilm drehte. Durch seine technische Perfektion hat er sich inzwischen einen der weltweit klingenden Namen des Trickfilms gemacht, doch die kindliche Fabulierkunst gefällt dem mittlerweile Vierzigjährigen nach wie vor. Yamamura sucht das Wesentliche des Lebens in den kleinen Augenblicken, etwas, was Kinder sehr zu schätzen wissen.

Der große Erfolg von *Mt. Head*, der ihm auch eine Oscar-Nominierung eintrug und in dem er die etwas grausame Fabel von einem Kirschbaum erzählt, der aus dem Kopf eines armen Mannes wächst, stellte den Höhepunkt einer Laufbahn dar, die die Gefühle der Kindheit mit der kritischen Wahrnehmung des Erwachsenen zu kombinieren weiß.

Yamamuras Filme folgen keiner Schablone. Vom japanischen Trickfilm heben sie sich durch ihre poetische Qualität ab und dadurch, dass der Humor zum Nachdenken anstiftet. Es sind unerschöpfliche Quellen des visuellen Genusses.

Auch hinsichtlich der Technik trotzen die Produktionen von Yamamura Animation, das 1993 gegründet wurde, jeglicher Klassifizierung. Sie umfassen Kurzfilme für Kinder, Werbefilme und Videos und arbeiten mit Knetmasse, Fotos, Farbstiften, Tusche, usw. Heutzutage gibt Yamamura seinen Filmen mit dem Computer den letzten Schliff, obwohl er immer versucht, eine große Bandbreite analoger Vorgehensweisen beizubehalten.

Die Lust an der Metamorphose charakterisiert die Geschöpfe Yamamuras, der die Möglichkeiten des Trickfilmes weit ausdehnte mit einem nicht abreißenden Strom an Bildern, die sich im Handumdrehen verwandeln. Bäume wachsen aus Köpfen, Fische fliegen im Regen, Kaimane gehen zum Friseur, Gebäude haben einen erstaunten Blick... Alles dient der Unterhaltung und dem Spott und ist gleichzeitig ein subtiles pädagogisches Instrument.

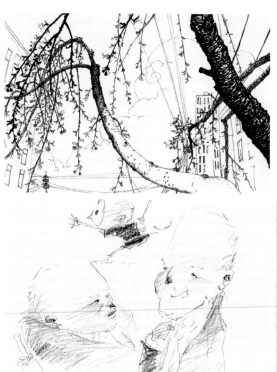

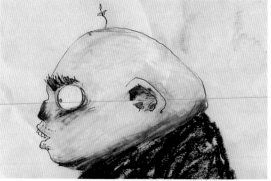

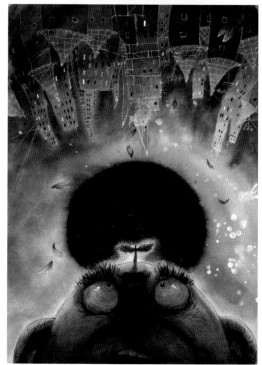

Pg. 168 Atama Yama / Mt. Head, 2002
Visual development

Pg. 169 Atama Yama / Mt. Head, 2002
Traditional animation

Pg. 170 Atama Yama / Mt. Head, 2002
Visual development

Pg. 170 (bottom) Atama Yama / Mt.
Head, 2002
Poster

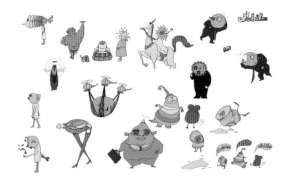

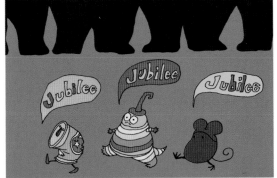

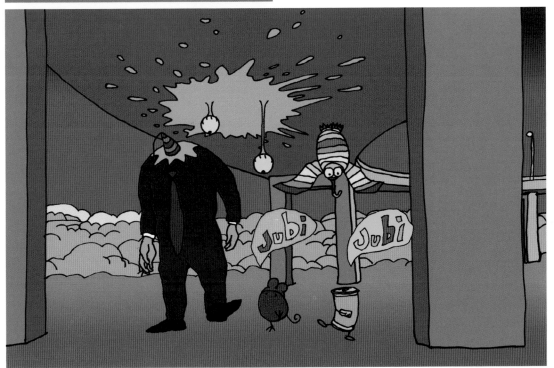

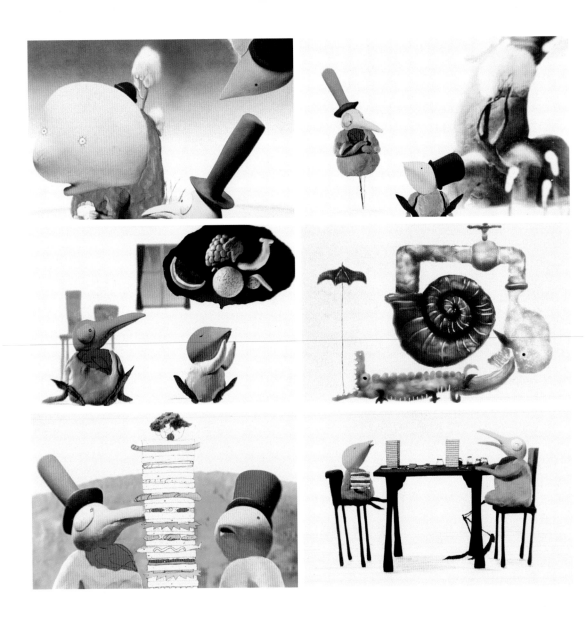

Pg. 172
(top row) Ouchi / A House, 1993
Clay, Puppet, Photo, Drawings on cel

(middle row) Ame no hi /
Imagination, 1993
Clay, Puppet, Photo, Drawings on cel

(bottom row) Sandoicchi / The
Sandwiches, 1993
Clay, Puppet, Photo, Drawings on cel

Pg. 173 Karo & Pyio, 1993
Work in progress

KONSTANTIN BRONZIT

Russia
"Melnitsa" Studio
196135, St. Petersburg,
Tipanove Str., 3 APT. 127
Phone: + 7 812 567 1552
Fax: + 7 812 567 8506
E-mail: kbronzit@pochta.ru

Karusel / The Round-about, 1988
Memento Mori, 1991
Farewell, 1993
Nock-Nock, 1993
Switchcraft, 1994
Pacifier, 1994
Die Hard, 1997
Au bout du monde / At the End of
 the Earth, 1999
Bog / The God, 2003

Grand Prix - *Annecy, 1995*
Grand Prix TV - *Annecy, 1997*
Best short - *Anima Mundi/Rio
 de Janeiro, 1999*
Special Prize of the Jury, Public Prize
 and Funniest Film - *Annecy, 1999*
Golden Spike - *Valladolid, 1999*
Best animation - *Tampere
 and Krakow, 1999*

Pencil on paper
Traditional animation
2D and 3D computer graphics

KONSTANTIN BRONZIT

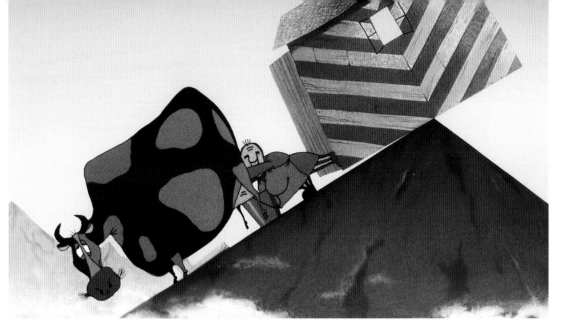

His total control of animated dramatic effects, his fine sense of parody and his willingness to experiment with new techniques have turned the Russian animator Konstantin Bronzit into one of the most outstanding names in European animation. The peculiar humor of his most recent movies, *At the End of the Earth* and *The God*, captivated the public and judges at some of the most important international film festivals. In the former, a little house precariously balanced on a mountain peak generates hilarious situations among its inhabitants. In the latter, the image of an oriental diety gradually disintegrates in inoffensive sacrilege.

Born in St. Petersburg in 1965, Bronzit studied at the School of Art and Design in his native city. He later worked as an animator in a studio specialized in popular scientific movies. While there he made his first film, *The Round-About*. Between 1988 and 1994 he designed cartoons for newspapers and magazines, many of which took first place in their category in several international contests. At the same time, he continued to direct award-winning short animation films that have proven his ability to work both in traditional animation and in digital graphic design.

He elaborated and filmed the short *At the End of the Earth* while participating in an internship program for European animators in the Folimage Valence Production studio of France. The movie received nearly 70 awards and was nominated for the César, the most highly revered prize in French cinema. *The God* is a digital short film in 3D, which participated in the Directors' Fortnight at the Cannes Festival. For 2004, Konstantin Bronzit is preparing the short film *Lavatory-Lovestory*, a title that indicates his faithfulness to satirizing daily life.

Le Russe Konstantin Bronzit s'inscrit parmi les grandes pointures de l'animation européenne grâce à trois armes infaillibles : sa maîtrise absolue des coups d'effet, son sens raffiné de la parodie et son ouverture aux innovations techniques. Public et jurys des principaux festivals internationaux sont déjà conquis par l'humour si original de ses deux derniers films, *Au bout du monde* et *Le Dieu*. Dans le premier, une maison en équilibre sur le pic d'une colline donne lieu à des situations hilarantes pour ses habitants. Le second traite de la réincarnation progressive d'une divinité orientale pour se débarrasser d'une mouche.

Né à Saint-Pétersbourg en 1965, Bronzit étudie à l'Institut supérieur d'art et de design de sa ville natale. Il travaille ensuite comme animateur pour un studio spécialisé en films scientifiques populaires ; il y réalise alors son premier film, *The Round-About*. Entre 1988 et 1994, il est l'auteur de bandes dessinées pour des journaux et des revues, ce qui lui vaut la vedette dans certains concours internationaux de sa catégorie.

En parallèle, il poursuit la direction de petits films d'animation, également primés et grâce auxquels il parvient à naviguer sans souci entre animation traditionnelle et traitement graphique numérique.

Il met au point et réalise son court *Au bout du monde* lors d'un programme d'accueil d'animateurs européens au studio Folimage de Valence. Le film décroche près de 70 prix et est nominé au Césars. Pour sa part, *Le Dieu* est un court numérique en 3D sélectionné pour la Quinzaine des réalisateurs du Festival de Cannes. Pour 2004, Konstantin Bronzit prépare le court *Lavatory-Lovestory*, dont le titre annonce déjà sa fidélité à la satire du quotidien.

Seine vollkommene Beherrschung animierter Gags und Effekte, sein Feingespür für alles Parodistische und seine Bereitschaft, neue Techniken zu erproben, haben dem Russen Konstantin Bronzit einen herausragenden Namen in der europäischen Animation verliehen. So haben auch das Publikum und die Jury der größten internationalen Festivals dem eigentümlichen Humor seiner beiden jüngsten Filme, *Am Ende der Welt* und *Der Gott*, Achtung gezollt. In ersterem bringt eine gefährlich über dem Abgrund eines dreieckigen Hügels schwankende Hütte ihre Gäste in erheiternde Situationen. In letzterem entledigt man sich nach und nach des Bildes einer orientalischen Gottheit in einem liebenswerten Sakrileg.

Bronzit, 1965 in Sankt Petersburg geboren, studierte in seiner Geburtsstadt Kunst und Gestaltung. Später arbeitete er als Trickfilmer in einem Studio, das auf populäre Wissenschaftsfilme spezialisiert war, wo er auch seinen ersten Film *The Round-about* realisierte. In den Jahren von 1988 bis 1994 zeichnete er Cartoons für Tageszeitungen und Zeitschriften. In dieser Kategorie gelang es ihm, den ersten Platz bei einigen internationalen Wettbewerben zu ergattern. Gleichzeitig führte er bei kleinen prämierten Trickfilmen weiterhin Regie, sodass er sich ebenso gut innerhalb der traditionellen Animation wie innerhalb des digitalen Grafikdesigns bewegt.

Den Kurzfilm *Am Ende der Welt* konzipierte und realisierte er im Studio Folimage im französischen Valence im Rahmen eines Programms für Praktika, das sich an europäische Animationskünstler richtet. Der Film erhielt an die siebzig Preise und wurde für den César, die höchste Auszeichnung des französischen Kinos, nominiert. *Der Gott* seinerseits ist ein digitaler 3D-Kurzfilm, der an der „Quinzaine des réalisateurs" genannten Reihe der Autorenfilmer des Festivals von Cannes teilnahm. Für 2004 befindet sich der Kurzfilm *Lavatory-Lovestory* in Vorbereitung, dessen Titel schon Konstantin Bronzits Treue zu den satirischen Momenten des Alltags verheißt.

① Ч/Ф. ОКНО В ЦЕНТРЕ. В ОКНЕ ЛУНА И ЗВЕЗДЫ. СВЕРХУ ТИТР НАЗ-ВАНИЯ (появл. и исчезает НПЛ) В ДОМЕ ЗВУК ХРАПА.

⑤ ДОМ НАЧИНАЕТ КАЧАТЬСЯ С "ПИКАНТНЫМИ" ЗВУКАМИ, ВЗДОХАМИ. ТУДА-СЮДА.

② ОТЪЕЗД ОТ ОКНА. ЛУНА "УЕЗЖАЕТ" ИЗ ОКНА. ВИДЕН ДОМ СИЛУЭТОМ. ДОМ "СТОИТ" НА НИЖНЕЙ РАМКЕ КАДРА.

⑥ НАКОНЕЦ, ДОМ КЛОНИТСЯ ВЛЕВО, УПИРАЕТ-СЯ НА СКЛОН. ОТКРЫВАЕТСЯ ДВЕРЬ, ВЫБЕ-ГАЕТ СОБАКА, РАДОСТНО ЛАЕТ, НОСИТСЯ ВВЕРХ ВНИЗ.

ГАВ!

← ПНР

③ ОТЪЕЗД ПРОДОЛЖАЕТСЯ. ВИДЕН ДОМ НА ОСТРИЕ ВЕРШИНЫ. СВЕТАЕТ. ВНИЗУ ОБЛА-КА. ХРАП.

⑦ ВЫСОВЫВАЕТСЯ КОРОВА. ЕЁ КТО-ТО ПЫТАЕТСЯ ВЫТОЛКНУТЬ ИЗ ДОМА. НО КОРОВА ОСТАНАВЛИВА-ЕТСЯ НА ПОЛПУТИ. ТУПО СМОТРИТ СТЕКЛЯН-НЫМИ ГЛАЗАМИ, ЖУЁТ. СОБАКА НАЧИНАЕТ МОЧИТЬСЯ ТУТ ЖЕ, ПЕРЕД ДОМОМ.

④ ЗВЕНИТ БУДИЛЬНИК. ЗВУКИ ПРОБУЖДЕНИЯ. КРЯХТЕНИЕ. ЛАЙ СОБАКИ, МЫЧАНИЕ КОРОВЫ. ЗЕВОТА. ГРОХОТ ВЕДРА. ПРОДОЛЖЕНИЕ ЧЬЕГО-ТО ХРАПА.

⑧ ПОПИСАВ, СОБАЧКА РАДОСТНО ВСЁ "ЗАРЫВАЕТ". КОМЬЯ ЗЕМЛИ ЛЕТЯТ В МОРДУ КОРОВЕ. КОРОВА ТРОГАЕТСЯ С МЕСТА І...

Pg. 174 Au Bout du Monde / At the End of the Earth, 1999
Visual developments

Pg. 175 Au Bout du Monde / At the End of the Earth, 1999
Traditional animation

Pg. 176 Au Bout du Monde / At the End of the Earth, 1999
Storyboard

Pg. 177
Lavatory-Lovestory, 2004
Traditional animation

Die Hard, 1997
Traditional animation

LITTLE FLUFFY CLOUDS

USA
Contact: Betsy De Fries
499 Alabama Street, Studio CXII,
 San Francisco CA 94110
Phone: 415.621.1300
Fax: 415.389.9304
E-mail: betsy@littlefluffyclouds.com

Zeppelin, 1996
Jack-in-the Box, 2001
Yo-Yo, 2002-2003
Au petite morte, 2003
Cinemania (series), 2003
Winnie the Pooh (series pilot), 2003

Clios
Anicom
London International
 Advertising Award
Creativity 27
SF Ad Club

Cell animation
Hand drawing
Computer graphics
Flash
Mixed techniques

LITTLE FLUFFY CLOUDS

www.littlefluffyclouds.com

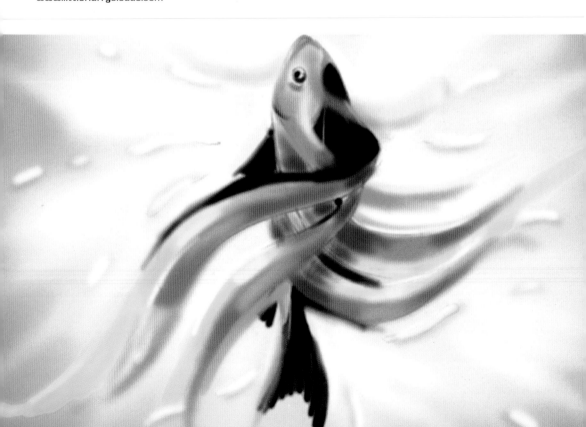

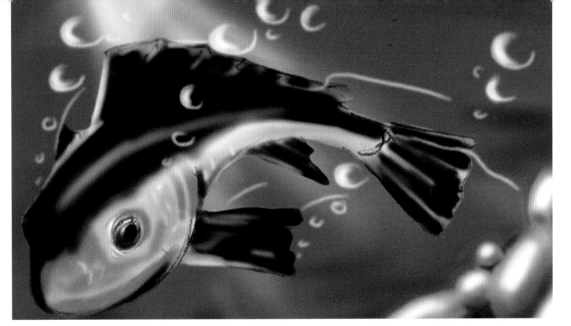

The English Betsy de Fries and the Dutch Jerry van de Beek insist on calling their Little Fluffy Clouds studio an "animation boutique". This is their way of emphasizing the small dimensions and distinctive touch that characterize the productions of this studio that they themselves formed in California in 1996. While their name comes from a song of the English group Orb, their style has emerged from a combination of the founders' technological knowledge and artistic sensitivity.

De Fries is a writer, poet and multimedia artist with vast experience in the creation of CD-ROMs, websites, exhibits, short films and games, while she at the same time has worked as a set designer, costume designer and artistic director. On the other hand, her associate is a devote researcher of digital resources and the author of animated short films like *Ja-Knikker/Oil Pumps* (1992) and *Jazz* (1994). At Little Fluffy Clouds, both join their talents in a series of commercial works and in their own personal projects, always following the same motto: to mix traditional methods with those of the computer, in pursuit of beauty and communication.

Both animators are responsible for award-winning commercials for Coca-Cola, Pringles, Budweiser, Nickelodeon and McDonald's, among others, in which graphic forms take on life and create memorable ads. In addition, they developed an animation package for the AMC cable television channel contest program *Cinemania* that included robots, sets and sceneries.

In their shorts, the duo takes on greater challenges as they film, in a poetic form, the representation of water and light in digital images. Thus, *Au Petite Morte* is a poetic exercise about life's cycle reflected in a river, and *Yo-Yo* tells of an object's brief odyssey through four different abstract worlds.

L'Anglaise Betsy de Fries et le Hollandais Jerry van de Beek insistent pour baptiser leur studio Little Fluffy Clouds de « boutique d'animation ». Ils soulignent de cette façon les petites dimensions et la touche distinctive de la production du studio qu'ils ont fondé en Californie en 1996. Alors que le nom s'inspire d'une chanson du groupe anglais Orb, le style tient quant à lui du mariage entre savoir technologique et sensibilité artistique des deux artistes.

De Fries est écrivain, poétesse et artiste multimédia avec une longue expérience dans la création de CD-ROM, sites Web, expositions, courts métrages et jeux ; elle a également exercé comme scénographe, accessoiriste et directrice artistique. Elle se plaît par ailleurs à assimiler sans relâche les techniques numériques et est l'auteur de courts d'animation tels que *Ja-Knikker/Oil Pumps* (1992) et *Jazz* (1994). Chez Little Fluffy Clouds, les deux associés conjuguent leurs talents pour créer une série de travaux commerciaux et d'auteur, tous obéissant à la même devise :

combiner méthodes traditionnelles et informatique en quête de beauté et de communication.

Ces deux animateurs sont à l'origine des spots très récompensés de Coca-Cola, Pringles, Budweiser, Nickelodeon et McDonald's, entre autres, dans lesquels les formes graphiques prennent vie et offrent un spectacle mémorable. Pour le jeu concours *Cinemania* de la chaîne de télévision câblée AMC, ils ont mis au point un paquet d'animation incluant robots, histoires et décors.

Dans les courts métrages d'auteur, le duo va plus loin avec une approche poétique de la représentation de l'eau et de la lumière dans les image numériques. *Au Petite Morte* livre ainsi un exercice poétique sur le cycle de la vie reflété dans une rivière, alors que *Yo-Yo* trace la brève odyssée d'un objet au travers de quatre monde abstraits distincts.

Die Britin Betsy de Fries und der Holländer Jerry van de Beek bestehen darauf, ihr Studio Little Fluffy Clouds „Animations-Boutique" zu nennen. Das ist ihre Art, die kleinen Dimensionen und den etwas anderen Touch zu unterstreichen, der die Produktionen des 1996 in Kalifornien von ihnen gegründeten Studios kennzeichnet. Während der Name seinen Ursprung in einem Lied der englischen Gruppe Orb hat, entspringt der Stil einer Kombination aus technologischem Know-how und künstlerischer Sensibilität ihrer Gründer.

De Fries ist Schriftstellerin, Dichterin und Multimedia-Künstlerin mit viel Erfahrung bei der Konzipierung von CD-Roms, Websites, Ausstellungen, Kurzfilmen und Spielen; ebenso arbeitete sie als Bühnenbildnerin, Kostümbildnerin und als Art Director. Auf der anderen Seite erforscht ihr Kompagnon, der Urheber von animierten Kurzfilmen wie *Ja-Knikker/Oil Pumps* (1992) und *Jazz* (1994), die digitalen Hilfsmittel mit Hingabe. Mit Little Fluffy Clouds verbinden beide ihre Fähigkeiten bei einer Reihe von kommerziellen Arbeiten und Autorenfilmen, immer gemäß dem Motto, traditionelle Methoden mit dem Computer zugunsten von Schönheit und Kommunikation zu verbinden.

Die beiden Animationskünstler waren u.a. für die prämierten Werbespots von Coca-Cola, Pringles, Budweiser, Nickelodeon und McDonald's verantwortlich, wo sie grafischen Formen Leben einhauchen und sie zu denkwürdigen Darbietungen veranlassen. Sie waren es auch, die für das Quizprogramm *Cinemania* für den Kabelfernsehsender AMC ein Trickfilm-Paket entwickelten, das Roboter, Ausstattung und Bühnenbilder umfasste.

An seine kurzen Autorenfilmen stellt das Duo noch größere Anforderungen, nämlich in poetischer Form Wasser und Licht in digitalen Bildern darzustellen, derart, dass *Au Petite Morte* eine poetische Übung über den Kreislauf des Lebens ist, der sich in einem Flusslauf spiegelt, während *Yo-Yo* die kurze Odyssee eines Dinges durch vier verschiedene abstrakte Welten ist.

Pg. 178-179 Au Petite Mort, 2003
2D & 3D computer graphics

Pg. 180 Jack-in-the Box, 2001
3D computer graphics

Pg. 181 Cinemania (series), 2003
3D computer graphics

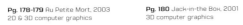

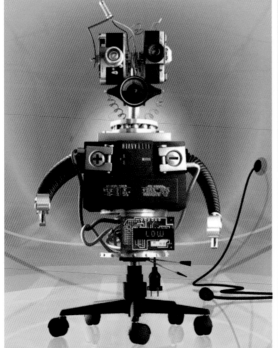

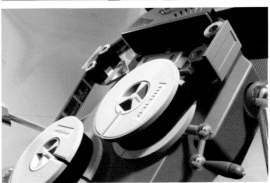

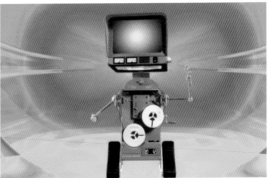

LOOSE MOOSE LTD

United Kingdom
Contact: Glenn Holberton
E-mail: info@loosemoose.net
74 Berwick Street,
 London W1F 8TF
Phone: 0207 287 3821
Fax: 0207 734 4220

Balloon, 1991
I pagliacci, Altered Ego, 1994
Interrogating Ernie, 2000
Thunder Pig, 2001
Fingathing

Best Animated Short - BAFTA, 1991
Gold Hugo Best Student Animated
 Film - Chicago, 1994
Best First Film - Ottawa, 1994
Best TV Pilot - WAC/USA, 2001
Jury Award - Anima Mundi/Rio de
 Janeiro, 2002

Traditional animation
Claymation
Puppet animation
2D and 3D computer graphics
Mixing all techniques
 with live action

LOOSE MOOSE

www.loosemoose.net

Pg. 182 Rocky (commercial spot), 1996
Visual development

Pg. 183 Rocky (commercial spot), 1996
Brisk - Beyond Cool
Stop Motion

Pg. 184 Interrogating Ernie, 2000
Dir.: Ken Lidster
Stop Motion

Visual developments

Pg. 185 Ernie and Anima Mundi's trophy
won in 2001 for Best Short Film

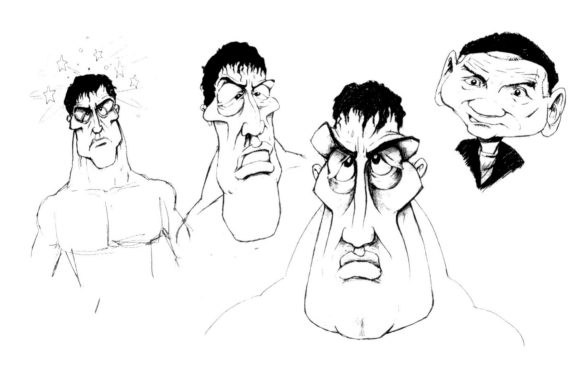

Sylvester Stallone, Frank Sinatra, Elvis Presley and Bruce Willis have found themselves transformed into the characters of the famous Lipton Brisk campaign in the United States. Similarly, the anarchistic commercials of Peperami snacks daily capture the attention of the English public. Behind these and other success stories of television commercial breaks around the world lies the talent of the Loose Moose team.

Director Ken Lidster and producer Glenn Holberton created this London-based company in 1994, and director Ange Palethorpe joined them a year later. Lidster had won a BAFTA award for his graduation film, the poetic *Balloon*, from the National Film and Television School. Ange, a graduate from this same institution, had been the big revelation of the Chicago and Ottawa festivals with the movie that she had also prepared as her graduation film, the hybrid and sophisticated *Altered Ego*. Holberton, who has worked in the industry since 1978, had produced some of Barry Purves' award-winning films, and had also directed other studios. Together, these three brought Loose Moose to the pantheon of the great commercial studios of the international market. Ken Lidster has stayed in touch with artistic cinema through his operatic production *I pagliacci* and his entertaining *Interrogating Ernie*, a movie featuring a friendly dinosaur that has to provide explanations for all the world's tragedies since the Glacial Age.

The Loose Moose team likes to take on challenging proposals, which include mixing different techniques with real-life action. Thus anything is possible, from photocopy machines venting their frustrations in *happy hour* to motorized skeletons moving in perfect synchrony to music from the group Fingathing. Anything is possible; just ask them.

Sylvester Stallone, Frank Sinatra, Elvis Presley et Bruce Willis sont les protagonistes de la fameuse campagne pour le thé Lipton Brisk aux États-Unis. Les spots anarchiques du snack Peperami captive chaque jour l'attention du public anglais. Derrière ces succès et bien d'autres encore d'intermèdes télévisés du monde entier se cache le talent de l'équipe de Loose Moose.

Installée à Londres, la compagnie voit le jour en 1994 de la main du réalisateur Ken Lidster et du producteur Glenn Holberton, rejoints l'année suivante par la réalisatrice Ange Palethorpe. Lidster avait déjà en poche un prix BAFTA pour le film réalisé comme projet de fin d'études pour la National Film and Television School, le poétique *Balloon*. Ange, diplômée de la même institution, avait été la grande révélation des festivals de Chicago et Ottawa là aussi pour son projet de fin d'études, un film hybride et sophistiqué intitulé *Altered Ego*. Dans le métier depuis 1978, Holberton avait quant à lui produit quelques-uns des films aux multiples récompen-

ses de Barry Purves et dirigé d'autres studios. Ensemble, ils placent Loose Moose au panthéon des grands studios commerciaux de la scène internationale. Ken Lidster entretient sa relation avec le cinéma artistique grâce à *I pagliacci*, aux allures d'opéra, et à la comédie *Interrogating Ernie*, dans laquelle un gentil dinosaure doit expliquer toutes les catastrophes dans le monde depuis l'ère glaciale.

L'équipe de Loose Moose aime les propositions difficiles faisant appel à une batterie de techniques et à la réalité. Résultat : des photocopieuses se défoulant lors d'une *happy hour*, des squelettes motorisés et parfaitement en rythme avec la musique du groupe Fingathing, etc. Il suffit de demander.

Sylvester Stallone, Frank Sinatra, Elvis Presley und Bruce Willis haben sich in Figuren der berühmten Werbekampagne für Lipton Brisk Tee in den Vereinigten Staaten verwandelt gesehen. Ebenso nehmen die anarchischen Werbespots der Imbisskette Peperami die Aufmerksamkeit des englischen Publikums gefangen. Hinter diesen und vielen anderen erfolgreichen Werbepausen im Fernsehen auf der ganzen Welt steckt das Talent des Teams von Loose Moose.

Das in London angesiedelte Unternehmen wurde 1994 von dem Regisseur Ken Lidster und dem Produzenten Glenn Holberton aus dem Ärmel geschüttelt, zu denen ein Jahr später die Regisseurin Ange Palethorpe ausgezeichnet worden ist für den den poetischen Film *Balloon*, den er als Abschlussarbeit der National Film and Television School vorgelegt hatte. Palethorpe, ihrerseits Absolventin der gleichen Institution, war mit den hybriden und ausgeklügelten *Altered Ego* – ebenfalls ihre Abschlussarbeit – die große Entdeckung auf den Festivals von Chicago und Ottawa gewesen. Holberton wiederum, schon seit 1978 im Geschäft, hatte einige der mehrfach ausgezeichneten Filme von Barry Purves produziert und bereits andere Studios geleitet.

Gemeinsam brachten sie Loose Moose in den Olymp der großen kommerziellen Studios auf internationaler Ebene. Ken Lidster blieb dem Kunstfilm verbunden mit seinem opernhaften *I pagliacci* und dem vergnüglichen *Interrogating Ernie*, wo ein liebenswerter Dinosaurier Erklärungen für alle Tragödien der Welt seit der Eiszeit abgeben muss.

Dem Loose Moose-Team gefallen Projekte, die Herausforderungen darstellen, indem sie die Kombination verschiedener Techniken miteinander und mit realer Handlung einschließen. Daher können ebenso Fotokopiergeräte auftauchen, die sich während der Happy Hour abreagieren, wie motorisierte Skelette in perfekter Synchronisation mit der Musik der Gruppe *Fingathing*. Schade, wenn man das verpasst.

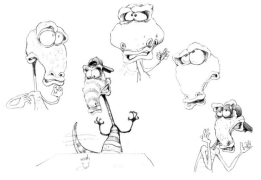

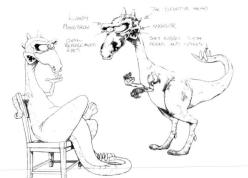

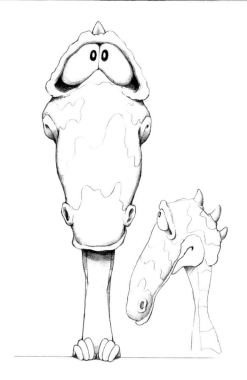

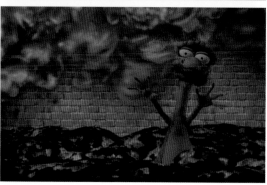

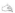 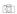

MICHAEL DUDOK DE WIT

Holland / United Kingdom
3 Birchwood Avenue
London N103BE England
E-mail: m@dudokdewit.com

The Interview, 1978
Tom Sweep, 1992
Le moine et le poisson / The Monk
 and the Fish, 1994
Father and Daughter, 2000

Grand Prize - *Espinho*, 1994/2000
Jury Prize - *Otawa*, 1994
Cartoon d'Or, 1995/2001
Best Short Animation - *César*, 1996
Hiroshima Prize, 1996
Academy Award, 2001
Jury Award - *Anima Mundi/Rio de
 Janeiro*, 2001
Grand Prize and Audience Prize -
 Annecy and Hiroshima, 2001
Best Short Animation - *BAFTA*, 2001
Grand Prize - *Zagreb*, 2001
Best Animation - *Clermont-Ferrand*, 2001
Audience Award - *Leipzig*, 2001
Winner 5-15 min - *WAC*, 2001

Drawing with pencil
Brush and charcoal on paper or
Watercolor backgrounds
Scanning
Digital coloring

MICHAEL DUDOC DE WIT

www.dudokdewit.com

A L'INTERIEUR
DU MONASTERE :

LE MOINE LIT
UN LIVRE , MAIS
IL N'ARRIVE PAS
A SE
CONCENTRER.

IL SE
RETROUVE SUR
L'AQUEDUC ...

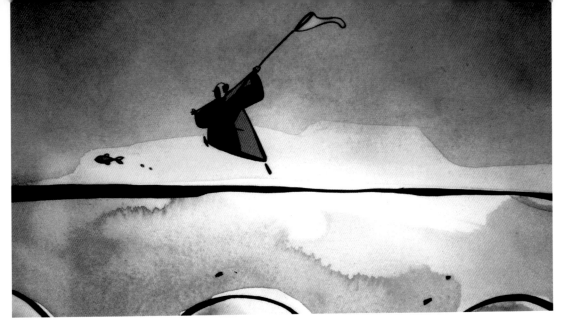

The artistic evolution of Michael Dudok de Wit proves true the maxim that an animator can become a celebrity from one day to the next after several decades of arduous work. This London-based Dutch artist has worked as an animator and independent animation director since 1978 in different studios, such as those of Richard Purdum, Passion Pictures and Folimage. He has also been a part of the Disney studios team for productions like *Mickey's Audition*, *Beauty and the Beast* and *Fantasia 2000* is name appears as well in the credits of feature films like *Heavy Metal* and the short film *T.R.A.N.S.I.T.*, among others.

Dudok de Wit directed two of his own movies before a stream of awards and an Oscar nomination brought him international recognition for the short *The Monk and the Fish*. Six years later the beautiful movie *Father and Daughter* consolidated his prestige with an Oscar and other important awards in major animation film festivals around the world.

Dudok de Wit's style stands out for his minimalist landscapes, his calligraphy-like lines, the nostalgic tones of his colorings and the absence of dialogue, all of which illustrate themes that sink deeply into the audience's emotions. While *The Monk and the Fish* evokes Zen spirituality to talk about obsession, *Father and Daughter* penetrates into the open and empty landscapes of Holland to address separation, waiting and reuniting.

An admirer of both Tintin and Eastern European animation, as well as the drawings of Buddhist monks, Dudok de Wit is also an award-winning illustrator of books and playing cards. Furthermore, he has extensive experience conducting conferences on animation. Despite his success, he continues producing commercials in order to make a living.

Le parcours artistique de Michael Dudok de Wit illustre bien l'adage selon lequel un animateur peut connaître la gloire du jour au lendemain après plusieurs décennies de dur labeur. Ce hollandais installé à Londres exerce comme animateur et réalisateur d'animation indépendant depuis 1978 pour des studios tels que Richard Purdum, Passion Pictures et Folimage. Il a également fait partie des équipes Disney pour des productions comme *Mickey's Audition*, *La belle et la bête* et *Fantasia 2000*. Son nom figure aussi au générique d'œuvres comme le long métrage *Heavy Metal* et le court *T.R.A.N.S.I.T.*

Dudok de Wit dirige deux films personnels avant qu'une avalanche de prix et une nomination aux Oscars ne récompensent son talent pour le court métrage *Le moine et le poisson* en 1994. Six ans plus tard, son remarquable *Père et fille* vient confirmer son prestige d'un Oscar et une première place dans les principaux festivals d'animation internationaux.

Le style de Dudok de Wit se reconnaît aux paysages minimalistes, à un tracé presque calligraphique, à des tons nostalgiques et à l'absence

de dialogue, sans compter les thèmes abordés, touchant la corde sensible du public. Alors que *Le moine et le poisson* se fonde sur une spiritualité zen pour traiter l'obsession, *Father and Daughter* part des paysages ouverts et vides de Hollande pour parler de séparation, d'attente et de retrouvailles.

Admirateur de Tintin, de l'animation d'Europe de l'Est et des dessins des moines bouddhistes, Dudok de Wit est aussi un illustrateur reconnu de livres et de jeux de cartes et a donné de nombreuses conférences sur l'animation. Malgré cette dose de succès, il doit continuer à produire des spots publicitaires pour survivre.

Die künstlerische Laufbahn von Michael Dudok de Wit erfüllt den Grundsatz, dass ein Trickfilmer nach mehreren Jahrzehnten harter Arbeit dann plötzlich über Nacht berühmt werden kann. Der in London ansässige Holländer hat seit 1978 im Bereich Animation und Animationsregie freie Aufträge unter anderem von Passion Pictures, Folimage und dem Studio von Richard Purdum übernommen. Er gehörte auch zum Produktionsteam der Disney Studios für den Kurzfilm *Mickey's Audition*, *Die Schöne und das Biest* und *Fantasia 2000*. Darüber hinaus taucht sein Name in der Liste der Mitwirkenden unter anderem bei dem abendfüllenden Spielfilm *Heavy Metal* und dem Kurzfilm *T.R.A.N.S.I.T.* auf.

Dudok de Wit hatte zwei eigene Filme gedreht, bevor eine wahre Preislawine, darunter eine Oscarnominierung, auf ihn hernieder ging und er 1994 unversehens sein Talent bei dem Kurzfilm *Der Mönch und der Fisch* einsetzte. Sechs Jahre später sollte der wunderbare Film *Vater und Tochter* sein Ansehen mit einem Oscar und Triumphen bei den wichtigsten Zeichentrickfilm-Festivals der Welt festigen.

Dudok de Wits Stil hebt sich durch die minimalistischen Landschaften, den fast kaligrafischen Strich, die nostalgischen Töne seiner Farbgebung und den Verzicht auf Dialoge ab; dazu kommen Themen, die dem Zuschauer zu Herzen gehen. Während der Film *Der Mönch und der Fisch*, der vom Phänomen der Besessenheit handelt, eine zen-typische Geistigkeit ausstrahlt, betritt man in *Vater und Tochter* die offenen und menschenleeren Landschaften Hollands, um etwas über Trennung, Hoffnung und Wiedersehen zu erfahren.

Dudok de Wit, der Tintin sowie den osteuropäischen Trickfilm und die Zeichenkunst buddhistischer Mönche bewundert, wurde auch als Buchillustrator und Gestalter von Spielkarten ausgezeichnet, ganz abgesehen davon, dass er Vorträge über Animation hält, worin er viel Erfahrung hat. Aber trotz all dieser Erfolge muss er weiterhin Reklame produzieren, um seine finanzielle Lebensbasis zu sichern.

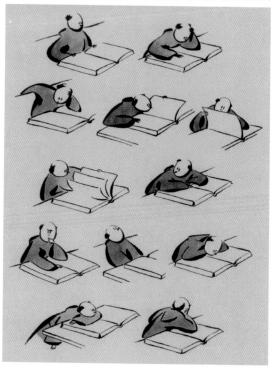

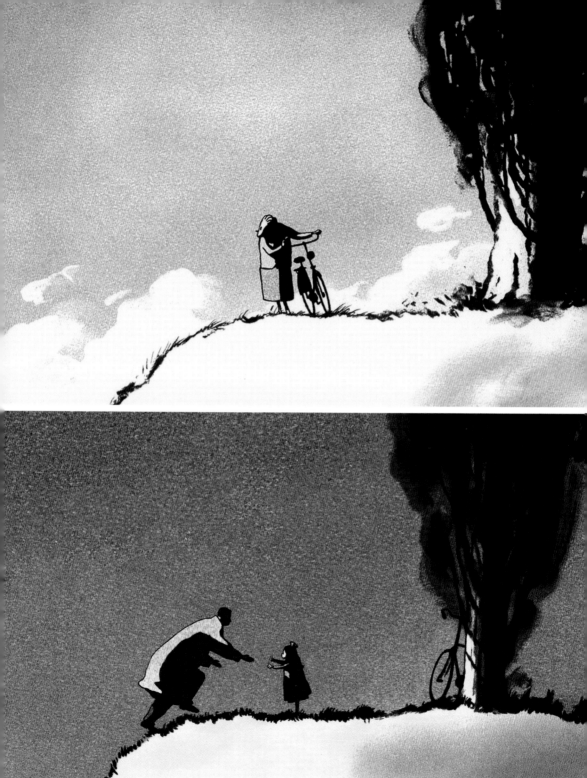

MICHAELA PAVLÁTOVÁ

Czech Republic
E-mail: mpavlatova@volny.cz

Etuda Z Alba / An Étude From the
 Album, 1987
Krizovka / The Crossword Puzzle, 1989
Reci, Reci, Reci, / Words, Words,
 Words, 1991
Uncles and Aunts, 1992
Repete, 1995
This Could Be Me, 1995
Az Naveky / Forever and Ever, 1998
O Babicce / On Grandma, 2000
Graveyard series, 2001
Taily Tales, 2002

First Prize - Espinho, 1990
Grand Prix - Montréal and Valladolid, 1991
Grand Prix and Audience Prize -
 Stuttgart, 1992
Silver Dove - Leipzig, 1992
First Prize - Zagreb, 1992
Prize of the Jury - Stuttgart, 1995
Special Prize of the Jury - Annecy, 1995
Golden Bear - Berlin, 1995
First Prize - Tampere, 1996 and 1998
Grand Prix - Hiroshima, 1996
Best Film - Anima Mundi/Rio de
 Janeiro, 1999
TV Special Prize - Ottawa, 1999
Best Animation for the Internet -
 WAC Hollywood, 2001

Cut out
Cell animation
Paintings under camera
Different techniques
 combined with
 documentary film
"Total animation"

MICHAELA PAVLÁTOVÁ

www.michaelapavlatova.com

The humor, irony, strong colors and surprising ideas of Czech animator Michaela Pavlátová make the public delight in her animations, although at the same time her movies lead the audience to reflect about the dynamics of couples, the institution of family and the complicated task of living in society.

Words, Words, Words received an Oscar nomination for its unusual script—the conversation in a cafe that takes place through an animated language of artistic symbols seems to take on its own life—and its communicative structure. In *Repete*, another contemporary classic that tells the story of three couples codified by the colors blue, green and red, is about the routine of life as a couple. Although this kind of life is revealed as an inevitable obstacle, it also represents a guarantee of security.

Michaela Pavlátová was born in Prague, where she studied at the Academy of Arts, Architecture and Design. She has worked in close collaboration with Pavel Koutsky, with whom she shares a technique called "total animation". Over the last few years, she has divided her time between the Czech capital and the United States, where she teaches animation classes and puts her talent to use by creating commercials.

In the year 2000, the inquisitive Pavlátová directed *On Grandma*, a movie that blends different animation techniques with documentary film, an innovative combination for animated films as well as for documentaries. Her recent Internet productions include the series of flash animations, *Graveyard*, which can be seen on her website. In 2003 she launched her first feature film, *Faithless Games*, a melodrama about love, fidelity, sex and nationalism that was filmed with real actors.

Humour, ironie, couleurs vives et idées surprenantes propres aux animations de la Tchèque Michaela Pavlátová lui ont fait une place dans le cœur du public. Ces films poussent à une réflexion sur la dynamique du couple, sur la cellule familiale et sur la difficulté de vivre en société.

Des mots, rien que des mots obtient une nomination aux Oscars pour sa trame inhabituelle (une conversation a lieu dans un café par le biais d'images symboliques qui prennent une personnalité propre) et sa capacité de communication. Dans *Repete*, autre classique contemporain relatant l'histoire de trois couples identifiés par la couleur bleu, vert ou rouge, raconte la routine de la vie à deux, à la fois obstacle inévitable et garantie de sécurité.

Michaela Pavlátová est née à Prague, où elle étudie à l'École supérieure des Arts et Métiers. Elle entretient une étroite collaboration avec Pavel Koutsky, dont elle applique la technique dite « d'animation totale ». Ces dernières années, elle a partagé son temps entre la capitale

tchèque et les États-Unis, où elle donne des cours d'animation et met son talent à la disposition de spots publicitaires.

En 2000, cette femme inquiète dirige *On Grandma*, film dans lequel se combinent différentes techniques d'animation et images d'archives : il s'agit là d'une approche totalement inédite, pour les films d'animation comme pour les documentaires. Sa récente production pour Internet concerne la série d'animations flash *Graveyard*, disponible sur son site Web. En 2003, elle crée son premier long métrage, *Les jeux infidèles*, un mélodrame sur l'amour, la fidélité, le sexe et le nationalisme filmé avec de vrais acteurs.

Humor, Ironie, starke Farben und verblüffende Ideen machen die Trickfilme der Tschechin Michaela Pavlátová zu einem Publikumsgenuss, wenngleich ihre Filme einen zum Nachdenken bringen über die Dynamik von Paarbeziehungen, die Institution Familie und die schwierige Aufgabe, in Gesellschaft zu leben.

In *Worte, Worte, Worte* scheint sich die Konversation, die in einem Café mittels einer Sprache aus künstlerisch gestalteten, animierten Symbolen geführt wird, zu verselbständigen; für die Verwirklichung dieser Art von Kommunikation und seinen ungewöhnlichen Drehbuchinhalt wurde dieser Film für den Oskar nominiert. *Repete*, inzwischen ebenfalls zum zeitgenössischen Klassiker avanciert, stellt die Geschichte dreier Paare dar, die durch die Farben Blau, Grün und Rot einander zugeordnet werden. Gezeigt wird die Alltagsroutine als Paar, eine Lebensform, die zwar eine Sicherheitsgarantie darstellt, sich aber andererseits als unumgängliches Hindernis enthüllt.

Michaela Pavlátová wurde in Prag geboren, wo sie an der Kunstakademie Architektur und Design studierte. Als enge Mitarbeiterin von Pavel Koutsky teilte sie mit ihm die Technik der so genannten "totalen Animation". In den vergangenen zehn Jahren pendelt sie zwischen der tschechischen Hauptstadt und den Vereinigten Staaten, wo sie Unterricht in Animation erteilt und gleichzeitig ihr Talent für Reklame einsetzt.

Im Jahr 2000 führte die rastlose Pavlátová Regie bei *On Grandma*, wobei sie verschiedene Trickfilmtechniken mit Archivbildern mischte. Diese Kombination ist für den Trick- und den Dokumentarfilm gleichermaßen innovativ. Zu ihrer jüngsten Internetproduktion gehört auch die Reihe an Blitzanimationen, die unter dem Titel *Graveyard* auf ihrer Homepage zu sehen sind. 2003 brachte sie ihren von echten Schauspielern gespielten Film *Faithless Games* heraus, ein Melodrama über Liebe, Treue, Sex und Nationalismus.

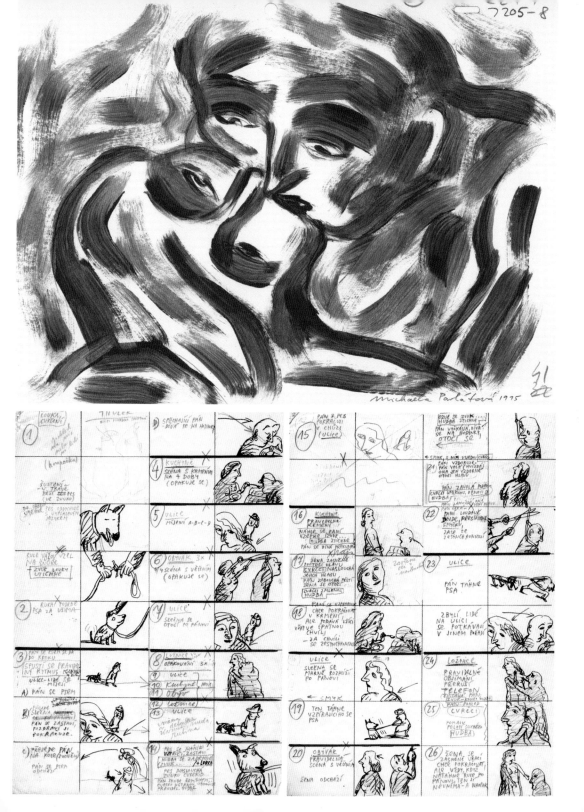

Michaela Pavlátová 1975

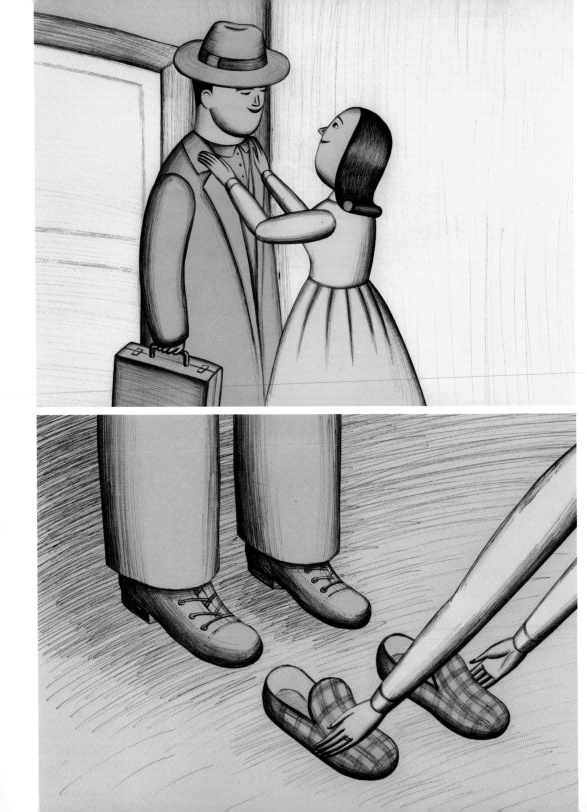

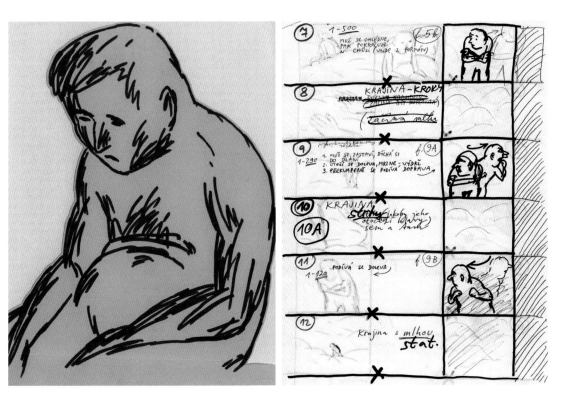

**NATIONAL FILM BOARD
OF CANADA**

Canada
3155 Côte de Liesse Road,
Ville Saint Laurent,
Montréal, Quebec H4N 2N4

Special Delivery, 1978
Chaque enfant / Every Child, 1980
Paradis / Paradise, 1985
The Big Snit, 1985
Animando, 1987
The Cat Came Back, 1988
**Droits au cœur / Rights from the
 Heart,** 1992
Bob's Birthday, 1995
Dinner for Two, 1997
**La plante humaine / The Human
 Plant,** 1997
When the Day Breaks, 1999
Le chapeau / The Hat, 1999
**Une leçon de chasse / A Hunting
 Lesson,** 2001

Academy Awards - 1953/ 1978/
 1980/ 1989/ 1993/ 1995/ 1999
Best Animated Short - *Cannes,*
 1953/ 1955/ 1999
**Prize for Animation in a
 Documentary** - *Cannes,* 1957
Special Jury Award - *Cannes,* 1976
Best Selection - *Annecy,* 1977/1979
Jean Renoir Humanities Award -
 Los Angeles, 1978
**Special Achievement Genie
 Award** - *Toronto,* 1989
Don Quichotte Prize - *Annecy,* 1989
Special Prize - *FestRio Brazil,* 1989
Silver Bear - *Berlin,* 1985/1990
Unicef Award - *Berlin,* 1997

Drawn and painted animation
Pixilation
Puppet animation
Paper cut-outs
Pinscreen
Engraving on film
Computer graphics

NFB
NATIONAL
FILM BOARD
OF CANADA

www.nfb.ca

For all of those who aspire to make animation a personal statement and a gesture of independence, the National Film Board of Canada is a kind of heaven on earth. The institution's golden rule is to stimulate auteur creations, artistic expression and investigation of new languages.

The National Film Board was founded in 1939 by the documentary maker John Grierson. Later, in 1941, the talented McLaren introduced the animation department, where he led an authentic revolution of the genre. The National Film Board's contribution to the development of different animation techniques is invaluable, whether from direct intervention on a cinematographic movie or to the first experiences in digital animation: *Metadata*, 1971 and *Hunger*, 1973. Between 1986 and 1992, the National Film Board's productions served as a testing ground for the most advanced software of the time. Today, Internet productions are an important part of the institution.

Interest in new technologies has always coexisted with a high regard for the handcrafted aspects of animation, as McLaren and René Jodoin –the first director of the Francophone production unit, created in 1966– have maintained. Creators associated with the National Film Board are encouraged by the institution's avant-garde notions, as well as by the ideal of including young talents, women and animators from less fortunate countries. Together with the nationalistic objective of promoting Canadian culture, the National Film Board has played a fundamental role in spreading auteur cinema all over the world by participating in co-productions and by sponsoring programs that offer courses and internships to promising foreign artists.

The international community's recognition of the National Film Board raises this Canadian public organization to the rank of trustee of animation heritage. The Board's list of individual and institutional awards is greater than all the entities of the world that work in animation.

Following is a profile of some of the animation directors currently associated with the National Film Board of Canada.

Pour tous ceux souhaitant faire de l'animation un mode de communication personnelle et une preuve d'indépendance, l'Office national du film du Canada représente une sorte de paradis terrestre. La règle d'or de cette institution consiste à motiver les créations d'auteur, l'expression artistique et la recherche de nouveaux langages.

L'Office national du film est fondé en 1939 par le documentariste John Grierson. Deux ans plus tard, le talentueux McLaren crée un département d'animation au sein duquel il mène une véritable révolution. La participation de l'Office national du film au développement de diverses techniques d'animation n'a pas de prix, de l'intervention directe dans des films aux expériences pionnières en animation numérique (*Metadata*, en 1971 et *Hunger*, en 1973). Entre 1986 et 1992, les productions de l'Office national du film servent de plate-forme pour tester le logiciel le plus avancé du moment. À l'heure actuelle, la production pour Internet occupe une place de choix dans cette institution.

L'intérêt pour les nouvelles technologies est toujours allé de pair avec la priorité accordée aux aspects artisanaux de l'animation, comme le prêchent McLaren et René Jodoin (premier réalisateur de l'unité de production francophone créée en 1966). La notion d'avant-garde motive

les créateurs collaborant avec l'Office national du film et permet d'inclure de jeunes talents, des femmes et des animateurs issus de pays défavorisés. Outre la tendance nationaliste de promotion de la culture canadienne, l'Office national du film a joué un rôle essentiel dans la diffusion du cinéma d'auteur à travers le monde grâce à des coproductions, des programmes d'études et des stages offerts aux artistes étrangers prometteurs.

La reconnaissance de la communauté internationale place cet organisme public au rang de trésor du patrimoine de l'animation. La liste de prix individuels et institutionnels est par ailleurs la plus longue dont les studios du monde peuvent se vanter.

Voici le profil de certains réalisateurs d'animation travaillant actuellement à l'Office national du film du Canada.

Für all diejenigen, die danach trachten, mit der Bildanimation die Persönlichkeit zu bekunden und Unabhängigkeit zu demonstrieren, stellt das National Film Board von Kanada eine Art Paradies auf Erden dar. Die goldene Regel der Institution heißt, die Schöpfungen des Autors, den künstlerischen Ausdruck und die Erprobung neuer Ausdrucksmittel anzuspornen.

Das National Film Board wurde 1939 von dem Dokumentarfilmer John Fierson gegründet. Zwei Jahre später schloss der geniale McLaren die Abteilung für Trickfilm an, mit der er eine echte Revolution innerhalb dieses Genres anführte. Das National Film Board leistete für die Entwicklung unterschiedlicher Trickfilmtechniken einen unschätzbaren Beitrag, angefangen beim direkten Eingriff in den Filmstreifen bis hin zu den ersten Erfahrungen mit digitaler Bildanimation in *Metadata* (1971) und *Hunger* (1973). Von 1986 bis 1992 dienten die Produktionen des National Film Boards als Plattform, um die fortschrittlichste Software der Zeit zu erproben. Heutzutage nimmt die Produktion für das Internet einen herausragenden Platz innerhalb der Institution ein.

Das Interesse an neuen Technologien ist seit jeher eine Verbindung mit der Wertschätzung kunsthandwerklicher Aspekte der Bildanimation eingegangen, so wie es McLaren und auch René Jodoin, der erste Leiter der 1966 gegründeten Abteilung für französischsprachige Produktionen gepredigt hat. Die Idee der Avantgarde animiert die Künstler, die dem National Film Board verbunden sind, ebenso das Ideal, junge Talente, Frauen und Trickfilmer aus benachteiligten Ländern aufzunehmen. Neben der nationalistischen Einstellung, wenn man darunter die Förderung der kanadischen Kultur versteht, hat das National Film Board mit seinen Koproduktionen sowie Kurs- und Praktikumsprogrammen, die sich an viel versprechende ausländische Künstler richten, bei der weltweiten Propagierung des Autorenfilms eine fundamentale Rolle gespielt.

Die große Anerkennung, die die internationale Gemeinschaft dieser öffentlichen Einrichtung Kanadas zuteil werden lässt, erhebt sie in den Stand, eine Art Weltkulturerbe des Trickfilms zu sein. So hat sie mehr Auszeichnungen errungen, sowohl für Einzelleistung wie solche, die an die Institution vergeben wurden, als jede andere Einrichtung, die mit der Trickfilmwelt zu tun hat.

Im folgenden wird das Profil einiger Trickfilmregisseure, die zur Zeit für das National Film Board in Kanada arbeiten, dargestellt.

NFB/CO HOEDEMAN

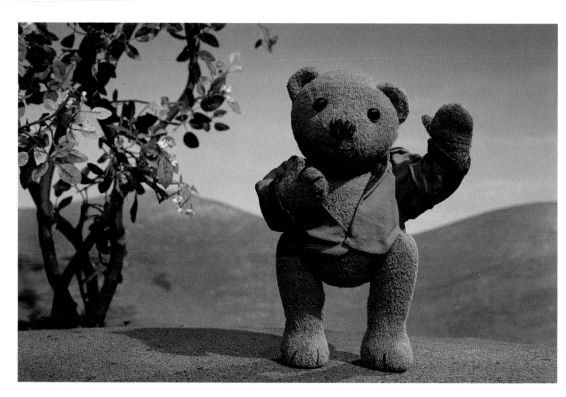

Born in Holland, Co Hoedeman immigrated to Canada at age 25, also having studied puppet animation in the former Czechoslovakia. His main interest is the observation of human movements and behaviors, as well as social interactions. For Hoedeman, swimmers at a beach or a child entertained by a toy can become a source of inspiration for a few minutes of animated poetry. Four of his films were done in close collaboration with Inuit artists. In others, the prevailing theme is the search for technical innovations in the manipulation of objects and puppets. The Oscar Award-winning film *The Sand Castle* has become a classic of sand animation. With his simple and, at the same time, magical stories, Hoedeman tries to bring the adult viewer back "to the garden of our childhood".

Né en Hollande, Co Hoedeman émigre au Canada à l'âge de 25 ans après avoir étudié l'animation de marionnettes en ex-Tchécoslovaquie. Il s'attache principalement à étudier les mouvements et comportements humains, ainsi que les interactions sur le plan social. Les baigneurs d'une plage ou un enfant s'amusant avec un jouet peuvent ainsi lui servir d'inspiration pour quelques minutes de poésie animée, et quatre de ses films ont été réalisés en étroite collaboration avec des artistes inuits.

Dans d'autres, il privilégie la recherche d'innovations techniques en manipulant des objets et des marionnettes. Récompensé par un Oscar, *Le château de sable* est devenu un classique de l'animation à base de sable. Avec des histoires à la fois simples et magiques, Hoedeman tente de mener le spectateur adulte « au jardin de l'enfance ».

Der gebürtige Holländer Co Hoedeman emigrierte mit 25 Jahren nach Kanada und studierte später Puppenanimation in der ehemaligen Tschechoslowakei. Sein Interesse gilt Bewegungs- und Verhaltensstudien zum Menschen sowie der Beobachtung der sozialen Interaktion. Die Badegäste an einem Strand oder ein Kind, das sich mit einem Spielzeug vergnügt, können ihm als Inspirationsquelle für einige Minuten Trickfilm-Poesie dienen. Vier Filme realisierte er in enger Zusammenarbeit mit Inuit-Künstlern. Bei anderen wiederum hatte die Suche nach technischen Innovationen bei der Handhabung der Objekte und Puppen die Oberhand. Der Oscar-gekrönte Film *Die Sandburg* wurde zu einem Klassiker der Sand-Animation. Mit seinen vergleichsweise einfachen und magischen Geschichten bezweckt Hoedeman, den erwachsenen Zuschauer zurück in den „Garten unserer Kindheit" zu lenken.

Pg. 196 Quatre saisons dans la vie de Ludovic / Four Seasons in the Life of Ludovic, 1998-2002
Puppet animation

Pg. 197 La boîte / The Box, 1989
Puppet animation

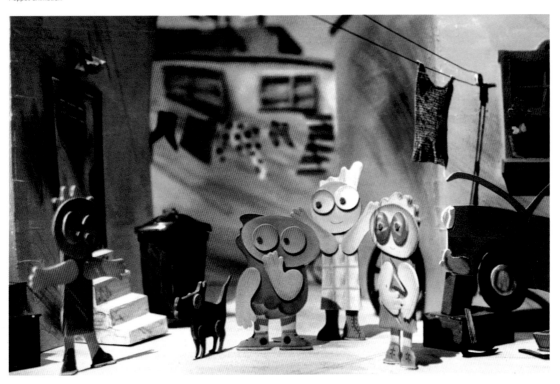

The Cat Came Back, 1988
Strange Invaders, 2001

Génie Award, 1988
First Prize Debut Works - *WAC/USA*, 1988
Best Humour, Best Music and Audience Awards - *Zagreb*, 1988
Gold World Medal - *New York*, 2001
Grand Prize - *Castelli Animati/Rome*, 2001

NFB/CORDELL BAKER

Cordell Barker has only made two of his own shorts, but both of them have been right on target. *The Cat Came Back*, the animated version of an old Canadian folk song about an old man who does all he can to free a cat, and *Strange Invaders*, a film about the dark side of fatherhood, immediately became classics of animation comedy. The National Film Board produced both of these films, which were nominated for Oscars and won uncountable awards in international festivals. However, the Canadian Cordell Barker has spent most of his time in the hectic business of commercials, with the biggest American and Canadian studios fighting to work with him. He was chosen to represent Canada in the famous "180" series of Nike's institutional movies, and he has directed commercials for Bell Telephone and Coca-Cola, among many other companies. His uniqueness lies in his belief that, in animation, time, story and color are more important than the drawing itself.

Ses deux uniques courts métrages personnels ont tapé droit dans le mille. *Le chat colla...*, version animée d'une ancienne chanson du folklore canadien parlant d'un vieil homme qui essaie de se débarrasser d'un chat par tous les moyens, et *Tombé du ciel*, abordant le côté obscur de la paternité, deviennent immédiatement des classiques de la comédie d'animation. Ces deux créations sont produites par l'Office national du film, nominées aux Oscars et récompensées par d'innombrables prix dans des festivals internationaux. Pourtant, le Canadien Cordell Barker a passé la majeure partie de son temps dans le tumulte de l'univers publicitaire, sollicité par les plus grands studios américains et canadiens. Il est choisi pour représenter son pays dans la célèbre série « 180 » de films institutionnels de Nike et dirige les spots de Bell Telephone et Coca-Cola, entre autres. Sa marque de fabrique : considérer que, en animation, temps, histoire et couleur l'emportent sur le dessin.

Obwohl er nur zwei eigene Kurzfilme gemacht hat, haben beide ins Schwarze getroffen. *The Cat Came Back*, die Trickfilmversion eines alten kanadischen Folksongs über einen alten Mann, der alles versucht, um eine Katze loszuwerden, und *Strange Invaders* über die dunkle Seite der Vaterschaft, wurden sofort zu Klassikern der Trickfilmkomödie. Beide wurden vom National Film Board produziert, erhielten Oscarnominierungen und gewannen unzählige Preise auf internationalen Filmfestivals. Dennoch hat der Kanadier Cordell Barker die meiste Zeit mit dem hektischen Geschäft der Werbespots zugebracht, um die sich die großen US-amerikanischen und kanadischen Studios rissen. Er wurde ausgewählt, um bei der berühmten Nike-Reihe „180", die institutionellen Filmen gewidmet ist, Kanada zu repräsentieren. Darüber hinaus hat er Werbung für Bell Telephone, Coca-Cola und viele andere Unternehmen gestaltet. Seine Besonderheit besteht darin, dass er die Meinung vertritt, beim Trickfilm käme es mehr auf das Timing, die Geschichte und die Farbe an als auf die Zeichnung selbst.

Pg. 198 The Cat Came Back
(storyboard), 1988
Traditional animation

Pg. 199 Strange Invaders, 2001
Traditional animation
© National Film Board of Canada

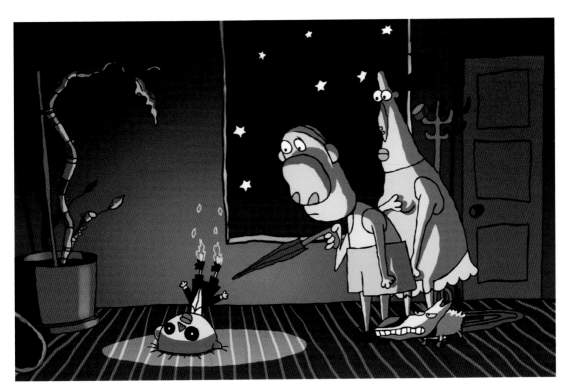

Second Class Mail, 1984
George and Rosemary, 1987
In and Out, 1989
Bob's Birthday, 1995
Bob and Margaret (series), 1998-2001

Best First Film - *Annecy*, 1985
Jury Award - *Montréal*, 1987
Génie Award, 1988/1993
Best Short - *Zagreb*, 1988
Best Short - *Berlin*, 1990
Academy Award, 1993
Best Short - *Annecy*, 1994
Best Short in category - *Espinho*, 1993
First Prize Primetime - *WAC/USA*, 2002

NFB/DAVID FINE
& ALISON SNOWDEN

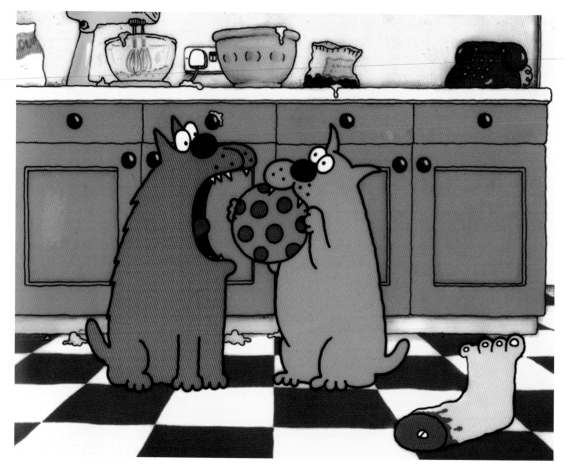

The English animator Alison Snowden and the Canadian David Fine met at London's National Film and Television School, and both of them got involved in the National Film Board of Canada for a period of time. They are known as Snowden and Fine, a pair that seems to have left their mark with fascinating animations such as the short *George and Rosemary* and the television series *Bob and Margaret*. The series, with 26 episodes that take place in London and 26 in Canada, is based on the short *Bob's Birthday*, a film that tells the hilarious story of a surprise birthday party that ends up in an extremely embarrassing situation. This co-production with the National Film Board won an Oscar for the best animated short. Snowden and Fine's movies deal with the different phases of human life with a refined sense of humor and a penetrating social perception.

L'Anglaise Alison Snowden et le Canadien David Fine font d'abord connaissance à la National Film and Television School de Londres avant de s'engager tous deux pendant une saison auprès de l'Office national du film du Canada. Ils sont connus comme Snowden et Fine, une unité palpable dans de passionnantes animations comme le court *Georges et Rosemarie* et la série télévisée *Bob et Margaret*. Cette dernière, de 26 épisodes se déroulant à Londres et 26 autres au Canada, s'inspire du court *L'anniversaire de Bob*, dans lequel une fête surprise tourne en situation extrêmement embarrassante. Cette coproduction avec l'Office national du film du Canada a remporté l'Oscar du meilleur court métrage d'animation. Les films de Snowden et Fine traitent des différentes phases de la vie humaine avec un humour raffiné et une vision sociale marquante.

Die Engländerin Alison Snowden und der Kandier David Fine lernten sich an der National Film and Television School von London kennen und verbrachten beide eine Zeit lang am National Film Board in Kanada. Man kennt sie als Snowden and Fine, ein Team, das mit seinen leidenschaftlichen Animationen wie dem Kurzfilm *George and Rosemary* und der Fernsehserie *Bob and Margaret* Anklang gefunden zu haben scheint. Die Serie mit 26 Folgen, die in London spielen und ebenso vielen in Kanada, basiert auf dem Kurzfilm *Bob hat Geburtstag*, in dem die erheiternde Geschichte einer Überraschungsparty in einer absolut peinlichen Situation endet. Diese Koproduktion mit dem National Film Board gewann den Oscar in der Sparte „Bester animierter Kurzfilm". Die Filme von Snowden and Fine bringen die verschiedenen Phasen des menschlichen Lebens mit sehr feinem Humor und eindringlichem sozialen Gespür zur Sprache.

Pg. 200 Bob's Birthday, 1995
Traditional animation

© 1993 Snowden Fine Animation, Channel 4 and National Film Board of Canada

Pg. 201 George and Rosemary, 1987
Traditional animation

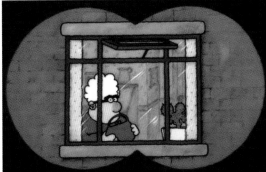

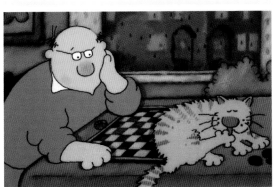

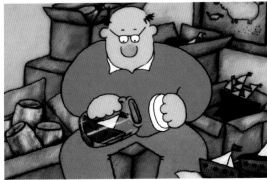

Trois exercices sur l'écran d'épingles d'Alexeieff / Three Exercises on
 Alexeieff's Pinscreen, 1974
Le paysagiste / Mindscape, 1976
L'heure des anges / Nightangel, 1986
Ex-enfant / Ex-Child, 1994
Une leçon de chasse / A Hunting Lesson, 2001
Imprints, 2004

Special Jury Award - *Espinho*, 1986
Silver Toucan - *FestRio*, 1986
Unicef Award - *WAC/USA*, 1997
Children's Jury Award - *Chicago*, 2002

NFB/JACQUES DROUIN

Considered the world's master of pinscreen animation, the Canadian Jacques Drouin has remained faithful to this technique ever since 1967, when he discovered, much to his amazement, the apparatus invented by Alexander Alexeieff and Claire Parker. His admiration was evident even in the first film that he completed at the National Film Board. In *Mindscape*, Drouin expresses the imaginary world of a painter, using an engraved effect obtained with a forest of pins. His masterpiece is perhaps *A Hunting Lesson*, a movie that achieves a sublime representation of the passing of time and of African and Canadian landscapes. Drouin also collaborated with the Czech animator Bretislav Pojar and his puppets in *Nightangel*. His participation in the National Film Board goes much beyond his own personal movies, as he has also had a historical role in many of the institution's activities.

Considéré comme le maître mondial de l'animation sur écran d'épingles, Jacques Drouin reste fidèle à cette technique depuis sa découverte en 1967, émerveillé, de l'appareil inventé par Alexander Alexeieff et Claire Parker. Son admiration est flagrante, à commencer par le titre même de ses premiers essais à l'Office national du film. Dans *Le paysagiste*, Drouin utilise l'effet de gravure obtenu grâce à une forêt d'épingles pour illustrer le monde imaginaire d'un peintre. Son œuvre majeure serait peut-être *Une leçon de chasse*, dans laquelle il offre une incroyable représentation du temps qui passe et des paysages africains et canadiens. Sa collaboration avec le Tchèque Bretislav Pojar et ses marionnettes est également mémorable dans *L'heure des anges*. Son travail à l'Office national du film va bien au-delà de ses films personnels, avec une contribution historique à la liste des productions de l'institution.

Der Kanadier Jacques Drouin gilt als der Weltmeister der Bildschirmanimation mit Nageltechnik. Er ist dieser Technik treu geblieben, seitdem er 1967 die von Alexander Alexeieff und Claire Parker erfundene Apparatur kennenlernte, die ihn mit Bewunderung erfüllte. Besagte Bewunderung war schon bei seiner ersten Erfahrung im National Film Board deutlich sichtbar. In *Der Landschaftsmaler* benutzt Drouin die Wirkung von Gravuren, die er mit einem Stecknadelwald erhält, um die imaginäre Welt eines Malers auszudrücken. Sein Meisterwerk ist vielleicht *A hunting Lesson*, wo ihm eine erhabene Darstellung des Zeitverrinnens und der afrikanischen bzw. kanadischen Landschaft gelingt. Erwähnenswert ist auch Drouins Zusammenarbeit mit dem Tschechen Bretislav Pojar und seinen Puppen in *Nightangel*. Sein Wirken im National Film Board geht über seine persönlichen Filme hinaus: Sein Anteil am Curriculum der Institution hat historische Dimension.

Pg. 202 Ex-enfant / Ex-Child, 1994
Pinscreen
© National Film Board of Canada

Pg. 203 Une leçon de chasse / A Hunting Lesson, 2001
Pinscreen
© National Film Board of Canada

NFB/JANET PERLMAN

Ever since she discovered, as a teenager, that life was not all about fairy tales and talking animals, Janet Perlman decided to dedicate her life to animation. At age 18 the National Film Board took her under contract, and once there she did not hesitate to animate jolly elves and dancing penguins. However, her work also contains much more dramatic subjects that deal with resolving conflicts, harassment or the proximity of death, all of which are treated, as much as possible, with humor. Perlman filmed several Sesame Street episodes and was the artistic director for the National Film Board's *ShowPeace* series. Almost all of her films have been animated in 2D, and they use music as a fundamental component that often precedes and even influences the creation of images. Perlman never abandoned her penguins, which were even nominated for an Oscar in 1982. They have appeared in four books that she herself wrote and illustrated, as well as in a recent television special.

Depuis sa découverte à l'adolescence que la vie n'est pas un conte de fée et que les animaux n'ont pas le don de parole, Janet Perlman se consacre à l'animation. À l'âge de 18 ans, elle est engagée par l'Office national du film et n'hésite pas à animer des elfes joyeux et des pingouins danseurs. Pourtant, son travail va aussi être marqué par des thèmes plutôt dramatiques, tels que la résolution de conflits, le harcèlement ou la proximité de la mort, le tout traité dans la mesure du possible avec une bonne dose d'humour. Perlman réalise certains épisodes du programme Rue Sésame et est directrice artistique de la série *ShowPeace* de l'Office national du film. La majorité de ses films sont animés en 2D et recourent à la musique comme élément clé précédant et guidant souvent la création des images. Par ailleurs, Perlman est restée fidèle aux pingouins et a été, grâce à eux, nominée aux Oscars en 1982 : elle les fait intervenir dans quatre livres écrits et illustrés de sa plume, ainsi que dans une émission spéciale à la télévision.

Janet Perlman widmet sich dem Trickfilm seitdem sie, bereits nicht mehr Kind, entdeckte, was hinter all den Filmmärchen und sprechenden Tierchen steckt. Mit achtzehn Jahren nahm sie das National Film Board unter Vertrag, und sie zögerte nicht, lustigen Elfen und tanzenden Pinguinen Leben einzuhauchen. Dennoch sollte ihr Werk auch von ziemlich dramatischen Themen geprägt sein, wie etwa Konflikten, Mobbing oder Todesnähe. All das, so weit möglich, sehr humorvoll behandelt. Perlman machte auch einige Episoden für die *Sesamstrasse* und war Art Director für die Serie *ShowPeace* des National Film Board. Fast alle ihrer Filme sind 2D-Animationen und setzen Musik als relevantes Element ein, das oft der Bildschöpfung vorangeht oder sie lenkt. Andererseits muss man hervorheben, dass Perlman niemals die (1982 sogar für einen Oscar nominierten) Pinguine aufgegeben hat, die in vier eigenhändig verfassten und illustrierten Büchern und kürzlich wieder in einem TV-Special auftauchen.

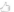

NFB/JOHN WELDON

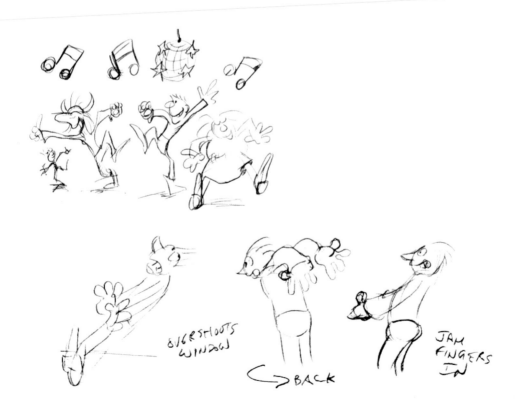

OVERSHOOTS WINDOW

BACK

JAM FINGERS IN

John Weldon has collaborated in nearly 50 of the National Film Board of Canada's productions, and he has directed more than 12 award-winning shorts, which display his rather particular dark humor. *Special Delivery*, a film about the misfortunes of a poor mailman, was filmed together with Eunice Macaulay and earned the two an Oscar award. John Weldon tries to transmit important messages through his movies, whether they are from a philosophical, moral or personal point of view. In truth, he does not care if the public is entertained by his films or not, as traditional cartoon comedy dictates. This filmmaker created an unforgettable parody of Pinocchio in *Spinnolio* and, in *Real Inside*, he anticipated the combination of animation and real action that was to be used in *Roger Rabbit*. Whatever the technique that he uses –drawing, puppets, computer technology–, Weldon is interested in making people think through humor or, more specifically, in making people laugh with the universe of thought.

Il a participé à près de 50 productions de l'Office national du film du Canada et dirigé plus de 12 courts récompensés, dans lesquels un humour noir très particulier y est employé. Vainqueur d'un Oscar, le film *Livraison spéciale* a été réalisé à quatre mains avec Eunice Macaulay et narre les aventures d'un pauvre facteur. John Weldon tente de faire passer des messages clés dans ses films, tant du point de vue philosophique que moral ou personnel et, au fond, peu importe si le public s'amuse ou non, contrairement à la vieille tradition de la farce. Le réa-

lisateur a, par exemple, créé une parodie inoubliable de Pinocchio dans *Spinnolio*, alors que dans *Real Inside* il anticipe le mélange d'animation et d'action réelle qui sera appliqué plus tard dans *Roger Rabbit*. Quelle que soit la technique employée (dessin, marionnettes, ordinateur), Weldon cherche à provoquer une réflexion par le biais de l'humour ou, plus précisément, à faire rire dans un contexte de réflexion.

John Weldon hat bei circa 50 Produktionen des National Film Boards mitgearbeitet und bei mehr als zwölf prämierten Kurzfilmen Regie geführt, wo er einen sehr speziellen Schwarzen Humor zum Zuge kommen lässt. *Eilzustellung*, der einen Oscar gewann und gewissermaßen vierhändig, nämlich zusammen mit Eunice Macaulay realisiert wurde, zeigte einen armen Briefträger als Unglücksraben. John Weldon versucht, mit seinen Filmen Botschaften zu übermitteln, die unter philosophischem, moralischem oder persönlichem Aspekt Wichtigkeit haben. Dabei interessiert es ihn im Grunde genommen nicht, ob das Publikum sich unterhält oder nicht, wie es eigentlich die alte Tradition der Komischen Oper vorschreibt. Mit *Spinnolio* hat der Regisseur eine unvergessliche Parodie auf Pinocchio geschaffen und mit *Real Inside* nahm er die Mischung aus Trickfilm und realer Handlung von *Roger Rabbit* vorweg. Egal, welche Technik er einsetzt, Zeichnung, Puppen, elektronische Datenverarbeitung, immer liegt Weldon daran, durch Humor nachdenklich zu machen oder umgekehrt: das Universum des Gedankens zum Lachen zu bringen.

Pg. 206 Home Security, 2004
Sketches

Pg. 207 Scant Sanity, 1996
© National Film Board of Canada

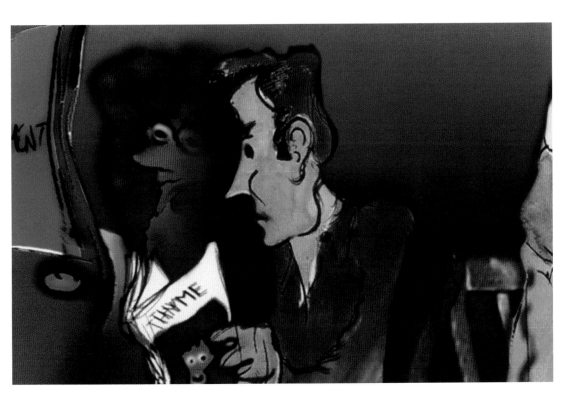

Toccata, 1978
Old Orchard Beach, P.Q., 1981
Dolorosa, 1988
La basse cour / A Feather Tale, 1992
Une artiste / An Artist, 1994
Le chapeau / The Hat, 1999
Accordéon, 2004

Best Short - *Montréal*, 1992
Best Film 5-30 min - *Zagreb*, 1994
Best Canadian Short - *Toronto*, 2000
Fipresci Prize - *Annecy*, 1999
Special Jury Award - *Ottawa*, 1999
Special Jury Prize - *WAC/USA*, 1999
Jutra Award, 1999

NFB/MICHÈLE COURNOYER

The relationship between men and women is not a bed of roses in the work of Canadian animator Michèle Cournoyer. Using quick, harsh strokes of black ink on paper, she has dealt with difficult subjects such as surviving incest –in *The Hat*– and the sexual victimization of women –in *A Feather Tale*–. Cournoyer works without a graphic script, following the wild flow of ideas that materialize in daring metamorphoses and forceful metaphors. Before bringing her career to the National Film Board, she worked as an art director and screenwriter for several movies of the Nouvelle Vogue of Quebec, and she was already making an independent career for herself with animated shorts. Currently, thanks to the use of various techniques ranging from traditional to digital design, she is one of the most well known artists of experimental animation. In *Accordion*, for example, a woman gives into a computer's lust in a film that was simply painted on paper.

L'œuvre de la Canadienne Michèle Cournoyer dépeint un tableau plutôt sombre des rapports entre hommes et femmes. Avec de vifs coups de pinceau d'encre noire sur papier, elle aborde des thèmes délicats comme la survie à l'inceste (*Le chapeau*) et la victimisation sexuelle des femmes (*La basse cour*). Cournoyer travaille sans story-board pour suivre le libre cours de ses idées qui prennent des formes osées et deviennent des métaphores radicales. Avant de rejoindre l'Office national du film, elle exerce comme directrice artistique et scénariste de plusi-

eurs films de la Nouvelle vague du Québec et suit déjà une carrière indépendante avec les courts d'animation. Aujourd'hui, grâce à l'emploi de techniques hybrides allant du design traditionnel au design numérique, elle fait partie des professionnels les plus renommés de l'animation. Dans *Accordéon*, une femme s'abandonne totalement à la séduction d'un ordinateur, un film simplement peint sur papier.

Die Beziehung zwischen Mann und Frau ist im Werk der Kanadierin Michèle Cournoyer ein oft mit Dornen gespickter Weg. Mit schnellen und harten Tuschstrichen auf Papier hat sie schwierige Themen behandelt, z.B. in *Der Hut* das Weiterleben nach einem Inzest, und in *La basse cour* die sexuelle Unterdrückung der Frau. Cournoyer arbeitet ohne Storyboard, sondern folgt dem ungebändigten Gedankenfluss, der sich in gewagten Metamorphosen und überzeugenden Metaphern niederschlägt. Vor ihrer Laufbahn am National Film Board war sie Art Director und Drehbuchautorin bei verschiedenen Filmen für das Studio Nouvelle Vague in Québec und hatte mit ihren animierten Kurzfilmen schon eine Laufbahn als Selbstständige eingeschlagen. Zur Zeit ist sie dank der Mischung heterogener Techniken, die vom traditionellen Zeichentrick bis zur Gestaltung am Computer reichen, eine der Renommiertesten, die experimentelle Animation praktiziert. In *Accordéon* gibt sich eine Frau völlig der Wolllust eines Computers hin. Der Film wurde ganz schlicht auf Papier gemalt.

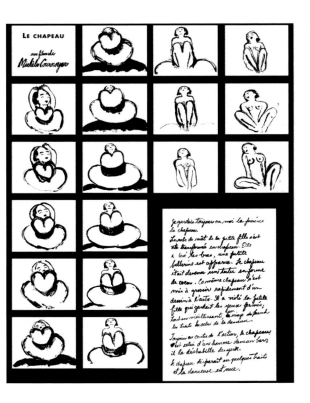

Pg. 208 Une artiste / An Artist, 1994
Mixed techniques

Pg. 209 Le chapeau / The Hat, 1999
Storyboard

NFB/PAUL DRIESSEN

With just a thread to begin with, Paul Driessen is capable of creating a fantastic story. This great master of animation knows how to bring simplicity and originality together in his own personal style, which, although easily recognizable, has not stopped changing in the more than 30 years of his career in cinema.

Driessen was born in Holland, where he studied graphic design and illustration. He began his work in the Dutch advertising industry, but he developed his career in animation in Canada. George Dunning offered him the golden opportunity of his life when he invited him to join the team of *Yellow Submarine*, an animated film of the Beatles' song, which they later presented to the National Film Board of Canada.

Paul Driessen's work includes everything from references to fables, fairy tales and biblical narrations to stories that spring out of his exuberant imagination. Multiple narrative lines alternate and merge together in his plots, which are full of irony and bitter, sometimes even morbid, humor. His movies are demanding and require the spectator's full attention, but the effort pays off as the attentive viewer discovers intelligent surprises in Driessen's films.

The fact that Driessen works in different countries, and also teaches animation classes in Germany, may explain the non-verbal aspect of his movies. His excellent power of communication comes from the richness of his fine and lively lines, the swift mixing of reality and fantasy at the different story levels, and the relatively economic use of his means. His most recent work, *2D or not 2D*, was made for Internet and speculates about the dimensions of space and drawings.

D'un seul trait, Paul Driessen est capable de construire toute une histoire fantastique. Ce maître incontesté du dessin animé sait en effet concilier simplicité et originalité dans un style bien à lui, certes facilement reconnaissable, mais qui n'a pas cessé de se renouveler au cours de plus de 30 ans de carrière cinématographique.

Hollandais de naissance après des études de design graphique et d'illustration, Driessen débute dans le monde de la publicité aux Pays-Bas avant de forger sa carrière d'animateur au Canada. George Dunning lui offre la chance de sa vie : faire partie de l'équipe de *Yellow Submarine*, le film d'animation des Beatles, pour le présenter ensuite à l'Office national du film du Canada.

L'œuvre de Paul Driessen est large, entre références et fables, contes de fées et récits bibliques ou fictions, fruit de son imagination débordante. Plusieurs thèmes s'enchaînent et se mélangent dans ses histoires riches en ironie et à l'humour grinçant, voire parfois morbide. Ses films sont exigeants et requièrent toute l'attention du spectateur; l'effort est cependant récompensé par nombre d'excellentes surprises.

Le fait de travailler dans différents pays et de donner des cours d'animation en Allemagne pourrait expliquer l'approche non verbale des films de Driessen. Son grand pouvoir de communication se doit à la richesse de son trait fin et déterminé, à la vitesse à laquelle réalité et fiction se mêlent à plusieurs niveaux et au peu de supports employés. Son dernier travail réalisé pour Internet, *2D or Not 2D*, traite de la dimension spatiale et du dessin.

Paul Driessen kann eine fantastische Geschichte anhand eines einzigen Themenfadens entwickeln. Der große Meister des Trickfilms weiß das Einfache mit dem Originellen zu einem eigenen Stil zu verbinden, der leicht wieder erkennbar ist, obgleich er ihn in den mehr als dreißig Jahren seiner filmkünstlerischen Karriere immer wieder erneuerte.

Nachdem der gebürtige Holländer Grafikdesign und Illustration studiert hatte, begann er in der holländischen Werbeindustrie zu arbeiten, begründete seine Karriere als Trickfilmer aber in Kanada. George Dunning bot ihm die Chance seines Lebens, als er ihm anbot, bei dem Beatles-Film *Yellow Submarine* mitzumachen, um ihn später am National Film Board von Kanada vorzuführen.

Paul Driessens Werk reicht von Anspielungen auf Fabeln, Märchen und biblische Geschichten bis hin zu Geschichten, die seiner überschäumenden Fantasie entspringen. Viele Erzählfäden schieben sich ineinander und verschmelzen in seinen Erzählgeweben voller Ironie und bitterem, zuweilen sogar morbidem Humor. Es handelt sich um anspruchsvolle Filme, die die ganze Aufmerksamkeit des Zuschauers erfordern, diese Anstrengung aber mit vielen intelligenten Überraschungsmomenten aufwiegen.

Die Tatsache, dass Driessen in verschiedenen Ländern arbeitet, unter anderem in Deutschland, wo er Unterrichtet in Zeichentrick gibt, könnte erklären, warum seine Filme auf Worte verzichten. Seine große Kommunikationskraft entstammt dem reichen Schatz seines feinen und ganz persönlichen Striches, der Geschwindigkeit, mit der Realität und Fantasie sich auf den verschiedenen Ebenen seiner Geschichten mischen, und dem relativ ökonomischen Einsatz der Mittel, mit dem er sich bewegt. Seine jüngste Arbeit, *2D or Not 2D*, die er für das Internet gemacht hat, sinnt über die Dimensionen von Raum und Zeichnung nach.

NFB/RICHARD CONDIE

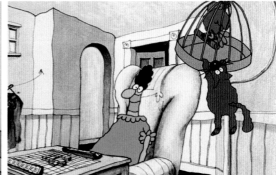

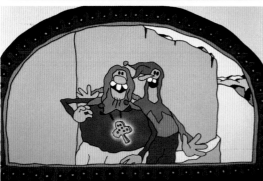

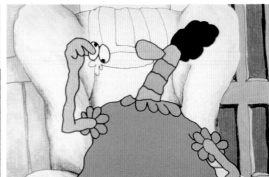

After working for some time as a social worker, the Canadian Richard Condie took advantage of two government grants in order to change the direction of his life and do what he had always dreamed of: working with music and visual arts. His third movie, *Getting Started*, was a great success in Europe and confirmed that Condie's destiny was to become a talented director. His success was even bigger with *The Big Snit* –with the contrast between a worldwide conflict and a tense game of Scrabble– which won awards in 14 festivals and was nominated for an Oscar. These movies make great use of irony with the purpose of criticizing society, and also reveal the director's fine sense of observation. Condie does not deny the influence that the masters of the National Film Board have had on his work, and he appreciates his long collaboration with the musician Patrick Godfrey.

Après avoir exercé pendant un temps comme scientifique social, le Canadien Richard Condie profite de deux bourses d'État pour changer de cap et se consacrer à ce dont il a toujours rêvé : travailler avec la musique et les arts visuels. Son troisième film, intitulé *Faut se grouiller*, remporte un franc succès en Europe et confirme que le destin de Condie consiste à devenir un réalisateur culte. L'accueil est encore plus favorable pour *Le p'tit chaos* comparant un grand conflit mondial à une partie

d'échec corsée : ce film lui vaut des reconnaissances dans 14 festivals et une nomination aux Oscars. Truffées d'ironie, ces productions transmettent une critique sociale et révèlent le sens de l'observation aiguisé du réalisateur. Condie ne cache pas l'influence que les grands maîtres de l'Office national du film exercent sur son travail et revendique la longue collaboration avec le musicien Patrick Godfrey.

Nachdem er einige Zeit als Sozialwissenschaftler gearbeitet hatte, nützte Richard Condie zwei Regierungsstipendien für eine Kursänderung in seinem Leben, um endlich seine Träume zu erfüllen, nämlich mit Musik und bildender Kunst zu arbeiten. Sein dritter Film, *Getting Started*, hatte großen Erfolg in Europa und bestätigte, dass Condie zum Kultregisseur bestimmt war. Noch größeren Erfolg hatte er mit *The Big Snit*, der einen großen Konflikt von Weltbedeutung und eine gespannte Schachpartie gegenüberstellt: Der Film wurde auf 14 Festivals ausgezeichnet und für einen Oscar nominiert. Diese Filme bedienen sich häufig der Ironie mit dem Ziel, Gesellschaftskritik zu üben, und sie enthüllen das feine Gespür, das der Regisseur bei der Beobachtung hat. Condie verleugnet nicht den Einfluss, den die Meister des National Film Board auf ihn hatten, und er bescheinigt seine lange Zusammenarbeit mit dem Musiker Patrick Godfrey.

Pg. 212
(left) L'Apprenti/The Aprentice, 1991
Traditional animation

(right) The big Snit, 1985
Traditional animation

© National Film Board of Canada

Pg. 213 La Salla, 1996
Computer animation

© National Film Board of Canada

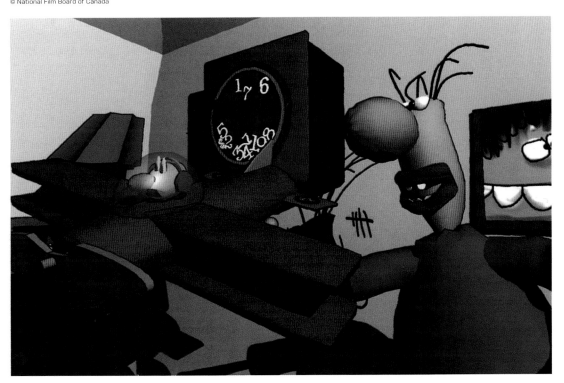

Wendy Tilby:
Tables of Content, 1986
Strings, 1991

Amanda Forbis:
The Man and the Moon, 1988
Bach's Pig, 1988
To Be Continued..., 1988

Tilby & Forbis:
When the Day Breaks, 1999

Wendy Tilby:
Grand Prix Best Short - *Montréal,* 1986
Best in category - *Espinho, 1987 and Ottawa,* 1988
Press Prize - *Annecy,* 1991
Génie Award, 1992
Best in category - *Hiroshima,* 1992

Tilby & Forbis:
Golden Palm - *Cannes,* 1999
Génie Award, 1999
Golden Hugo - *Chicago,* 1999
Grand Prix - *Annecy,* 1999
Golden Dove - *Leipzig,* 1999
Grand Prix - *Hiroshima, Zagreb and WAC/USA,* 2000
Best Canadian Film - *Ottawa,* 2000

NFB/WENDY TILBY
& AMANDA FORBIS

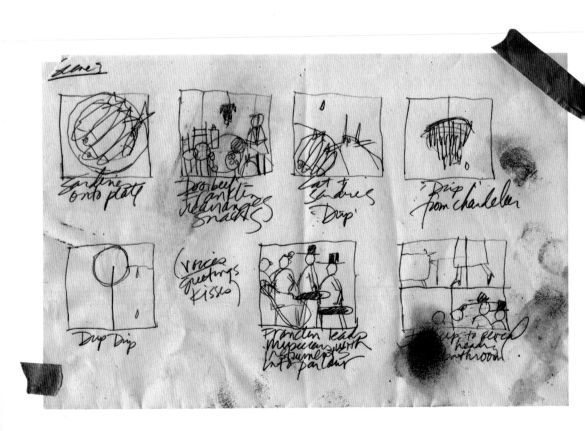

These two Canadian animators followed separate careers until, in 1995, their paths crossed at the National Film Board, and together they directed the award-winning film *When the Day Breaks*. Both directors describe the film as "a four-year labor of love". Through the story of a little pig that is dramatically changed after witnessing an accident, the movie analyzes the way in which people's lives interrelate in the day-to-day life of the big city. Through their movies and commercials Tilby and Forbis promote an industrious combination of commercial techniques and digital resources, and with them they achieve results that are reminiscent of a lithograph. At the same time, they try to incorporate a dose of spontaneity into the inevitable rigor required in animation planning. Tilby's *Strings* and *When the Day Breaks* have received several Oscar nominations. For 2004, the duo is preparing the short *Wild Life* at the National Film Board.

Ces deux animatrices canadiennes ont chacune évolué de leur côté avant que leurs chemins ne se croisent en 1995 à l'Office national du film : elles dirigent alors en duo le si récompensé *When the Day Breaks*, qu'elles décrivent comme un « travail de quatre années d'amour ». En contant l'histoire d'une petite truie dont la vie est bouleversée après avoir été témoin d'un accident, le film analyse le mode d'interaction des personnes dans le quotidien d'une grande ville. Dans leurs films et spots publicitaires, Tilby et Forbis affichent une combinaison complexe de techniques commerciales et de moyens numériques, ce qui donne des résultats semblables à des lithographies. En parallèle, elles s'attachent à intégrer une dose de spontanéité dans la planification rigoureuse que demande l'animation. *Cordes*, de Tilby, et leur film en commun *When the Day Breaks* ont reçu plusieurs nominations aux Oscars. Pour 2004, le duo prépare à l'Office national du film le court *Wild Life*.

Diese beiden kanadischen Trickfilmerinnen gingen zunächst getrennte Wege, bis sich 1995 am National Film Board ihre Wege kreuzten und sie sich für den vielfach ausgezeichneten Film *When the Day Breaks* zusammentaten. Beide beschreiben es als einen „vierjährigen Liebesdienst". Über die Geschichte einer kleinen Sau, die große Veränderungen erleiden muss, nachdem sie Augenzeuge eines Unfalls geworden ist, analysiert der Film die Art und Weise, wie sich die Lebensläufe von Personen im großstädtischen Alltag miteinander verbinden. Tilby und Forbis sind in ihren Filmen und Werbespots Fürsprecher einer arbeitsaufwändigen Kombination kommerzieller Techniken und digitaler Hilfsmittel, mit denen sie Wirkungen erzielen, die an Lithografien erinnern. Gleichzeitig versuchen sie, der unvermeidlichen Strenge, mit der ein Trickfilm durchgeplant wird, eine Prise Spontaneität beizumischen. *Strings* von Tilby und *When the Dark Breaks* haben mehrere Oscarnominierungen erreicht. Für 2004 erarbeitet das Duo gerade im National Film Board den Kurzfilm *Wild Life*.

Pg. 214 *Strings*, 1991
Storyboard

Pg. 215
(left) *String*, 1991
Paint on glass
© National Film Board of Canada

(right) *Tables of Content*, 1986
© National Film Board of Canada,
Emily Carr College of Art and Design.
All rights reserved.

NEXUS PRODUCTIONS LTD.

United Kingdom
Contact: Chris O'Reilly /
 Charlotte Bavasso
113-114 Shoreditch High Street,
London E1 6JN
Phone: + 44 20 7749 7500
Fax: + 44 20 7749 7501
E-mail: Info@nexusproductions.com

Natwest "Escape", 1999
Honda "OK Factory"/"Pecking
 Orders"/"Seats", 2002
Sexiest Man in Jamaica, 2002
"Miranda" main titles, 2002
"Catch Me If You Can" main titles, 2003
Aiwa "Slurp"/"Petrol Station", 2003
Robinsons "Barleydino", 2003
Monkey Dust - series, 2003
Ikara Colt "Wanna Be That Way", 2004

2D
3D
Puppets
Flash
Mixed/live action

NEXUS

www.nexusproductions.com

Although they often do co-productions with other countries, Nexus Productions, which has its headquarters in London, is a leading company that creates animation for television, advertising and videos, as well as animated material for feature films. The production company, directed by Chris O'Reilly and Charlotte Bavasso, was founded in 1997 and has been rather eclectic when it comes to establishing its relationships with Japanese directors of anime like Satoshi Tomioka, masters of Swedish cartoons such as Jonas Odell, among others, and French animators like Florence Deygas and Olivier Kuntzel.

The first important commission that Nexus received was to make animation for a giant television screen for U2's Pop Mart world tour. Since then their client load has multiplied as they have accumulated dozens of works of dynamic language and irreverent, even erotic, content, with which they have been able to achieve their objectives with precision. The wide variety of techniques and the incorporation of animation logic to the production of real images have guaranteed the rapid growth of Nexus in the market of big brand names and film and recording studios.

Movie viewers delighted in the stylized forms that sensually evolved in the opening credits of Steven Spielberg's detective comedy Catch Me If You Can and Marc Munden's psychological thriller Miranda. In both cases the animation not only provided information about the movies, but also summarized the plot and insinuated the film's setting in such a way that the openings were like small shows in themselves.

Alternatively, the BBC's series Monkey Dust takes stock of a spectrum of British society and represents the most contemporary aspect of English animation in television.

Avec un siège à Londres mais une participation fréquente à des co-productions internationales, Nexus Productions est une entreprise leader en animations pour la télévision, la publicité, les clips vidéo et le matériel animé pour des longs métrages. Dirigée par Chris O'Reilly et Charlotte Bavasso, cette maison fondée en 1997 se caractérise par des choix de collaboration plutôt éclectiques dans le monde du dessin animé, en faisant appel à des réalisateurs japonais, tels que Satoshi Tomioka, des maîtres suédois, comme Jonas Odell, ou français, comme Florence Deygas et Olivier Kuntzel.

La première commande importante que Nexus reçoit est l'animation pour l'immense écran géant de la tournée mondiale Pop Mart du groupe U2. Depuis lors, le portefeuille de clients est allé grossissant et des dizaines de projets au langage dynamique et au contenu provocateur, voire érotique et servant les objectifs de l'entreprise, se sont succédés. La variété des techniques et l'incorporation de la logique d'animation à l'édition de

l'image réelle ont permis la croissance rapide de Nexus sur le marché des grandes marques et des studios de cinéma et d'enregistrement.

Le public s'est régalé avec les formes stylisées qui se mouvaient de façon sensuelle dans le générique de début de la comédie policière Arrête-moi si tu peux de Steven Spielberg et du thriller psychologique Miranda de Marc Munden. Dans les deux cas, l'animation non seulement apportait des informations sur les films, mais résumait aussi la trame et dévoilait l'atmosphère, ce qui en a fait un petit spectacle en soi.

La série Monkey Dust de la BBC brosse, quant à elle, tout le spectre de la société britannique et incarne l'approche la plus contemporaine de l'animation anglaise à la télévision.

Die Firma Nexus Productions arbeitet mit vielen Ländern bei ihren häufigen Koproduktionen zusammen, hat ihren Hauptsitz aber in London. Das wegweisende Unternehmen liefert Fernsehanimationen, Werbung, Videoclips und Trickfilmmaterial für Spielfilme. Die von Chris O'Reilly und Charlotte Bavasso geleitete Produktionsfirma wurde 1997 gegründet und bediente sich ganz heterogener Stilrichtungen, als sie Beziehungen zu japanischen Anime-Regisseuren wie Satoshi Tomioka u.a. und französischen Trickfilmern wie Florence Deygas und Olivier Kuntzel knüpfte.

Der erste Großauftrag, den Nexus erhielt, war die Bildanimation für den riesigen Fernsehbildschirm bei der Welttournee Pop Mart der Gruppe U2. Seit damals haben sich in den Auftragsbüchern des Unternehmens Dutzende von Arbeiten mit einer dynamischen Sprache, frechem und sogar erotischem Inhalt gesammelt, womit es exakt die jeweilige Zielsetzung erreicht. Die bunte Palette an Techniken und die eigene Logik, mit der Trickfilmsequenzen in real gefilmte Bilder geschnitten werden, garantierten Nexus einen raschen Zuwachs an Marktanteilen bei den großen Marken und den Film- und Aufnahmestudios.

Das Kinopublikum ergötzte sich an den stilisierten Formen, die sich mit viel Sinnlichkeit im Filmvorspann zu Steven Spielbergs Polizei-Komödie Catch Me If You Can bzw. zu Marc Munens Psychothriller Miranda entwickelten. In beiden Fällen bietet die Bildanimation nicht nur Information zum nachfolgenden Film, sondern fasst dessen Handlung zusammen und deutet die Atmosphäre des Films an – in einer Weise, die selbst schon eine kleine Sensation ist.

Auf der anderen Seite inventarisiert die BBC-Serie Monkey Dust gewissermaßen das gesellschaftliche Spektrum Großbritanniens und repräsentiert die aktuellste Strömung des englischen Trickfilms im Fernsehen.

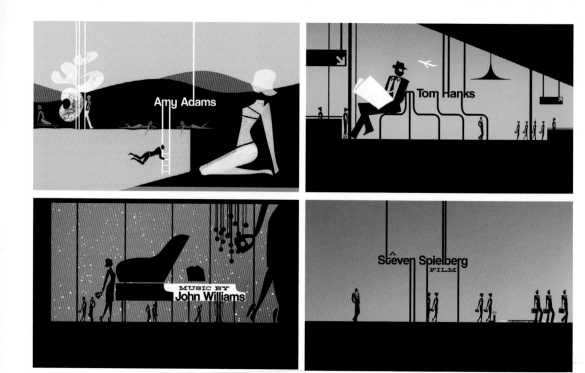

Pg. 217 Sexiest Man in Jamaica', 2002
Dir.: Smith & Foulkes (formerly Vehicle) @
Nexus Productions
3D animation
Record co: Faith and Hope
Artist: Mint Royale

Pg. 218 'Catch Me If You Can'
(main titles), 2003
Dir.: Kuntzel•Deygas @ Nexus Productions
Traditional animation
Feature film directed by: Steven
Spielberg, DreamWorks SKG

Pg. 219 Honda 'OK Factory', 2002
Dir.: Satoshi Tomioka @ Nexus
Productions
3D animation
Agency: Wieden & Kennedy

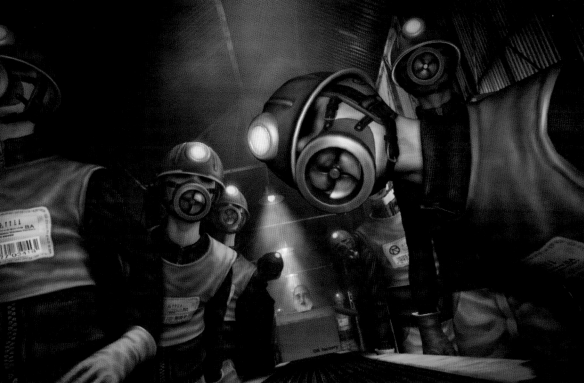

NUKUFILM OÜ

Estonia
Niine 11, Tallinn 10414
Phone: +372 6414 307
E-mail: nukufilm@nukufilm.ee

Little Peter's Dream, 1957
Little Motor Scooter, 1962
Nail, 1972
Songs to the Spring, 1975
Souvenir, 1977
Pigeon Aunt, 1983
Bride of the Star, 1984
Enchanted Island, 1985
Cabbagehead, 1993
Way to Nirvana, 2000

International Competition of Cinema
 Technology - Salerno/Italy, 1974
Special Prize of the Jury - Tampere,
 1988/ 1994/ 2003
Grand Prix - Espinho, 1989
Best Children's Film - Bombay, 1992
Best Experimental Film - Espinho, 1993
Estonian Cultural Endowment, 1994
Best Design - Annecy, 1998
I Prize - Ottawa, 1998
Leipzig Sparkasse, 1998
I Prize - Kecskemet/Hungary, 1999
Bronze Price - Seoul, 1999
Best Animation Film and Best
 Director - Riga, 2000
Grand Prix - Oberhausen, 2001

Puppet animation
Scratch
Cut out
Pixilation
Stereoscopic (ex-
 tridimensional) animation

NUKUFILM

www.nukufilm.ee

For eleven years the pioneer animator Elbert Tuganov drew and painted titles and opening sequences for Tallinnfilm studios in the former soviet republic of Estonia. However, Estonian animation is only considered to have begun when Tuganov decided to create Nukufilm in 1957. The name of the studio, which means "puppet films", reveals a lot about its initial vocation, which today coexists with a wide variety of other techniques.

The Ossetian Tuganov is the creator of *Souvenir* and *The Dappled Colt*, the first stereoscopic films –or, as they used to say, three-dimensional– with puppets as protagonists. In 1961 Tuganov asked Heino Pars to work with him, and thus the two began a saga of survival that took them through the censorship of the Soviet era, the economic changes that came with the country's independence and the more recent globalization trend. Estonia, a country with close to 1.5 million inhabitants, is one of the largest animation producers of the world.

Tuganov and Pars' generation was followed by a new group of creators equally able to stand out in the northern European animation scene. Rao Heidmets, Kalju Kivi, Riho Unt and Hardi Volmer have carried on Estonia's particular identity, which is characterized by its satirical bent, its use of a wide variety of techniques and its intelligent mixture of local culture and international taste.

After 45 years of almost non-stop activity, Nukufilm owes its success not only to the talent of its animators, but also to the tradition of worshipping a totem called "Multipus-Animus" before beginning work on each film. In all truth, the endurance of this studio is miraculous.

Pendant onze ans, le pionnier Elbert Tuganov dessine et peint des titres et des séquences de transitions pour les studios Tallinnfilm de la ex-République soviétique d'Estonie. Pourtant, l'animation ne voit vraiment le jour dans ce pays que lorsque Tuganov décide de fonder Nukufilm en 1957. Le nom signifie « film de poupées », annonciateur de sa vocation d'origine qu'il a avec le temps combinée à toute une gamme de techniques.

Originaire d'Azerbaïdjan, Tuganov crée *Souvenir* et *The Dappled Colt*, premiers films stéréoscopiques de l'histoire ou, pour reprendre l'ancienne dénomination, en trois dimensions. Les protagonistes sont alors des poupées. En 1961, il propose une collaboration à Heino Pars ; le duo entreprend une lutte pour survivre face à la censure de l'ère soviétique, aux bouleversements économiques au moment de l'indépendance et, plus récemment, aux courants globalisateurs. Avec près d'1,5 million d'habitants, l'Estonie est l'un des principaux producteurs d'animation au monde.

Après la génération de Tuganov et de Pars apparaît un groupe de créateurs capables eux aussi de se démarquer dans le milieu de l'animation au Nord de l'Europe. Rao Heidmets, Kalju Kivi, Riho Unt et Hardi Volmer sont à l'origine de l'identité estonienne reconnaissable à son aspect satirique, à la variété de techniques en jeu et à une interaction constructive entre culture locale et tendances internationales.

Au terme de 45 ans d'activité quasiment ininterrompue, Nukufilm doit son succès au talent de ses animateurs, mais aussi à la tradition de rendre hommage à un totem nommé « Multipus-Animus » avant d'entamer la réalisation de chaque film. Autant dire que l'existence de ce studio tient du miracle.

Elf Jahre lang zeichnete und malte der Filmpionier Elbert Tuganov Titel und Eingangssequenzen für die Filmstudios von Tallinnfilm in Estland, das damals noch zur Sowjetunion gehörte. Genau genommen fiel die Geburtsstunde des estländischen Trickfilms mit der Gründung von Nukufilm durch Tuganov im Jahre 1957 zusammen. Der Name des Studios, der „Puppenfilm" bedeutet, enthüllt die ursprüngliche Bestimmung, die heute noch neben einer großen Bandbreite an anderen Techniken besteht.

Der Aserbaidschaner Tuganov, der mit *Souvenir* und *The Dappled Colt* die ersten stereoskopischen oder, wie man früher zu sagen pflegte, 3D-Filme schuf, in denen Puppen die Protagonisten waren, lud Heino Pars zur Zusammenarbeit mit ihm ein. Das Paar begründete eine Legende, indem es sowohl die Zensur der sowjetischen Ära wie auch die wirtschaftlichen Umwälzungen, die mit der Unabhängigkeit einhergingen und die jüngsten Strömungen der Globalisierung überlebte. Estland mit seinen circa 1,5 Millionen Einwohnern gehört zu den größten Trickfilm-Produzenten der Welt.

Der Generation von Tuganov und Pars folgte eine Gruppe von Trickfilm-Schaffenden, die genauso befähigt ist, sich innerhalb des Panoramas des nordeuropäischen Trickfilms abzuheben. Rao Heidmets, Kalju Kivi, Riho Unt und Hardi Volmer trieben die Ausprägung der estländischen Identität voran, die von einer satirischen Seite, einer technischen Vielfalt und einem intelligenten Wechselspiel zwischen lokaler Kultur und internationalem Geschmack geprägt ist.

Nach 45 Jahren praktisch ununterbrochener Aktivität verdankt Nukufilm seinen Erfolg nicht nur dem Talent seiner Trickzeichner, sondern auch der Tradition, vor der Realisierung eines jeden Films einem Totem namens „Multipus-Animus" Ehre zu erweisen. In Wahrheit grenzt das Fortbestehen dieses Studios an ein Wunder.

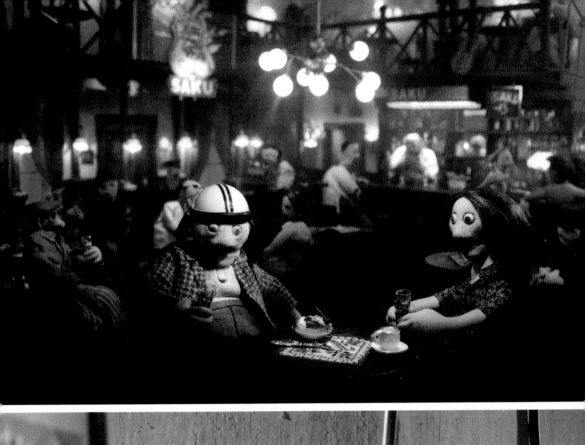

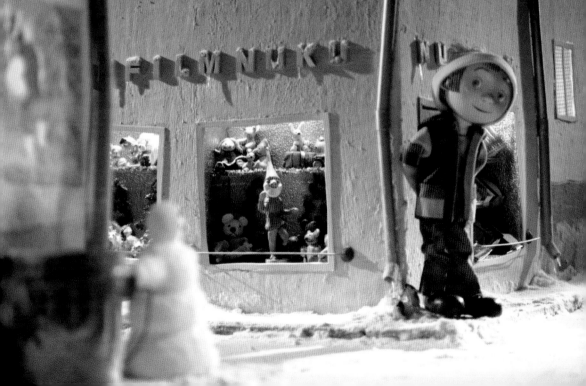

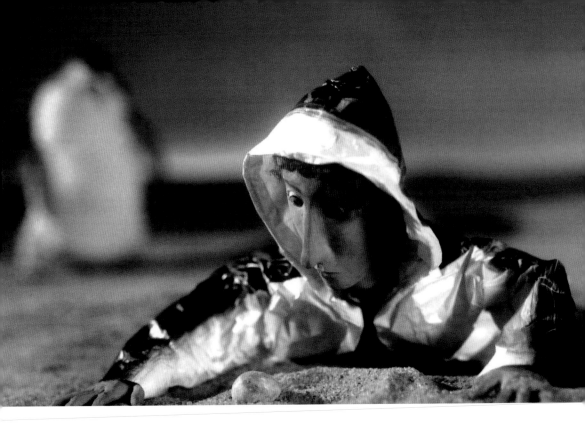

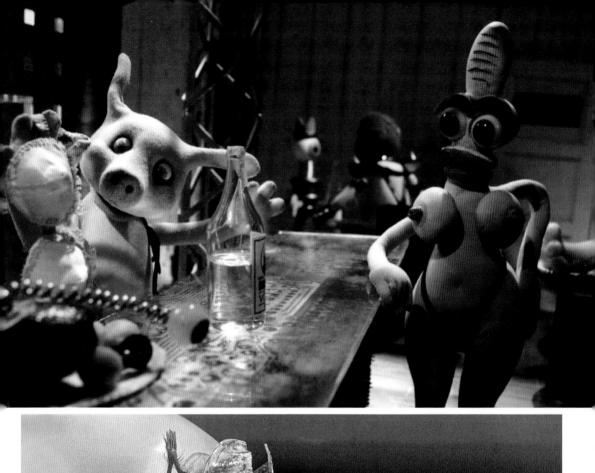

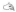

OTTO GUERRA

Brazil
Otto Desenhos Animados Ltda.
Rua Domingos José de
 Almeida, 35 - 90430-180
 Porto Alegre - RS
Phone: + 55 51 3028 7777
E-mail: otto@ottodesenhos.com.br

O Natal do Burrinho / Donkey's
 Christmas, 1984
Treiler – A Última Tentativa / Trailer
 – The Last Attempt, 1986
O Reino Azul / The Blue Kigdom, 1989
Novela / Soap Opera, 1992
Rocky e Hudson / Rocky and
 Hudson, 1994
O Arraial / Back Country, 1997
Cavaleiro Jorge / Knight Jorge, 2000
Wood & Stock, Sexo, Orégano e
 Rock / Wood & Stock, Sex, Oregano
 and Rock, 2002

Special Jury Award - Gramado, 1987
Best Gaúcho Short - Gramado, 1989
Second Prize Coral - Havana, 1993

Traditional animation
Computer graphics

OTTO GUERRA

www.ottodesenhos.com.br

Otto Guerra belongs to the creative and animated gaucho cinema group in the Brazilian state of Rio Grande do Sul. With his diverse career that includes advertising films, institutional movies and his own bitter comedies, he has become the name of reference for Brazilian *underground* animation, and the twisted path his films have forged has gained a group of followers.

The word "guerra" means war in Portuguese, and Otto Guerra does justice to his name. In 1978 he armed his trenches by establishing the company Otto Desenhos Animados. Since then he has tried to reach mass culture and address children's themes with his wonderful satire. Soap opera advertising spots, cinema trailers and western myths have all come under fire in his films. The feature film *Rocky and Hudson*, a saga about two wimpy, homosexual, schizophrenic cowboys, has become one of the cult films of Brazilian animation.

Otto Guerra owes his start in cinema to a course he took by Félix Follonier, from Argentina. Until that time he had the habit of drawing children's comic strips inspired in the adventures of Tintin, Blake & Mortimer, etc. When he did finally take on the moving image, he started by filming commercials and collaborating in successful Brazilian movies, such as *Os Trapalhões* and *Turma da Mônica*. He later went on to participate in festivals with his own creations, which were full of original humor and often contained narrative innovations. In *The Blue Kingdom*, for example, a tyrant wards off boredom by painting his whole kingdom blue.

Advances in graphic computation shook up Guerra's work methods, as he adopted the new technologies to his Internet and television productions; after all, a good warrior never rejects new weapons for his arsenal.

Otto Guerra appartient au dynamique groupe brésilien de cinéma gaucho, dans l'état de Rio Grande do Sul. Sa carrière des plus variées regroupe des films publicitaires, des vidéos institutionnelles et des comédies grinçantes d'auteur. Guerra est ainsi devenu une référence dans l'*underground* d'animation au Brésil et a fait école avec son parcours peu linéaire.

Guerra fait entièrement justice à son nom : dès ses débuts en 1978, il creuse une tranchée, la compagnie Otto Desenhos Animados. Depuis lors, il tente de toucher à la culture de masse et aux thèmes pour enfants avec ses incroyables satires. Les interludes publicitaires des téléséries, les bandes annonces de films et les mythes de l'Ouest s'inscrivent déjà comme cibles de son artillerie. Le long métrage *Rocky et Hudson*, qui conte les aventures de deux cow-boys gays, lavettes et schizophrènes, est devenu l'un des films *cultes* de l'animation au Brésil.

C'est grâce à un cours de l'Argentin Félix Follonier qu'Otto Guerra fait ses débuts au cinéma. Jusqu'alors, il a l'habitude enfantine de dessiner des bandes dessinées que les aventures de Tintin ou Blake & Mortimer lui inspirent. Lorsqu'il passe enfin à l'image animée, il commence avec des spots et des films à succès dans son pays, tels que Os Trapalhões et Turma da Mônica. Plus tard, il participe à des festivals pour présenter ses propres œuvres, pleines d'un humour original et d'histoires innovantes. Dans *O Reino Azul* par exemple, un tyran chasse l'ennui en peignant son royaume en bleu.

L'avènement des outils de traitement graphique bouleverse les méthodes de travail de Guerra, qui intègre les nouvelles technologies à ses productions pour Internet et la télévision. Il va de soi qu'un bon guerrier ne refuse jamais de nouvelles armes pour assortir son arsenal.

Otto Guerra gehört zu der munteren und kreativen Gruppe des sogenannten Gaucho-Kinos im brasilianischen Bundesstaat Rio Grande do Sul. Mit seiner abwechslungsreichen und nicht geradlinigen Laufbahn, die kommerzielle und von Institutionen in Auftrag gegebene Filme genauso umfasst wie Autorenfilme, nämlich seine beißenden Komödien, machte er Schule: Sein Name wurde zur Empfehlung für den Zeichentrickfilm der brasilianischen Underground-Kultur.

Guerra, was auf Deutsch soviel wie Krieg heißt, macht seinem Nachnamen alle Ehre. Seit 1978 markierte er mit seinem Unternehmen „Otto Desenhos Animados" die Gefechtslinien und versuchte mit seinen Themen für Kinder und seinen wunderbaren Satiren von Anfang an, die Massen zu erreichen. Die Werbepausen während seichter Fernsehserien, Kinotrailer und die Mythen des Westens waren schon Zielscheibe seiner Artillerie. Sein Spielfilm *Rocky e Hudson*, der von zwei homosexuellen, verweichlichten und schizophrenen Cowboys handelt, wurde zu einem Kultfilm des brasilianischen Zeichentricks.

Otto Guerra verdankt seinen Einstieg ins Kino einem Kurs bei dem Argentinier Félix Follonier. Bis dahin hatte er die Angewohnheit aus seiner Kindheit beibehalten, humoristische Streifen zu zeichnen, die von den Abenteuern Tintins, von Blake & Mortimer und anderen angeregt waren. Als er schließlich das bewegte Bild übernahm, begann er zunächst mit Reklame und Beiträgen für Erfolgsfilme des brasilianischen Kinos wie *Os Trapalhões* (*The Brazilian Star Wars*) und *Turma da Mônica*. Später nahm er an Festivals mit eigenen Werken teil, die sich durch einen ganz eigenen Humor auszeichnen und erzählertechnisch häufig innovativ sind. In *The Blue Kingdom* zum Beispiel vertreibt sich ein Tyrann die Langeweile damit, dass er sein gesamtes Reich blau anmalen lässt.

Die Einführung der Computergrafik rüttelte Guerras Arbeitsmethoden auf; er machte sich die neuen Technologien für seine Internet- und TV-Produktionen zu Eigen. Ein guter Krieger verzichtet eben nicht auf neue Waffen für sein Arsenal.

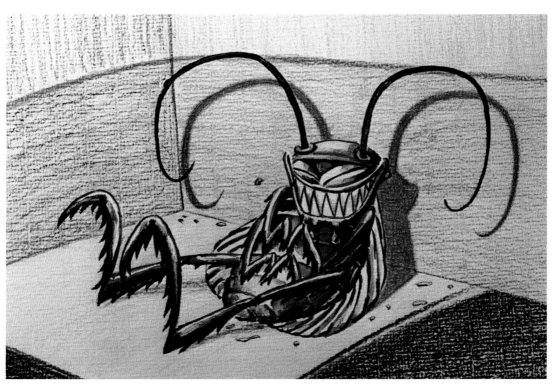

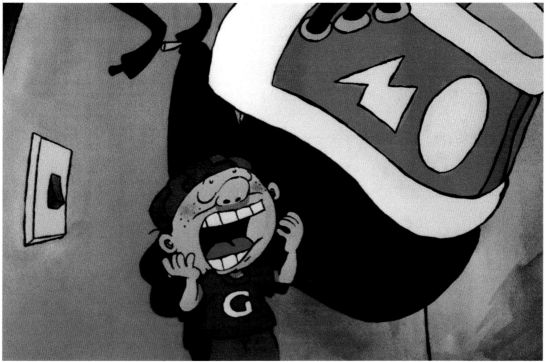

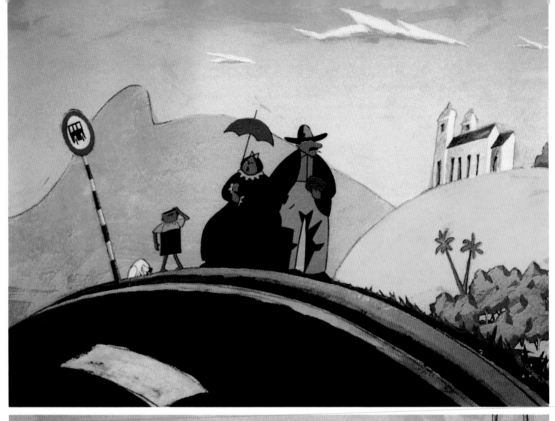

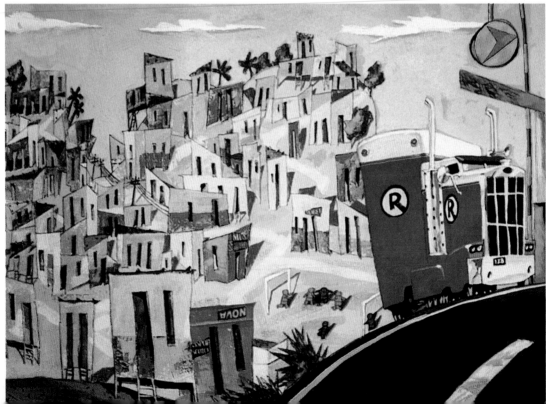

Pg. 225
(top) Barata

(bottom) Gastonzinho

Pg. 226–227 O Reino Azul / The
Blue Kingdom, 1989
Traditional animation

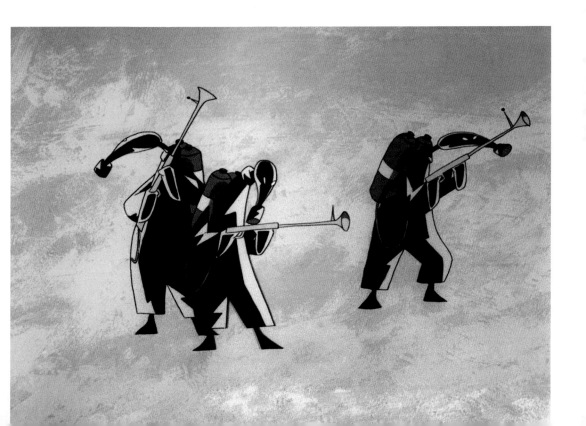

PAVEL KOUTSKY

Czech Republic
Na Kampe 13, 11000 Prague 1
Phone: + 420 32 759 5240
E-mail: pkoutsky@tiscali.cz

Laterna Musica, 1985
Curriculum Vitae, 1986
Láska na první pohled / Love at First Sight, 1986
Od kroku k pokroku / Step by Step, 1987
Portrét / The Portrait, 1988
Duel, 1990
Long Live the Mouse, 1993
Media, 1999
Towards Fairy-Tales series, 2002
Four Loves, 2003

First Prize - *Chicago,* 1984
Golden Bear - *Berlin,* 1987
First Prize and Audience Prize - *Huesca,* 1987
First Prize and Critics Prize - *Espinho,* 1987
Best Animation - *Tampere,* 1987
Golden Dancer - *Huesca,* 1988
Silver Bear - *Berlin,* 1988/1993/2000
First Prize - *Espinho,* 1988
Jury's Prize - *Bombay,* 1992
Fipresci Prize - *Annecy,* 2000

Traditional animation
Stop-motion
"Total animation"

PAVEL KOUTSKY

The critical aspect of Eastern European animation is perfectly represented in the movies of Pavel Koutsky, author of several recent Czech animation films, such as *Curriculum Vitae, Media* and *Long Live the Mouse,* all of which have won awards in the Berlin Film Festival. In these films of great intellectual vivacity and bitter humor, the individual is subjugated to the forces of a system that manipulates and imposes conformation, whether that system is the media, modern technology or ideological indoctrination. In addition, the victories achieved in his movies are always provisional, pure illusions.

Koutsky was born in Prague in 1957 and studied at the Academy of Applied Arts in the Czech capital. He had his first experience with animation at age 13, and at 16 he began to win awards. When he was still quite young he collaborated with great film masters like Jiri Trnka. In 1985 he made his first professional film, *Laterna Musica,* a movie that launched one of the motifs of his work: music as a theme and as an instigator of the rhythm of animation.

Together with Michaela Pavlátová, Koutsky represents a technical innovation that they call "total animation", which consists of throwing the spectator into a whirlwind of action with captivating spatial relations. Following the tradition of Czech satire, in some works Koutsky animates real objects such as newspapers, casseroles and even pieces of meat.

Alongside his revered philosophical comedies – some 20 short films that he himself has written, drawn and animated – Pavel Koutsky has directed some material for television and advertising, and has done other commissioned work.

L'esprit critique caractéristique de l'animation des pays de l'Est trouve toute son expression dans la filmographie du Tchèque Pavel Koutsky, auteur de quelques œuvres phares d'une discipline toute récente dans son pays : ses créations *Curriculum Vitae, Media* et *Long Live the Mouse* ont reçu un prix au Festival de cinéma de Berlin. Dans ces films de grande stimulation intellectuelle et d'un humour grinçant, l'individu est sous l'emprise d'un système manipulateur et d'homogénéisation, tel que moyens de communication, informatique ou endoctrinement idéologique; ses victoires sont alors toujours provisoires et illusoires.

Koutsky naît à Prague en 1957 et étudie à l'Académie des arts appliqués de la capitale tchèque. Il est âgé de 13 ans seulement lorsqu'il découvre l'animation, et de 16 lorsqu'il remporte ses premiers prix. Encore très jeune, il collabore avec de grands maîtres comme Jiri Trnka. En 1985, il réalise son premier film professionnel intitulé *Laterna Musica,*

qui vaut l'introduction d'un thème récurrent dans son œuvre, à savoir la musique comme sujet et source du rythme de l'animation.

Avec Michaela Pavlátová, Koutsky symbolise un choix technique qu'ils qualifient « d'animation totale », l'idée étant de plonger le spectateur dans un tourbillon d'actions, avec une dimension spatiale absolument fascinante. Dans certains films, des objets réels tels que journaux, casseroles ou encore morceaux de viande sont animés dans la lignée de la tradition satirique tchèque.

Outre ses comédies philosophiques qui font l'unanimité (une vingtaine de courts métrages dont il a assumé scénario, dessin et animation), Pavel Koutsky a dirigé quelques productions pour la télévision, des spots publicitaires et autres projets commerciaux.

Den für Osteuropa typisch kritischen Charakter des Trickfilms repräsentiert das Filmwerk von Pavel Koutsky. Er ist Urheber einiger erstklassiger Werke des jüngeren tschechischen Trickfilms, wie etwa *Curriculum Vitae, Media* und *Es lebe die Maus,* die allesamt auf der Berlinale prämiert wurden. In diesen sehr scharfsinnigen und von beißendem Humor geprägten Filmen erscheint der Einzelne, dessen Siege immer nur vorübergehend, also reine Illusion sind, den Kräften eines manipulierenden und gleichmacherischen Systems unterworfen, verkörpert durch die Massenmedien, die elektronische Datenverarbeitung oder die ideologische Indoktrination.

Koutsky, der 1957 in Prag zur Welt kam, studierte in der tschechischen Hauptstadt an der Hochschule für Angewandte Künste. Seine erste Erfahrung mit Animation machte er mit dreizehn, mit sechzehn gewann er bereits erste Preise. Noch sehr jung arbeitete er schon mit Altmeistern wie Jiri Trnka. Seinen ersten professionellen Film, nämlich *Laterna Musica,* drehte er 1985 und setzte da schon eine Konstante seines späteren Werkes ein: die Musik, die Thema und Rhythmus des Zeichentricks vorgibt.

Zusammen mit Michaela Pavlátová steht Koutsky für eine technische Möglichkeit, die sie "totale Animation" nennen und die darin besteht, den Zuschauer in einen Handlungsstrudel, in eine wahre Ekstase räumlicher Beziehungen zu reißen. In einigen Arbeiten haucht er realen Dingen Leben ein, z.B. Zeitungen, Tiegeln und sogar Fleischstücken, und folgt damit der tschechischen Tradition der Satire.

Neben seinen philosophischen Komödien, denen alle Ehre gebührt – dazu zählen ungefähr zwanzig Kurzfilme, für deren Drehbuch, Zeichnung und Trick er allein verantwortlich war - übernahm Pavel Koutsky auch kommerzielle Regieaufträge für das Fernsehen und für Reklamefilme.

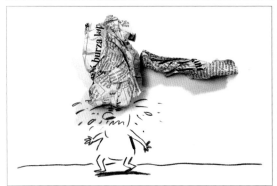

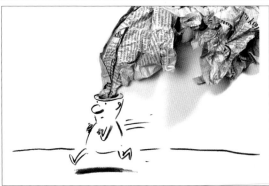

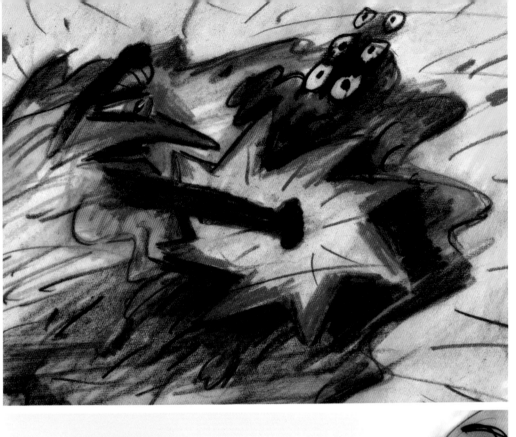

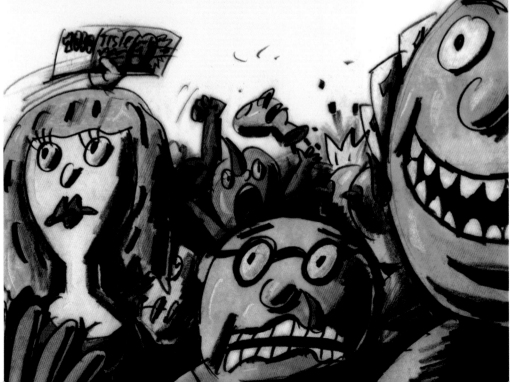

PHIL MULLOY

United Kingdom
Spectre Films
87 Kingsmead Road, Tulse Hill,
SW2 3HZ London
Phone: + 44 20 8674 5838
E-mail: philmulloy@hotmail.com

Possession, 1991
Cowboys - series, 1992
The Sound of Music, 1993
The Ten Commandments - series,
 1993-1996
The History of the World - series, 1994
The Wind of Changes, 1996
The Chain, 1997
The Sexlife of a Chai, 1998
Season's Greetings, 1999
Intolerance I, II and III, 2000-2003
Love is Strange, 2002

Kino Award - *Melbourne*, 1991
McLaren Award, 1993
Critics Award - *Zagreb*, 1993/1998
Design Award - *Mediawave*, 1993
Special Award - *Hiroshima*, 1996
Special Award - *Stuttgart*, 1996
Life Achievement - *Grenada*, 1999
Jury Prize - *Annecy*, 2000
Best Animation - *Mediawave*, 2000
Best Short - *Imago*, 2000
Grand Prix - *Tampere*, 2001
Jury Prize - *Castelli Animati Rome*, 2001
City of Espinho Award, 2001

Traditional animation

PHIL MULLOY

www.philmulloy.com

"Thou shalt not remain indifferent to the explosive provocations of Phil Mulloy". This could very well be one of the commandments for animation film enthusiasts. In the series *The Ten Commandments*, Mulloy analyzes contemporary life through the tablets of a God that is conceived in the image and likeness of the cruellest of men, while in the *Cowboys* series the Western scenery lends itself to a devastating vision of male-chauvinist culture and a system ruled by competition and violence.

The only limit to the sarcasm and bitterness of this great British animator's dark comedies is the incredible openness with which he un-masks social behavior submitted to different types of repression. Viewers laugh a lot, although deep down they shudder. Some of his movies take place on the planet Zog, which is an amusement park for metaphors. Thus, "zogs" have their penises on their heads, an anatomical detail that suggests an uncomfortable similarity with certain inhabitants of planet Earth. The history of the world, according to Mulloy, is marked by recurring errors and irreparable brutality.

In keeping with his extremely critical themes, Phil Mulloy's style is minimalist, crude and consciously primitive; a million light years from the good feelings and clean lines of conventional cartoons. This lover of the grotesque entered animation later in life, after having worked for almost 20 years on documentaries and television programs. Mulloy graduated from the Royal College of Arts in 1971, but he did not dedicate himself to animation completely until after 1988. Initially set up in a renovated stable in Wales, this filmmaker has produced and distributed all of his work through Spectre Films of London.

« Vous ne resterez pas indifférents aux provocations explosives de Phil Mulloy »: tel pourrait être l'un des commandements du cinéphile averti en matière d'animation. Dans la série *Les dix commandements*, Mulloy analyse la vie contemporaine via les tables d'un Dieu dont l'apparence est celle du plus méprisable des hommes, alors que dans *Cowboys*, l'Ouest renvoie une image destructrice de la culture machiste et d'un système régi par la compétition et la violence.

La seule limite au sarcasme et à l'humour corrosif de cet animateur britannique de talent est l'incroyable franchise avec laquelle il décortique le comportement social soumis aux divers types de répression. Le spectateur rit beaucoup, mais il tremble aussi. La planète Zog, théâtre de certains de ses films, est un parc d'attractions pour la métaphore. Les « Zogs » ont le pénis sur la tête, un détail anatomique offrant une comparaison dérangeante avec certains terriens. Selon Mulloy, l'histoire du monde est marquée par des erreurs récurrentes et une brutalité irrémédiable.

En accord avec cette thématique extrêmement critique, l'esthétique de Phil Mulloy est minimaliste, brute et volontairement primitive, à des millions d'années lumière des bons sentiments et de la pureté des dessins animés traditionnels. Cet amateur du grotesque est arrivé à l'animation à un âge avancé, après près de 20 ans à travailler sur des documentaires et des programmes télévisés. Mulloy obtient en 1971 le diplôme du Royal College of Arts, sauf qu'il n'exerce pas avant 1988 comme animateur. D'abord installé dans une étable restaurée au Pays de Galles, le cinéaste produit et distribue toutes ses œuvres via la société Spectre Films de Londres.

"Phil Mulloys explosive Provokationen werden dich nicht unberührt lassen." Diese Weisheit könnte eines der Zehn Gebote für den guten Trickfilmfan sein. In der Serie *The Ten Commandments* analysiert Mulloy das zeitgenössische Leben mittels der Gesetzestafeln eines Gottes, der Ebenbild des gemeinsten aller Menschen ist, während in der Serie *Cowboys* die Westernszenerie für eine verheerende Sicht der Macho-Kultur und eines von Konkurrenz und Gewalt regierten Systems herhalten muss.

Der Sarkasmus und die beißende Schärfe der schwarzen Komödie dieses großen britischen Trickfilmers kennt keine Grenze, und mit unglaublicher Freiheit entblößt er das gesellschaftliche Verhalten mit seinen unterschiedlichen Arten der Unterdrückung. Das gibt dem Zuschauer viel zu lachen, doch im Grunde lässt es ihn erschauern. Der Planet Zog, wo einige seiner Filme spielen, ist ein Vergnügungspark der Metaphern. So haben die Zogs ihren Penis auf dem Kopf, ein anatomisches Detail, das eine unangenehme Parallele zu gewissen Bewohnern des Planeten Erde ziehen lässt. Die Weltgeschichte ist für Mulloy von unverbesserlichen Fehlern und nicht kurierbarer Brutalität geprägt.

In Übereinstimmung mit dieser zutiefst kritischen Thematik ist Phil Mulloys Ästhetik auf ein Minimum beschränkt, roh und bewusst primitiv – Lichtjahre entfernt von den guten Gefühlen und der Reinheit konventioneller Zeichentricks. Dieser Liebhaber des Grotesken stieß erst in reifem Alter zum Trickfilm, nachdem er fast 20 Jahre lang für Dokumentarfilme und Fernsehprogramme gearbeitet hatte. Mulloy schloss 1971 am Royal College of Arts ab, aber erst seit 1981 widmet er sich definitiv dem Beruf des Animationskünstlers. Die Firma Spectre Films mit Sitz in London war von Anfang an zuständig für Produktion und Verleih des gesamten Werks des Filmemachers, obwohl er zunächst noch in einem umgebauten Stall in Wales untergebracht war.

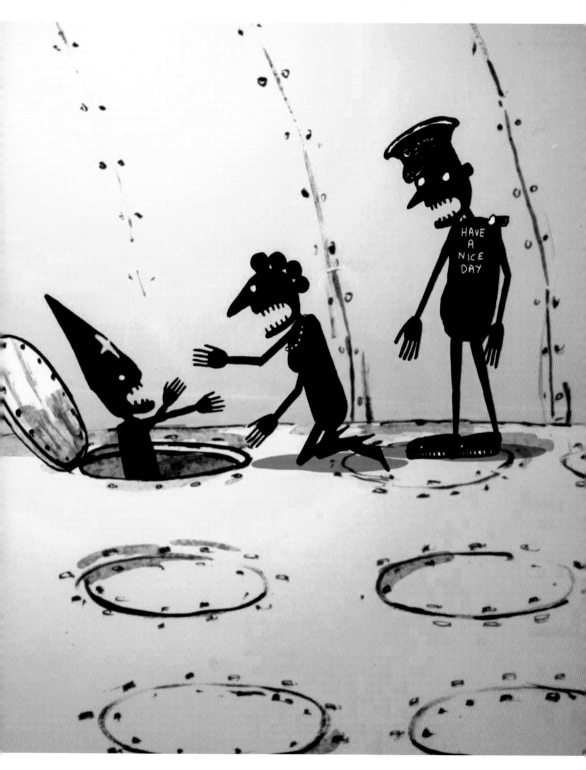

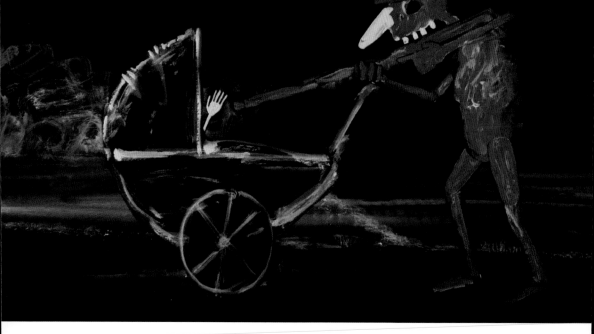

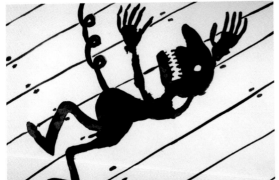
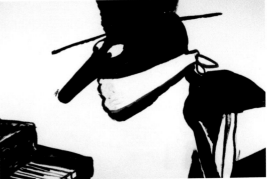
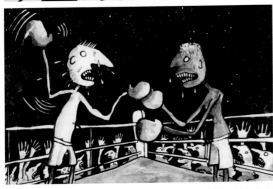
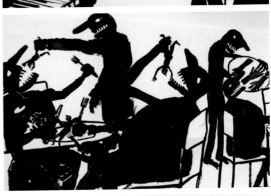
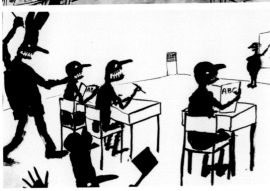
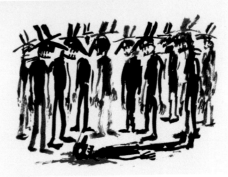

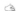

"PILOT" MOSCOW ANIMATION STUDIO

Russia
"Pilot" Moscow Animation Studio
Contact: Natalia Khenkina
Khohlovsky per., 16/1
Moscow 109028
Phone: + 7 09 5925 1679
E-mail: festival@pilot-film.com
office@pilot-film.com

The Cow, 1989
The Lift, 1989
Aviators, 1990
Andrei Svislotski, 1991
The Hunter, 1991
Pacifier, 1993
Gagarin, 1994
Pilot Brothers series, 1995-1998
Gone With the Wind, 1998
Bookashkis, 2002

Grand Prix and Best Debut Film
 Hiroshima and Ottawa 1990,
Fipresci Prize Oberhausen 1991,
First Prize in category
 WAC/USA 1991,
Best in category Ottawa 1994,
Golden Palm Cannes 1995,
Best Debut Film and Audience
 Prize Annecy 1995,
Prize of the Jury Hirsohima 1996,
3 Nika Awards,
Melhor Curta Metragem - Juri
 Popular Anima Mundi 2003,
Melhor Filme - Juri Profissional
 Anima Mundi 2003.

Traditional animation
Computer graphics
Mixed media
Animation combined
 with live action

PILOT MOSCOW

www.pilot-film.com

Pilot Moscow Animation has left its mark in history as the first private animation studio in Russia. Since Alexander Tatarsky and Igor Kovalyov founded it in 1988, Pilot has been involved in uncountable initiatives for the modernization of Russian mass culture, whether in the development of new media or in the creation of new animation techniques. Free from state control, although not exempt from financial difficulties, the studio has had to collaborate with several different countries to be able to carry out their experimental programs.

With a solid list of clients in the area of advertising, Pilot uses its commercial profits to finance the artistic projects of its directors. The end result is some of the classics of animation cinema from the last two decades, which have been awarded with more than 100 international prizes and created by people like Kovalyov, Alexander Petrov, Aleksei Kharitidi (author of Gagarin, winner of the Cannes Golden Palm award and nominated for an Oscar), Konstantin Bronzit and Mikhail Aldashin, among others.

At the end of the nineties, the creative engines of Pilot went on to emphasize production for alternative media, animation for Internet and computer games. In addition, the studio maintains contact with the public through popular television series that combine digital animation with real action. Pilot also has its own school of animation, the School of New Screen Technologies, where it has already educated an entire generation of directors who are admired internationally.

Pilot Moscow Animation a joué un rôle historique en tant que premier studio d'animation privé de Russie. Depuis sa création en 1988 par Alexander Tatarsky et Igor Kovalyov, Pilot a participé à d'innombrables initiatives de modernisation de la culture de masse du pays, tant par le développement de nouveaux supports que par la création de techniques d'animation. Exempt du contrôle de l'État mais pas de difficultés financières, le studio a établi des collaborations avec plusieurs pays pour mener à bien ses projets expérimentaux.

Pilot possède un grand nombre de clients dans le monde de la publicité et consacre ses bénéfices au financement des projets artistiques de ses réalisateurs. Parmi ces œuvres se comptent quelques classiques de l'animation des deux dernières décennies ayant raflé plus de 100 prix internationaux. Les auteurs sont, entre autres, Kovalyov, Alexander

Petrov, Aleksei Kharitidi (créateur de Gagarin, vainqueur de la Palme d'or à Cannes et nominé aux Oscars), Konstantin Bronzit et Mikhail Aldashin.

À la fin des années 90, les moteurs créatifs de Pilot ont changé de cap et accordé la priorité à des médias alternatifs, à l'animation sur Internet et aux jeux pour ordinateur. Le studio maintient un échange avec le public via de célèbres séries télévisées qui marient animation numérique et action réelle. Pilot possède en outre sa propre école d'animation, la School of New Screen Technologies, qui a déjà formé toute une génération de réalisateurs reconnus à travers le monde.

Pilot Moscow Animation hat als erstes privates Studio für Bildanimation in Russland eine historische Rolle gespielt. Seit seiner Gründung durch Alexander Tatarsky und Igor Kovalyov 1988 hat Pilot bei unzähligen Initiativen zur Modernisierung der russischen Massenkultur die Hände im Spiel gehabt, sei es im Bereich der Entwicklung neuer Kommunikationsmedien oder der Erschaffung neuer Trickfilmtechniken. Um seine experimentellen Programme voranzutreiben, ist Pilot Koproduktionen mit verschiedenen Ländern eingegangen, da das Studio zwar von staatlicher Kontrolle, aber nicht von Finanzierungsschwierigkeiten befreit ist.

Mit einem festen Kundenstamm in der Werbebranche erzielt Pilot Gewinne aus kommerziellen Produkten, die es zur Finanzierung der künstlerisch ambitionierten Projekte der Studioleiter investiert – mit dem Ergebnis, in den vergangenen zwei Jahrzehnten mit mehr als hundert internationalen Preisen ausgezeichnete Trickfilmklassiker hervorgebracht zu haben, für die Leute zeichneten wie Igor Kovalyov, Alexander Petrov, Aleksei Kharitidi (der mit Gagarin die Goldene Palme von Cannes gewann und für einen Oscar nominiert wurde), Konstantin Bronzit und Mikhail Aldashin.

Ende der neunziger Jahre liefen die kreativen Turbinen auf Hochtouren und man ging dazu über, besonderen Nachdruck auf die Produktion für andere Kommunikationsmedien wie das Internet und Computerspiele zu legen. Andererseits pflegt das Studio weiterhin den Dialog mit dem Publikum durch populäre Fernsehserien, die digitale Animation mit real gefilmten Passagen kombinieren. Pilot kann auf eine eigene Schule für Trickfilmkunst verweisen, die School of New Screen Technologies. Dort wurde schon eine ganze Generation von international anerkannten Regisseuren ausgebildet.

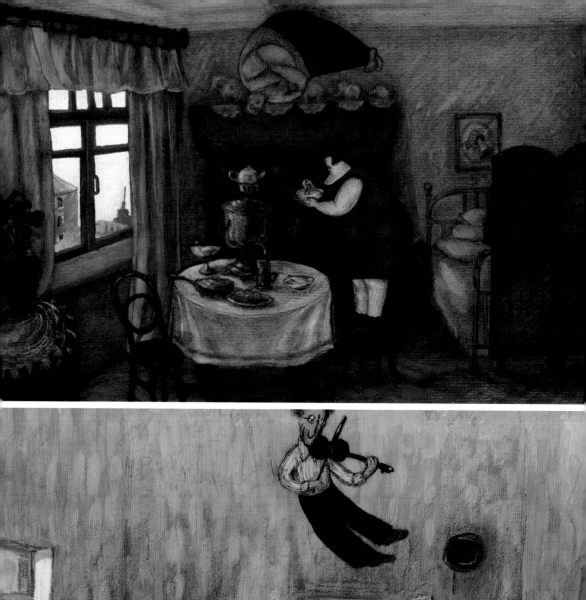

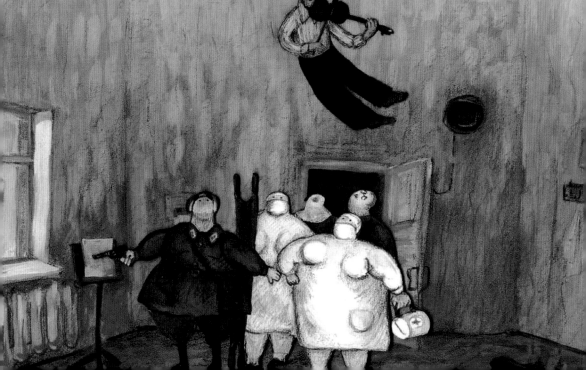

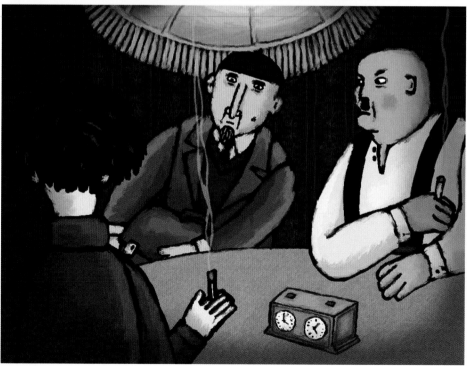

PIOTR DUMALA

Poland
Phone: + 48 22 651 5642
E-mail: pjdumala@yahoo.com

Lykantropia / Lycantrophy, 1981
Czarny Kapturek / Little Black
Riding Hood, 1982
Latajace Wlosy / Flying Hair, 1984
Lagodna / Gentle Spirit, 1985
Nerwowe Zycie Kosmosu / Nervous
Life of Cosmos, 1986
Sciany / Walls, 1987
Wolnosc Nogi / Freedom of the Leg, 1988
Franz Kafka, 1991
Zbrodnia i Kara / Crime and
Punishment, 2000

Golden Ducat - *Mannheim*, 1985
Grand Prize - *Zagreb*, 1992
Grand Prize - *Espinho*, 1992
Best Animated Cartoon - *Ottawa*,
1992
Grand Prize - *Krakow*, 1998
Jury Special Prize - *Annecy*, 1998
Most Innovative Design - *Ottawa*,
2000

Scratching and painting
on plaster plates

PIOTR DUMALA

Piotr Dumala was studying sculpture at Warsaw's Academy of Fine Arts when he discovered animation cinema. While working with heavy plates of plaster, he thought that he could paint them and then scratch them with sharp instruments until obtaining a sequence of images capable of telling a story. Thus a genius of this technique was born, and a dreamlike, taciturn universe began that would distinguish Dumala in the international scene.

His admiration for writers like Kafka and Dostoyevski, as well as for classic Dutch painting, took care of the rest. Dumala's movies are cruel tales with themes relating to the dark areas of human nature. *Lycantrophy*, for example, reflects a terrible succession of events in which man clearly appears as a wolf of man, and *Walls* synthesizes the fear and fatalism of life under a totalitarian regime.

In his films, the human body is usually fragmented and wounded without mercy, the purpose of which is "making visible that which is physically impossible", as Dumala has stated. The nocturnal and poorly illuminated settings of his stories offer a very peculiar expressionism. This is especially manifest in the two films based on Dostoyevski's works, *Gentle Spirit* and *Crime and Punishment*. The latter, which took him three years to produce, is considered by the director to be "the film of his life".

Piotr Dumala is an artist of many talents who has drawn comics, published a book of short stories, writes screenplays for feature films, works as a journalist, paints, creates illustrations and posters and teaches animation classes in Poland, Sweden and the United States, in addition to directing commercials and trailers for television. Dumala has also won awards for four illustrations that he created for MTV.

Piotr Dumala découvre le cinéma d'animation au cours de ses études de sculpture à l'Académie des beaux-arts de Varsovie. Il pense alors pouvoir peindre de grandes plaques de plâtre et les graver avec des outils afin de représenter des séquences d'images et raconter une histoire. C'est ainsi que naissent un génie de cette technique et un univers onirique et taciturne lui permettant de se démarquer dans le panorama international.

Son admiration pour des écrivains comme Kafka et Dostoïevski, ainsi que pour les grands peintres hollandais classiques, ont fait le reste. Les films de Dumala relatent des contes cruels s'inspirant des zones obscures de la nature humaine. Par exemple, *Lycantrophy* enchaîne une terrible série d'événements où l'homme apparaît comme un loup pour son espèce ; *Walls* traite de la peur et du fatalisme de la vie sous un régime totalitaire.

Le corps humain est bien souvent déstructuré et lacéré sans pitié afin de « montrer ce qui est physiquement impossible », selon Dumala. De l'ambiance nocturne ou peu éclairée de ses histoires suinte un expressionnisme très particulier. Tel est notamment le cas des deux productions basées sur les œuvres *L'idiot* et *Crime et châtiment* de Dostoïevski, la seconde étant considérée par l'auteur comme le «film de sa vie» et qui lui aura demandé trois ans de préparation.

Piotr Dumala est un artiste polyvalent, auteur de bandes dessinées, d'un livre de contes, de scénarios pour des longs métrages, journaliste, peintre, dessinateur d'illustrations et d'affiches, professeur d'animation en Pologne, en Suède et aux États-Unis, sans compter la direction de spots publicitaires et de bandes annonces. Dumala a également été récompensé pour quatre illustrations réalisées pour la MTV.

Piotr Dumala studierte Bildhauerei an der Kunstakademie von Warschau, als er den Trickfilm für sich entdeckte. Er arbeitete mit schweren Gipsplatten in der Überzeugung, dass er diese bemalen und mit spitzen Werkzeugen zerkratzen könnte, um so Bildsequenzen zu erhalten, mit denen sich eine Geschichte erzählen ließe. In der Geburtsstunde dieser Technik, die er genial handhabte, entstand auch eine in sich gekehrte Traumwelt, die innerhalb des internationalen Panoramas ihresgleichen sucht.

Die Bewunderung für Autoren wie Kafka und Dostojewski wie für die altniederländische Malerei besorgte den Rest. Dumalas Filme sind grausame Geschichten, die die dunklen Seiten der menschlichen Natur zum Thema haben. In *Lykantropia* z.B. entfaltet er eine furchtbare Abfolge von Ereignissen, bei denen der Mensch deutlich als Wolf erscheint, und *Die Wände* fasst die Angst und den Fatalismus eines Lebens unter totalitärem Regime zusammen.

Entsprechend wird bei ihm gewöhnlich der menschliche Körper erbarmungslos zerstückelt und zerrissen mit dem Ziel, „sichtbar zu machen, was physisch eigentlich unmöglich ist", wie Dumala es selbst ausdrückt. Destillat seiner Geschichten, die meist in nächtlichem oder recht dunklem Ambiente spielen, ist ein sehr eigener Expressionismus. Das schlägt sich besonders in den beiden auf Dostojewski beruhenden Filmen *Die Sanfte* und *Schuld und Sühne* nieder, letzterer vom Regisseur selbst als „der Film seines Lebens" angesehen, dessen Realisierung ihn drei Jahre kostete.

Piotr Dumala ist ein vielseitiger Künstler, der Comics gezeichnet, ein Geschichtenbuch publiziert, Drehbücher für Spielfilme verfasst, als Journalist gearbeitet hat, der malt, Illustrationen und Plakate entwirft sowie in Polen, Schweden und den Vereinigten Staaten Trickfilm unterrichtet, nicht zu vergessen, dass er bei Werbespots und TV-Trailern Regie führt. Dumala wurde auch für vier Illustrationen, die er für den Musiksender MTV ausgeführt hat, ausgezeichnet.

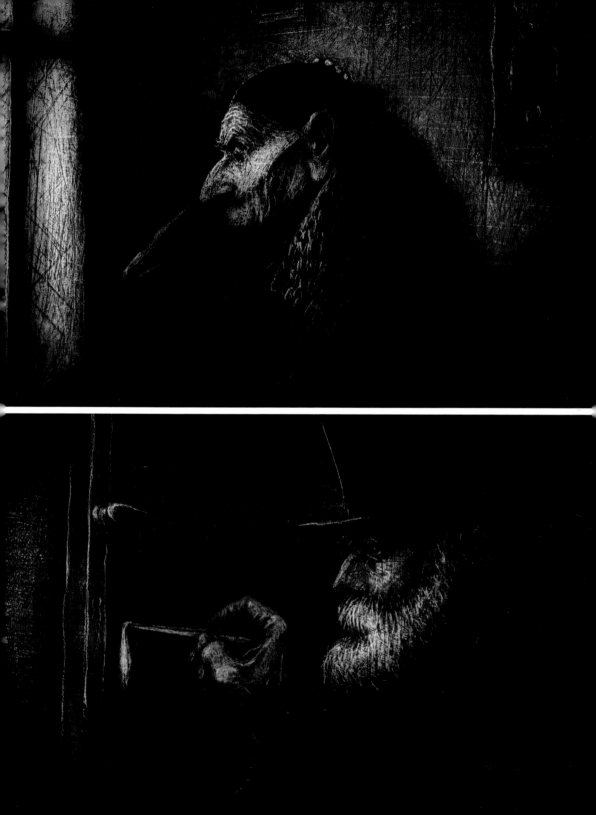

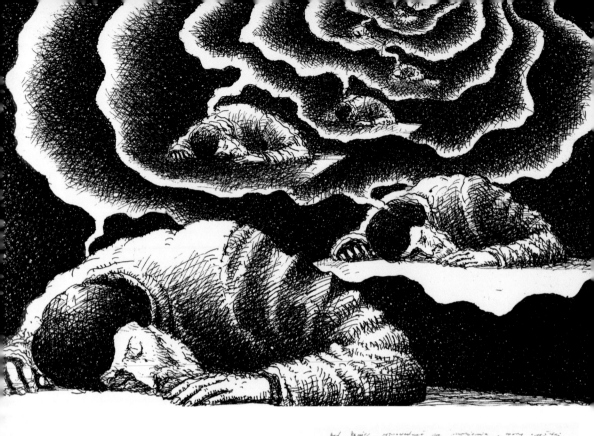

Pg. 241 Zbrodnia i Kara / Crime and
Punishment, 2000
Scratching and painting on plaster plates

Pg. 242-243 Child, 2002
Pencil on paper

(right) Storyboard

**PIXAR ANIMATION
STUDIOS**

Luxo Jr., 1986
Red's Dream, 1987
Tin Toy, (1988),
Knick Knack, 1989
Toy Story, 1995
Geri's Game, 1997
A Bug's Life, 1998
Toy Story 2, 1999
For the Birds, 2000
Monsters, Inc., 2001
Mike's New Car, 2002
Finding Nemo, 2003
The Incredibles, 2004
Boundin', 2004

Gold Gate Award San Francisco 1987,
Academy Award Best Short Animated
Film 1988/1997/2001,
Academy Award Scientific and
Engineering 1991/1992/1994/1995/1997,
Gold Medal Clio Awards 1993/1994,
Academy Award for Special
Achievement (1995),
Academy Award for Technical
Achievement 1996/1998,
Annie Awards 1996/1998/2000/2003,
Public Prize Annecy 1998,
Grammy 1999,
Academy Award of Merit 2000,
Golden Globe Best Picture 2000,
Academy Award Best Original
Song 2001,
Children's Award BAFTA 2002,
Vanguard Award Producer's Guild of
America 2002
Academy Award Best Animated
Film 2003 (Finding Nemo)

3D Computer animation

www.pixar.com

For the Pixar team, technology is Art written with a capital A. The work of this Emeryville, California, studio has hastened the non-specialized public's acceptance of 3D computerized cartoons and helped change the image of worldwide animation.

The company's logo, which appears at the opening of all their movies, evokes the first success of John Lasseter, executive creative vice president. The fun and sensitive Luxo Jr. lamps shed light on the possibilities of associating graphic computation with emotional values that, in the eighties, seemed to be a privilege of traditional animation alone. Since then, jealous toys, dreamy bicycles, unadjusted insects, panicky little monsters, vengeful birds and mischievous fish have all popped out of the company's microchips.

Lasseter, a former animator for Disney and Lucasfilm, has been at the center of this company since Steve Jobs, of Apple, created Pixar in 1986. Each studio production has challenged the limits of three-dimensional animation with respect to improving textures and constructing palpable characters from bits and pixels. Pixar has also developed exclusive software systems – Marionette, Ringmaster and RenderMan – that give them quick and excellent results.

Through an agreement signed with Disney in 1991, John Lasseter directed his first totally digital animated feature film, the revolutionary movie Toy Story. Other highly successful full-length films and four Oscar awards have since followed, and with them Pixar has become a more and more popular and renown studio.

Pour l'équipe de Pixar, la technologie est un art majeur. Dans ce studio installé à Emeryville, en Californie, tout vise à habituer un public non initié aux dessins animés réalisés en 3D sur ordinateur, ce qui contribue à l'évolution de l'image de l'animation au niveau mondial.

Au début de chaque film, le logo de l'entreprise qui apparaît illustre le premier succès de John Lasseter, producteur exécutif. Dans Luxo Jr., l'amusant jeu entre des lampes a permis de combiner traitement graphique et émotions, ce qui semblait être encore dans les années 80 un privilège réservé à l'animation traditionnelle. Depuis lors, Lasseter et sa troupe ont donné vie à des jouets jaloux, des bicyclettes rêveuses, des insectes dérangés, de petits monstres hystériques, des oiseaux vindicatifs et des poissons espiègles.

Ancien animateur des studios Disney et de Lucasfilm, Lasseter est le pilier de cette aventure depuis que Steve Jobs, PDG d'Apple, a fondé

Pixar en 1986. Chaque production suppose un défi aux limites de l'animation en 3D en matière de textures et de personnalités si réelles à partir de bits et de pixels. Pour cela, Pixar a mis au point des programmes exclusifs (Marionette, Ringmaster, RenderMan), garants de résultats optimaux en moins de temps.

Grâce à l'accord signé avec Disney en 1991, John Lasseter dirige son premier long métrage d'animation totalement numérique qu'est le révolutionnaire Toy Story. D'autres longs métrages de grand impact suivent, de même que quatre Oscars, faisant de Pixar un nom de plus en plus célèbre et reconnu.

Das Team von Pixar schreibt Technologie groß. Dieses Studio in Emeryville, Kalifornien, hat die Akzeptanz von computeranimiertem 3D-Zeichentrick beim Laienpublikum beschleunigt und dazu beigetragen, die Vorstellung von Trickfilm weltweit zu ändern.

Das Signet des Unternehmens, das im Vorspann aller seiner Filme erscheint, ruft den ersten Erfolg des Kreativdirektors und ausübenden Vizepräsidenten John Lasseter wach. Die unterhaltsamen und empfindlichen Lampen von Luxo Jr. ermöglichten es, digitale Grafik mit gewissen emotionalen Werten in Zusammenhang zu bringen, die in den achtziger Jahren anscheinend noch dem traditionellen Zeichentrickfilm vorbehalten waren. Seit damals sind eifersüchtige Spielsachen, verträumte Fahrräder, orientierungslose Insekten, kleine panische Monster, rachsüchtige Vögel und schräge Fische den CDs vom Studio entsprungen.

Seit Steve Jobs von der Firma Apple 1986 Pixar ins Leben rief, befand sich Lasseter, ehemals als Trickzeichner bei Disney und Lucasfilm tätig, im Zentrum des Geschehens. Jede einzelne Produktion des Studios reizte die Grenzen der dreidimensionalen Animation aus, was die Analyse der Beschaffenheit und die Konstruktion von greifbaren Figuren mittels Bits und Pixels betrifft. Pixar hat allein zu diesem Zweck Softwaresysteme wie Marionette, Ringmaster und RenderMan entwickelt, die exzellente Ergebnisse bei gleichzeitiger Zeitersparnis erlauben.

Durch einen Vertrag, den er 1991 mit Disney schloss, konnte Lasseter seinen ersten Spielfilm mit komplett digitaler Animation machen, die umwälzende Toy Story. Andere Spielfilme, die auf große Resonanz stießen, folgten, wodurch die Marke Pixar sich zunehmender Beliebtheit erfreut.

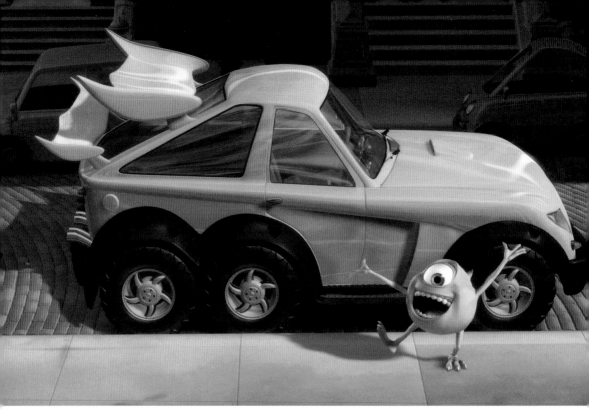

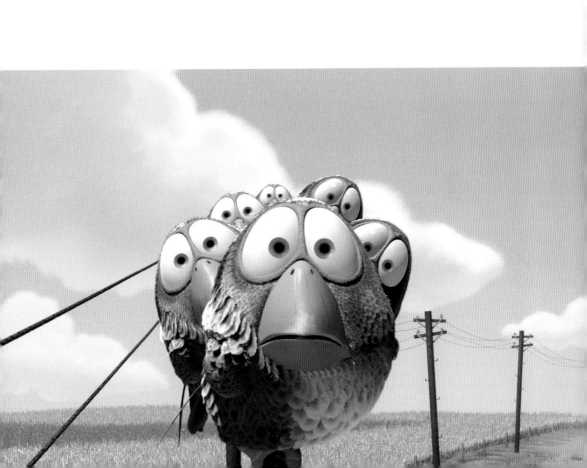

PRIIT PÄRN

Estonia
Eesti Joonisfilm
Roo 9, Tallinn 10611
Phone: + 372 513 2569
Fax: + 372 677 4122
E-mail: priit.parn@neti.ee

Kas Maakera on Ümmargune? / Is
 the Earth Round?, 1977
Ja Teeb Trikke / And Plays Tricks, 1978
Harjutusi Iseseisvaks Eluks / Some
 Exercises in Preparation of an
 Independent Life, 1980
Kolmnurk / The Triangle, 1982
Aeg Maha / Time Out, 1984
Eine Murul / Breakfast on the
 Grass, 1987
Hotel E, 1992
1895, 1995
Porgandite öö / Night of the
 Carrots, 1998
Karl ja Marilyn / Karl and Marilyn, 2003

First Prize - Espinho, 1985/1988
Grand Prix - Tampere, 1988
First Prize in category and Critic's
 Prize - Zagreb, 1988
Bronze Lion - Cannes, 1988
Nika Prize/USSR, 1989
Prize of Land - Baden-Württemberg
 Stuttgart, 1992
Best Film - Oslo, 1996
Grand Prix - Zagreb, 1996
Best Design - Ottawa, 1996
Grand Prix - Ottawa, 1998
Silver Dove - Leipzig, 1999
First Prize - WAC/USA, 2000
ASIFA Life Achievement Award, 2002

Traditional animation

PRIIT PÄRN

www.joonisfilm.ee

If an investigator from the next millennium only had on hand two movies of Priit Pärn, he would have enough material to reconstruct the great socio-political questions of our time. The short films –actually not so short, as some are almost a half-hour long– of this courageous Estonian, born in 1946, are harsh commentaries. His subjects include life under the communist regime, the supposed differences between the East and West during the cold war years, and the fetish of digitalization and the era of Internet.

This future investigator would have to understand a few stereotypes, as Priit Pärn uses them with absurd humor. Additionally, he would also have to understand this filmmaker's logic, and not simply follow common taste. Pärn's lines are somewhat primitive, the colors he uses often clash and, clearly, his drawings cannot be called "pretty". At the same time, the uncomfortable feeling the spectator has when watching Pärn's films only points to his effectiveness. His films are modern fables for a public interested in imagining the world beyond what is superficially perceived.

Pärn worked as a biologist and a stuntman before dedicating himself completely to animation in the mid-seventies. The Triangle and Breakfast on the Grass marked a new era in Estonian animation, as these films combine stories of everyday people with explicit political criticism. Pärn's influence in world animation is widely recognized, as is his work as a professor in several different countries. His more than 30 individual exhibits over the course of the last twelve years have also earned him the title of renowned caricaturist and illustrator. Since 1994, Priit Pärn has given shape to his works in the Eesti Joonisfilm Studio of Tallinn, the capital of independent Estonia.

Si au prochain millénaire un chercheur dispose uniquement de deux films de Priit Pärn, il a suffisamment de quoi retracer les grands thèmes sociopolitiques de notre temps. Les courts métrages (qui ne sont d'ailleurs pas si courts, sachant que certains durent près d'une demi-heure) de ce courageux Estonien, né en 1946, expriment de vives critiques sur la vie sous le régime communiste, les prétendues divergences entre l'Orient et l'Occident au cours de la guerre froide, ainsi que le culte de l'ère numérique et de l'Internet.

Ce chercheur du futur devrait alors révéler plusieurs stéréotypes dont Priit Pärn tire son humour absurde, de même qu'il lui faudrait comprendre toute la logique du réalisateur au lieu de s'en remettre au sens commun. Le tracé de Pärn a quelque chose de primitif, avec une dissonance des couleurs et un dessin résolument esthétique. Le malaise ressenti par le spectateur au contact de ses œuvres est lié à l'efficacité

de l'ensemble : des fables modernes pour un public désireux d'imaginer un monde au-delà du superficiel.

Avant de se consacrer entièrement à l'animation au milieu des années 60, Pärn travaillait comme biologiste et a servi de doublures dans des films. Le triangle et Déjeuner sur l'herbe marquent l'histoire de l'animation estonienne en associant personnes de la rue et critique politique explicite. Son influence sur l'animation mondiale est amplement reconnue, tout comme la qualité des cours qu'il donne dans plusieurs pays. En outre, les quelque 30 expositions individuelles de ses créations lors des douze dernières années lui ont valu le titre de caricaturiste et illustrateur de renom. Depuis 1994, Priit Pärn travaille au Eesti Joonisfilm Studio de Tallinn, capitale de l'Estonie indépendante.

Angenommen, ein Forscher des nächsten Jahrtausends verfügte ausschließlich über zwei Filme von Priit Pärn, so hätte er doch genügend Material, um die großen gesellschaftspolitischen Fragestellungen unserer Zeit zu rekonstruieren. Die eigentlich nicht ganz kurzen, sondern teilweise bis zu halbstündigen „Kurzfilme" dieses mutigen Estländers des Jahrgangs 1946 sind harte Kommentare des Lebens unter kommunistischem Regime, der angenommenen Differenzen zwischen Ost und West zu Zeiten des Kalten Krieges und des Fetischs Computer in der Ära der digitalen Vernetzung.

Unser Forscher aus der Zukunft hätte einige Klischees zu entlarven, aus denen Priit Päarn seinen absurden Humor zieht. Andererseits müsste er die gesamte innere Logik des Regisseurs begreifen und sich nicht dem allgemeinen Geschmacksurteil unterwerfen. Pärns Strich mutet irgendwie primitiv an, seine Farben beißen sich und sein Zeichenstil kann wahrlich nicht als „schön" gelten. Gleichzeitig beweist der Verdruss des Zuschauers beim Betrachten seiner Filme die Wirksamkeit dieser Mittel. Es sind moderne Fabeln für ein Publikum, das daran interessiert ist, sich eine Welt hinter der bloßen Oberfläche auszumalen.

Pärn war ausübender Biologe und arbeitete als Double, bevor er sich Mitte der 70er Jahre der Faszination des Trickfilms ergab. The Triangle und Breakfast on the Grass schrieben in Estland im Trickfilm Geschichte, indem sie Geschichten von stinknormalen Leuten mit offener politischer Kritik verbanden. Viele gestehen ihm weltweiten Einfluss auf den Trickfilm zu, den er nicht zuletzt dank seiner Dozenturen hatte, die er in verschiedenen Ländern ausübte. Andererseits haben ihm die mehr als 30 Einzelausstellungen im Laufe der vergangenen zwölf Jahre den Ruf eingetragen, ein anerkannter Karikaturist und Illustrator zu sein. Seit 1994 bildet das Eesti Joonisfilm Studio in Tallinn, der Hauptstadt des unabhängigen Estland, den Rahmen für Priit Pärns Arbeiten.

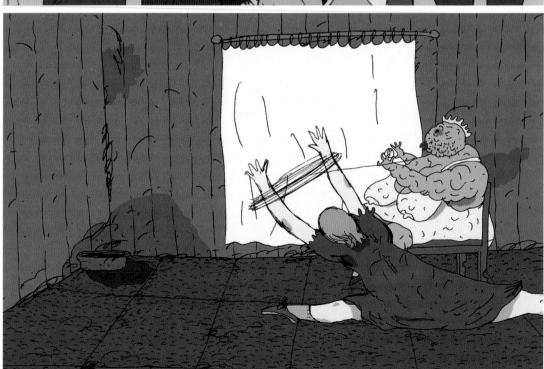

Pg. 249–253 Karl ja Marilyn / Karl and Marilyn, 2003
Traditional animation

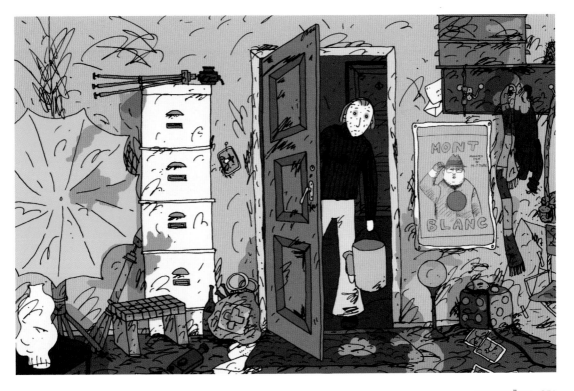

RAOUL SERVAIS

Belgium
Fondation Raoul Servais
Contact: Monsieur Jacques DuBrulle
c/o Festival International
 du Film de Flandre
Kortrijksesteenweg 1104
 Sint-Denijs-Westrem 9051
Phone: 32 9 221 89 46
Fax: + 32 9 221 90 74

Chromophobia, 1965
Goldframe, 1967
Sirene, 1968
To Speak or Not to Speak, 1970
Operation X-70, 1971
Pegasus, 1973
Harpya, 1979
Taxandria, 1994
Nachtvinders / Nocturnal
 Butterflies, 1998
Atraksion, 2001

Primo Premio - Venice Biennale, 1966
Golden Palm - Cannes, 1969
Special Prize of the Jury - Cannes, 1972
 and Zagreb, 1972
Méliès d'Argent - Fantasporto, 1996
Grand Prix and Critics Award -
 Annecy, 1998
International Fantasy Film Award -
 Fantasporto, 2003

Traditional animation
Live action
"Servaisgraphy"

RAOUL SERVAIS

The creator of an extremely personal style and technique, Raoul Servais is considered to be a living legend of art cinema. Before starting in animation, Servais worked with René Magritte on the Domaine Enchanté panel and painted murals for the 1958 World's Fair in Brussels. References to expressionism and Flemish painting are constant in his films.

Servais' short movies and his feature film Taxandria mobilize a series of mythological and political archetypes in graphically daring and conceptually stirring arrangements. His themes include ethical and moral questions as well as political fables wherein power and individual freedom clash. These struggles take place in a totally artificial world, ruled by a logic that can only belong to the language of animation.

In the movie Harpya Servais used an innovative technique: he filmed real actors and objects against a background draped in black velvet and projected the results in color on the multiplane. He later created "Servaisgraphy", a process in which he films characters and prints the shots on cellophane sheets that are colored on the backside. These are then filmed on different backgrounds.

Raoul Servais' movies are surprising for their radical techniques and dense content. The Cannes, Venice and Annecy film festivals have all placed him in the pantheon of the greatest artists of his time, and the MoMa of New York, the Contemporary Art Museum of Chicago and the Georges Pompidou Center of Paris have organized retrospectives of his work. Servais founded a school of animation in Ghent, Belgium, and he was the president of the International Animated Film Association from 1985 to 1994.

À l'origine d'un style et de techniques bien à lui, Raoul Servais est considéré comme une véritable légende vivante du cinéma artistique. Avant de se lancer dans le monde de l'animation, il travaille avec René Magritte sur la fresque Domaine Enchanté et réalise des peintures murales pour la Foire mondiale de Bruxelles en 1958. Les références à l'expressionnisme et à la peinture flamande sont une constante dans ses films.

Ses courts et son long métrage Taxandria rassemblent une série d'archétypes mythologiques et politiques, avec des arrangements graphiquement osés et conceptuellement instigateurs. La thématique compte des questions éthiques et morales, mais aussi des fables politiques dans lesquelles se heurtent pouvoir et liberté individuelle. Ces affrontements ont lieu dans un monde totalement artificiel, régi par une logique que seul le langage de l'animation maîtrise.

Avec Harpya, Servais inaugure une technique inédite : il filme de vrais acteurs et des objets devant un fond de velours noir et projette ensuite le résultat sur un décor peint. Plus tard, il met au point la « Servais-graphie », processus permettant de filmer des personnages et d'imprimer les images sur des feuilles d'acétate, avant d'en colorer le verso et de les filmer à nouveau devant les décors appropriés pour incrustation.

Les films de Raoul Servais surprennent par leur technique radicale et la densité de leur contenu. Les festivals de Cannes, Venise et Annecy l'ont déjà placé au panthéon des grands artistes de son temps, alors que le MoMA de New York, le Musée d'art contemporain de Chicago et le Centre Georges Pompidou de Paris ont organisé des rétrospectives de son œuvre. Servais a fondé une école d'animation à Gand, en Belgique, et a présidé l'Association internationale du film d'animation de 1985 à 1994.

Raoul Servais, der einen eigenen Stil geprägt und außerordentlich individuelle Techniken entwickelt hat, gilt als lebende Legende des Kunstfilms. Bevor er sich dem Zeichentrickfilm zuwandte, arbeitete er mit René Magritte an dem Gemälde Domaine Enchanté und schuf für die Weltausstellung 1958 in Brüssel Wandgemälde. In seinen Filmen sind Bezüge zum Expressionismus und die flämische Malerei konstant.

Servais' Kurzfilme und sein Spielfilm Taxandria setzen eine Reihe mythologischer und politischer Archetypen in grafisch kühnen Arrangements, die auch konzeptionell zu neuen Taten auffordern, in Bewegung. Thematisch befasst er sich mit ethischen und moralischen Fragen genauso wie mit Fabeln politischen Gehalts, in denen die Macht und die Freiheit des Einzelnen aufeinanderprallen. Diese Kämpfe finden in einer durch und durch künstlichen Welt statt, die von einer der Trickfilm-Sprache eigenen Logik beherrscht wird.

Seit Harpya verwendet Servais eine neuartige Technik: Er filmt echte Schauspieler und Dinge vor einem mit schwarzem Samt verhängten Hintergrund und projiziert das Ergebnis in Farbe auf den so genannten Multiplan, eine Anordnung von Zeichnungen auf verschiedenen Ebenen, um so den Eindruck räumlicher Tiefe zu vermitteln. Später entwickelte er "Servaisgrafik". Bei diesem Prozess filmt er die Figuren und druckt die Einzelaufnahmen dann auf Azetatpapier; nachdem sie ihrerseits von hinten eingefärbt worden sind, werden sie in die entsprechenden Szenarien gestellt und erneut abgefilmt.

Raoul Servais' Filme verblüffen durch ihre radikale Technik und ihre inhaltliche Dichte. Die Festivals von Cannes, Venedig und Annecy haben ihn in den Olymp der großen zeitgenössischen Künstler erhoben, während das Museum of Modern Art in New York, das Museum of Contemporary Art in Chicago und das Centre Georges Pompidou in Paris Retrospektiven seines Werkes gezeigt haben. Servais gründete eine Trickfilmschule im belgischen Gent und war von 1985 bis 1994 Präsident der Internationalen Animationsfilm-Vereinigung (ASIFA).

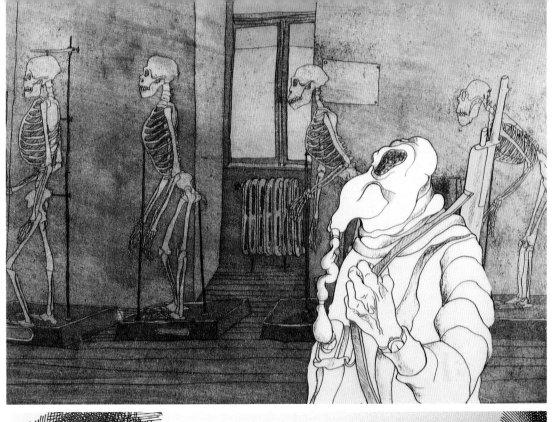

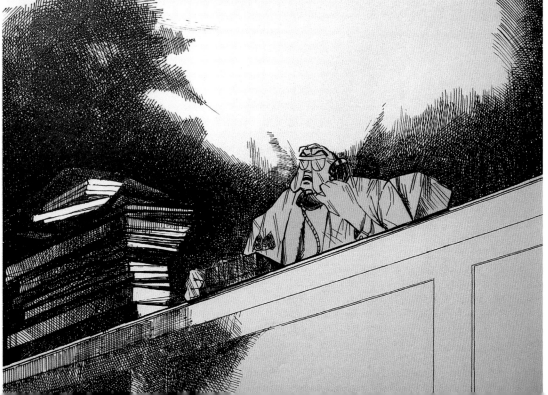

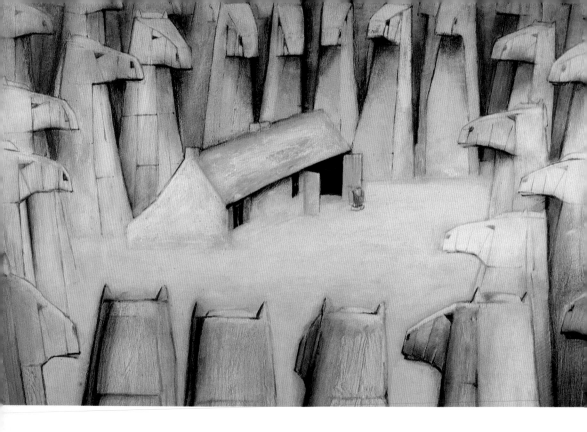

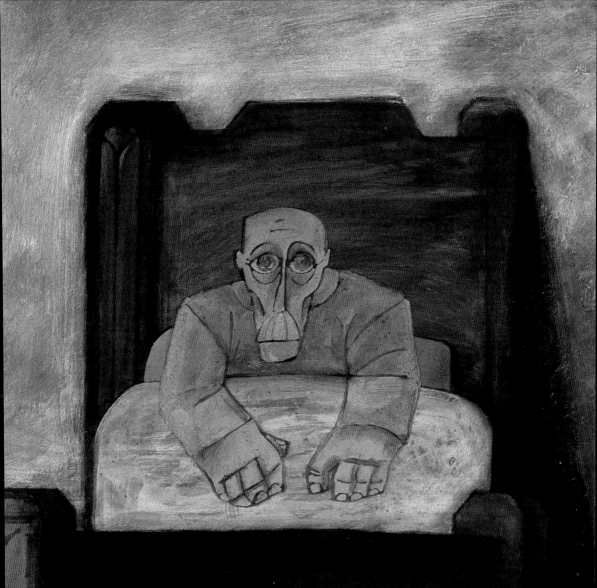

Terminator 2, 1991
Flight of the Intruder, 1991
Alien 3, 1993
Batman Forever, 1995
Babe, 1995
Titianic, 1997
Face/Off, 1997
X-Men, 2000
Hollow Man, 2000
Fantasia 2000, 2000
The Lord of the Rings, 2001
Harry Potter and the Sorcerer's
 Stone, 2001
The Sum of All Fears, 2002
Solaris, 2002
Around the World in 80 Days, 2004

Clio Award Best Computer
 Animation, 1992
First Prize - AICP/MoMA, 1992
Best Visual Effects - Academy of
 Television Arts & Sciences, 1993
Annie Award, 1993
Entrepreneur of the Year, 1993
Special Jury Prize - Hiroshima, 1994
Academy Award for Scientific &
 Technical Achievement, 1994/1998
Oscar Best Visual Effects, 1995
Best of Show - Imagina, 1995
Silver Clio Animation, 1999
Best Supporting Visual Effects in a
 Motion Picture - Visual Effects
 Society, 2003

CGI
Blending CGI with live action

RHYTHM & HUES

www.rhythm.com

What do the incredible visual effects of *Face/Off*, the madness of *X-Men*, the magic of *The Lord of the Rings* and the mischievousness of the mouse in *Stuart Little* all have in common? All of the technological wonders of these films have involved the participation of the Rhythm & Hues studio of Los Angeles. The film division of this studio has taken part in the production of more than 75 box-office movies, and it obtained an Oscar for the best special effects for the film *Babe*.

The perfection with which the animals of *Babe* articulated their texts lead R&H's technique to be used in other commercials and movies featuring talking animals. However, the company's computers are even more versatile, creating digital characters, vehicles and scenes, as well as visual effects that can captivate even the most feverish of imaginations, and then masterfully integrating these special effects into live action scenes.

When Rhythm & Hues was founded in 1987 there was only one computer in producer John Hughes' room. The company quickly grew in the advertising and animated logo sectors. In 1999 it acquired VIFX, a special effects production company, and thus became Los Angeles's largest private animation and special effects studio. In 2002 the magazine *Wire* ranked the company as one of the five powerhouses of the industry.

The wide range of R&H's clients in the advertising industry includes Coca-Cola—with the famous polar bear campaign—, GEICO (Gecko), Intel, Ford Motor and Proctor & Gamble, among many others. The company also has a division of theme parks and has produced several simulated motion movies and programs formatted for IMAX.

Quel est le point commun entre les incroyables effets visuels de *Volte-face*, les péripéties de *X-Men*, la magie dans *Le seigneur des anneaux* et les espiègleries du petit rat dans *Stuart Little* ? Toutes ces merveilles technologiques au service du septième art sont imputables à l'intervention du studio Rhythm & Hues de Los Angeles, dont la division cinéma a déjà pris part à la production de plus de 75 films à succès et remporté l'Oscar des meilleurs effets spéciaux pour *Babe*.

Au vu de la perfection avec laquelle les animaux de *Babe* prononcent leur texte, d'autres spots publicitaires et films intégrant des animaux qui parlent ont adopté la technique de R&H. Cependant, les ordinateurs de l'entreprise sont encore plus versatiles et créent des personnages, des véhicules et des décors numériques, ainsi que des effets visuels capables de répondre à l'imagination la plus délirante, pour ensuite les insérer à des scènes réelles.

Rhythm & Hues voit le jour en 1987 avec pour tout équipement un ordinateur dans la salle du producteur, John Hughes. La compagnie grossit rapidement dans le monde de la publicité et des logos animés. En 1999, elle rachète la société d'effets spéciaux VIFX pour former le plus important studio privé d'animation et d'effets visuels de Los Angeles. En 2002, la revue *Wired* la classe parmi les cinq meilleures de la catégorie.

La palette de clients de R&H dans le monde de la publicité inclut, entre autres, Coca-Cola (la célèbre campagne des ours polaires), GEICO (Gecko), Intel, Ford Motor et Procter & Gamble. L'entreprise gère également une unité de parcs thématiques ayant développé des simulations de mouvement et des programmes au format IMAX.

Was haben die unglaublichen visuellen Effekte des Thrillers *Face/Off*, die Verrücktheiten von *X-Men*, die Magie von *Der Herr der Ringe* und die Streiche des Mäuschens in *Stuart Little* gemeinsam? Alle diese Wunderwerke der Technik im Dienste des Kinos schätzen sich glücklich, dass die Rhythm & Hues-Studios von Los Angeles daran mitwirkten; deren Filmabteilung war an der Produktion von mehr als 75 Kassenschlagern beteiligt und gewann mit *Ein Schweinchen namens Babe* einen Oscar für die besten Spezialeffekte.

Babe brachte es bei der Sprechsimulation der Tiere zur Perfektion, weshalb diese Technik inzwischen auch bei anderen Filmen eingesetzt wird, in denen sprechende Tiere eine Rolle spielen. Die Computer des Unternehmens sind aber noch weit vielseitiger. Sie bringen digitale Figuren, Fahrzeuge und Bühnenräume hervor, ebenso visuelle Effekte, die die irrwitzigste Fantasie befriedigen können, um sie anschließend gekonnt in die Szenen der real gespielten Handlung einzubauen.

Rhythm & Hues wurde 1987 gegründet – mit einem einzigen Computer, der sich im Zimmer des Produzenten John Hughes befand. Das Unternehmen verzeichnete rasch Zuwachsraten im Sektor Werbung und animierte Logos. 1999 wurde VIFX, eine Produktionsfirma von Spezialeffekten, erworben, und so entstand das größte private Studio für Animation und visuelle Effekte von ganz Los Angeles. 2002 bewertete die Zeitschrift *Wired* das Unternehmen als eines der fünf führenden der Branche.

Zum großen Kundenstamm von R&H in der Werbeindustrie gehören neben vielen Anderen Coca-Cola (man denke an die bekannte Kampagne mit den Polarbären), GEICO (Gecko), Intel, Ford Motor und Procter & Gamble. Es gibt auch den unternehmenseigenen Sektor der Vergnügungsparks, der diverse Fahrsimulatoren und Programme für die IMAX-Großbildleinwände entwickelt hat.

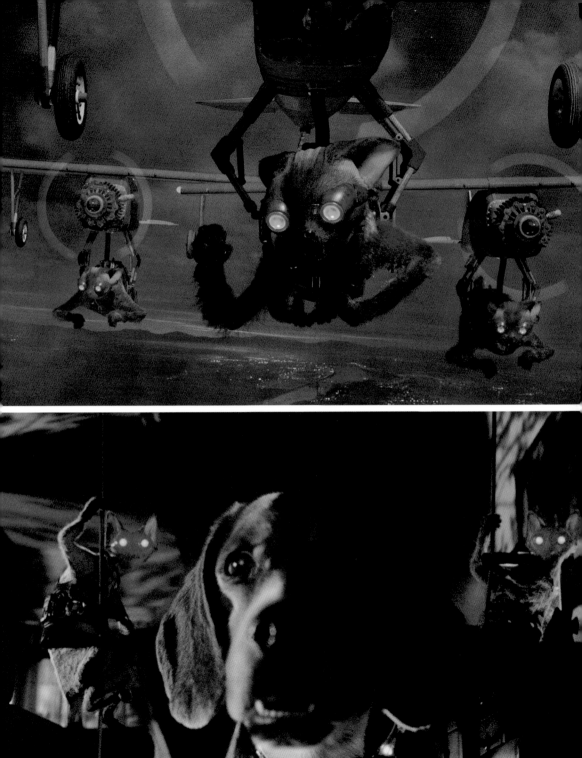

Pg. 259 Cats & Dogs, 2001
Computer animation

Pg. 260 Nascar Thunder
(commercial), 2003
CGI
Client: Electronic Arts

Pg. 261 Race for Atlantis
(Theme Park), 2003
CGI
Client: Ceasars Palace
Las Vegas, Nevada

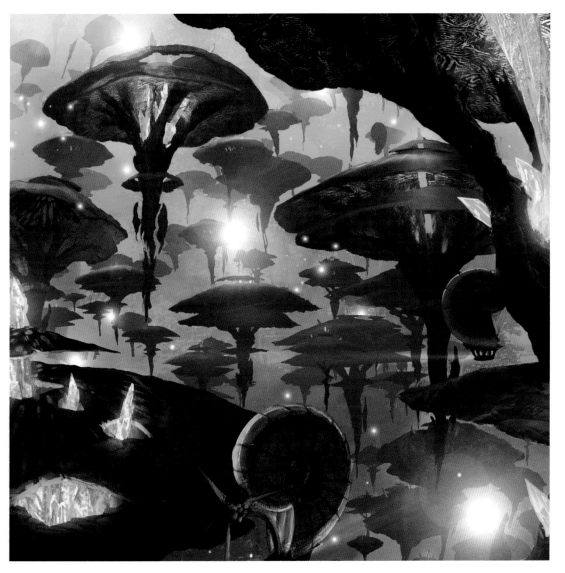

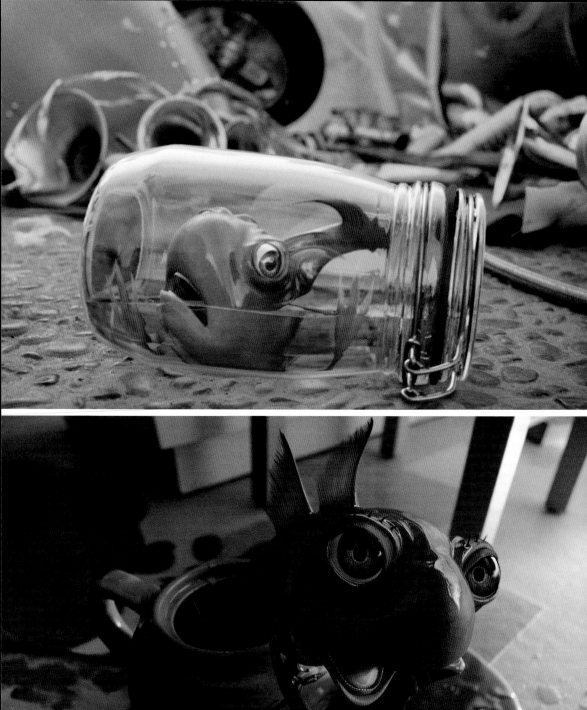

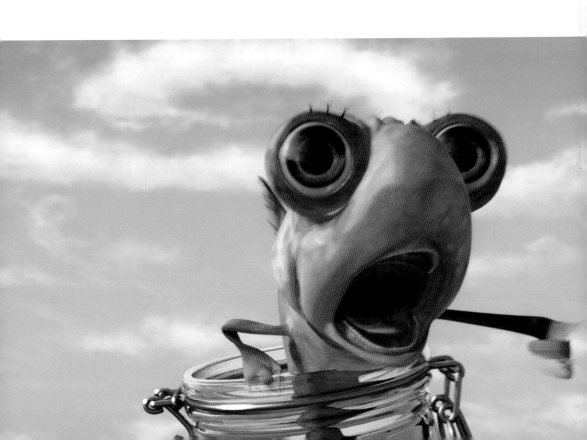

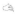

INTERNATIONAL ROCKETSHIP LIMITED

USA/Canada
Marv Newland
204-2630 York Ave.
Vancouver, BC V6K 1E5
Phone: + 1 604 738 1778
Fax: + 1 604 738 0009

Bambi Meets Godzilla, 1969
Sing Beast Sing, 1980
Anijam, 1984
Hooray for Sandbox Land, 1985
Black Hula, 1988
Pink Konkommer / Pink Cucumber,
 1991
Gary Larson's Tales From the Far
 Side I, 1994 and II, 1996
FUV, 1999

Silver Hugo - *Chicago,* 1980
Jury Prize - *Annecy,* 1980
Grand Prix - *Annecy,* 1995

Traditional 2D animation
Marionettes

ROCKETSHIP

The more delicate souls may be scandalized by Marv Newland's movies; however, those who appreciate extravagant and devastating humor will find his films to be authentic entertainment. This California animator started his career at age 21 with *Bambi Meets Godzilla,* a short that shows his synthetic, corrosive and extremely entertaining vision of the law of the jungle. From then on lewd, violent, disturbing stories, that make use of a peculiar and intriguing narrative timing have fueled all of his independent films.

This same tendency prevails in other directors' creations that Marv Newland has produced with his company, International Rocketship Limited, which he founded in 1975, two years after having settled in Vancouver, Canada. In spite of its pompous name, Rocketship is a source of irreverent ideas and a bastion of defense of traditional animation based on comic strips. With these credentials, the production company has won clients like Nintendo, Microsoft, Shell Canada, MTV, NBC, Nickelodeon, Cartoon Network and the National Film Board of Canada.

As a producer, Newland has sponsored very successful group projects like *Anijam,* a jam session that had 22 animators working on one character, or *Pink Cucumber,* an erotic illustrated sound track that brought nine international talents together. As a director, his adaptation to the screen of cartoonist Gary Larson's works won him the Gran Prix at the Annecy Festival. More recently, Newland has worked on some episodes of the stop-motion series *The P.J.s* from the Will Vinton studios, and he has given classes at the Vancouver Film School.

Les films de Marv Newland peuvent scandaliser les âmes sensibles ; ils seront en revanche un véritable régal pour les amateurs d'humour décalé et dévastateur. À 21 ans, cet animateur californien présente son premier travail comme carte de visite : il s'agit de *Bambi Meets Godzilla,* un court offrant une vision synthétique, corrosive et délirante de la loi de la jungle. Toute sa filmographie indépendante s'est, à partir de là, nourrie d'histoires lubriques, violentes et dérangeantes, ainsi que d'un contrôle unique et intrigant des temps de narration.

Le même penchant prévaut dans les créations d'autres réalisateurs que produit l'entreprise de Marv Newland, International Rocketship Limited. Il la fonde en 1975, deux ans après s'être définitivement installé à Vancouver. En dépit de son nom pompeux, Rocketship est une source d'idées marginales et un bastion de résistance contre les dessins animés conventionnels à base d'histoires drôles. En défendant de tels principes, la maison de production a convaincu des clients tels que Nintendo,

Microsoft, Shell Canada, MTV, NBC, Nickelodeon, Cartoon Network et l'Office national du film du Canada.

En tant que producteur, Newland a parié sur des projets collectifs à grand succès comme *Anijam,* une jam session pour laquelle il a réuni 22 animateurs, ou *Pink Konkommer,* une bande-son érotique illustrée pour laquelle il a recruté neuf talents internationaux. Côté réalisation, ses adaptations de l'œuvre du dessinateur humoristique Gary Larson lui ont valu le grand prix du Festival d'Annecy. Plus récemment, Newland a réalisé quelques épisodes de la série de marionnettes *P.J.s* pour les studios Will Vinton et donné des cours à la Vancouver Film School.

Es könnte passieren, dass zart besaitete Gemüter an Marv Newlands Filmen Anstoß nehmen, aber für all jene, die einen wunderlichen und destruktiven Humor zu schätzen wissen, sind sie ein wahres Vergnügen. Seine erste Arbeit, die er mit 21 Jahren realisierte, wurde zur Visitenkarte des kalifornischen Trickfilmers: In dem Kurzfilm *Bambi Meets Godzilla* zeigte er seine zusammenfassende Vorstellung vom Gesetz des Stärkeren, gleichzeitig beißend und sehr vergnüglich. Sein ganzes, unabhängig entstandenes Filmoeuvre sollte sich fortan von schlüpfrigen, gewalttätigen und verblüffenden Geschichten ebenso nähren wie von einem eigentümlichen und verwickelten Umgang mit der Erzählzeit.

Die gleiche Neigung bestimmt auch die Arbeiten anderer Regisseure, die von International Rocketship Limited produziert wurden, dem Unternehmen, das Marv Newland 1975, also zwei Jahre, nachdem er seinen endgültigen Wohnsitz im kanadischen Vancouver nahm, gründete. Trotz seines großspurigen Namens sprudelt Rocketship Ideen hervor, die dem traditionellen Zeichentrickfilm, der auf Comic Strips basiert, ohne falsche Ehrfurcht, sozusagen als Bollwerk des Widerstandes begegnet. Mit diesem Ausweis hat die Produktionsfirma Kunden wie Nintendo, Microsoft, Shell Canada, MTV, NBC, Nickelodeon, Cartoon Network und den National Film Board Kanadas erobert.

Als Produzent hat Newland sehr erfolgreiche Gemeinschaftsprojekte wie *Anijam* gefördert, eine Jam Session, für die er 22 Animationskünstler zusammenbrachte, oder *Pink Cucumber,* ein erotisches Tonband mit Illustrationen, für das sich neun internationale Talente zusammenfanden. Als Regisseur trugen ihm seine Adaptionen des zeichnerischen Werks des Humoristen Gary Larson einen Großen Preis beim Festival in Annecy ein. In jüngster Zeit hat Newland nicht nur einige Episoden der Marionettenserie *P.J.s* für die Studios von Will Vinton gedreht, sondern auch an der Vancouver Film School unterrichtet.

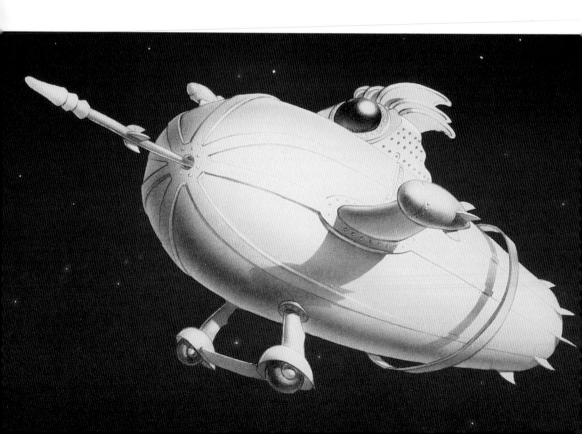

Produced and Directed by

MARV NEWLAND

RUTH LINGFORD / SHERBET

United Kingdom
Contact: Jane Colling,
Sherbet/Ruth Lingford
112-114 Great Portland
 Street, London W1N 5PE
Phone: +44 (0)20 7636 6435
Fax : +44 (0)20 7436 3221
E-mail: jane@sherbet.co.uk /
 abi.lingford@btinternet.com

Whole Lotta Love, 1989
Sea in the Blood, 1990
Baggage, 1992
Crumble, 1992
What She Wants, 1994
Death and the Mother, 1997
Pleasures of War, 1998
An Eye For an Eye, 2001
The Old Fools, 2002

Best Graphics - *Annecy*, 1997
Best Film 6-13 min - *Espinho*, 1997
Special Prize of the Jury - *Cartoon
 d'Or*, 1997
Best Film over 10 min - *BAA*, 1998
Public Prize - *Stuttgart*, 1998
Best Animation L'Alternativa -
 Barcelona, 1999
Critics Award - *Brisbane*, 2000
Best Animation - *Taichung/Taiwan*, 2000
McLaren Award - *Edinburgh*, 2002

2D and 3D computer animation
Digital drawing combined with
 archival footage

RUTH LINGFORD

www.sherbet.co.uk

Once upon a time there was a painter who wished to film the different layers applied to her paintings throughout the creation process. One day, Ruth Lingford grabbed an old Super 8 camera and ended up making her debut in animation cinema. She discovered right away that the repetitive act of animating put her into a kind of trance and allowed her to gain access to the subconscious.

This former occupational therapist for psychiatrically disturbed senior citizens was already over 30 years old when she received a degree in animation from the Royal College of Art in London, where she has now become a well-known professor. Since the beginning of her career at the end of the eighties, Lingford has specialized in 2D digital animation, which she frequently combines with archival footage. In *Pleasures of War* she used some scenes from footage found in the Imperial War Museum archives, and in *The Old Fools* she recreated some of her father's images; he was also a filmmaker.

Lingford is not satisfied with spending a good part of her life in front of the computer only to tell jokes. Her movies are deliberately somber and deal with difficult themes like death, sexuality, violence, capitalism and infertility. The psychological hell that modern women go through is one of her recurring themes. She finds the dense content of her films in the works of Sara Maitland, Hans Christian Andersen, Philip Larkin, and even in the Bible.

The commissioned work that Lingford does for the British Channel Four has been an important motivation for her work. However, among her current endeavors is the research program Animation Elsewhere, which attempts to find new ways of showing animation films.

Il était une fois un peintre qui souhaitait enregistrer l'application de différentes couches sur une toile, lors de la création d'un tableau. Pour ce faire, Ruth Lingford se munit un beau jour d'une vieille caméra Super 8 et fait ainsi ses premiers pas dans le monde du cinéma d'animation. Elle découvre très vite que répéter cette démarche la place dans une sorte de transe et lui ouvre la porte de son subconscient.

D'abord thérapeute pour personnes âgées souffrant de problèmes psychiatriques, elle a plus de 30 ans lorsqu'elle décroche un diplôme d'animatrice au Royal College of Art de Londres, dont elle deviendra plus tard un professeur de renom. Depuis le début de sa nouvelle carrière, à la fin des années 80, Lingford s'est spécialisée dans l'animation numérique 2D, même si elle fait souvent intervenir du matériel d'archives. Dans *Pleasures of War*, elle emploie par exemple certaines scènes de films archivés au Musée impérial de la guerre ; dans *The Old Fools*, elle recrée des images de son père, lui-même cinéaste.

Lingford ne passe pas autant d'heures face à un ordinateur juste pour raconter des histoires drôles. Ses films sont volontairement noirs et abordent des thèmes délicats comme la mort, la sexualité, la violence, le capitalisme ou l'infertilité. L'enfer psychologique que subit la femme moderne est l'un des scénarios récurrents. La densité de contenu de sa filmographie s'inspire des œuvres de Sara Maitland, Hans Christian Andersen, Philip Larkin, voire de la Bible.

Les commandes de la chaîne britannique Channel Four ont grandement motivé le travail de Lingford. Parmi ses préoccupations du moment, elle collabore au programme de recherche Animation Elsewhere, dont l'objectif est de trouver de nouveaux espaces pour présenter des films d'animation.

Es war einmal eine Malerin, die wollte die verschiedenen Stadien ihrer Bilder während des Schaffensprozesses aufnehmen. Eines schönen Tages nun nahm Ruth Lingford eine alte Super 8-Kamera zur Hand und machte damit schließlich ihre ersten Gehversuche in der Welt des Animationsfilms. Alsbald entdeckte sie, dass das dort gültige Wiederholungsprinzip sie in eine Art Trance versetzte und ihr Zugang zum Unterbewussten verschaffte.

Die ehemalige geriatrische Beschäftigungstherapeutin war bereits über dreißig, als sie ihr Diplom als Animationskünstlerin am Londoner Royal College of Art erhielt, wo sie später selbst anerkannte Professorin werden sollte. Von Anbeginn ihrer neuen beruflichen Laufbahn Ende der achtziger Jahre spezialisierte sich Lingford auf digitale 2D-Animation, die sie allerdings oft mit Archivmaterial kombiniert. So setzte sie in *Pleasures of War* einige Filmszenen aus dem Archiv des Reichskriegsmuseums (Imperial War Museum) ein, und in *Die alten Narren* bearbeite sie einige Bilder ihres Vaters, seines Zeichens selbst Filmemacher.

Lingford gibt sich nicht damit zufrieden, einen Großteil ihres Lebens vor dem Computer zuzubringen, nur um Witze zu erzählen. Ihre Filme sind bewusst düster gehalten und behandeln so schwierige Themen wie Tod, Sexualität, Gewalt, Kapitalismus, Unfruchtbarkeit. Die psychologische Hölle, durch die die moderne Frau zu gehen hat, ist ein Szenarium, das sich durch ihr Werk zieht. Die dichten Inhalte ihres filmischen Oeuvres findet sie in den Werken von Sara Maitland, Hans Christian Andersen, Philip Larkin und sogar in der Bibel.

Die Auftragsarbeiten für den britischen TV-Kanal Chanel Four gaben Lingford wichtige Impulse. Und dennoch kümmert sie sich zurzeit im Rahmen des Programms „Animation Elsewhere" auch darum, neue Einsatzorte für den Animationsfilm zu erkunden.

Pg. 269 The Old Fools, 2002
2D computer animation

Pg. 270 Death and the Mother, 1997
2D computer animation

Pg. 271 Stills - Whole Lotta Love, 1989
2D computer animation

SARAH WATT

Australia
Sarah Watt Productions
PO Box 6173,
West Footscray, Vic. 3012
Email: sarahwatt@bigpond.com

The Candle, 1993
Small Treasures, 1995
Local Dive, 1999
Way of the Birds, 1999
Living With Happiness, 2001

Best Short - *Venice*, 1995
Australian Film Award, 1995
Special International Jury Prize -
Hiroshima, 1996

Traditional and
photographic animation

SARAH WATT

Animation is inseparable from the rest of Sarah Watt's life. The pains and pleasures of pregnancy served as an inspiration for her film *Small Treasures*, a short that won an important award for her at the Venice Film Festival and made her name known internationally. The unpopular girl who tries to escape the grief inflicted on her at the public pool in *Local Dive*, or the woman who fights against a world of paranoia in *Living With Happiness*, evoke common anxieties of the feminine soul.

Watt's animation techniques also reflect her work with painting and photography. This notable animator's movies are marked by her sensitive observations and by a fluid movement and visual style that suggest dream and memory narratives.

Watt was born in New Zealand and completed a master's degree at the prestigious Swinburne Institute of Technology in Melbourne, Australia. Sarah Watt has already received various awards for the scripts that she has written for other directors. She has also filmed some TV series episodes, completed some highly praised advertising jobs, and regularly gives talks on animation themes. She has worked on several Australian movies and television series as a contracted animator and production drawer. In addition, she has directed theater and even played the lead role in some live performances.

For her first feature film, Watt created a story of four people disturbed by the unexpected news of a hectic weekend, which she planned on filming live with some animated sequences.

Sarah Watt continues to search for happiness through animation.

L'animation fait totalement partie intégrante de la vie de Sarah Watt. Les douleurs et plaisirs ressentis lors de sa grossesse ont par exemple été une source d'inspiration pour *Small Treasures*, court métrage qui a remporté un prix important au Festival de Venise et lui a permis de se placer sur la scène internationale. Tant la jeune fille peu aimée des autres et qui tente d'oublier ses peines dans une piscine municipale de *Local Dive* que la femme qui lutte contre tout un univers de paranoïa de *Living With Happiness* expriment des angoisses propres à l'âme féminine.

De la même façon, les techniques d'animation de Watt sont évocatrices de ses peintures et photographies. Ses films sont rythmés par des observations pleines de sensibilité, une fluidité du mouvement et un style visuel comparable aux déroulements oniriques et de la mémoire.

Née en Nouvelle-Zélande, elle étudie un mastère au prestigieux Swinburne Institute of Technology de Melbourne, en Australie. Sarah Watt a déjà reçu plusieurs prix récompensant des scénarios élaborés pour d'autres réalisateurs. Elle a par ailleurs dirigé quelques épisodes de séries télévisées, des productions publicitaires fort appréciées et donne régulièrement des conférences sur l'animation. En outre, elle a participé à plusieurs séries et films australiens comme animatrice et dessinatrice de production, s'est adonnée à la direction théâtrale et a joué dans des spectacles en direct.

Pour son premier long métrage, Watt développe une histoire autour de quatre personnes bouleversées par les nouvelles d'un week-end agité ; elle envisage de tourner l'action en direct avec des séquences animées.

En d'autres termes, Sarah Watt poursuit sa quête du bonheur dans l'animation.

Der Trickfilm ist untrennbarer Bestandteil von Sarah Watts Leben. Freud und Leid ihrer Schwangerschaft dienten ihr als Inspirationsquelle für den Kurzfilm *Small Treasures*, mit dem sie einen wichtigen Preis auf dem Filmfest von Venedig errang und ihren Namen international berühmt machte. Das wenig beliebte Mädchen in *Local Dive*, die der Bekümmerung in einer öffentlichen Badeanstalt zu entfliehen versucht, und die Frau in *Living With Happiness*, die gegen eine Welt der Paranoia ankämpft, spielen beide auf Qualen an, die der weiblichen Seele geläufig sind.

Watt malt und fotografiert auch, was sich in ihren Animationstechniken spiegelt. Hochsensible Beobachtungen, eine flüssige Bewegung und ein visueller Erzählstil, der an Traum- und Erinnerungsvorgänge erinnert, prägen die Filme dieser bemerkenswerten Trickfilmerin.

Die gebürtige Neuseeländerin beendete ihr Studium an dem renommierten Swinburne Institute of Technology in Melbourne, Australien, mit einem Master. Sarah Watts Drehbücher, die sie für andere Regisseure erarbeitet hat, sind mehrfach ausgezeichnet worden; sie hat aber auch bei einigen Episoden für Fernsehserien selbst Regie geführt genauso wie bei – übrigens hochgelobten - Reklame-Arbeiten. Sie hält außerdem regelmäßig Vorträge über Themen des Trickfilms und hat in mehreren australischen Filmen und Fernsehserien, wo sie als Trick- und Produktionszeichnerin beauftragt wurde, mitgespielt, hat Theaterregie geführt und sogar bei einigen Life-Darbietungen eine Hauptrolle gespielt.

Für ihren ersten Spielfilm ersann Watt eine Geschichte mit vier Personen, welche die unerwarteten Nachrichten an einem bewegten Wochenende durchdrehen lässt; sie dachte daran, die Handlung direkt mit Zeichentricksequenzen umzusetzen.

Sarah Watt gibt die Suche nach dem Glück im Trickfilm nicht auf.

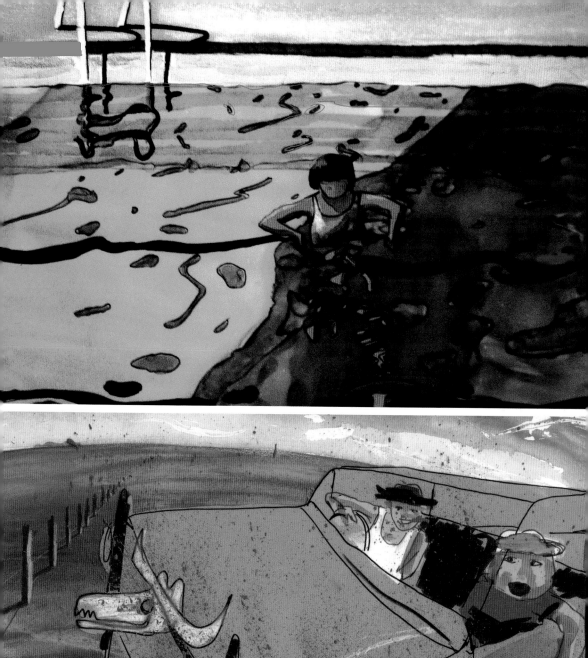

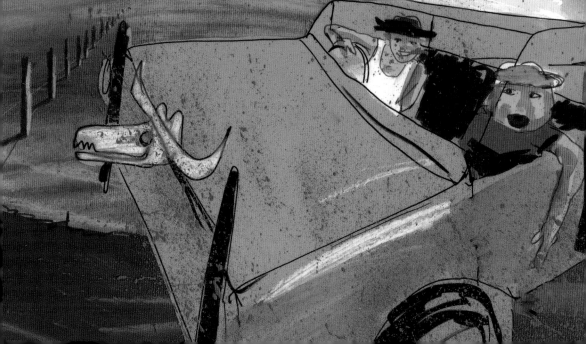

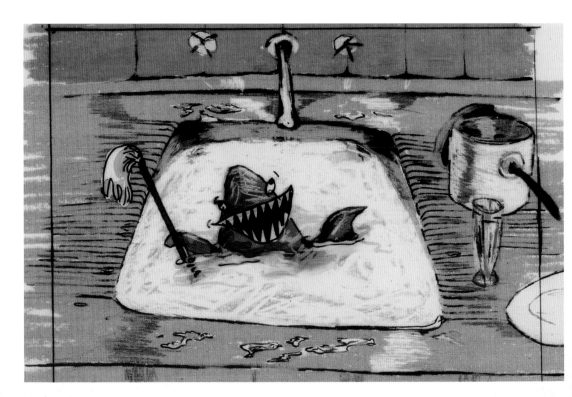

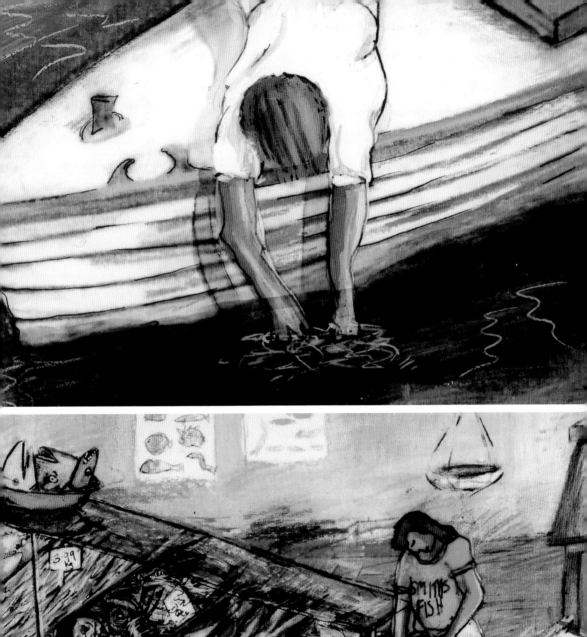
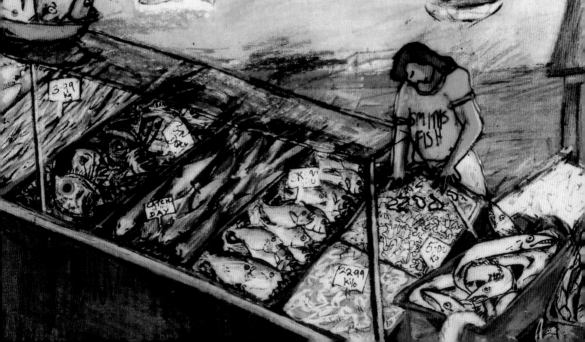

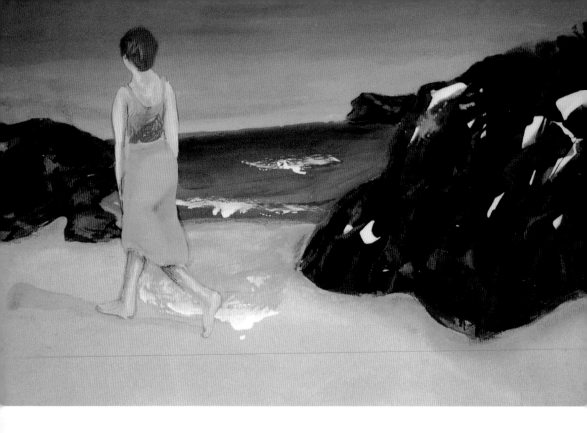

Pg. 276–277 Small Treasures, 1995
Traditional animation

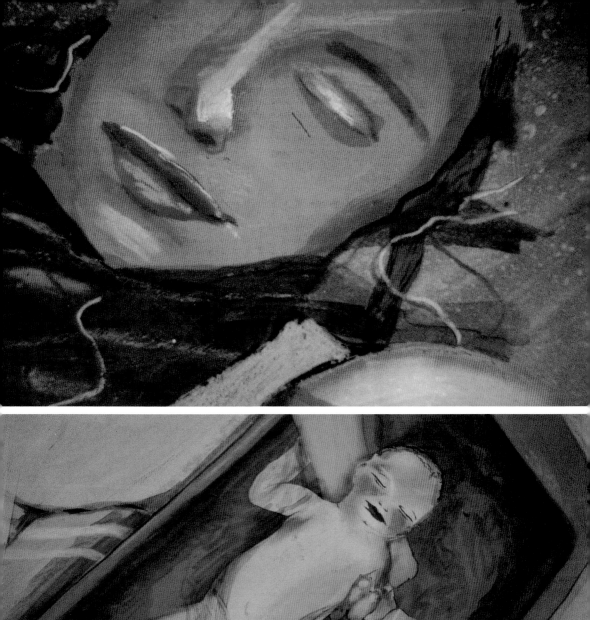
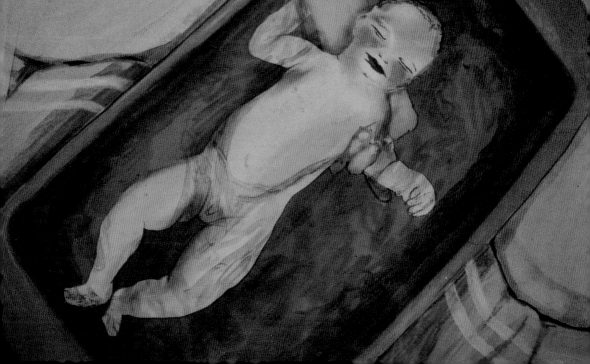

SPARX*

France
Contact: Guillaume Hellouin
91, Rue Lauriston, 75116 Paris
E-mail: contact@sparx.com
Phone: + 33 1 44 34 01 34
Fax: + 33 1 44 34 01 00

Pierre et le loup / Peter and the
 Wolf, 1995
Bob & Scott, 1996
Rolie Polie Olie, 1998
Meldu, 2000
Les filles, l'âne et les bœufs / Red-
 Light Christmas, 2002
Basile, la Taupe, 2002
Zoé Kézako, 2003
Robota - teaser, 2003

7 d'Or Best Animation - *Paris*, 1996
First Prize Imagina - *Monaco*, 1996
Emmy Award : « Best Design », 1999
 and « Outstanding Special Class
 Animated Program», 2000
Silver Plaque for Special
 Achievement - *Chicago*, 1999
Prize for Advertizing or Promotional
 Film - *Annecy*, 2003
Two Annie Awards, 2003

3D CGI

SPARX*

www.sparx.com

"If you can draw it, we can give it life", this is the slogan of Sparx*, one of the largest animation and special digital effects companies in Europe. The quality of their work confirms their motto. Their biggest endeavor involves transferring the talents of traditional animation to digital language, thus offering authors the necessary resources for bringing the most challenging ideas to the big screen.

Sparx* was founded in 1995 by Jean-Christophe Bernard and Guillaume Hellouin, two enthusiasts of graphic digital design. In their first year of existence the studio was already extremely successful and earned several awards for the TV special *Pierre et le loup*. A short time later they earned recognition for series that were distributed in several different countries, as well as for artistic shorts and commercials. The Sparkling* production company was created with the purpose of carrying out the studio's projects.

Their willingness to explore new areas of experimentation brought Sparx*/Sparkling* to the digital effects market for feature films distributed in cinemas. This was the case of internationally successful films like *My Life in Pink* by Alain Berliner, and *Thomas in Love* by Pierre-Paul Renders. In 2003, the Annecy Festival awarded the trailer of the feature film *Robota*, a 3D futuristic animation delight, directed by Doug Chiang.

In this Parisian studio, technological research goes hand in hand with a spirit of reverence towards traditional animation. This fact is evident in the short *Red-Light Christmas*, a film that blends different techniques of computer graphic design to obtain a beautiful watercolor effect. On the other hand, the pseudo-naive series *Zoé Kézako* was created completely in 3D, but the final effect might make the audience swear that we have returned to the early days of 2D.

« Tout ce que tu peux dessiner, nous pouvons lui donner vie » : tel est le slogan de Sparx*, l'une des principales agences d'animation et d'effets spéciaux numériques d'Europe. Et le fait est que la qualité de ses créations vient confirmer cette formule. Tous les efforts visent à traduire le savoir-faire de l'animation traditionnelle en langage numérique afin d'offrir aux auteurs les moyens de transposer à l'écran les idées les plus folles.

Sparx* est fondée en 1995 par Jean-Christophe Bernard et Guillaume Hellouin, deux passionnés d'infographie. Dès la première année d'existence, le studio connaît un grand succès et obtient des récompenses pour la production télévisée *Pierre et le loup*. Peu après suivent d'autres prix pour des séries diffusées dans plusieurs pays, des courts métrages artistiques et des spots publicitaires. La maison de production Sparkling* est fondée dans le but de mener à bien les projets du studio.

Cette ouverture à de nouvelles sources d'inspiration conduit Sparx*/Sparkling* au marché des effets numériques pour des longs métrages distribués dans les salles obscures. Tel a été le cas de succès internationaux comme *Ma vie en rose* d'Alain Berliner et *Thomas est amoureux* de Pierre-Paul Renders. En 2003, le Festival d'Annecy décerne au long métrage *Robota*, une merveille d'animation 3D futuriste dirigée par Doug Chiang, le prix du meilleur film promotionnel.

Dans ce studio parisien, la recherche technologique cohabite avec le respect de l'animation conventionnelle, ce qui est évident dans le court *Les filles, l'âne et les bœufs*, où se mêlent diverses techniques de CAO pour parvenir à un sublime rendu d'aquarelle. Par ailleurs, la série pseudo-naïve *Zoé Kézako* a été exclusivement créée en 3D, même si le résultat final laisse plutôt penser à du pur 2D.

"Wenn du es zeichnen kannst, dann können wir ihm Leben einhauchen", so lautet der Slogan von Sparx*, das zu den größten Unternehmen für digitale Animation und Spezialeffekte in Europa zählt. Die Qualität seiner Produkte gibt dem Slogan Recht. Die größte Anstrengung verwendet es darauf, das traditionelle Verständnis von Zeichentrick auf die digitale Sprache zu übertragen, indem es den Drehbuchautoren die notwendigen Instrumente an die Hand gibt, damit sie ihre noch so hochfliegenden Ideen auf dem Bildschirm konkretisieren können.

Jean-Christophe Bernard und Guillaume Hellouin, beide Fans des digitalen Grafikdesign, gründeten 1995 Sparx*. Bereits im ersten Jahr seines Bestehens genoss das Studio großen Erfolg und erhielt für das TV-Special *Peter and the Wolf* einige Preise. Schon bald sollten weitere Anerkennungen folgen, und zwar für Serien, die in verschiedenen Ländern liefen, künstlerische Kurzfilme und Reklame. Um die Projekte des Studios voranzutreiben, wurde später die Produktionsfirma Sparkling* gegründet.

Die Bereitschaft, im Einsatz für den Experimentalfilm auch neue Schlachten zu schlagen, öffnete Sparx*/Sparkling* den Markt für Digitaleffekte bei Kinospielfilmen. Das war der Fall bei den internationalen Kinohits *Mein Leben in Rosarot* von Alain Berliner und *Thomas est amoureux* von Pierre-Paul Renders. 2003 wurde auf dem Festival von Annecy der Trailer für den Spielfilm *Robota* ausgezeichnet, ein Meisterwerk der zukunftsweisenden 3D-Animation, bei dem Doug Chiang Regie führte.

Die Forschung im Bereich Technologie geht in dem Pariser Studio mit einem gewissen Respekt für den traditionellen Zeichentrick einher. Diese Verbindung fand ihren Niederschlag beispielsweise in dem Kurzfilm *Red-Light Christmas*, in dem verschiedene Techniken mit computergesteuertem Grafikdesign gemischt werden, um damit die wunderschöne Wirkung eines Aquarells zu erzielen. Auf der anderen Seite wurde die pseudonaive Serie *Zoé Kézako* komplett in 3D-Technik geschaffen, obwohl das Resultat einen schwören lassen könnte, zu den Anfängen des 2D zurückgekehrt zu sein.

— Version **4** — Décor Plan 7 2.35

— Maquette Couleur 3 — Plan 7

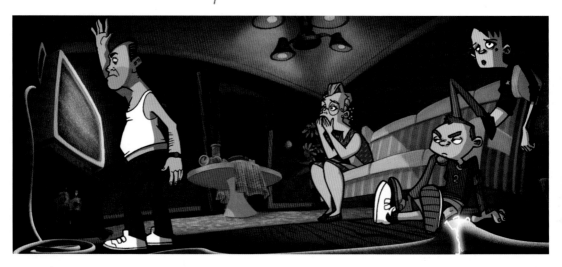

Pg. 279 Les filles, l'âne et les bœufs /
Red-Light Christmas, 2002
3D CGI

Pg. 280 Mon Idole, 2003
Visual developments

Pg. 281 Mon Idole, 2003

Character development

Animation and digital visual
effects : Spark*

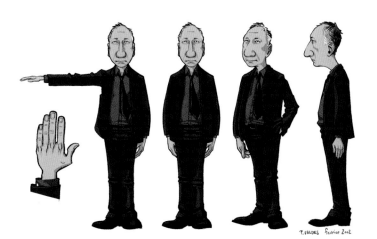

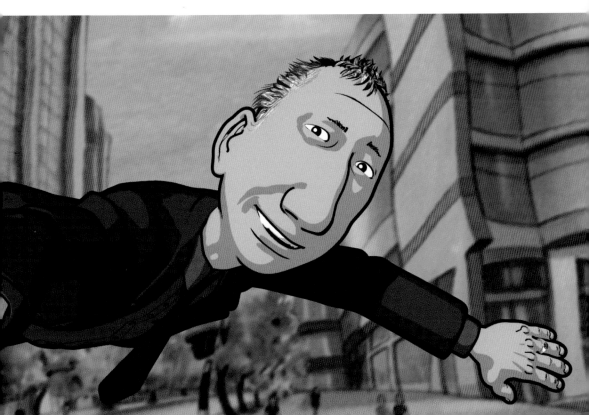

**START DESENHOS
ANIMADOS LTDA**

Brazil
Contact: Walbercy Ribas
Rua França Pinto, 964
Vila Mariana São Paulo,
SP 04016-004
Phone: + 55 11 5572 8644
Fax: + 55 11 5572 7041
E-mail: start@start-desenhos-
 animados.com.br /
 walbercy@terra.com.br

O rinoceronte / Rhino, 1980
O vidro / Glass, 1986
The Other Wiseman, 1989
Safe Motherhood, 1991
Child's Play, 1992
The Teen Years, 1994
The Ride, 1995
Condor Crux, 1998
O grilo feliz / The Happy Cricket, 2001

Special Prize Animation - *Venice*, 1972
Grand Prix ACC - *Tokyo*,
 1975/1976/1978/1979
Golden Medal - *New York Film Festival*,
 1976/1977/1978/1979
Grand Prix - *Clio*, 1977/1978
Grand Prix - *Wisconsin*, 2002
Life Achievement - *Award Anima
 Mundi/Rio de Janeiro*, 2002
Special Award - *Brazilian Academy of
 Cinema*, 2002

Traditional animation
3D computer graphics

START
DESENHOS
ANIMADOS

www.start-desenhos-animados.com.br

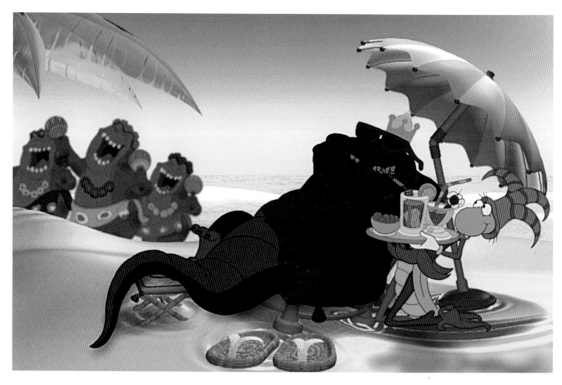

Brazilian television viewers have long enjoyed the characters and fantastic ideas of Walbercy Ribas Camargo, a veteran of animated advertising. Some of his creations, like the cockroach for the Rodox insecticide advertising campaign, or the cats for Eveready batteries, make up part of the collective memory of the country. Likewise, the psychedelic commercials that he created for Sharp are another icon of Brazilian animation.

Walbercy Ribas is a self-taught animator, who began his career in 1959 and produced his first film, in black and white, at age 17. Sensing that the advertising market would soon grow, in 1966 he founded the company Start Desenhos Animados Ltda., where he continues to create and produce his films today. Ribas has directed more than 2,000 animated commercials and several educational movies for Brazil as well as for foreign countries. He has worked in the United States, England, Mexico and Portugal, and for Unicef Caribbean, but in spite of all this moving around, he has never abandoned his Brazilian roots.

Start grew and matured under the leadership of its persistent and creative founder. It entered the age of digital animation without a glitch, and its animators continue to use new techniques without losing touch with their inheritance from the classics. The company has opened the door for a new generation of professionals that has already begun to win awards for the short 3D film *A última gota / The Last Drop* (2003).

In spite of the recognition that a long list of national and international awards for his films and his work as a whole have granted him, Ribas considers his feature film *The Happy Cricket* to be the best movie of his career. Completed independently and sporadically over the course of almost 15 years, this captivating fable exalts values like freedom, friendship, solidarity and respect for the environment.

Au Brésil, voilà longtemps que les téléspectateurs se divertissent avec les personnages et les idées incroyables de Walbercy Ribas Camargo, vétéran de la publicité animée. Certaines de ses créations, telles que le cafard de la campagne pour l'insecticide Rodox ou les chats des piles Eveready, sont ancrées dans la mémoire collective du pays. Il en va de même des spots psychédéliques pour Sharp comme référence de l'animation brésilienne.

Walbercy Ribas est un autodidacte qui débute sa carrière en 1959 et produit son premier film d'animation en noir et blanc à l'âge de 17 ans. Anticipant la croissance du marché publicitaire, il fonde en 1966 la compagnie Start Desenhos Animados Ltda., via laquelle il crée et produit encore maintenant ses films. Ribas a dirigé plus de 2 000 spots animés et divers films éducatifs pour le Brésil et d'autres pays. Il a travaillé aux États-Unis, en Angleterre, au Mexique, au Portugal ainsi que pour Unicef Caraïbes, et ce sans jamais oublier ses racines brésiliennes.

Start grandit sous la direction de son créatif de fondateur. La compagnie entre sans difficulté dans l'ère de l'animation numérique qu'elle aborde sans perdre de vue l'héritage des œuvres classiques. Une nouvelle génération de professionnels remporte des prix pour le court en 3D *A última gota* (2003).

Au-delà des nombreuses reconnaissances au niveau national et international et des prix couronnant l'ensemble de son œuvre, Ribas voit dans le long métrage *Le joyeux grillon*, sorti en 2001, le véritable point de repère dans sa carrière. Ce film, qui représente un travail de près de 15 années de façon indépendante et intermittente, conte une histoire passionnante défendant des valeurs telles que la liberté, l'amitié, la solidarité et le respect de l'environnement.

Seit langem schon erfreut sich der brasilianische Fernsehzuschauer an den Figuren und den fabelhaften Ideen von Walbercy Ribas Camargo, einem Veteranen der animierten Reklame. Einige seiner Schöpfungen, etwa die Kakerlake für die Werbekampagne des Insektizids Rodox oder die Katzen der Eveready-Batterien, sind inzwischen Bestandteil des kollektiven Gedächtnisses seines Landes. Eine weitere Ikone der brasilianischen Animation sind die psychedelischen Werbefilme, die er für die Firma Sharp schuf.

Der Autodidakt Walbercy Ribas begann seine Laufbahn als Siebzehnjähriger, als er 1959 seinen ersten Schwarz-Weiß-Film produzierte. Das Wachstum der Werbebranche vorausahnend, gründete er 1966 das Unternehmen Start Desenhos Animados Ltda., wo er bis heute seine Filme entwirft und produziert. Ribas führte bei über zweitausend animierten Werbefilmen und etlichen didaktischen Filmen für das In- und Ausland die Regie. Obgleich er in den Vereinigten Staaten, Großbritannien, Mexiko, Portugal und für Unicef Caribbean gearbeitet hat, hat er doch niemals seine brasilianischen Wurzeln gekappt.

Unter der Führung seines ausdauernden und kreativen Gründers wuchs und reifte das Unternehmen Start. Den Übergang in die Ära der digitalen Animation schaffte Ribas ohne Traumata. Er erhielt die Verbindungen zum Erbe der Klassiker und bahnte gleichzeitig den Weg für eine neue Generation professioneller Animationskünstler, die bereits ausgezeichnet wurde, nämlich für den 3D-Kurzfilm *A última gota* (2003).

Die Anerkennung, die Ribas zuteil wurde, lässt sich an einer langen Liste nationaler und internationaler Preise für Einzelfilme und etlichen Auszeichnungen für sein Gesamtoeuvre ablesen. Er selbst aber hält den Spielfilm *O grilo feliz* von 2001, der nicht als Auftragsarbeit konzipiert war und an dem er fünfzehn Jahre lang mit zeitweiligen Unterbrechungen gearbeitet hat, für den großen Wurf seiner Karriere. In dieser fesselnden Erzählung werden Werte wie Freiheit, Freundschaft, Solidarität und Umweltbewusstsein hochgehalten.

Pg. 282–283 O Grilo Feliz, 2001
Traditional animation

Pg. 284 O Grilo Feliz, 2001
Poster

Pg. 285 Sharp (commercials)
Traditional animation

STUDIO AKA

United Kingdom
Contact: Sue Goffe/Head
 of production
30 Berwick Street, Soho
London, W1F 8RH
Phone: + 44 20 7434 3581
Fax: + 44 20 7437 2309

Ah Pook Is Here, 1994
The Knights Tale, 1999
Annie and Boo, 2003
Birdfeed, 2003
Where Do I Begin, 2000
Pica Towers Trilogy, 2003
Jojo in the Stars, 2003

Best Film Category B - Espinho, 1994
First Prize Hamburg Film Festival, 1995
First Prize Dresden Film Festival, 1995
Jury Prize Montreal Short film
 Festival, 1995
Best film: cutting edge British
 animation Awards, 1996
Best Short Film, BAFTA 1999
Oscar Nomination 2000
Best Short Animation, BAFTA 2004
Special Jury Recognition - Aspen
 2004

Traditional animation
3D computer graphics
Interactive projects

STUDIO AKA

www.studioaka.co.uk

One good reason to watch television in the United Kingdom is to see the commercials created by Studio AKA. Among the clients of their visually sophisticated and creative advertising reports are companies like Volvo, BBC, Vodafone, Compaq, Orange, Ballantines, Time and Oilatum.

The company has been on the market for 18 years and, as far as commercial animation is concerned, has few rivals in the country. Equipped with the best software and hardware available, company directors Pam Dennis, Sue Goffe and Philip Hunt are proud of their eclecticism and their ability to constantly reinvent themselves in order to adjust to the market's needs and challenges.

In addition to filling TV commercial breaks in with brilliant ideas and memorable characters, the London-based Studio AKA develops interactive and on-line projects for FIFA, for various other companies and for their own use. A good number of these projects can be accessed through the studio's website.

Studio AKA's own short films exhibit the same variety of techniques as their commercials, and exploit references to the world of advertising. However, lately they have given more importance to the gray and frightening, and at the same time seducing, universe of director Marc Craste's *Pica Towers* trilogy.

The London studio is currently made up of animation directors such as Marc Craste, Mic Graves, Philip Hunt, Grant Orchard, Steve Small and Studio Soi of Germany, not to mention a number of rising talents that promise to stretch the limits of commercial animation even more.

Les spots publicitaires du studio AKA sont une raison suffisante pour regarder la télévision au Royaume-Uni. Parmi les clients habituels de ces créations si sophistiquées et créatives se trouvent des entreprises comme Volvo, la BBC, Vodafone, Compaq, Orange, Ballantines, Time et Oilatum.

Le studio est présent depuis 18 ans sur le marché et compte peu de concurrents en matière d'animation commerciale. Dotée des meilleurs équipements et programmes disponibles, la compagnie de Pam Dennis, Sue Goffe et Philip Hunt peut se targuer de son éclectisme et de sa capacité de se renouveler constamment pour s'adapter aux besoins et défis du marché.

Installé à Londres, le studio AKA ne se contente pas de peupler les coupures publicitaires d'idées brillantes et de personnages légendaires. En parallèle sont développés des projets interactifs en ligne pour la FIFA,

pour diverses entreprises ou pour un usage personnel, dont la plupart sont consultables sur le site Web de la compagnie.

Les courts d'auteur du studio AKA affichent la même variété de techniques et exploitent des références propres à l'univers publicitaire. Toutefois, c'est finalement le monde grisâtre et terrifiant mais non moins attirant de la trilogie *Pica Towers*, créée par le réalisateur Marc Craste qui l'emporte.

Aujourd'hui, le studio londonien se compose des responsables d'animation Marc Craste, Mic Graves, Philip Hunt, Grant Orchard, Steve Small et le studio allemand Soi. S'ajoute aussi une série de talents émergents qui promettent de repousser encore les frontières de l'animation commerciale.

Ein guter Grund, im Vereinigten Königreich Fernsehen zu schauen, sind die von Studio AKA gemachten Werbefilme. Zu den Stammkunden der visuell raffinierten und kreativen Werbereportagen zählen Unternehmen wie Volvo, BBC, Vodafone, Compaq, Orange, Ballantines, Time und Oilatum.

Nach achtzehn Jahren im Geschäft haben sie, was kommerzielle Animation betrifft, wenig Konkurrenz im Land. Ausgerüstet mit der besten Soft- und Hardware, die es überhaupt gibt, ist die Firma von Pam Dennis, Sue Goffe und Philip Hunt stolz auf ihre Vielfalt an Stilrichtungen und ihre Fähigkeit zur kontinuierlichen Häutung, um sich auf die Erfordernisse und Anreize des Marktes einzustellen.

Mit brillanten Ideen und Figuren, die Spuren hinterlassen, füllt das in London ansässige Studio AKA Pausen im Fernsehprogramm und entwickelt außerdem interaktive und Online-Projekte für die FIFA, für verschiedene Firmen und für den Eigengebrauch. Über die Website des Studios hat man Zugang hat zu einem Großteil dieser Arbeiten.

Die kurzen Autorenfilme von Studio AKA demonstrieren die gleiche Bandbreite an Techniken und beuten Anspielungen aus dem Werbekontext aus. Allerdings hat man in letzter Zeit dem gräulichen und erschreckenden, obgleich auch verführerischen Universum der Trilogie *Pica Towers* des Regisseurs Marc Craste mehr Bedeutung gegeben.

Zurzeit besteht das Londoner Studio aus den Animationsregisseuren Marc Craste, Mic Graves, Philip Hunt, Grant Orchard, Steve Small und Studio Soi aus Deutschland, ohne eine ganze Reihe aufsprießender Talente mitzuzählen, die versprechen, die Grenzen der kommerziellen Animation noch weiter auszudehnen.

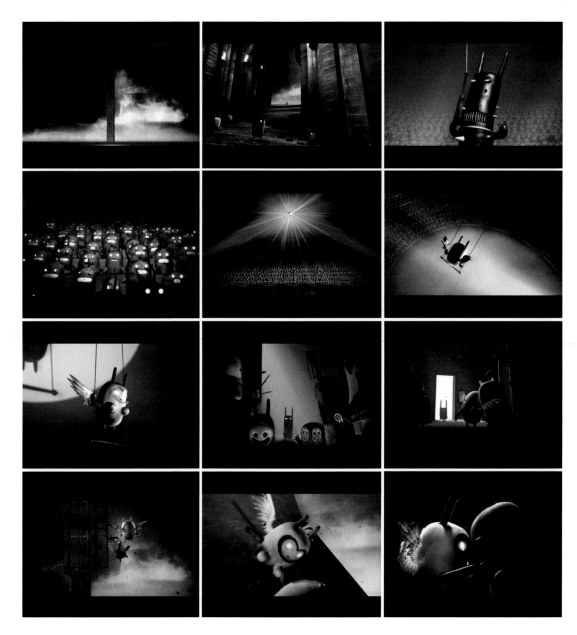

Pg. 286 Compaq Bird TV
Traditional animation
Dir.: Grant Orchard, Dominic Griffiths &
Mario Cavalli
Client: Compaq
Agency: BMP DDB

Pg. 287 Ballentines Band
3D computer animation
Dir.: Marc Craste
Client: Ballentines Whisky
Agency: 141 International

Pg. 288 Jojo in the Stars, 2003
3D computer animation

Pg. 289 Jojo in the Stars, 2003
Poster

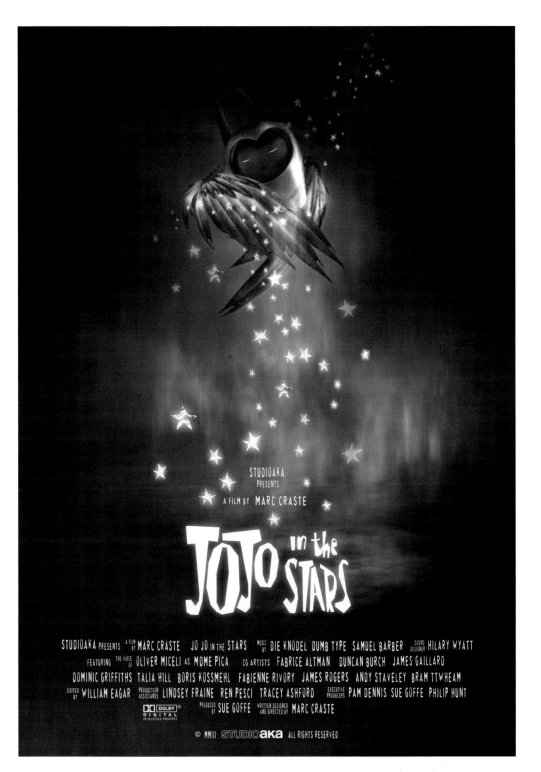

STUDIOAKA
PRESENTS

A FILM BY MARC CRASTE

JOJO in the STARS

STUDIOAKA PRESENTS A FILM BY MARC CRASTE JO JO IN THE STARS MUSIC BY DIE KNODEL DUMB TYPE SAMUEL BARBER SOUND DESIGNER HILARY WYATT

FEATURING THE VOICE OF OLIVER MICELI AS MDME PICA CG ARTISTS FABRICE ALTMAN DUNCAN BURCH JAMES GAILLARD

DOMINIC GRIFFITHS TALIA HILL BORIS KOSSMEHL FABIENNE RIVORY JAMES ROGERS ANDY STAVELEY BRAM TTWHEAM

EDITED BY WILLIAM EAGAR PRODUCTION ASSISTANTS LINDSEY FRAINE REN PESCI TRACEY ASHFORD EXECUTIVE PRODUCERS PAM DENNIS SUE GOFFE PHILIP HUNT

DOLBY DIGITAL IN SELECTED THEATRES PRODUCED BY SUE GOFFE WRITTEN DESIGNED AND DIRECTED BY MARC CRASTE

© MMIII STUDIOaka ALL RIGHTS RESERVED

STUDIO GHIBLI

Japan
E-mail: post@ghibli.co.jp
1-4-25, Kajino-cho, Koganei-shi,
184-0002
Phone: + 81 4225 02511

Nausicaä of the Valley
 of the Wind, 1984
Laputa Castle in the Sky, 1986
My Neighbor Totoro, 1988
Grave of the Fireflies, 1988
Kiki's Delivery Service, 1989
Only Yesterday, 1991
Porco Rosso, 1992
Pom Poko, 1994
Whisper of the Heart, 1995
Princess Mononoke, 1997
My Neighbors the Yamadas, 1999
Spirited Away, 2001
The Cat Returns, 2002
the GHIBLIES episode 2, 2002
Howl's Moving Castle, scheduled
 for 2004

Best Long Feature Chicago
 1994 (Grave of the Fireflies),
Best Long Feature Annecy
 1993 (Porco Rosso),
Best Long Feature Annecy
 1995 (Pom Poko),
Best Picture Japanese Academy
 1998 (Princess Mononoke)
Best Picture Japanese Academy
 2002 (Spirited Away),
Golden Bear Berlin 2002
 (Spirited Away),
Outstanding Achievement in an
Animated Theatrical Feature
 Annie Awards 2003 (Spirited Away),
Best Animated Feature
 US Academy Awards 2003
 (Spirited Away)

Traditional hand-drawn
animation with partially
use of computer graphics

STUDIO GHIBLI

www.ntv.co.jp/ghibli/ (in Japanese)

Ghibli Studio follows a solid work philosophy. The growing success of their feature films for the big screen allows the studio to be profitable although they basically do not produce TV series, the main market for Japanese animation studios. Even though they primarily aim to reach the Japanese public, their films have had a growing impact throughout the rest of the world. The Oscar and the Berlin Festival Golden Bear Awards triumph for *Spirited Away* definitively confirmed the importance of the director Hayao Miyazaki. The studio's other mainstay, Isao Takahata, is Miyazaki's senior colleague as well as mentor.

Miyazaki and Takahata worked together in the seventies on television series such as the famous show *Heidi*, directed by Takahata, setting design and layout served by Miyazaki. Later, in 1982, while Miyazaki was drawing the manga (comic) *Nausicaä of the Valley of the Wind*, he received an offer from the publishing magnate Tokuma Shoten to adapt it for cinema. Miyazaki directed the film, and Takahata served as producer. Following the success of *Nausicaä*, Miyazaki, with cooperation from Takahata, created their own studio, Studio Ghibli, for the production of *Laputa Castle in the Sky*. The story continues with nearly one feature film every one to two years, most of which are directed by Miyazaki or Takahata. As a result of these films Ghibli has conquered the hearts and minds of people of all ages in Japan.

Since the movie *Pom Poko*, the studio gradually brought digital techniques into their films, and ink and paint and photographing process has become completely digitalized from *My Neighbors the Yamadas*. However, in some of their biggest international hits such as *Princess Mononoke* and *Spirited Away*, animation and background is basically drawn by hand, and the use of the 3D computer graphics is limited to necessary scenes to achieve the desired expression and style. Ghibli's movies manage to preserve in this way, the essence of hand-drawn creations just as the philosophy of the studio dictates: by producing high quality animation that has an impact on the human mind and illustrates the joys and sorrows of life as it is.

Le studio Ghibli obéit à une philosophie de travail catégorique : peu de productions pour la télévision, principal marché des studios d'animation japonais, et développement assuré par le succès croissant de longs métrages pour le grand écran. Bien que l'objectif premier soit d'atteindre le public japonais, le reste du monde est de plus en plus sensible à ces créations. Récompensant *Le Voyage de Chihiro*, un Oscar et l'Ours d'or au Festival de Berlin sont venus consacrer définitivement le nom de Hayao Miyazaki. L'autre pilier du studio, Isao Takahata, est à la fois associé et mentor de Miyazaki.

Dans les années 70, Miyazaki et Takahata avaient déjà collaboré pour des séries télévisées comme le célèbre *Heidi*, dirigé par Takahata et avec un design et une composition de Miyazaki. En 1982, alors qu'il dessine le manga *Nausicaä de la Valllée du Vent*, Miyazaki reçoit une offre du magnat de la presse Tokuma Shoten pour une adaptation au cinéma. Il en assure alors la réalisation et Takahata la production. Le succès de *Nausicaä* conduit le duo a fondé le studio pour produire *Le Château dans le Ciel*. Et ainsi de suite, avec quasiment un long métrage par an ou tous les deux ans, réalisés par Miyazaki ou Takahata et grâce auxquels Ghibli a conquis le cœur et l'âme de toutes les générations du Japon.

À partir de *Pompoko*, le studio introduit progressivement des techniques numériques ; depuis *Mes Voisins les Yamada*, l'encre, la peinture et les photographies sont totalement numérisées. Toutefois, pour certains succès internationaux comme *Princesse Mononoké* et *Le Voyage de Chihiro*, l'animation et le fond sont faits à la main et les images en 3D interviennent seulement dans certaines scènes, pour atteindre l'expression et le style recherchés. Les films de Ghibli préservent ainsi l'essence du tracé manuel, en accord avec la philosophie du studio : faire une animation de qualité qui reflète l'esprit humain et illustre les joies et les peines de la vie réelle.

Das Ghibli Studio hat eine solide Arbeitsphilosophie. Obgleich es sehr wenig für das Fernsehen, den eigentlichen Hauptmarkt der japanischen Animationsfilm-Studios, produziert, bleibt das Geschäft dank des wachsenden Erfolges seiner Spielfilme für die Kinoleinwand dennoch lukrativ. Sein Hauptanliegen ist zwar, vor allem das japanische Publikum zu erreichen, doch auch in der übrigen Welt findet es ein zunehmend größeres Echo. Definitiv durchgesetzt hat sich der Name von Hayao Miyazaki, die zusammen mit ihrem Seniorpartner und Mentor Isao Takahata die treibende künstlerische Kraft bei Ghibli ist, durch einen Oscar und den Goldenen Bären, mit dem *Chihiros Reise ins Zauberland* auf der Berlinale ausgezeichnet wurde.

Bereits in den siebziger Jahren haben beide für berühmte Fernsehserien wie *Heidi* zusammen gearbeitet, wobei Miyazaki für Ausstattung und Gestaltung und Takahata für die Regie zuständig war. Später, 1982, schlug der Verlagsmagnat Tokuma Shoten Miyazaki, die gerade das Manga *Nausicaä aus dem Tal der Winde* zeichnete, eine Kinoadaption vor. Der Erfolg von Nausicaä, für den Miyazaki als Regisseur und Takahata als Produzent verantwortlich waren, führte zur Gründung des Studios Ghibli, um dort *Laputa Castle in the Sky* zu produzieren. Und so ging die Erfolgsgeschichte weiter: Praktisch jedes Jahr entstand ein Spielfilm, meistens unter der Regie von Miyazaki oder Takahata, mit dem Ghibli die Herzen und Gemüter aller Altersklassen in Japan zu erobern wusste.

Mit *Pom Poko* begann das Studio allmählich digitale Techniken einzuführen, bis es bei *My Neighbors the Yamadas* das Bild aus Tinte, Farbe und Photografie komplett digitalisierte. Allerdings wurden bei einigen der großen Welterfolge wie *Prinzessin Mononoke* und *Chihiros Reise ins Zauberland* die eigentliche Bildanimation und die Hintergründe von Hand gezeichnet und der Einsatz von 3D-Computergrafiken wurde auf solche Szenen beschränkt, wo der gewünschte Ausdruck und Stil nicht anders zu erreichen war. So schaffen es die Ghibli-Filme, den Anschein von handgefertigten Zeichnungen aufrechtzuerhalten, wie es ja auch die Philosophie des Studios vorschreibt: Trickfilme von hoher Qualität zu machen, die im menschlichen Geist Anklang finden, indem sie Freud und Leid wie im wirklichen Leben illustrieren.

Pg 290 Left Nausicaä of the Valley of the Wind (Kaze no tani no naushika) © 1984 Nibariki - Tokuma Shoten - Hakuhodo

Pg 290 Right Laputa Castle in the Sky (Tenku no shiro Rapyuta) © 1986 Nibariki - Tokuma Shoten

MY NEIGHBORS THE YAMADAS

ホーホケキョ
高畑 勲監督作品

My Neighbors the Yamadas
(Ho-hokekyo tonari no Yamada kun)
© 1999 Hisaichi Ishii - Hatake
Jimusho - TGNHB

猫の国。それは、自分の時間を
生きられないやつの行くところ。
猫になっても、いいんじゃないッ?

猫の恩返し

宮崎 駿 企画 ● 森田宏幸 第一回監督作品
池返千鶴/袴田吉彦 ● 前田亜季
● 山田孝之/佐藤仁美 ● 岡江久美子
● 丹波哲郎

The Cat Returns
(Neko no ongaeshi)
© 2002 Nekonote-Do-TGNDHMT

TANDEM FILMS

United Kingdom
Contact: Lynn Hollowell
26, Cross Street, Islington,
London N1 2BG
Phone: + 44 20 7688 1717
Fax: + 44 20 7688 1718
lynn@tandemfilms.co

Alarm Call, 1980
Family Tree, 1988
Manipulation, 1991
Rabbit Rabbit, 1996
Flatworld, 1997
Rockin' & Rollin', 2001
How to Cope With Death, 2002
Colour Keys
Empathy
Little Things, 2004

First Prize - *Los Angeles,* 1991
Marie Kuttna Award - *BFI,* 1991
Oscar Best Animated Short, 1992
Cartoon d'Or, 1992
First Prize Children's Category -
 Berlin, 1992
Audience Prize - *Leipzig,* 1997
Special International Jury Prize -
 Seoul, 1997
Best Animation for TV - *WAC*
 Pasadena/USA, 1998
Audience Award - *BAA London,* 1998
Jury and Audience Prizes - *Zagreb,* 1998
Best Debut Film - *New York EXPO,* 2001
Grand Prix - *Riga,* 2003
Jean-Luc Xiberras Award - *Annecy,* 2003

Traditional animation
Stop-motion
CGI

TANDEM FILMS

www.tandemfilms.com

Daniel Greaves and Nigel Pay, two of Great Britain's most experienced animators, founded Tandem Films studios in London in 1986. Talented animators like Adam Larkun, Richard Jack, David Daniels and the Argentinean Ignacio Ferrera were quickly attracted to their studio. As a result, an excellent and highly respected team was formed. This team never tires of snatching up awards in the most important festivals, nor of attracting big clients like the BBC, British Airways, Expedia and Hellmann's mayonnaise.

There are no technical limitations to Tandem's creations. Daniel Greaves' movie *Manipulation*, filmed in *stop motion*, has become a classic of metalinguistic animation. It won an Oscar for best animated short film, as well as other top awards. The TV special *Flatworld*, also directed by Greaves, won 30 international awards, 17 of which were for best film. *Flatworld* uses an extremely sophisticated technique, which involves drawings that are mounted on cards, cut out, filmed frame by frame against three-dimensional backgrounds and combined with the latest digital special effects. The result is a captivating adventure through a world of flat forms.

Rockin' & Rollin' is a psychological thriller starring billiard balls in the leading roles, while *Rabbit Rabbit* is a graphic multiplication exercise. The film *Little Things* brings indescribable characters into motion in everyday situations that are elevated to a surrealist level. In each of these imaginative short movies, Greaves and his colleagues at Tandem Films seem to broaden a bit more the horizons of animation language.

Daniel Greaves et Nigel Pay, deux animateurs expérimentés de Grande-Bretagne, fondent en 1986 les studios Tandem Films à Londres. Des talents comme Adam Larkun, Richard Jack, David Daniels et l'Argentin Ignacio Ferrera les rejoignent rapidement. Ils forment ainsi une équipe méritant le respect pour son travail, et qui ne cesse de remporter des récompenses dans les principaux festivals et de conquérir des clients de poids tels que la BBC, British Airways, Expedia ou la marque de mayonnaise Hellmann's.

Les créations de Tandem ne connaissent aucune frontière technique. *Manipulation*, film de Daniel Greaves réalisé en *stop motion* et récompensé, entre autres prix importants, par l'Oscar du meilleur court métrage d'animation, est devenu un classique de l'animation métalinguistique. Pour sa part, la production télévisée *Flatworld*, également de Greaves, a reçu 30 prix internationaux, dont 17 comme meilleur film. La

technique employée est fort complexe : des dessins sont montés sous forme de cartes, découpés, filmés image par image sur des fonds en 3D et assortis d'effets spéciaux numériques dernier cri. Il en résulte une aventure captivante via un monde aux formes planes.

Rockin' & Rollin' est un thriller psychologique mettant en scène des boules de billard, alors que *Rabbit Rabbit* offre un exercice graphique de multiplication et *Little Things* anime des personnages indescriptibles dans des situations de la vie quotidienne prenant une dimension surréaliste. Dans tous ces courts des plus imaginatifs, il semble que Greaves et ses collègues de Tandem Films étendent un peu plus encore l'horizon du langage de l'animation.

Daniel Greaves und Nigel Pay, die zu den alten Hasen unter den Trickfilmern in Großbritannien gehören, gründeten 1986 in London das Studio Tandem Films. Talente wie Adam Larkun, Richard Jack, David Daniels und der Argentinier Ignacio Ferrera stießen rasch dazu. So formierte sich ein Team, das allen Respekt verdient und das nicht müde wird, Preise bei den wichtigsten Festivals abzuräumen und Großkunden wie BBC, British Airways, Expedia und Hellmann's-Mayonnaise zu erobern.

Für die Tandem-Schöpfungen existieren keine technischen Grenzen. Daniel Greaves' *Manipulation*, in Stop-Motion ausgeführt, wurde mit dem Oscar für den besten animierten Kurzfilm und mit anderen erstrangigen Preisen ausgezeichnet; er ist zu einem Klassiker der Animation auf metalinguistischer Ebene avanciert. Daneben hat das TV-Special *Flatworld*, ebenfalls unter der Regie von Greaves, dreißig internationale Preise eingeheimst, siebzehn davon für die Kategorie Bester Film. *Flatworld* bedient sich einer extrem raffinierten Technik, die aus Zeichnungen besteht, die auf Karten montiert, dann ausgeschnitten werden, um sie Bild für Bild vor dreidimensionalen Hintergründen abzufilmen und mit digitalen Spezialeffekten der jüngsten Generation zu kombinieren. Das Ergebnis ist ein Abenteuer, das mit seiner Welt planer Formen gefangen nimmt.

Rockin' & Rollin' ist ein Psychothriller, dessen Hauptakteure ein paar Billardkugeln sind, während *Rabbit Rabbit* eine grafische Multiplikationsübung ist und *Little Things* unbeschreibliche Figuren in alltäglichen Situationen, die auf eine surrealistische Ebene gehoben sind, in Bewegung setzt. Mit jedem einzelnen dieser fantasievollen Kurzfilme scheinen Greaves und seine Mitstreiter von Tandem Films den Horizont der Animationssprache behutsam zu weiten.

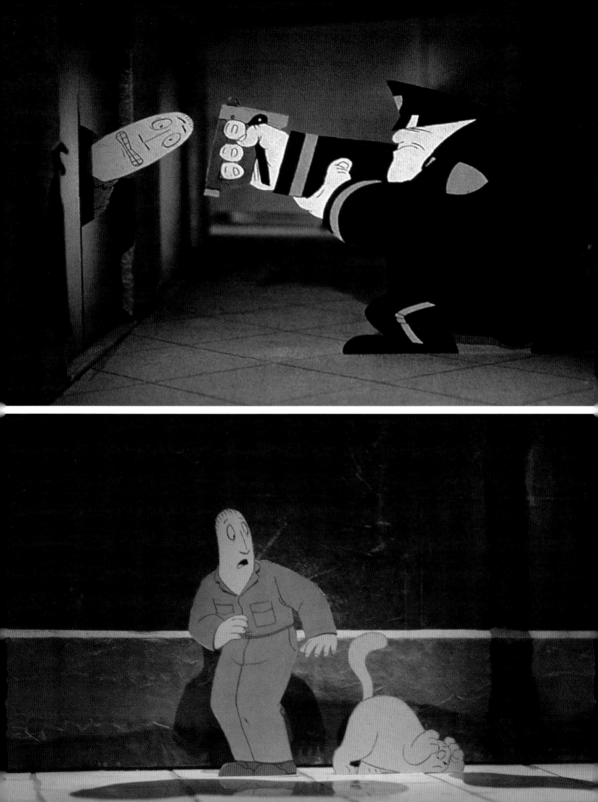

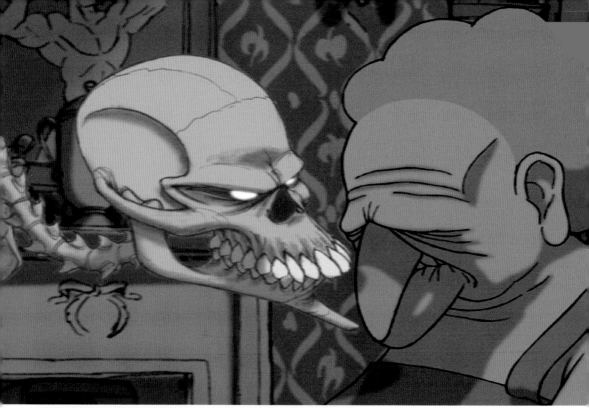

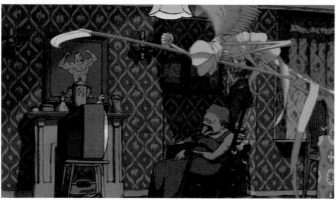

Pg. 297 Flatworld, 1997
Stop-motion
Dir.: Daniel Greaves
© Tandem Films Entertainment / BBC /
Videal / S4C / Eva Entertainment

Pg. 298 How to Cope With Death, 2002
2D traditional animation
with digital composing
Dir.: Ignacio Ferreras
© Tandem Films Entertainment

Pg. 299 Manipulation, 1991
Traditional animation with live action
Dir.: Daniel Greaves
© Tandem Films Entertainment

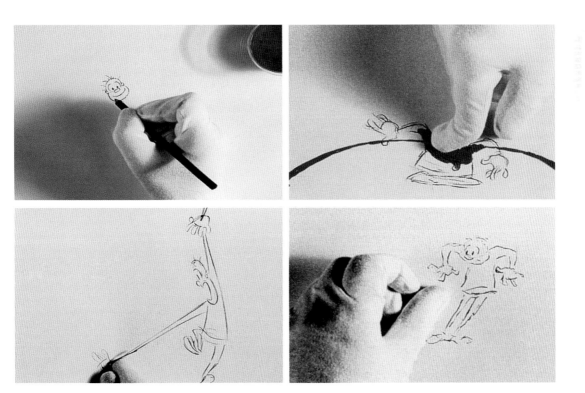

TEZUKA PRODUCTIONS CO., LTD

Japan
Contact: Yoshimi Suzuki
4-32-11 Takadanobaba
Shinjuku-ku, Tokyo 169-857
Phone: + 81 3 3371 6411
Fax: + 81 3 3371 6431
E-mail: yoshimi@tezuka.co.jp

Hsi Yu Chi / The Journey
 to the West, *1960*
Astro Boy, *series, 1963*
Jungle Emperor Leo, *1965/1966/1997*
Cigarettes and Ashes, *1965*
One Million-Year Trip:
 Bander Book, *1978*
Jumping, *1984*
Broken Down Film, *1985*
The Legend of the Forest, *1987*
The Film Is Alive *1990*
Black Jack: The Movie, *1993*

The 1st Ofuji Nobuo Award
 Mainichi 1963,
Special Award *Asian Film Festival 1967,*
Grand Prize and Unesco
 Award *Zagreb 1984,*
Grand Prix *Hiroshima 1985,*
CIFEJ Youth Award *Zagreb 1988*

Traditional animation
Computer graphics
Flash

TEZUKA PRODUCTIONS

www.tezuka.co.jp

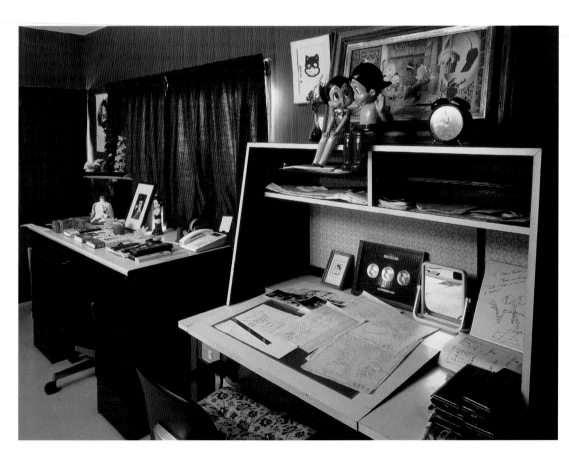

From mangas to anime, Osamu Tezuka (1928-1989) practically redefined Japanese popular culture after World War II using pioneering narratives with "cinematic" art and novelistic plots in printed comics. He diversified the style of comics by turning them into an art form and a product of national preference. He also created many of the features that are repeated in mangas even today, such as the characters' big eyes. He was also the first Japanese to discover, with the pioneer series *Astro Boy*, the potential that television represented for showing cartoons.

He founded his first animation studio, Mushi, in 1960 and started to produce the first TV animated series in Japan from many of his previous creations, including *Mighty Atom* ("Astro Boy"), *Jungle Emperor* ("Kinba the White Lion"), and *Princess Knight*. Over the course of four decades, Tezuka Productions has brought more than 1,000 characters to life, using everything from the most rudimentary techniques to digital animation. At Tezuka Productions, founded in 1968, he produced Japan's first two-hour TV animated, special *Bander Book*, realed in, and a new color version of the *Mighty Atom* ("Astro Boy"), TV series, and *Phoenix 2772*, a theatrical feature, both in 1980.

The films of Osamu Tezuka, who died at age 61, motivated an intellectual criticism that is not all that common in anime today. His followers have inherited his love for formal research and his spirit of defense of the environment, peace and the fundamental values of humanity, especially of children.

Together with their feature film productions, television series and specials, Tezuka Productions created experimental animations that have left their mark on a whole era. The I International Animation Festival of Hiroshima granted its grand prize to *Broken Down Film*, an old-style Western film in which the hero has to fight not only against bandits, but also against the deteriorating movie. In *Jumping*, another masterpiece of metalanguage, a subjective camera moves through time and space.

The studio Tezuka Production is still very active and keeps producing material based on Tezuka's creations, and has been releasing titles such as *Black Jack* in 1993. They are currently producing a new version of Tezuka's greatest lifetime piece *Phoenix* (Hinotori in Japanese) that should be ready around 2006.

Du manga au dessin animé, Osamu Tezuka (1928-1989) a quasiment remodelé la culture populaire japonaise depuis la Seconde Guerre mondiale. Ce cinéaste a apporté une grande variété à la bande-dessinée et en a fait un art et un produit de préférence nationale. Par ailleurs, il a créé nombre d'éléments récurrents dans le manga, tels que les grands yeux conférés aux personnages, et a été le premier Japonais à découvrir, avec la série pionnière *Astro le petit robot*, le potentiel de la télévision pour la diffusion de dessins animés.

Au fil de quatre décennies, Tezuka Productions donne vie à plus de 1 000 personnages en combinant techniques rudimentaires et animation numérique. Black Jack, le lionceau Léo, le prince du soleil et tant d'autres justiciers et scélérats ont conquis le public et réussi à éliminer les tabous qui empêchaient la présentation d'animations sur le petit écran.

Les films d'Osamu Tezuka, disparu à l'âge de 61 ans, ont fait naître une critique intellectuelle plutôt absente pour le dessin animé. Ses adeptes ont hérité du goût pour la recherche formelle et la défense de l'environnement, de la paix et des principes fondamentaux de l'humanité, notamment ceux ayant trait aux enfants.

Outre la production de longs métrages, de séries et de programmes pour la télévision, Tezuka Productions est à l'origine d'animations expérimentales ayant marqué leur temps. La première édition du Festival international d'animation d'Hiroshima a octroyé son grand prix à une production de l'Ouest à l'ancienne, *Le film cassé*, dans laquelle le héros doit faire face à des bandits et empêcher en parallèle la dégradation de la pellicule. Dans *Le saut*, autre chef-d'œuvre du métalangage, une caméra subjective se déplace dans le temps et dans l'espace.

Le studio conserve une activité soutenue et ne cesse de produire des œuvres inspirées de créations de Tezuka. En 1993 par exemple, il proposait *Black Jack* ; actuellement est en cours la production d'une adaptation de la pièce maîtresse de Tezuka intitulée *Phœnix* et dont la sortie est prévue autour de 2006.

Es war Osamu Tezuka (1928-1989), der praktisch die gesamte japanische Popkultur vom Manga bis zum Anime nach dem Zweiten Weltkrieg neu definierte. Der Filmemacher brachte Abwechslung in den Comic-Stil, indem er ihn zu einer Kunstform erhob und für dieses Produkt eine nationale Vorliebe weckte. So schuf er viele der heute in den Mangas gültigen Muster, etwa die Großäugigkeit der Figuren. Er war auch der erste Japaner, der mit der Pionierfilmreihe *Astro Boy* das Potential für die Ausstrahlung von Zeichentricks im Fernsehen entdeckte.

Im Laufe die vier Jahrzehnten hat Tezuka Productions mehr als tausend Figuren ins Leben gerufen, wobei man von den rudimentärsten Techniken bis hin zu digitaler Animation praktisch alles einsetzte. Black Jack, der kleine Löwe Leo, das Kind Bander und so viele andere Gerechtigkeitsliebende und ungehobelte Klötze haben die Sympathie des Publikums gewonnen und es geschafft, die Tabus zu brechen, die verhinderten, dass Trickfilme auch auf dem Bildschirm zu sehen waren.

Die Filme von Osamu Tezuka, der mit 61 Jahren verstarb, motivierten sogar intellektuelle Kritiker, was beim aktuellen Anime nicht gerade üblich ist. Seine Nachfolger haben den Gefallen an der formalen Untersuchung geerbt genauso wie einen Geist, der sich für die Ökologie, den Frieden und die menschlichen Grundwerte und besonders die Kinder einsetzt.

Neben der Produktion von Spielfilmen, Serien und TV-Specials, schuf Tezuka Productions experimentelle Animationen, die Epoche prägend waren. Das Erste Internationale Trickfilm-Festival von Hiroshima verlieh seinen Großen Preis an *Broken Down Film*, einen Western alten Stils, in dem der Held nicht nur gegen Banditen kämpfen muss, sondern auch gegen den Verfall des Films. In *Jumping*, einem weiteren Meisterwerk der Metasprache, bewegt sich eine subjektive Kamera durch Zeit und Raum.

Das Studio Tezuka Productions ist nach wie vor sehr aktiv und produziert weiterhin Stoffe auf der Grundlage von Tezukas Schöpfungen; 1993 hat es beispielsweise *Black Jack* herausgebracht. Zur Zeit ist man dabei, eine neue Version von *Phoenix* (japanisch: *Hinotori*), Tezukas größtem Lebenswerk, herauszubringen; sie wird voraussichtlich 2006 fertiggestellt sein.

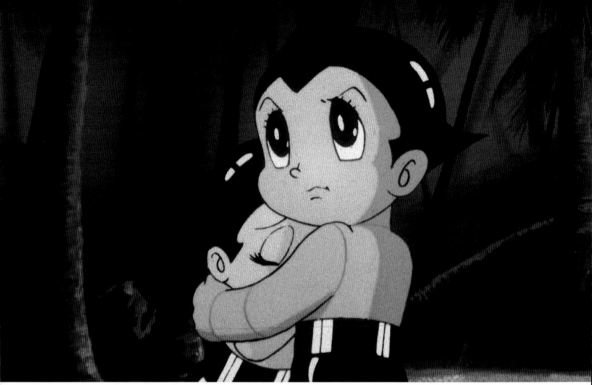

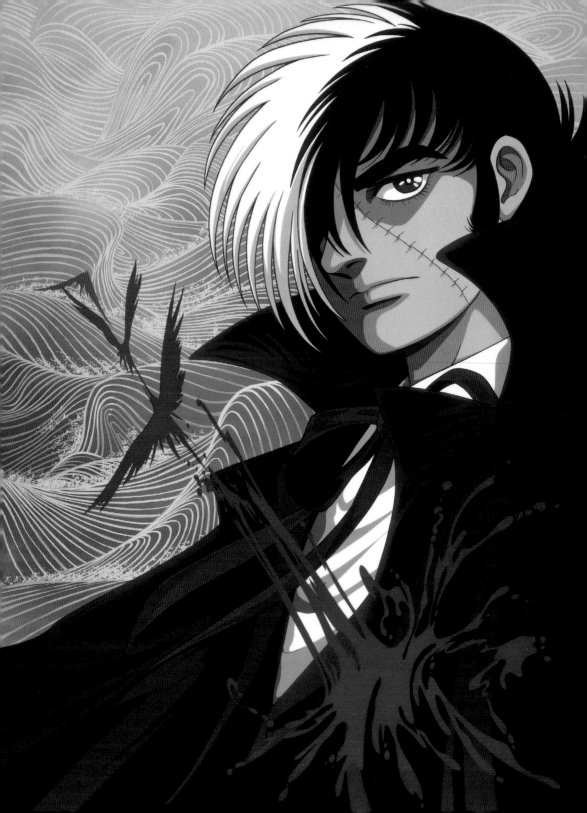

THE CHARACTER SHOP

United Kingdom
Contact: Paul Howell or Mark Vale
c/o Room PSB 201, BBC
Broadcasting Centre, Pebble Mill
 Road, Birmingham B5 7QQ
Phone: + 44 121 432 8326/8702
Fax: + 44 121 432 8130
E-mail: info@thecharactershop.com

Night Flight, 2002
**British Animation Awards opening
 film,** 2002/2004
What Would Jesus Do?, 2002
Slaughter House, 2004

Bronze Award - *BDA/USA,* 2002
Best Animated Sequence - *Annecy,*
 2002
Prize for applied animation - *Holland,*
 2002

3D animation
GCI special effects

THE CHARACTER SHOP

www.thecharactershop.com

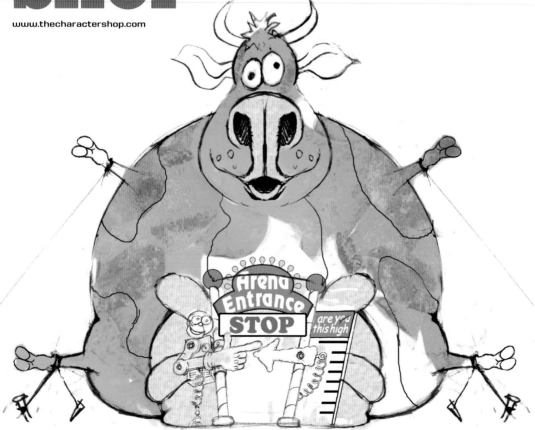

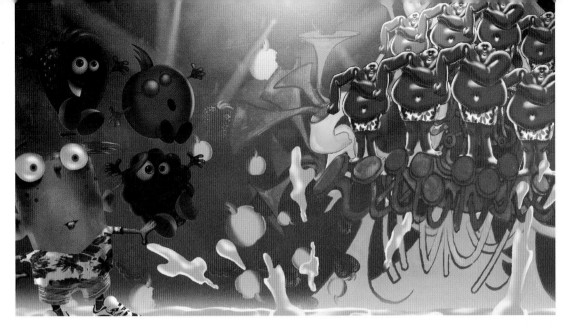

One of the United Kingdom's newest companies in the sector, The Character Shop began as an independent production company in September of 2002. Until then it was part of MediaArc, the commercial design unit of the BBC. Directors Paul Howell and Mark Vale showed their creativity and skill in different jobs, such as the special effects for the television drama *Night Flight*, where they recreated a troop of old Lancaster bombers from just one real airplane.

However, their big boost did not come from machines but rather from the entertaining sheep of the opening film at the 2002 British Animation Awards ceremony. In the movie a flock of sheep has to cross fields and battle weather and natural disasters before finally reaching a movie theater. The short film was given an award at the festivals of Annecy and Holland, a fact that had great repercussions for The Character Shop.

After this success they were commissioned to do the colorful Nestle commercials, as well as to work on the animation and special effects for a new BBC series called *Friends & Heroes* based on Biblical characters. In their work Howell and Vale typically present characters that are drawn simply but with apparent originality, and created directly on the computer. The studio also creates digital special effects, makes 3D models and elaborates concepts of style for advertising commercials, television and film.

The Character Shop est l'une des entreprises les plus jeunes du Royaume-Uni, née comme maison de production indépendante en septembre 2002. Jusqu'alors, elle dépendait de BBC MediaArc, unité de design commercial de la BBC. À sa tête, Paul Howell et Mark Vale ont fait leurs preuves en matière de créativité et d'expertise avec, par exemple, les effets spéciaux pour le téléfilm dramatique *Night Flight*, dans lequel ils ont recréé un escadron d'anciens bombardiers Lancaster à partir d'un véritable aéronef.

Pourtant, leur grande avancée n'est pas liée aux machines, mais bien aux amusantes brebis du film d'ouverture pour la cérémonie des British Animation Awards en 2002 : dans cette production, un troupeau doit traverser des champs, des intempéries et des dangers naturels pour arriver à une salle de cinéma. Le court a été récompensé aux festivals d'Annecy et de Hollande, avec de grandes conséquences pour The Character Shop.

Depuis lors, la compagnie a reçu des commandes pour les spots riches en couleurs de Nestlé et pour l'animation et les effets spéciaux d'une nouvelle série de la BBC intitulée *Friends & Heroes* et basée sur des personnages bibliques. Les créations de Howell et Vale se caractérisent par un tracé simple des personnages, tout en leur conférant un aspect original conçu sur ordinateur. Le studio est aussi à l'origine d'effets spéciaux numériques, de modelages en 3D et de styles pour des spots publicitaires, la télévision et le cinéma.

The Charakter Shop, eines der jüngsten Unternehmen der Filmbranche Großbritanniens, entstand im September 2002 als unabhängige Produktionsfirma. Bis dahin war es Teil von BBC MediaArc, der Abteilung für kommerzielles Design bei BBC. Proben ihrer Kreativität und Sachkenntnis hatten seine Leiter Paul Howell und Mark Vale etwa mit ihrer Arbeit an den Spezialeffekten für das Teledrama *Night Flight* gegeben, wo sie – von nur einem einzigen realen Flugzeug ausgehend – eine ganze Schwadron alter Lancaster-Bomber neu erschufen.

Allerdings gaben nicht die Maschinen den großen Impuls, sondern die sympathischen Filmschafe für die Eröffnungszeremonie der British Animation Awards im Jahr 2002. In dem Film muss eine Schafherde Weiden überqueren und sich den Unbilden und Gefahren der Natur stellen, bevor sie den Kinosaal erreicht. Der Kurzfilm wurde auf den Festivals von Annecy und Holland ausgezeichnet, mit entsprechend großem Nachhall für The Charakter Shop.

Von da an kamen Aufträge für quietschbunte Werbespots für Nestlé ebenso wie für Arbeiten im Bereich Trickfilm und Spezialeffekte für die neue BBC-Serie *Friends & Heroes*, die biblische Gestalten zugrunde legt. Kennzeichnend für die Arbeiten von Howell und Vale ist, dass die Figuren mit einfachem Strich, aber originellem Erscheinungsbild direkt am Computer entworfen werden. Das Studio widmet sich auch digitalen Spezialeffekten, 3D-Modellierung und der Erarbeitung von Stilvorlagen für Werbespots, Fernsehen und Kino.

Pg. 308-309 Space Man, 2003
Dir.: Bob Cosford, the CharacterShop
3D animation

Pg. 310–311 Slaughter House, 2004
Dir.: Bob Cosford, the CharacterShop
3D animation

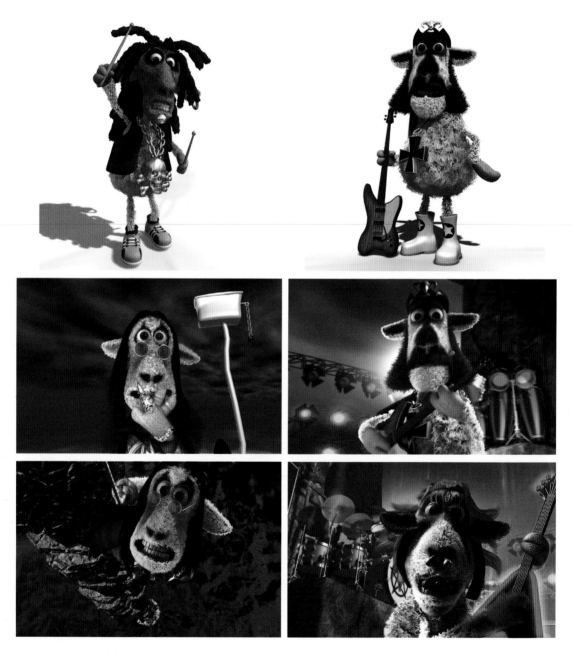

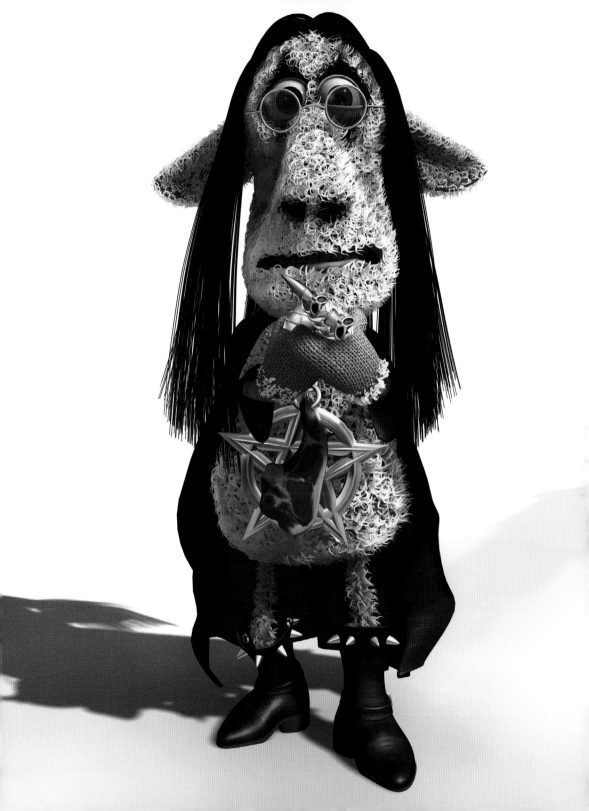

TRATTORIA

Brazil
Contact: Guto Carvalho
Rua Votupoca, 236
São Paulo, SP 05055-000
Phone: + 55 11 3874 0000
E-mail: guto@trattoria.com

Tortuguitas - Stupid, 1996
Kaiser, Mário de Blond, 1998
Kama Stra, 1999/2000
Airon Bungy, 2001
Itaú - Sightseeing, 2002
M&M`s Photos, 2003
Marida Monte music video, 2003
Luftal - Birthday, 2004

Best Animated Ad - *Hiroshima*, 1996
 and Espinho, 1999
Bronze Lion - *Cannes*, 2000

Traditional animation
Stop motion
Pixilation
Cut out
Computer animation

TRATTORIA DI FRAME

www.trattoria.com

Founded in 1991 by young special effects professionals, Trattoria is one of the most active Brazilian producers of advertising films. Curiously enough, artistic directors Guto Carvalho and Guilherme Ramalho, recently joined by Fábio Mendonça, have evolved in the opposite direction of most animators. In the beginning, they started with mostly electronic productions, and have since turned to a wide variety of techniques that includes traditional cartoons and works in *stop motion*.

A love for experimenting and a spirit for creating in groups have attracted a whole new generation of animators to Trattoria. Fábio Yamaji, Fábio Mendonça, Laurent Cardon, Fernando Coster, Guilherme Alvernaz, César Cabral, Léo Cadaval and Ageo Simões are some of the talented Brazilian animators that collaborate, or have collaborated, with this São Paulo studio. Through careful recruiting of foreign technology as well as professionals, Trattoria has known how to establish itself as a diversified and always up-to-date producer, and it has become one of the preferred companies for commercial and advertising agencies in Brazil.

The studio has already produced more than 1,000 commercials, videos, CD-ROMs, DVDs and animated series that have won several different awards in important national and international festivals. In Brazil, Trattoria has had an important role in establishing animation as an advertising method and in battling the stereotype that classified this kind of cinema as children's entertainment. Together with this work, the company also maintains a large production of real image films.

Fondée en 1991 par de jeunes professionnels en effets spéciaux, Trattoria est l'une des maisons de production de films publicitaires les plus actives du Brésil. Curieusement, les directeurs artistiques Guto Carvalho et Guilherme Ramalho, récemment rejoints par Fábio Mendonça, ont emprunté le chemin inverse de la plupart des animateurs. D'une production surtout électronique à leurs débuts, ils sont en effet passés à une variété de techniques incluant dessins traditionnels et *stop motion*.

Le goût pour l'expérimentation et l'esprit créatif du groupe a attiré une nouvelle génération de réalisateurs, tels que Fábio Yamaji, Fábio Mendonça, Laurent Cardon, Fernando Coster, Guilherme Alvernaz, César Cabral, Léo Cadaval et Ageo Simões. Tous sont des animateurs brésiliens collaborant ou ayant collaboré avec le studio de São Paulo. Grâce à un recrutement exigeant sur le plan technologique comme pour les intervenant étrangers, Trattoria a su renvoyer l'image d'une maison de production diversifiée et en évolution constante pour devenir l'une des préférées des annonceurs et agences de publicité du pays.

Le studio a déjà à son actif plus de 1 000 spots publicitaires, clips vidéo, CD-ROM, DVD et séries animées qui ont raflé des prix dans d'importants festivals nationaux et internationaux. Au Brésil, il a joué un rôle essentiel dans l'instauration de l'animation comme langage publicitaire et réussi à déjouer le cliché cantonnant ce type de production au monde des enfants. En parallèle, la compagnie poursuit la production intensive de tournages d'images réelles.

Trattoria, 1991 von jungen Profis für Spezialeffekte gegründet, ist eine der aktivsten brasilianischen Produktionsfirmen in der Werbefilmbranche. Witzigerweise haben die beiden für den künstlerischen Bereich zuständigen Direktoren Guto Carvalho und Guilherme Ramalho, zu denen sich kürzlich noch Fábio Mendonça gesellte, genau den umgekehrten Weg wie die meisten anderen Trickfilmer eingeschlagen: Sie gingen von einer anfangs hauptsächlich elektronischen Produktionsweise zu einer Vielfalt an Techniken über, die den traditionellen Zeichentrick und Arbeiten in Stop Motion umfassen.

Der Spaß am Experimentieren und der kreative Gruppengeist haben eine ganze Generation an Regisseuren zu Trattoria geführt. Fábio Yamaji, Fábio Mendonça, Laurent Cardon, Fernando Coster, Guilherme Alvernaz, César Cabral, Léo Cadaval und Ageo Simões sind einige jener talentierten brasilianischen Trickfilmer, die mit dem Studio in São Paulo zusammen arbeiten oder gearbeitet haben. Mittels einer klug abgewogenen Anwerbung sowohl von Know-How und von Profis aus dem Ausland hat Trattoria sich als vielseitige Produktionsfirma, die immer auf dem neuesten Stand ist, zu positionieren gewusst. Inzwischen ist das Studio bei Werbekunden und Reklameagenturen eines der beliebtesten in Brasilien.

Das Studio hat bereits mehr als tausend Werbespots, Videoclips, CD-Roms, DVDs und Tickfilm-Serien produziert, mit denen es bei den wichtigen nationalen und internationalen Festivals verschiedene Preise einheimste. In Brasilien hat es bei der Begründung der Bildanimation als Werbesprache eine herausragende Rolle gespielt, nicht zuletzt, indem es die stereotypen Vorurteile bekämpft, die diese Filmsparte auf Kinderunterhaltung konditionieren wollen. Nebenher unterhält das Unternehmen eine breite Produktpalette an traditionell gefilmten Streifen.

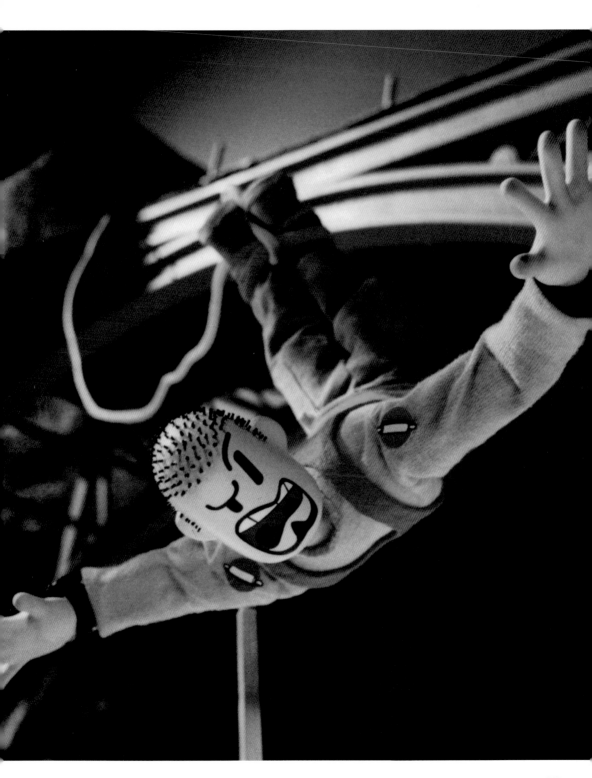

Pg. 313 Airon Bungy, 2001
Dir.: Fábio Mendonça, Gui Ramalho, Guto
Carvalho
Puppet animation

Pg. 314 (clockwise) Itaú - Sightseeing
(commercial), 2002
Puppet animation
Dir.: Fábio Mendonça

Puppets with metalic support

Camera on travelling track

Puppets with metalic support

Pg. 315 (clockwise) Tortuguitas - Stupid
(commercial), 1996
Dir.: Gui Ramalho

Set

Film frame

VETOR ZERO

Brazil
Contact: Alberto Lopes
Rua Joaquin Floriano, 913 -
8º andar São Paulo,
SP 04534-013
Phone: • 55 11 3709 2222
alberto@vetorzero.com.br

Tartaruga – Brahma /
 Turtle, 2001-2002
Lesma – Audi / Snail, 2001
Kaya's Screen Test, 2002
Ventania – Arno / Storm, 2003
Peixe – Brahma / Fish, 2003
Ameaça – Hellmann's / Threat, 2003
Médico – Comfort / Doctor, 2003
Astronautas / Astronauts, 2004

**7 Lions Cannes, Advertising Film
 Award** - *Annecy,* 2002
**First Prize Advertising & TV
Spots/Virtual Character -**
 Animago/Germany, 2002
Mobius Award - *Los Angeles,* 2004
Bronze Prize - *New York,* 2004

Computer animation,
Traditional animation
Stop motion

VETOR ZERO

www.vetorzero.com.br

The beautiful Kaya, a hyperrealist 3D girl created by Alceu Baptistão, was considered the best virtual character at the 2002 Animago festival in Germany. However, Kaya is not Vetor Zero's only muse. The entertaining turtle, able to make quick decisions and even play soccer with a beer can, or the dim-witted but good-natured girl that climbs into a new car for a test drive in what will be an unforgettable trip, are also among the icons that this studio in São Paulo, Brazil, has animated.

Since 1985 Vetor Zero has gradually entered the market and helped create a more favorable mentality towards digital animation in Brazilian advertising. The persevering and pioneering attitude of Alberto Lopes, Alceu Baptistão and Sérgio Salles has not been in vain. Although they began as a small company, today it is one of Latin America's most important producers of 3D animation and special effects, as well as being one of the most respected in the creation of graphic and aesthetic solutions. The Vetor Zero team also won seven Lions at the Cannes International Advertising Festival.

Many professionals have passed through Vetor Zero's studios and then later established themselves in the industry. The team prides themselves on developing their own instruments and techniques, according to the specific needs of each job. The interaction of animated characters with real image film has been a great success. To their excellence in digital work they added, in the year 2000, the experience of a new partner, the producer Lobo Films, in the areas of *stop motion*, traditional animation and developing projects for television. It is thus now possible to jump from "Zero" to infinity.

La superbe Kaya, jeune femme en 3D ultra réaliste créée par Alceu Baptistão, a été déclarée meilleur personnage virtuel au festival allemand Animago 2002, même s'il ne s'agit pas de l'unique muse de Vetor Zero. Il y a aussi l'amusante tortue capable de prendre des décisions en un rien de temps et de jouer au football avec une canette de bière, ou encore la brave limace qui monte dans une voiture et rend inoubliable la conduite d'essai d'un nouveau modèle, deux icônes animées par le studio de São Paulo.

Depuis 1985, Vetor Zero n'a cessé de renforcer sa position sur le marché et réussi à imposer une mentalité en faveur de l'animation numérique dans le monde brésilien de la publicité. La démarche à la fois pionnière et persévérante d'Alberto Lopes, Alceu Baptistão et Sérgio Salles a porté ses fruits, transformant leur modeste entreprise des débuts en l'une des maisons de production d'animation en 3D et d'effets spéciaux de référence en Amérique du Sud. Elle s'inscrit également parmi les plus respectées pour le développement de solutions graphiques et esthétiques. Au Festival international de publicité de Cannes, l'équipe a ainsi remporté sept Lions.

Nombre de professionnels ont fait leurs classes chez Vetor Zero avant de s'installer à leur tour. Le studio peut également se targuer de mettre au point des outils et des techniques propres pour répondre à des besoins ponctuels. Le mélange de personnages animés et d'images réelles a connu un franc succès. La perfection des créations numériques est depuis 2000 assortie de l'expérience d'un nouveau partenaire, la maison de production Lobo Filmes, pour le *stop motion*, l'animation traditionnelle et les projets pour la télévision. Il est désormais possible de passer de «zéro» à l'infini...

Die wunderschöne Kaya, ein hyperrealistisches Mädchen in 3D, das sich Alceu Baptistão ausgedacht hat, wurde auf der Animago 2002 in Deutschland als die beste virtuelle Figur bewertet. Dennoch ist Kaya nicht die einzige Muse, die Vetor Zero geküsst hat. Zu den Ikonen, die das brasilianische Animationsstudio mit Sitz in São Paulo schuf, gehören auch eine unterhaltsame Schildkröte, die durchaus schnelle Entscheidungen fällen und sich sogar zum Fußball spielen mit einer leeren Bierdose anschicken kann, oder eine einfältige Nacktschnecke, die zu einer unvergesslichen Reise in ein Auto einsteigt, nicht ahnend, dass es sich um die Testfahrt eines neuen Modells handelt.

Seit 1985 hat Vetor Zero den Markt für sich entdeckt und es geschafft, in der brasilianischen Werbebranche eine positive Haltung gegenüber der Computeranimation zu schaffen. Alberto Lopes, Alceu Baptistão und Sérgio Salles vertreten eine Mentalität, die von Ausdauer und Pioniergeist geprägt ist. Sie haben sich von einem anfangs kleinen Unternehmen zu einer der wichtigsten Produktionsfirmen im Bereich 3D-Animation und Spezialeffekte in ganz Lateinamerika gemausert und haben für ihre grafischen und ästhetischen Lösungen höchste Anerkennung erfahren. Das Team hat sieben Löwen auf dem Internationalen Festival für Werbung in Cannes errungen.

Durch die Räume von Vetor Zero sind viele Profis gegangen, die sich später in der Branche etabliert haben. Das Team verweist auch mit Stolz auf eigene Werkzeuge und Techniken, die immer in Hinblick auf die besonderen Erfordernisse des Augenblicks entwickelt wurden. Die Interaktion von Trickfiguren und real gefilmten Szenen ist ein ganzer Erfolg. Im Jahr 2000 bekam Vetor Zero durch die Produktionsfirma Lobo Filmes Zuwachs: Damit gesellt sich zur Vorzüglichkeit der Aktivitäten auf digitalem Gebiet die Erfahrung des neuen Mitglieds im Bereich Stop Motion, traditioneller Zeichentrick und Projektentwicklung für das Fernsehen. Jetzt kann Vetor „Zero" von „null" auf hundert, ja unendlich beschleunigen.

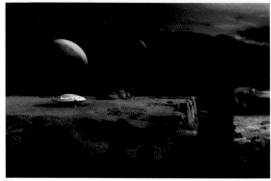

Pg. 317 Tartaruga / Turtle
(commercial), 2003
Dir.: Alceu Baptistão
Agency : F/Nazca S&S
Client: Brahma
Product: Brahma Beer

Pg. 318 Skol – Skolbeats - Astronautas
(commercial), 2003
Live Action, 3D, Composing
Dir.: Alceu Baptistão
Agency: F/Nazca Saatchi & Saatchi

Pg. 319 Fuga / Scape
(commercial), 2003
Live action, 3D, Composing
Dir.: Gustavo Yamin
Agency: Lowe Mexico
Product: Hellmann's Mayonaise

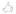

VINTON STUDIOS

USA
Contact: Paul Golden
1400 NW 22nd Avenue,
Portland, OR 97210
Phone: + 1 503 225 1130
Fax: + 1 503 226 6056
E-mail: info@vinton.com

Closed Mondays, 1974
Rip Van Winkle, 1978
Claymation, 1978
Dinosaur, 1980
The Creation, 1981
The Great Cognito, 1982
The Adventures of Mark Twain, 1985
Mr. Resistor, 1993
The PJs - series, 1999-2001
Insect Poetry, 2001
Dia de los muertos, 2002
Ananda, 2003
Joe Blow, 2004

Academy Award Best Animated
 Short, 1975/1992
Critics Award - *Annecy*, 1975
First Prize - *Ottawa*, 1976
Gold Hugo - *Chicago*, 1978/1980
Grand Prix - *Chicago*, 1979
Banc Titre Prize - *Annecy*, 1983
Emmy Awards, 1987/1991/1992/1999
Best Animation for TV - *Annecy*, 1988
Annie Awardss for Outstanding
 Achievement, 1999/2000/200
10 Clio Awards
2 Lion Advertising Awards - *Cannes*

Stop motion
Cell animation
Computer graphics
Mixed/live action

VINTON STUDIOS

www.vinton.com

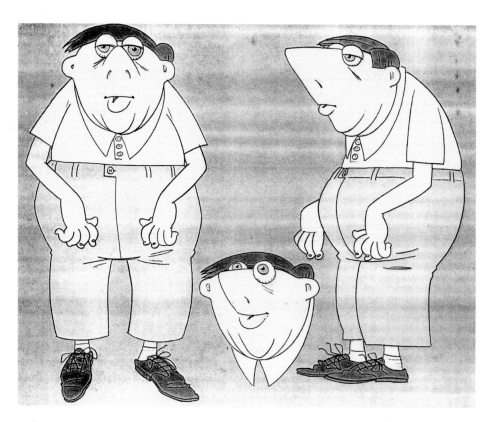

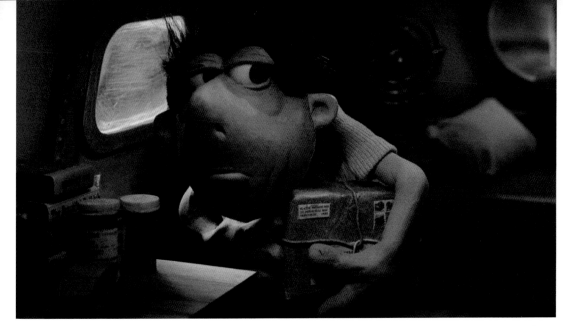

The studio founded in 1976 by Will Vinton is not only one of the world's largest in animated advertising, but also a legend in the history of animation. A large part of what is done nowadays in clay animation is a result of the pioneering initiatives of Vinton back in the sixties, so much so that the technique called "Claymation", his registered trademark, earned him an Oscar—together with Bob Gardiner—for the classic short Closed Mondays. The studio has also received several Academy nominations for the films Rip Van Winkle, The Creation and The Great Cognito.

Clay characters have reached unprecedented levels in Vinton's productions. This technique gave shape to their first feature film, The Adventures of Mark Twain, and is present again in Tim Burton's new feature film, Corpse Bride, which was also produced by this company and will premiere in 2005. The award-winning series The PJs is considered the largest project in stop motion in American television and the first of its kind to air at prime time. Vinton has also produced two of Joan Gratz's movies, one of which is the Oscar award-winning Mona Lisa Descending a Staircase.

Nevertheless, nothing can compare to the fame of the studio's advertising creations. Vinton's commercials for M&M and Nissan usually appear on the lists of the best commercials of all times and, as far as the dancing and singing California Raisins are concerned, suffice it to say that they have become an icon in the United States. The shape of these raisins has to be altered 1,440 times a minute in order to animate them correctly. This studio loves to calculate: Vinton claims to have produced more than 1.5 million animation frames between 2000 and 2003.

Fondé en 1976 par Will Vinton, le studio est l'un des plus importants au monde en matière de publicité animée; il est aussi une véritable légende dans l'histoire de l'animation. Une bonne partie des créations réalisées par animation de plastiline est imputable aux initiatives pionnières de Vinton dans les années 60, à tel point que la technique nommée « Claymation » (marque déposée) lui a valu un Oscar avec Bob Gardiner pour leur court devenu un classique, Closed Mondays. Le studio a également décroché diverses autres nominations de l'Académie, telles que Rip Van Winkle, The Creation et The Great Cognito.

Les personnages en pâte à modeler ont atteint une cote sans pareil dans les productions Vinton. La technique a donné jour au premier long métrage intitulé Les aventures de Mark Twain et se retrouve dans le prochain film de Tim Burton, Corpse Bride, également produit par la compagnie et dont la sortie en salles est prévue pour 2005. Par ailleurs, la série aux multiples récompenses, The PJs, est considérée comme le plus

important projet en stop motion pour la télévision américaine et la première à passer aux heures d'audience maximale. Vinton a également produit deux films de Joan Gratz, dont Mona Lisa Descending a Staircase, récompensé par un Oscar.

Quoi qu'il en soit, rien n'égale le succès des créations publicitaires du studio. Celles pour M&M et Nissan figurent généralement dans la liste des meilleurs spots de tous les temps ; pour leur part, les raisins chanteurs et danseurs de California Raisins sont devenus une icône aux États-Unis, avec 1 440 changements de forme par minute pour l'effet obtenu. Le studio aime d'ailleurs faire des calculs : entre 2000 et 2003, Vinton affirme avoir produit plus de 1,5 million de cadres d'animation.

Das 1976 von Will Vinton gegründete Studio gehört nicht nur zu den weltweit größten im Bereich animierter Werbung, sondern ist auch eine Legende in der Geschichte des Trickfilms. Ein Großteil dessen, was man heutzutage im Bereich Animation mit Plastilin macht, geht auf Anstöße von Vinton zurück, der hier in den 60er Jahren Pionierarbeit leistete, bis zu dem Punkt, dass die so genannte „Claymation"-Technik, sein eingetragenes Markenzeichen, ihm einen Oscar (den er mit Bob Gardiner teilte) für den klassischen Kurzfilm Closed Mondays eintrug. Auf der anderen Seite bekam das Studio für Rip Van Winkle, The Creation und The Great Cognito mehrere Nominierungen von der Academy.

Die Plastilinfiguren haben unerhörte Produktionshöhen bei Vinton erreicht. Die Technik gab seinem ersten Spielfilm The Adventures of Mark Twain Form und taucht bei Corpse Bride, dem neuen Spielfilm von Tim Burton, wieder auf, der ebenfalls von dem Unternehmen produziert wurde und dessen Filmstart für 2005 erwartet wird. Ebenso gilt die preisgekrönte Serie The PJs als das größte Stop Motion-Projekt des US-amerikanischen Fernsehens und zudem als das erste, das zur besten Sendezeit ausgestrahlt wird. Vinton hat auch zwei Filme von Joan Gratz produziert, von denen der Oscar gekrönte Mona Lisa Descending a Staircase hervorzuheben ist.

Jedenfalls haben die Werbefilme des Studios einen unvergleichlichen Ruf. Vintons Spots für M&M und Nissan tauchen üblicherweise in den Bestenlisten aller Zeiten auf, und was die singenden und tanzenden Rosinen von California Raisins anbelangt, mag es genügen zu sagen, dass sie zu einer Ikone der Vereinigten Staaten wurden. Ein paar Rosinen, deren Form sich 1440 Mal pro Minute ändern muss, um richtig „lebendig" zu wirken. Und da es dem Studio offenbar gefällt, diese Art von Berechnungen anzustellen, noch folgendes: Vinton versichert, allein in den Jahren 2000 bis 2003 mehr als 1,5 Millionen Trickfilmbilder produziert zu haben.

JOY (MID SEQ) PAGE ⑤

25 MECHANICAL ELEPHANT CUT
FOOT CRUSHES FLOWERS..

26 CUT TO ONWARD MOVING
ELEPHANTS...

27 (FAST PULL BACK) →
...TO SEE BOY
WATCHIN THEM COME

28 HE IS INSPIRED BY CUT
THEIR LARGE BALL OF
BLACK SMOKE

29 AND BOYISHLY
SHOWS OFF —

30 — SPINS HIS MACE

JOY (MID-SEQ) PAGE ⑦

37 (MOVE UP) AS SHE CUT
OPENS HER THIRD EYE...
— IT EXPELS LIGHT →

38 THE LIGHT STARTS
TO PUSH BACK THE
BLACK SMOKE...

39 SHE LEANS IN, AS
CUT HER EYE BEGINS TO
BREAK DOWN THE

40 BLACK CLOUD, CUT
DISPELLING IT...

41 .FROM OUT OF THE
CLOUD COMES

42 A BEAUTIFULLY
COLORED ELEPHANT..

Pg. 320–321 Joe Blow, 2004
Stop motion

Pg. 322 Ananda, 2003
Storyboard

Pg. 323 Ananda, 2003
Work in progress in the set

Final scene

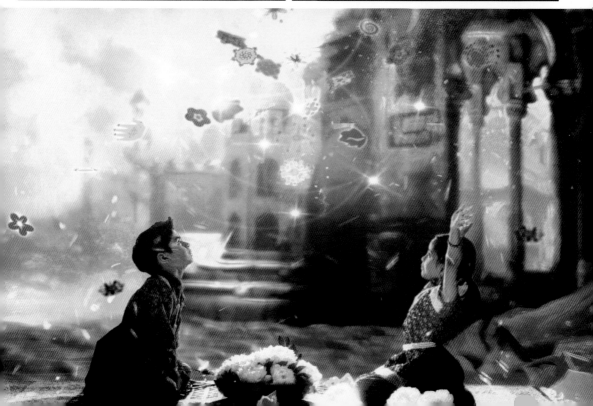

DISNEY ENTERPRISES, INC.

USA

Fantasia, 1940
Cinderella, 1950
Lady and the Tramp, 1955
Sleeping Beauty, 1959
101 Dalmatians, 1961
The Jungle Book, 1967
Little Mermaid, 1990
Beauty and the Beast, 1991
Aladdin, 1992
The Lion King, 1994
Disney/Pixar's Toy Story, 1995
Disney/Pixar's A Bug's Life, 1998
Fantasia 2000, 2000
Disney/Pixar's Monsters, Inc., 2001
Treasure Planet, 2002
Disney/Pixar's Finding Nemo, 2003
Brother Bear, 2003

32 Academy Awards
 (to Walt Disney himself),
Best Animation Design Cannes 1947,
Special Prize Venice 1950,
Golden Bear Berlin 1951,
David di Donatello Italy 1956,
BAFTA 1962/2003,
Golden Globe Best Original Score
 and/or Original Song 1990/1992/
 1993/1995/1996/2000,
Grammy 1991/1993/1994/1996/2000
 /2001/2003,
Golden Globe Best Picture
 1992/1995/2000,
Annie Awards 1996/1997/1999/2000
 /2001/2003

Traditional animation
Computer graphics

WALT DISNEY

www.disney.com

For a great part of the general public worldwide, Disney is simply synonymous with animation. Walter Elias Disney released the first *Mickey Mouse* movie in 1928, inaugurating the era of the animated cartoon with sound, and making this kind of film commercially viable for a wide audience.

Walt Disney recognized early on that to create an animation industry, he would have to quit drawing himself in order to coordinate a team of the best artists searching for the best stories and for the most sympathetic characters. Thanks to his determination and competence, in the succeeding decades Disney's tradition and influence on animation became so deep and complex that they created a style that marks, in an indelible way, the history of the art of animation.

Disney wanted his collaborators and successors never to forget that "everything began with a mouse". But in the following decades Disney's ark would be full of unforgettable species: the dogs *Pluto* and *Goofy*, *Donald Duck*, *Bambi*, the *Aristocats*, Joe Carioca, *The Lion King* and Nemo among so many others. Disney's animated movies made the various fairytales and epic tales that already are part of the universal cultural heritage even more popular.

Disney's impressive collection of awards includes the first Academy Awards nomination of an animated movie (*Beauty and the Beast*) for the Oscar® for best film. History repeats itself now, in the era of computer graphics. A highly successful partnership with Pixar Animation Studios produced *Toy Story*, another landmark in the history of animation, and already has continued for five films, which together sold US$ 2,5 billions in tickets and more than 150 millions of DVDs and videos.

Walt Disney Pictures also produces movies in live action as well as TV series. The company is part of an empire in the entertainment sector that includes radio, TV, theatre, musicals, theme parks, tourism, toys, Internet, and productions of all kinds of family entertainment.

Pour une grande partie du public, Disney rime avec animation. En 1928, Walter Elias Disney sort le premier film de *Mickey Mouse* et inaugure par là même les dessins animés sonores. Ce type de production s'avère alors commercialement exploitable pour tous types de spectateurs.

Walt Disney comprend très vite qu'il doit abandonner ses planches et crayons s'il veut créer un studio de dessins animés et coordonner une équipe d'artistes, à la recherche des meilleures histoires et de personnages sympathiques. Après plusieurs décennies de succès, sa détermination et ses compétences lui ont valu un style unique, fort d'une tradition et d'une influence telles dans le monde de l'animation qu'il marque de façon indélébile l'histoire de cette discipline et dicte l'approche d'artistes du monde entier.

Disney voulait que ses collaborateurs et successeurs n'oublient jamais que « tout a commencé avec une souris ». Cependant, l'univers Disney a depuis accueilli des spécimens inoubliables que sont les chiens *Pluto et Goofy*, le canard Donald, le cerf Bambi, les *Aristochats*, le perroquet Joe Carioca, le *Roi Lion* et le poisson Némo, parmi l'abondante faune. Par ailleurs, les animations de Disney ont rendu populaires certains contes de fées et autres histoires épiques appartenant aux mythes universels.

L'impressionnante collection de prix reçus commence avec *La belle et la bête*, première animation nominée à l'Oscar® du meilleur film ; l'histoire se répète aujourd'hui à l'ère du traitement graphique par ordinateur. La collaboration avec Pixar Animation Studios s'est soldée par un succès avec *Toy Story*, autre repère dans l'histoire de l'animation qui a donné pas moins de cinq longs métrages et signifié 2,5 milliards de dollars de recettes d'entrées et 150 millions de DVD et vidéos vendus.

Walt Disney Pictures produit également des fictions et des séries télévisées. La compagnie fait partie d'un empire incluant radio, télévision, théâtre, spectacles musicaux, parcs thématiques, tourisme, industrie du jouet, créations pour Internet, jeux et autres divertissements.

Für die meisten Menschen auf der Welt ist Disney ein Synonym für Zeichentrick. Walt Disney brachte den ersten *Micky Maus*-Film 1928 heraus und begründete damit die Ära des vertonten Zeichentrickfilms, wobei er diesen Filmtyp, der sich an unterschiedlichstes Publikum wendet, kommerziell tragfähig machte.

Walt Disney war sich sofort im Klaren darüber, dass er das Zeichnen aufgeben müsste, um eine Zeichentrick-Industrie aufzuziehen und ein Künstlerteam zu koordinieren, das sich der Suche nach den besten Geschichten widmete sowie der Erfindung von Figuren, in die man sich sehr gut einfühlen kann. Dank seiner Entschlossenheit und seiner Qualität sind nach mehreren erfolgreichen Jahrzehnten

die Tradition und der Einfluss Disneys auf den Zeichentrick so tief und komplex geworden, dass sie einen Stil geschaffen haben, der auf eine unauslöschliche Weise die Geschichte dieser Kunstform prägt und Künstler aus aller Welt beeinflusst.

Disney wollte, dass seine Mitarbeiter und Nachfolger niemals vergessen sollten, dass „alles mit einer Maus begann". Aber in den folgenden Jahrzehnten füllte sich die Arche Disneys mit unvergesslichen Exemplaren aller Arten: mit den Hunden Pluto und Goofy, der Ente Donald, dem Rehkitz Bambi, den Katzen von *Aristocats*, dem Papageien Joe Carioca, dem König der Löwen und dem Fisch Nemo neben vielen anderen. Gleichzeitig popularisierten Disneys Zeichentrickfilme verschiedene Märchen und epische Erzählungen, die zum Mythenschatz der Menschheit gehören.

Zu der eindrucksvollen Sammlung an Auszeichnungen gehört auch die erste Nominierung eines Zeichentrickfilms überhaupt für den Oscar® in der Sparte „Bester Film", nämlich für *Die Schöne und das Biest*. Die Geschichte wiederholt sich heute in der Ära des computeranimierten Grafikdesigns. Die Zusammenarbeit mit Pixar Animation Studios setzte mit dem Erfolgsfilm *Toy Story* einen weiteren Meilenstein in der Geschichte des Trickfilms; die mittlerweile fünf Spielfilme spielten zusammen 2,5 Milliarden US-Dollar ein und verkauften sich mehr als 150 Millionen Mal als DVD oder Video.

Walt Disney Pictures produziert auch Live-Filme und Fernsehserien. Das Unternehmen ist Teil eines ganzen Imperiums der Unterhaltungsindustrie, das Hörfunk und Fernsehen, Theater, Musikshows, Themenparks, Tourismus, Spielzeugindustrie, Produktionen fürs Internet, Spiele und jede Art der Unterhaltung für die ganze Familie umfasst.

| DISNEY ENTERPRISES, INC. | Toy Story, 1995 | Academy Award Best Animated | 3D Computer animation |

DISNEY ENTERPRISES, INC.

PIXAR ANIMATION STUDIOS

USA

Toy Story, 1995
A Bug's Life, 1998
Toy Story 2, 1999
Monsters, Inc., 2001
Finding Nemo, 2003
The Incredibles, 2004

Academy Award Best Animated
 Feature 2004,
Academy Award Best Original
 Song 2001,
Annie Awards 1996/1998/2000,
Golden Globe Best Picture 2000,
Golden Globe Best Original Score
 and/or Original Song 1996/2000,
BAFTA 2003,
Children's Award BAFTA 2002,
Grammy 1996/2000/2001/2003,
Annie Awards 1996/1997/1998/1999/
 2000/2001/2003/2004.

3D Computer animation

DISNEY/PIXAR

www.disney.com

www.pixar.com

Some of the greatest commercial successes in the history of animation were born from the partnership between Walt Disney Pictures and Pixar Animation Studios. On one hand, the traditional company, creator of so many classics, benefited from Pixar's freshness, and the possibility to get into the realm of 3D graphics. On the other hand, the team emerging from Pixar counted on Disney's mighty distribution machine in order to reach each movie theatre and every residential television worldwide.

Pixar's John Lasseter directed the revolutionary Toy Story, the first film entirely animated by computers. Following that, there were four other films, which together sold almost 3 billion dollars in movie tickets, and over 150 millions in DVDs and videos worldwide. The countless awards culminated in the Oscar ® for the best animated feature, for Finding Nemo in 2003.

More than numbers, these great results consolidated a new concept of entertainment, and approximated digital technologies to the state of art, the naturalist perfection already achieved by the traditional animation.

Certains des plus grands succès commerciaux ayant ponctué l'histoire de l'animation se doivent à la collaboration entre Walt Disney Pictures et Pixar Animation Studios. La compagnie chevronnée à l'origine de tant de classiques a su profiter de la fraicheur de Pixar et se faire une place dans le monde des images en 3D. Pour sa part, la jeune équipe de Pixar s'est appuyée sur l'énorme machinerie de distribution de Disney pour s'assurer une présence dans toutes les salles de cinéma et sur toutes les télévisions du monde.

À la tête de Pixar, John Lasseter réalise le révolutionnaire Toy Story, premier film entièrement animé sur ordinateur. Suivent quatre autres films dont les recettes cumulées s'élèvent à près de 3 milliards de dollars

en entrées et à 150 millions en ventes de DVD et vidéos. Pour couronner la longue liste de récompenses, Le monde de Nemo reçoit en 2003 l'Oscar® du meilleur film d'animation.

Au-delà des chiffres, ces excellents résultats ont instauré une nouveau principe de divertissement et rapproché les technologies numériques de l'expression artistique, la perfection naturaliste étant déjà atteinte par les techniques d'animation traditionnelle.

Einige der größten kommerziellen Erfolge in der Geschichte der Bildanimation gehen auf die Partnerschaft zurück, die Walt Disney Pictures mit Pixar Animation Studios einging. Auf der einen Seite profitierte das traditionsreiche Unternehmen, auf dessen Konto so viele Filmklassiker gehen, vom frischen Wind, der mit Pixar aufkam, und auch von der Möglichkeit, ins Reich der 3D-Graphik zu gelangen. Andererseits konnte das Team, das aus Pixar hervorging, auf Disneys mächtige Infrastruktur für den Filmverleih zählen, um auch jedes Filmtheater und jeden Heimfernseher weltweit zu erreichen.

John Lasseter von Pixar war es, der bei der revolutionären Toy Story Regie führte. Diesem ersten Film, der jemals vollständig computeranimiert erstellt wurde, folgten vier weitere Filme, die zusammen fast 3 Milliarden Dollar an den Kinokassen einspielten und weitere 150 Millionen durch den weltweiten Verkauf von DVDs und Videos. Die endlose Reihe an Auszeichnungen fand ihren vorläufigen Höhepunkt mit dem Oscar® für den besten animierten Spielfilm, den Findet Nemo 2003 erhielt.

Diese großartigen Erfolge, die sich auf weit mehr als Verkaufszahlen beziehen, festigten ein ganz neues Unterhaltungskonzept und verliehen digitalen Technologien den künstlerischen Rang der naturalistischen Perfektion, wie sie der traditionelle Zeichentrickfilm schon erreicht hat.

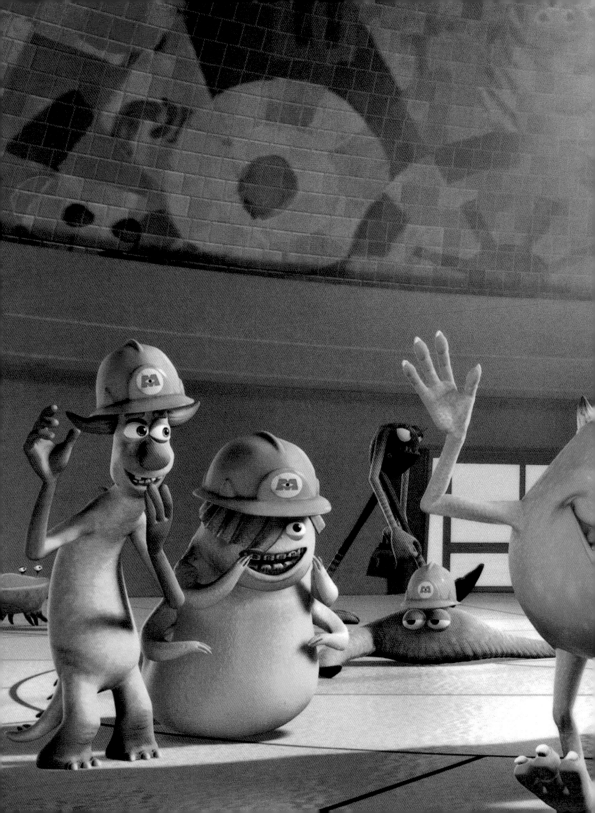

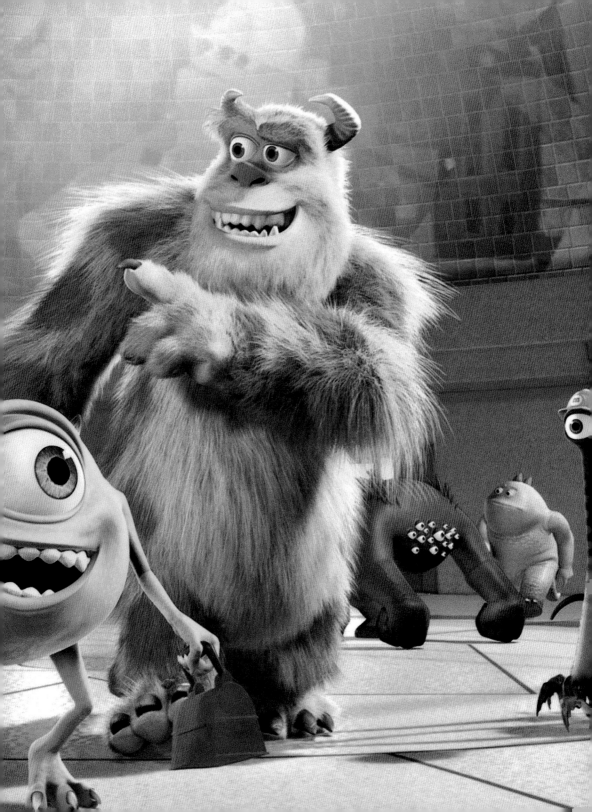

WALTER TOURNIER

Uruguay
Tournier Animation
Anzani 2015 Montevideo
Phone: + 598 2 486 1779
E-mail: tournier@adinet.com.uy

El clavel desobediente / The
Disobedient Carnation, 1981
Nuestro pequeño paraíso / Our Little
Paradise, 1983
Los cuentos de Don Verídico / The
Tales of Don Verídico, 1985
Los escondites del sol / Hideouts
From the Sun, 1990
Los Tatitos / The Tatitos, 1997 and 2001
El jefe y el carpintero / The Boss
and the Carpenter, 2000
Navidad caribeña / Caribbean
Christmas, 2001
A pesar de todo / In Spite of
Everything, 2003

Coral - *Havana*, 1980 and 1984
Unesco - *Divercine/Uruguay*, 1998 and
2000
Golden Tatu - *Jornada da Bahia/Brasil*,
2001
Prince Claus - *Holland*, 2002
Unesco and Children Audience
Award - *Chicago*, 2002

Paper cut
Marionettes,
Animation with wood,
Plastiline
Cardboard
Latex

WALTER TOURNIER

¿QUIÉN ES?

¿QUIÉN ES?

LA QUE SACO LA ESPINA

CURO MI HERIDA

Y MI LAGRIMA SECÓ

¿QUIÉN ES?

EL QUE JUGO CONMIGO

SIEMPRE FUE MI AMIGO

Y CONMIGO RIÓ

QUE NUNCA EXISTIÓ

¿QUIÉN ES?

SON MI FAMILIA

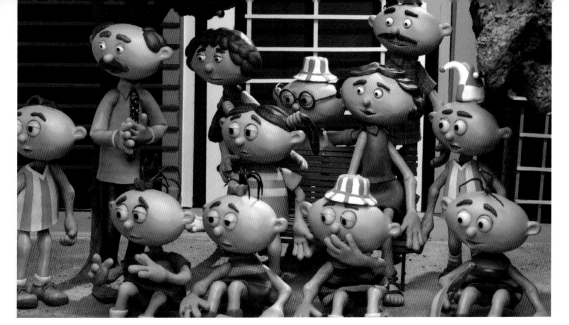

Walter Tournier's work is an example of the great challenge of creating animation in a country without a tradition in this art. Tournier studied Architecture and Archeology, but he has also spent a good part of his life working as a craftsman and as a furniture and antique salesman. His first movie, *In the Jungle There's a Lot To Do*, is 17 minutes long and, at the time it was made, was the longest animation film ever produced in Uruguay.

To overcome a lack of resources, Tournier used paper cutouts and all kinds of material that, although very basic, were easy for him to acquire, such as cardboard, wood, latex, wire, etc. Tournier turns these materials into high-quality works that reflect powerful social themes. The legends of Peru—where the filmmaker lived during his exile–, the indiscriminate use of television, life during the Uruguayan dictatorship, children's rights and ecological concerns are some of the themes of both his animated films and his documentaries.

The children's TV series *The Tatitos*, extremely successful in both Uruguay and Argentina, opened the door for him to the international world, which he delighted with *The Boss and the Carpenter* and *Caribbean Christmas*, produced for a welsh television company. Tournier also elaborated the special participation of puppets in the documentary *El siglo del viento* by the Argentinean director Fernando Birri.

Walter Tournier is based in Montevideo, where he and his friend Mario Jacob founded the company *Imágenes* in 1985. Through his company he continues to encourage the advancement of Latin American animation, and considers himself satisfied when his efforts fulfill their main objective: to make a child smile.

L'œuvre de Walter Tournier relève le défi qu'est la pratique de l'animation dans des pays dépourvus de cette tradition. Tournier étudie d'abord l'architecture et l'archéologie, mais il passe une grande partie de sa vie comme artisan et vendeur de meubles et d'antiquités. Son premier film, *En la selva hay mucho por hacer*, d'une durée de 17 minutes, est le plus long travail d'animation effectué à cette époque en Uruguay.

Pour pallier le manque de moyens, il se lance dans le découpage de papiers et autres matériaux plutôt rudimentaires mais faciles de se procurer (carton, bois, latex, fil de fer, etc.). Il en résulte une production de grande qualité traitant d'une thématique sociale. Les légendes du Pérou, où le cinéaste a vécu en exil, l'utilisation sans distinction de la télévision, la vie sous la dictature uruguayenne, le droit des enfants et les préoccupations écologiques sont quelques-uns des sujets clés de ses films d'animation et documentaires.

La série télévisée pour enfants *Los Tatitos*, véritable succès en Uruguay et en Argentine, lui offre l'accès à la scène internationale. Il conquiert son public avec *El jefe y el carpintero* et *Navidad caribeña*, deux productions pour la télévision du Pays de Galles. Pour le réalisateur argentin Fernando Birri, Tournier se charge de l'intervention de marionnettes dans le documentaire *Le siècle du vent*.

Walter Tournier réside à Montevideo, où il fonde en 1985 la compagnie Imágenes avec son ami Mario Jacob. Il y poursuit le développement de l'animation en Amérique latine et s'estime satisfait lorsque l'objectif principal, le sourire d'un enfant, est atteint.

An Walter Tourniers Werk lässt sich die Skepsis, die in Ländern ohne entsprechende Tradition gegenüber dem Trickfilmgenre herrscht, gut aufzeigen. Tournier studierte zwar Architektur und Archäologie, musste sich aber einen Großteil seines Lebens als Kunsthandwerker und Möbel- und Antiquitätenverkäufer durchschlagen. Sein siebzehnminütiger Erstling *In the Jungle There´s a Lot To Do* von 1974 war der längste Trickfilm, der bis dahin jemals in Uruguay gedreht worden war.

Mangels finanzieller Mittel schnitt er Figuren aus Papier und griff zu jeder Art von rudimentären Materialien, die er leicht bekommen konnte, zum Beispiel Pappe, Holz, Latex, Draht. So entstand eine qualitativ hochwertige Arbeit mit deutlich sozialer Thematik. Der Legendenschatz Perus, wo der Filmkünstler während seines Exils lebte, der vorurteilslose Gebrauch des Fernsehens, das Leben zu Zeiten der Diktatur in Uruguay, die Rechte des Kindes und die Beschäftigung mit ökologischen Fragen sind einige der Themen, die er in seinen Trick-, aber auch Dokumentarfilmen aufgreift.

Die in Uruguay und Argentinien sehr erfolgreiche Kinderserie *The Tatitos* öffnete ihm die Türen zur internationalen Filmwelt, die er mit *The Chief and the Carpenter* und *Caribbean Christmas* beglückte, beides Produktionen für den Fernsehkanal País de Gales. Für den argentinischen Regisseur Fernando Birri fertigte Tournier die Marionetten an, die einen besonderen Part in dem Dokumentarfilm *Das Jahrhundert des Sturms* spielen.

Walter Tournier ist in Montevideo ansässig, wo er mit dem befreundeten Mario Jacob 1985 das Unternehmen Imágenes gründete. Von dort aus stimuliert er die Entwicklung der lateinamerikanischen Animation, und er gibt sich erst zufrieden, wenn seine Anstrengungen ihr Ziel erreichen: ein Kinderlächeln.

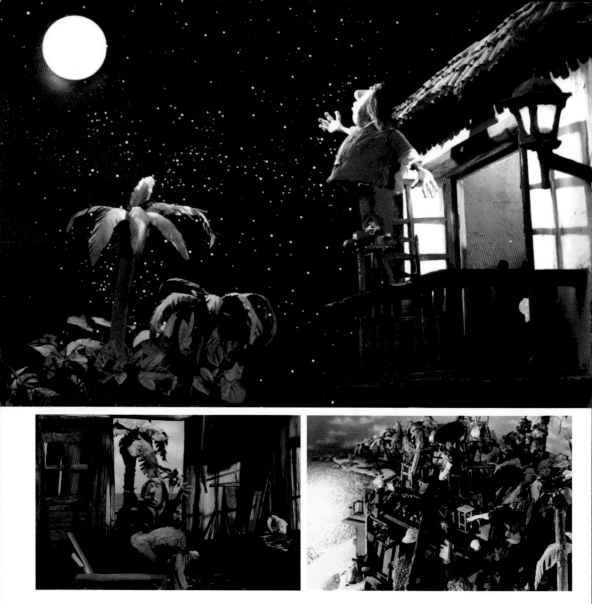

Pg. 334 The Family / La Familia, 2002
Storyboard

Pg. 335 Los Tatitos, 2001

Pg. 336 The Chief and the Carpenter / El
Jefe y el Carpintero, 2000

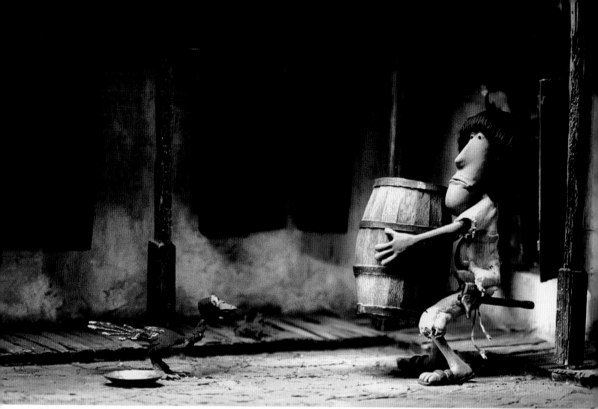

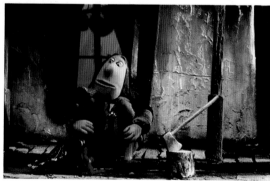

Pg. 337 Navidad Caribeña / Caribbean
Christmas, 2001

WILD BRAIN, Inc

USA
Contact: Jeff Fino,
Phone: + 1 415 553 8000
info@wildbrain.com

FernGully 2: The Magical
 Rescue, 1998
El Kabong, 1999
Glue, 2000
Romanov, 2000
Hubert's Brain, 2001
Frank Tripper: the Perfect
 Weapon, 2001
Mr. Baby, 2001
Graveyard, 2001
Poochini, 2002
Vanilla Pudding, 2003
A Dog Cartoon, 2004

Best Internet Film - Ottawa, 2000
4 Prizes Best in category - WAC/
 USA, 2001
Annie Awards, 2001
Grand Prix Jury - Imagina
 /Monaco, 2002
Best Short - Asifa/SF, 2002

Traditional animation
Stop motion
Computer graphics

WILD BRAIN

www.wildbrain.com

Wild Brain is one of the leading suppliers of content for the American animation market, with a large number of clients in television, film, advertising, multi-media and Internet. Founded in 1994, the company provides work for some of the biggest talents of the sector, ranging from veterans of the industry to the most recent revelations.

Wild Brain's list of clients includes giants like Universal, 20th Century Fox, Disney, Dreamworks, Warner Bros, Nickelodeon, Cartoon Network, Coca-Cola, Ford, Nabisco, Nestlé, McDonald's, Nike and Chevrolet, among many others. In the company's past record books one finds the animations of the classic characters of Hanna-Barbera and the Looney Tunes, as well as the first animated commercial of The Wall Street Journal.

There are no animation techniques or ways of reaching the market that are unknown to this San Francisco company, which directly produced the animated feature film Ferngully 2 for the home video market. At the same time Glue and Romanov have helped popularize series made specifically for Internet. By way of multimedia books, their version of famous Dr. Seuss' Green Eggs and Ham earned them the prestigious Annie award in their category.

The artistic team of Wild Brain includes the multi-talented Phil Robinson, one of the company's co-founders, as well as original artists like the Czech animator Michaela Pavlátová and the American Gordon Clark. This variety guarantees the impressive versatility of the studio and their reputation as a place where traditional methods and the latest digital instruments come together in an impeccable fashion.

Wild Brain est l'une des entreprises phare pour l'approvisionnement du marché américain de l'animation, avec un épais portefeuille de clients à la télévision, au cinéma, dans la publicité, dans le multimédia et sur Internet. Fondée en 1994, elle emploie une partie des plus grands talents de la branche, des vétérans de l'industrie aux ultimes révélations.

La liste des clients de Wild Brain comprend des pointures telles que Universal, 20th Century Fox, Disney, Dreamworks, Warner Bros, Nickelodeon, Cartoon Network, Coca-Cola, Ford, Nabisco, Nestlé, McDonald's, Nike et Chevrolet, parmi tant autres. Dans son historique, on trouve les animations de personnages classiques d'Hanna Barbera et des Looney Tunes, mais aussi le premier spot animé de The Wall Street Journal.

Aucune technique d'animation ou façon de capter le marché n'échappe aux activités de cette entreprise de San Francisco, productrice du long métrage animé Ferngully 2 pour le secteur de la home vidéo.

Pour leur part, Glue et Romanov ont permis de populariser des séries spécialement conçues pour une diffusion sur Internet. En terme de livres multimédia, la version du célèbre Green Eggs and Ham du Dr Seuss s'est vu attribuer le prestigieux prix Annie pour sa catégorie.

La composition de l'équipe artistique de Wild Brain est assez éclectique, du polyvalent Phil Robinson, l'un des cofondateurs, à des auteurs de forte personnalité comme la Tchèque Michaela Pavlátová et l'Américain Gordon Clark. Grâce à ce brassage, le studio jouit d'une incroyable diversité et est réputé comme un lieu où méthodes traditionnelles et outils numériques dernier cri font excellent ménage.

Wild Brain gehört zu den führenden Unternehmen im Bereich Materialversorgung für den US-amerikanischen Trickfilm-Markt mit einer großen Anzahl an Kunden aus der Fernseh-, Film-, Werbe-, Multimedia- und Internetbranche. Die 1994 gegründete Firma beschäftigt einige der künstlerischen Toptalente auf diesem Gebiet, angefangen bei Veteranen der Filmindustrie bis zu Neuentdeckungen.

Zu den Kunden zählen Giganten, wie Universal, 20th Century Fox, Disney, Dreamworks, Warner Bros., Nickelodeon, Cartoon Network, aber auch Multis wie Coca-Cola, Ford, Nabisco, Nestlé, McDonald's, Nike und Chevrolet, neben vielen anderen. Kapitel der Firmengeschichte sind die klassischen Figurenanimationen von Hanna-Barbera und Looney Toones und ebenfalls der erste animierte Werbespot für The Wall Street Journal.

Es gibt praktisch keine Technik der Bildanimation oder Marktstrategie, die den Aktivitäten dieses in San Francisco ansässigen Unternehmens fremd wäre, das mit Blick auf den Heimvideomarkt in eigenem Auftrag den abendfüllenden Trickfilm Ferngully 2 (Die magische Rettung) herausbrachte. Glue und Romanov haben ihrerseits dazu beigetragen, Serien populär zu machen, die besonders für das Internet gemacht sind. Was Multimedia-Bücher angeht, so hat die Version des berühmten Dr. Seuss' Green Eggs and Ham den angesehenen Annie-Preis in der entsprechenden Kategorie bekommen.

Zum künstlerischen Team von Wild Brain gehören Leute wie der vielseitige Firmenmitbegründer Phil Robinson und ebenso Leute von so ausgeprägter Persönlichkeit wie die Tschechin Michaela Pavlátová und der US-Amerikaner Gordon Clark. Das gewährleistet die beeindruckende Wandlungsfähigkeit des Studios und seinen Ruf als ein Ort, an dem traditionelle Methoden und Software der jüngsten Generation einwandfrei kombiniert werden.

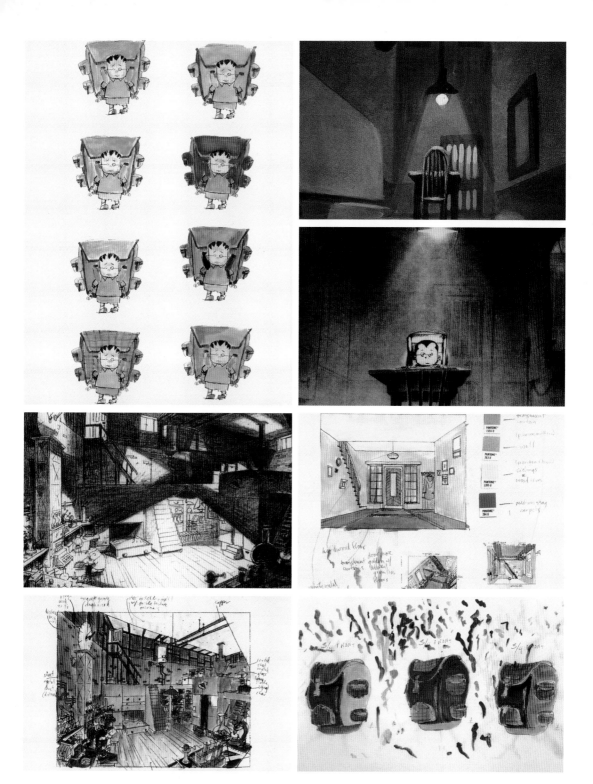

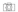

WILLIAM KENTRIDGE

South Africa
72 Mougwon Drive,
Mougwon, 2198
Phone: + 011 483 3246
E-mail: wkentr@netactive.co.za

Johannesburg, 2nd Greatest City After Paris, 1989
Monument, 1990
Mine, 1991
Sobriety, Obesity and Growing Old, 1991
Felix in Exile, 1994
History of the Main Complaint, 1996
Weighing...and Wanting, 1997
Stereoscope, 1999
Journey to the Moon, 2003
Tide Tabel, 2003

Rembrandt Gold Medal - *Cape Town,* 1991
Jewels of the Century - *Annecy,* 2000

Animation with charcoal and pastel drawings
Three dimensional objects and insects
Cut out
Stop motion
All sometimes mixed with live action and archival footage

WILLIAM KENTRIDGE

William Kentridge, probably the most famous South African artist of today, has exhibited his charcoal and pastel drawings in some of the most important museums and galleries around the world, as well as in the Venice Biennale and Dokumenta, in Kassel. These generally large-dimensional works are the raw material for his equally celebrated animated films. He is a multimedia artist who incorporates animation into installations and theater. The work *Shadow Procession,* for example, was shown on the 100 meter-high ceiling of the Royal Palace of Amsterdam in 1999.

The city of Johannesburg, where the artist was born in 1955 and continues to live today, is an obsessive presence in his work, with the ghosts of colonialism and *apartheid* lurking in the shadows. Kentridge is an advocate of a political art that defends optimism and nihilism. Nine of his shorts have the characters Soho Eckstein—an adipose and tormented real estate speculator—and Felix Teitlebaum—a passive and dreamy observer—in lead roles, representing the ambiguities and contradictions of his country.

A self-taught animator, William Kentridge has a degree in Political Science and African Studies, and has also studied Fine Arts and Theater. He collaborated with the Handspring Puppet Company in multimedia shows and was one of the founders of the Free Filmmakers Cooperative (Johannesburg, 1988). His films make aesthetic use of the imperfect erasure of charcoal on paper, an almost obsolete basic technique. However, his experiences also challenge other limits, such as the reversion of the third dimension in *Stereoscope,* and animation with ants in *Day for Night* (2003).

William Kentridge est sans doute l'artiste sud-africain le plus célèbre à l'heure actuelle. Il a déjà exposé ses dessins au charbon et au pastel dans d'importants musées et galeries du monde, ainsi qu'à la Biennale de Venise et à la Documenta de Kassel. Généralement de grandes dimensions, ces travaux constituent la matière première de ses films d'animation, tout aussi appréciés. Il s'agit d'un artiste multimédia qui intègre l'animation à des installations et à des œuvres théâtrales. En 1999, *Shadow Procession* est exposé au Palais royal d'Amsterdam à 100 mètres de hauteur.

Johannesburg où il naît en 1955 et vit encore maintenant occupe une place obsessive dans son œuvre, marquée par les fantasmes de la colonisation et de l'apartheid. Kentridge se livre à un art politique plaidant optimisme et nihilisme. Neuf de ses courts métrages mettent en scène les personnages Soho Eckstein (spéculateur immobilier adipeux et tor-

turé) et Felix Teitlebaum (observateur passif et rêveur), lesquels incarnent les ambiguïtés et contradiction de son pays.

Autodidacte dans le domaine de l'animation, William Kentridge obtient un diplôme en sciences politiques et études africaines, puis prend des cours aux beaux-arts et de théâtre. Il collabore avec la Handspring Puppet Company pour des spectacles multimédias et fonde en partenariat la Free Filmmakers Cooperative (Johannesburg, 1988). Sur le plan esthétique, ses films tirent parti du tracé imparfait du charbon sur le papier et de sa technique de base obsolète. Toutefois, ses expériences touchent à d'autres approches, telles que l'approche inverse de la représentation en 3D dans *Stereoscope* et l'animation de fourmis dans *Day for Night* (2003).

William Kentridge, zurzeit wohl der bekannteste südafrikanische Künstler, hat seine Kohle- und Pastellzeichnungen schon in einigen der renommiertesten Museen und Galerien der Welt ausgestellt, so auch auf der Biennale von Venedig und der Documenta in Kassel. Diese im Allgemeinen großformatigen Arbeiten bilden das Rohmaterial für seine ebenso berühmten Zeichentrickfilme. Er ist ein Multimedia-Künstler, der Animationstechnik in Installationen und Theaterstücke einbaut. So wurde *Shadow Procession* 1999 einhundert Meter über dem Erdboden, auf dem Dach des Königlichen Palastes in Amsterdam gezeigt.

Sein Werk ist besessen von Johannesburg, jener durch das Gespenst der Kolonisation und der Apartheid verzagten Stadt, in der er seit seiner Geburt 1955 lebt. Kentridge ist Anhänger einer politischen Kunst, die Optimismus und Nihilismus gleichermaßen in Frage stellt. In neun seiner Kurzfilme sind die Figuren Soho Eckstein, ein fettsüchtiger und gepeinigter Immobilienspekulant, und Felix Teitlebaum, ein passiver Zuschauer und Träumer, die Protagonisten. Diese beiden repräsentieren die Ambivalenzen und Widersprüche seines Landes.

Kentridge, im Bereich Animation Autodidakt, machte seinen Abschluss in Politikwissenschaften und Afrikanistik, studierte aber auch bildende Kunst und Schauspiel. Er beteiligte sich an Multimedia-Darbietungen der Handspring Puppet Company und gehörte 1988 zu den Gründern der Free Filmmakers Cooperative in Johannesburg. Das teilweise Verwischen der Kohle auf Papier und die schon überholte Grundtechnik kommen seinen Filmen ästhetisch zugute. Aber seine Erfahrungen mit der Umkehrung der Dreidimensionalität in *Stereoscope* und der Animation mittels Ameisen in *Day for Night* (2003) geißeln auch andere Einschränkungen.

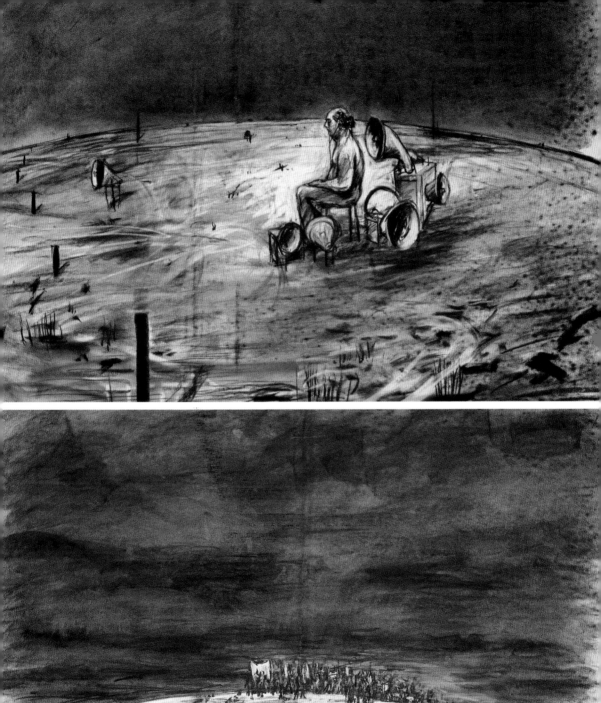
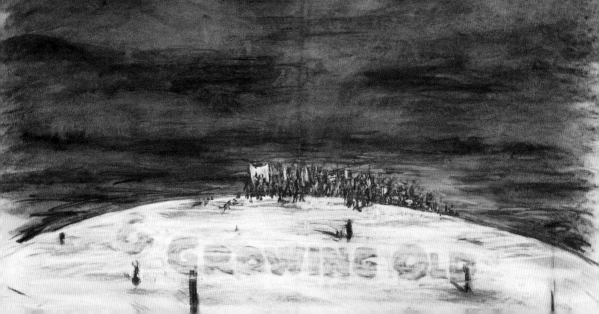

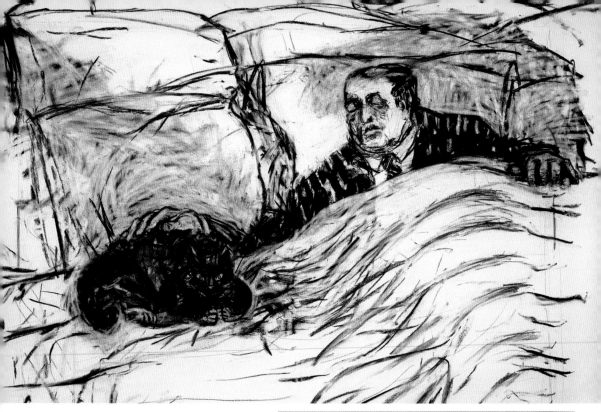

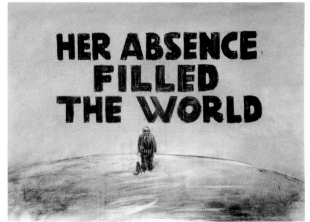

Pg. 343-344 Sobriety, Obesity and
Growing Old, 2000
Charcoal and pastel drawing

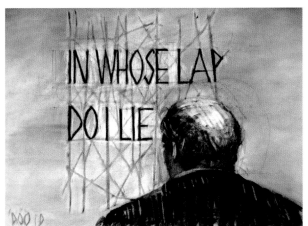

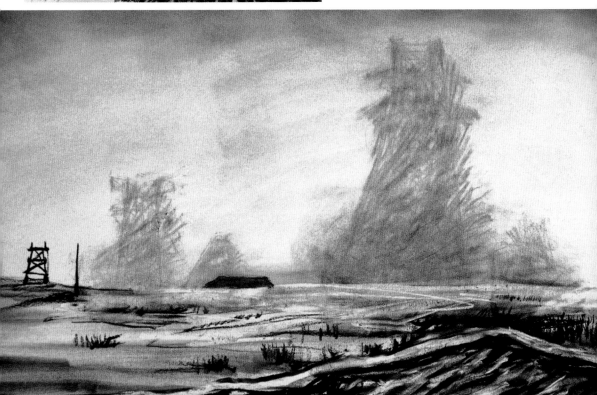

ANIMA MUNDI / THE AUTHORS

www.animamundi.com.br

The American continent's biggest event dedicated to animation cinema takes place annually in July in the Brazilian cities of Rio de Janeiro and São Paulo. Each year some 80,000 people, in addition to filmmakers and journalists, are captivated by the charm of the Anima Mundi festival. The event brings together hundreds of movies selected from among the world's best, and also includes special retrospectives, an Internet animation contest, personal encounters with today's most celebrated animators and open workshops in which those who attend are initiated into the secrets of animation and able to give their own talent a try.

With the creation of the Anima Mundi festival in 1993 in the Centro Cultural Banco do Brasil of Rio de Janeiro, a new period in the history of Brazilian animation began. Since then, the festival has stimulated an entire generation of new creators and has helped Brazilian animators form their own style within the sector. It has also contributed in a definitive way to developing the industry and market, and to making Brazilian animation known internationally. The Anima Mundi program continues throughout the whole year, and provides students from all kinds of social conditions with the opportunity of an enriching experience.

The festival's distinctive character stems from its origin: it was created and continues to be directed by four animators who met in Rio while taking a course in collaboration with the National Film Board of Canada. With great pleasure, Aida Queiroz, Cesar Coelho, Léa Zagury and Marcos Magalhães took on the mission of bringing their country a bit of the revival that animation art was experiencing in the world at that time. The emphasis of the creators has always been placed on the artistic, experimental, informative and educational aspects of the animated image, highlighting auteur works and diversity in techniques and styles.

Aida Queiroz won the Coral Negro award for best animation at the 1986 Havana Film Festival with the short Noturno and, together with Cesar Coelho, she has co-directed Alex –which received awards in Havana in 1987 and in Espinho in 1989–, Tá Limpo! and Petróleo! Petróleo! In 1990 her work Mom's Love won 11th place in the vignette contest sponsored by MTV, which enjoyed the participation of more than 600 animators from all over the world.

Cesar Coelho, who began his career creating illustrations and vignettes with political content, is also the author of Informística (1986).

This animator, twice selected for exchange programs with the National Film Board of Canada, has specialized in the techniques of industrial animation. Together with Queiroz he directs the Campo 4 Desenhos Animados company, the largest traditional animation production company of Rio de Janeiro, with important clients in the world of advertising and television.

Léa Zagury received a Master's degree in cinema from the Department of Experimental Animation at the California Institute of the Arts. She has co-directed Uma cidade contra seus coronéis and is the author of the shorts Instinto animal, Slaughter, Salamandra and Karaíba. This last film was launched at the Sundance Festival in 1994, and that same year it won awards in Houston, Aspen and Ann Arbor, and was also the winner of the National Educational Media Award in 1995. Zagury works free-lance in Los Angeles on animation and illustration projects, underwater videos, and television documentaries.

Marcos Magalhães won the Jury Special Prize at the Cannes Festival in 1982 with the short film Meow! He also created Mão Mãe (1979), Animando (1982) –produced at the National Film Board of Canada–, Tem boi no trilho (1988), Precipitação (1990), Pai Francisco entrou na roda (1997) and DoiS (2000) –University of Southern California–. Magalhães is one of the co-directors of Tá limpo! and he was responsible for the first professional course on animation held in Brazil in 1987. He coordinated Planeta Terra, a group film made by 30 Brazilian animators for the UN's International Year of Peace, and he directed the unusual movie Estrela de oito pontas, in collaboration with the painter Fernando Diniz, who spent his life in a psychiatric hospital.

Le plus grand événement consacré au cinéma d'animation sur le continent américain se déroule chaque mois de juillet dans les villes de Rio de Janeiro et São Paulo. Lors de chaque édition, quelque 80 000 personnes (outre les journalistes et les réalisateurs) se laissent en effet tenter par le festival Anima Mundi. C'est l'occasion d'y découvrir des centaines de films sélectionnés parmi les meilleurs au monde, des rétrospectives, d'assister à des ateliers dévoilant les coulisses de l'animation pour y démontrer son talent, de participer à un concours sur Internet et de rencontrer les plus grands animateurs du moment.

Avec la naissance d'Anima Mundi au centre culturel du Banco do Brasil à Rio de Janeiro, l'année 1993 marque le début d'une nouvelle étape dans l'histoire de l'animation brésilienne. Depuis lors, le festival sert de moteur pour toute une génération de nouveaux créateurs et permet de façonner un mode d'expression propre au pays. Grâce à cette rencontre, aussi, ont mûri l'industrie et le marché, et les œuvres nationales ont pris une ampleur internationale. En proposant un programme tout au long de l'année, Anima Mundi permet aux élèves de tous les milieux sociaux de vivre une expérience enrichissante.

La personnalité du festival tient à ses origines. Il a été créé et est encore maintenant dirigé par quatre animateurs qui se sont connus à Rio, à l'occasion d'un cours en collaboration avec l'Office national du film du Canada. À l'époque, Aida Queiroz, Cesar Coelho, Léa Zagury et Marcos Magalhães s'engagent à faire profiter leur pays du regain que l'animation connaît hors des frontières. Depuis les débuts, la ligne directrice des organisateurs est présente dans les aspects artistiques, expérimentaux, informatifs et éducatifs de l'image animée, notamment pour les travaux d'auteur et la diversité de techniques et de styles.

En 1986, Aida Queiroz remporte le prix Coral Negro de la meilleure animation au Festival de la Havane pour le court métrage Noturno. Elle codirige avec Cesar Coelho Alex (également récompensé à ce festival l'année suivante et à Espinho en 1989), Tá Limpo! et Petróleo! Petróleo! En 1990, elle obtient la 11e place sur 600 avec Mom's Love au concours d'illustrations organisé par la chaîne américaine MTV.

Cesar Coelho, qui débute sa carrière comme illustrateur et dessinateur de thèmes politiques, est l'auteur de Informística (1986). Deux fois retenu pour les programmes d'échange avec l'Office national du film du Canada, cet animateur s'est spécialisé dans les techniques d'animation industrielle. Avec Queiroz, il dirige l'entreprise Campo 4 Desenhos Animados, principale maison de production d'animation traditionnelle de Rio de Janeiro comptant des clients dans la publicité et la télévision.

Léa Zagury décroche le diplôme de mastère en cinéma au département d'animation expérimentale du California Institute of the Arts. Elle codirige Uma cidade contra seus coronéis et est l'auteur des courts Instinto animal, Slaughter, Salamandra et Karaiba. Ce dernier est projeté au Festival de Sundance édition 1994 et récompensé à Houston, Aspen et Ann Arbor la même année, puis par le prix National Educational Media en 1995. Zagury travaille en indépendante sur des projets d'animation et d'illustration à Los Angeles et prend part à des vidéo sous-marines. Elle réalise également des documentaires pour le petit écran.

Marcos Magalhães remporte le prix spécial du jury de Cannes en 1982 avec le court métrage Meow! Il réalise Mão Mãe (1979), Animando (1982, produit à l'Office national du film du Canada), Tem boi no trilho (1988), Precipitação (1990), Pai Francisco entrou na roda (1997) et DoiS (2000, University of Southern California). Magalhães est l'un des co-réalisateurs de Tá Limpo! et donne le premier cours professionnel d'animation proposé au Brésil en 1987. Il coordonne Planeta Terra, un film collectif réalisé par 30 animateurs brésiliens pour l'Année internationale de la paix de l'ONU. Il dirige aussi le surprenant Estrela de oito pontas, en collaboration avec le peintre Fernando Diniz qui a passé sa vie dans un hôpital psychiatrique.

Das größte regelmäßig stattfindende Ereignis, das auf dem amerikanischen Kontinent dem Animationsfilm gewidmet ist, findet alljährlich im Juli in den beiden brasilianischen Städten Rio de Janeiro und São Paulo statt. Jedes Mal erliegen neben den Regisseuren und Journalisten an die 80 000 Zuschauer dem Charme des Festivals Anima Mundi. Hier findet man konzentriert Hunderte von ausgewählten und zu den weltbesten gehörenden Filmen, spezielle Retrospektiven, offene Workshops, bei denen die Teilnehmer in die Geheimnisse des Trickfilms eingeführt werden und ihr Talent erproben, außerdem einen Wettbewerb im Web und, nicht zu vergessen, die persönlichen Begegnungen mit den zur Zeit berühmtesten Trickfilmern.

Die Geburtsstunde von Anima Mundi im Centro Cultural Banco do Brasil in Rio de Janeiro 1993 markierte den Beginn einer neuen Phase in der Geschichte der brasilianischen Bildanimation. Seit damals hat das Festival eine ganze neue Generation kreativer Geister stimuliert und geholfen, einen eigenen brasilianischen Ausdruck auf diesem Gebiet zu prägen. Gleichzeitig hat es definitiv zur Reifung der Filmindustrie und des -marktes beigetragen und dafür gesorgt, dass man innerhalb des Landes von der internationalen Entwicklung im Bereich Animation Notiz nimmt. Mit einem Programm, das auch während des Jahres fortgeführt wird,

bietet Anima Mundi Schülern aller sozialen Schichten die Gelegenheit, eine bereichernde Erfahrung zu machen.

Das individuelle Profil des Festivals erklärt sich aus seiner Entstehungsgeschichte: Vier Trickfilmer, die sich bei einem Kurs kennen gelernt hatten, der in Zusammenarbeit mit dem kanadischen National Film Board in Rio abgehalten wurde, waren es, die das Festival gründeten und es seither auch leiten. Aida Queiroz, Cesar Coelho, Léa Zagury und Marcos Magalhães übernahmen mit Vergnügen den Auftrag, ihr Land an der Renaissance teilhaben zu lassen, welche die Kunst der Bildanimation zu jener Zeit auf der ganzen Welt erlebte. Die intensive kuratorische Auswahl fand stets ihren Niederschlag bei den künstlerischen, experimentellen, informativen und didaktischen Aspekten des animierten Bildes, wobei man die Autorenfilme und die Vielfalt der Techniken und Stile betonte.

Mit Noturno gewann Aida Queiroz auf dem Festival von Havanna 1986 den Coral Negro-Preis für den besten animierten Kurzfilm. Zusammen mit Cesar Coelho führte sie Regie bei Alex, einem Film, der 1987 in Havanna und 1989 in Espinho ausgezeichnet wurde, bei Tá Limpo! und bei Petróleo! Petróleo!. 1990 erzielte sie mit ihrer Arbeit Mom's Love immerhin den 11. Platz bei einem Wettbewerb, den der US-amerikanische Musikkanal MTV für Comiczeichnungen ausgeschrieben hatte und an dem sich mehr als 600 Trickfilmer aus aller Welt beteiligten.

Cesar Coelho, der Autor von Informística (1986), schuf am Anfang seiner Karriere Illustrationen und Comiczeichnungen mit politischem Inhalt. Der Trickfilmer, der zweimal für Austauschprogramme mit dem National Film Board von Kanada ausgewählt wurde, hat sich auf Techniken des industriellen Animationsfilms spezialisiert. Zusammen mit Queiroz leitet er das Unternehmen Campo 4 Desenhos Animados, die größte Produktionsfirma traditioneller Trickfilme in Rio de Janeiro, die große Kunden aus der Werbe- und Fernsehwelt betreut.

Léa Zagury hat ihr Filmstudium an der Fakultät für Bildanimation am California Institute of the Arts mit einem Master abgeschlossen. Sie war Ko-Regisseurin bei Uma cidade contra seus coronéis und Urheberin der Kurzfilme Instinto animal, Slaughter, Salamandra und Karaiba. Karaiba wurde beim Sundance-Filmfestival 1994 vorgestellt und im gleichen Jahr in Houston, Aspen und in Ann Arbor prämiert und ein Jahr später außerdem mit dem National Educational Media Award ausgezeichnet. Zagury arbeitet unabhängig an Trickfilm- und Bebilderungs-Projekten in Los Angeles, ebenso an Unterwasservideos und hat auch Fernsehdokumentationen realisiert.

Mit seinem Kurzfilm Meow! errang Marcos Magalhães 1992 in Cannes den Spezialpreis der Jury. Er realisierte auch Mão Mãe (1979) und den am National Film Board in Kanada produzierten Film Animando (1982), des weiteren Tem boi no trilho (1988), Precipitação (1990), Pai Francisco entrou na roda (1997) und an der University of Southern California DoiS (2000). Bei Tá limpo! war Magalhães einer der Ko-Regisseure. Er war nicht nur für den ersten professionellen Trickfilm-Kurs überhaupt, der 1987 in Brasilien durchgeführt wurde, verantwortlich, sondern koordinierte auch Planeta Terra, eine Gemeinschaftsproduktion von 30 brasilianischen Trickfilmern für das von der UNO ausgerufene Jahr des Friedens. Er führte auch Regie bei dem ungewöhnlichen Film Estrela de oito pontas, der in Zusammenarbeit mit Fernando Diniz entstand, einem Maler, der sein Leben in einer psychiatrischen Klinik zubrachte.

ANIMA MUNDI –International Animation Festival of Brazil

Contact: Aida Queiroz,
 Cesar Coelho, Léa Zagury
 and Marcos Magalhães
Rua Elvira Machado 7
 casa 5 – Botafogo
22280-060 Rio de
 Janeiro - RJ Brazil
Phone: + 55 21 2543 8860
 & + 55 21 2541 7499
E-mail: info@animamundi.com.br

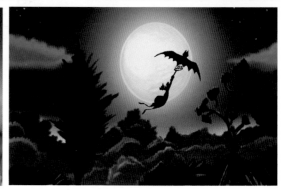

Pg. 348 Vampiro Mania (commercial spot), 2002
Rede Globo de Televisão
Dir.: Cesar Coelho
Traditional animation

Pg. 349 Animando / Animating, 1983
Dir.: Marcos Magalhães
Multiple techniques.

Pg. 350 Noturno, 1986
Dir.: Aida Queiroz
Pencil on paper

Pg. 351 (clockwise)

Flying Dutchman, 1995
Visual development
2D computer painting

The Red Shoes, 1995
Visual development
Pastel & guache

The Red Shoes, 1995
Visual development
Pastel & guache

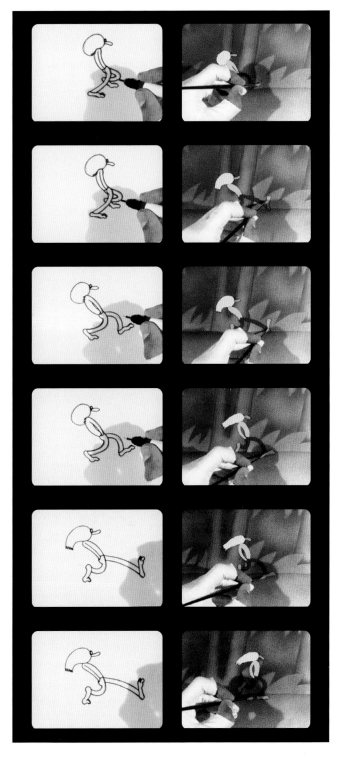

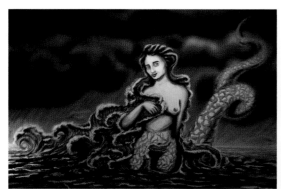

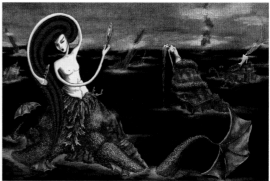

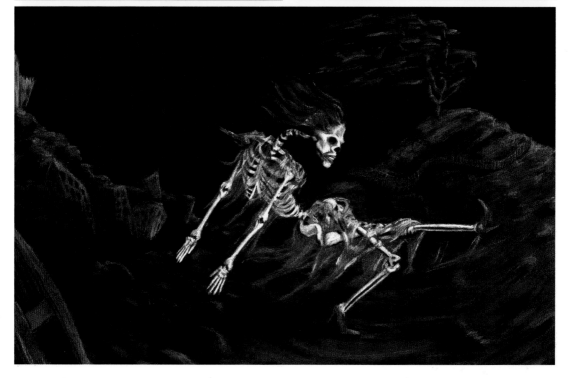

IMPRINT

To stay informed about upcoming TASCHEN titles,
please request our magazine at www.taschen.com/magazine
or write to TASCHEN, Hohenzollernring 53, D-50672 Cologne,
Germany, contact@taschen.com, Fax: +49-221-254919.
We will be happy to send you a free copy of our magazine
which is filled with information about all of our books.

© 2007 TASCHEN GmbH
Hohenzollernring 53, D-50672 Köln
www.taschen.com
Original edition: © 2004 TASCHEN GmbH
Design: Sense/Net, Andy Disl and Birgit Reber, Cologne & Julius Wiedemann, Cologne
Layout: Refinaria Design, Rio de Janeiro & Julius Wiedemann, Cologne
Production: Stefan Klatte

Anima Mundi
Directors: Aida Queiroz, Cesar Coelho,
Léa Zagury, Marcos Magalhães
Directors' assistant: Mariana Magalhães
General secretary: Leticia Cruz
Texts written and edited by Carlos Alberto Mattos, Rio de Janeiro

Editor: Julius Wiedemann
English Translation: Amanda T. Warren
German Translation: Isabel Rith
French Translation: Valérie Lavoyer
Spanish Translation: Anabel Galán
Italian Translation: Susy Manca

ISBN 978-3-8228-3789-4

Printed in China